Photography

Second edition

by John Ingledew with new text by Lorentz Gullachsen

Laurence King Publishing

1. Loading...

What's so great about photography? 6 / Why do we like photographs? 8 / Catching the shutter bug 9 / How does photography work? 12 / The eye and the camera 14 / Colour and black and white 16 / Where has photography come from? 17 /

2. The Big Picture

The portrait 26 / The self-portrait 41 / The city 49 / The landscape 58 /
The still life 63 / The body 66 / Fashion 74 / Telling a story with photos 82 /
The news photo 82 / Photojournalism and reportage 87 /
Documentary photography 90 / Telling the story of war 94 /
Telling a story in a book of pictures 100 / Sequence 103 /
Persuasion 108 / Manipulation 112 /

3. The Bridge

Finding inspiration 118 / Seeing things 120 / Creating your own projects 128 /
The camera in the hands of artists 134 / In the digital age 140 /
What makes a great photographer? 146 / What makes a great photograph? 148 /
The world's best-known pictures 148 / Trusting photographs 154 /
A photographer's responsibilities 156 / The snapshot 157 /
The Lomo snapshot 160 / The camera - the time machine 161 /
Beyond the print 163 / Where next for photography? 164 /

4. This Is A Camera, Now Go Out And Take Some Pictures

The tools of photography 166 / The camera 167 / Selecting a camera 170 /
Try these cameras 176 / The controls of the camera 188 /
Lenses 188 / Focus - to infinity and beyond 191 /
Aperture - the iris of the camera's eye 192 / Shutter speed - all in the timing 194 /
Exposure - bringing together aperture, shutter speed and focus 196 /
Composition - order or disorder 201 / Black-and-white photography 202 /
Colour photography 208 / Photography and light 214 /
Photoshop 223 / The photographic studio - Narnia 224 /
Pictures without a camera 225

5. So You Want To Be A Photographer?

Photo opportunities 228 / Photographer's portfolio - marketing 229 /
Fashion magazines 237 / Design groups and advertising agencies 239 /
Further photo opportunities 241 / Being an assistant - the sorcerer's apprentice 243 /
What do you need to be a photographer? 245 / Art college and university 247 /
Competitions 249 / Stock libraries 249 / Your archive 250 / Exhibiting 251 /
Prints and limited editions 251 /

6. The Bible

Photography and the law **254** / The language of photography **255** / Photographers' and artists' websites **265** / Must-see photo books **265** / Index **266** / Photo sources and credits **271** / Acknowledgements **272** /

Published in 2013 by Laurence King Publishing Ltd

361–373 City Road London EC1V 1LR Tel: +44 20 7841 6900 Fax: +44 20 7841 6910 email: enquiries@laurenceking.com www.laurenceking.com

© text 2005, 2013 John Ingledew and Central Saint Martins College of Art & Design, University of the Arts, London First published in Great Britain in 2005 Second edition published in 2013 by Laurence King Publishing Ltd The moral right of the author has been asserted.

All rights reserved. No part of this publication may be reproduced or transmitted in any form or by any means, electronic or mechanical, including photocopy, recording or any infomation storage and retrieval system, without prior permission in writing from the publisher.

A catalogue record for this book is available from the British Library

ISBN: 978-1-78067-096-6

New text for second edition: Lorentz Gullachsen
Picture research: Lorentz Gullachsen, John Ingledew, Peter Kent and Mari West
Design: Draught Associates Limited
Editor: Sarah Batten

Printed in China

Frontispiece: Nancy Wilson-Pajic Front cover: Lorentz Gullachsen Back cover: Lorentz Gullachsen

Loading...

What's so great about photography?

'Photography is a magical thing.' Jacques-Henri Lartigue.

The brilliant thing about photography is that anyone can take pictures and every photographer has the chance to create images in his or her own unique way. Photography is a potent and powerful force, able to tell huge stories in single images. Its diversity and possibilities are immense, and it is constantly evolving in exciting new directions. Photography is a very young medium and is now developing very, very fast. It has been around for such a short time compared to other means of artistic expression and it has so much more potential still to be explored.

'Photography is so young, we are still at the cave-painting stage. Maybe in another 500 years we'll reach photography's Renaissance.' Michael Hoppen, photographic collector, curator and dealer.

Photography's breadth is amazing. It feeds many aspects of communication including design, advertising, newspapers, magazines and the internet. The camera is increasingly used by artists to express their vision. Some photographers take pictures with extremely expensive cameras, but you can also make your own camera for next to no money at all. You don't even need a camera to produce images. The key to creating great pictures is not the equipment you use; it's about finding your own way of seeing things using photography. That's what all the photographers featured in this book have done.

It's thrilling when the results of your photographic experiments exceed your hopes. To stand in the darkroom and watch your pictures slowly appear from sheets of white paper is a magical experience. With its flashes of light, chemicals and formulae, photography is a kind of sorcery. Photography is the magic medium; people say that a particular photograph 'conjures up' memories or emotions for them. The fact that photographs can stop time by preserving moments that have now passed is itself extraordinary.

What is this book about and who is it for?

This book aims to be clear, easy to read and easy to apply. It explores the themes that have obsessed and driven photographers and takes an eye-opening look at the many wonderful things that can be done by creating and manipulating pictures. It looks at where photography has come from, at the modern medium and its future direction. It aims to inspire experimentation and exploration, give an overview of careers and education in photography, and be an essential creative resource and reference book.

Why is it called photography?

'Photo' comes from the Greek word *phos*. The ancient Greeks named the brightest star Phosphorus; *phos* meant 'created by light'. The combining form '-graph' comes from the word graphic, meaning sharply defined. Photographs are clear images created by light.

What makes a photograph?

Creating a photograph involves the consideration of lighting, focus, colour, contrast, quality and what can be seen sharply. Controlling these elements is what makes an image photographic.

This book is for people thirsty for knowledge about photography but bemused and bewildered by the more technical and theoretical books on the subject. As a starting point for many photographic adventures, this book is for people who want to learn more about photography in an active way. Nothing beats doing.

The mix that makes photography

Photography is a cauldron in which many different elements are mixed – chemistry, physics, optics, computers, electronics, commerce and, of course, creativity. Photography has always involved chemistry. Many experiments were needed to find the formula to make successful photographs. Today much home photography is still sent to the chemist for processing or printing, and professional photographers still take their pictures to the 'lab'.

Chemistry provides the active ingredients for film-based photography, which when carefully measured and controlled can ensure consistent and successful results. Electronics and computers have helped cameras and digital photography to evolve. Commerce ensures that photography is a medium developing much faster than other creative media, both technically and creatively. Manufacturers employ scientists and engineers to ceaselessly invent new ways of taking pictures, aiming to make us desire the latest equipment. Grand claims are made at every new product launch, predicting that the future direction of the medium has been found. In reality, photographers have an ever-expanding choice of tools and can pick materials and techniques from any stage of photography's progress to create their pictures. You can choose ancient processes such as cyanotypes or the very latest digital technology. Better still, you can combine the two. The final element in the mix is creativity. Only when creative minds explore the possibilities of all the materials invented by scientists and manufacturers can wonderful images be made.

Photography in the digital age

Digital photography is not just about taking pictures with a different type of camera. It involves combining digitized images with the power of the computer. These images can be produced not only from digital cameras but also from film negatives, slides and prints, which can all easily be digitized using scanners. A scanner simply converts an image into a form understood by a computer. Digital images can be edited and manipulated on the computer. They can then be printed, attached to emails and disseminated via the internet. Digitization has caused a sea change in photography, altering forever the way we think about photography and use cameras.

Digital cameras now outsell those that use film. Today it is possible to be a photographer without ever buying a roll of film, going into a darkroom or visiting a photo lab. But to limit oneself in this way would be to miss the opportunity of exploring to the full the joys and possibilities of the medium.

The structure of this book

Loading... is an introduction to photography and how we see, and a motordrive through the early history of the medium up to the pivotal date of 1900, at which point the camera came into the hands of everyone.

The big picture looks at the subjects and themes that have fascinated and driven photographers, and examines how they have evolved. Much of the power of photography is directly attributable to the passion with which the portrait, the self-portrait, the city shot, the landscape, the still life, the body, fashion and storytelling have been explored by photographers intent on finding fresh approaches. The Big Picture also looks at advertising and propaganda pictures, photomontage, sequence and the manipulation of images.

The bridge examines creativity and inspiration, and forms a link between the subjects of photography and how to take pictures.

This is a camera, now go out and take some pictures examines the ways in which photographs are created and the tools used in the process.

So you want to be a photographer? looks at careers in photography.

The bible is a help and reference section.

Why do we like photographs?

Photos and photography inspire us:

'When you're a kid, you sit and stare for hours at a great record sleeve or a book full of pictures – you want to take photographs so that you can create things that somebody else will want to stare at for hours.'

Kjell Ekhorn, photographer and art director.

'My father used to teach me things. He taught me about photography, how light passed through a lens and created a negative, bleaching out areas on sensitized paper. Somehow I realized that my skin could be a sensitized surface. Since [my sister] Louise was the photographic subject of the house, I put a negative of a picture of her on my upper arm, and taped it there with surgical tape. I was eight or nine, and we were still living in Cedarhurst, so I went out into the sun, in the backyard, with the negative taped to my shoulder. I actually kept it there for two or three days. Then I peeled it off, and there was Louise, burned into my skin. That was my first portrait.'

Richard Avedon, interviewed in *The New Yorker* magazine.

- Photographs get at the essence of things.
 They have the power to evoke, inform and inspire.
- Photography is a democratic medium global, inexpensive and accessible.
- We like the immediacy and clarity of photography: we read photographs quickly, if not instantly, and know straight away whether we like or dislike them.
- Photographs are seductive, they feed our imagination about what we want to look like and how we want to live. They fire our aspirations.
- Photos also allow us to treasure things.
 As the photographer Nan Goldin says, with photography 'you don't lose anything again'.

- We live our lives through photographs.
 They mark our rites of passage birth, birthdays, graduation, marriage, even death; they record our loves, encounters and travels all our arrivals and departures. The camera is omnipresent.
- Photography parallels the way we remember things. We recall an event or a person by seeing an image in our mind's eye. Our museums of personal memories are largely photographic.
- Photographers bear witness to events for us; they inform and educate us through their eyes.
- The camera preserves things that are now past, allowing us to see things that would otherwise be unseeable.

Catching the shutter bug

Photographers are curious – curious about the world, people, places and objects. They fall in love with the process of photography. They love the materials and tools; each contributes its own particular character to a completed picture.

Photographers are also obsessive and are possessed by passions. They are visual magpies, amassing series and sequences of pictures.

Our need to hold and pass on representations of ourselves is an instinctive human desire. For thousands of years this was only possible with drawings and paintings. Photography has now made this activity easy for us all. Confronted with our fading memories and mortality, we all want to make a permanent impression on the world and to leave a record of ourselves and our lives. Photos grant everyone this wish.

'We want to be photographers because we want to communicate. Photography gives us a direct means of engaging and speaking to an audience.'

Andrew Watson, photographer and teacher.

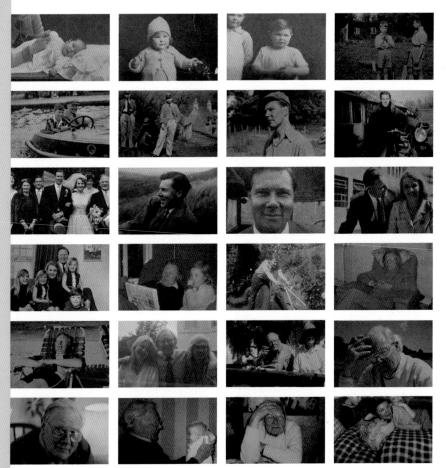

Derek Dawson, A Life in Pictures, 1922-2001

We record our lives in photographs taken from birth to death. These photographs are from the Dawson family albums.

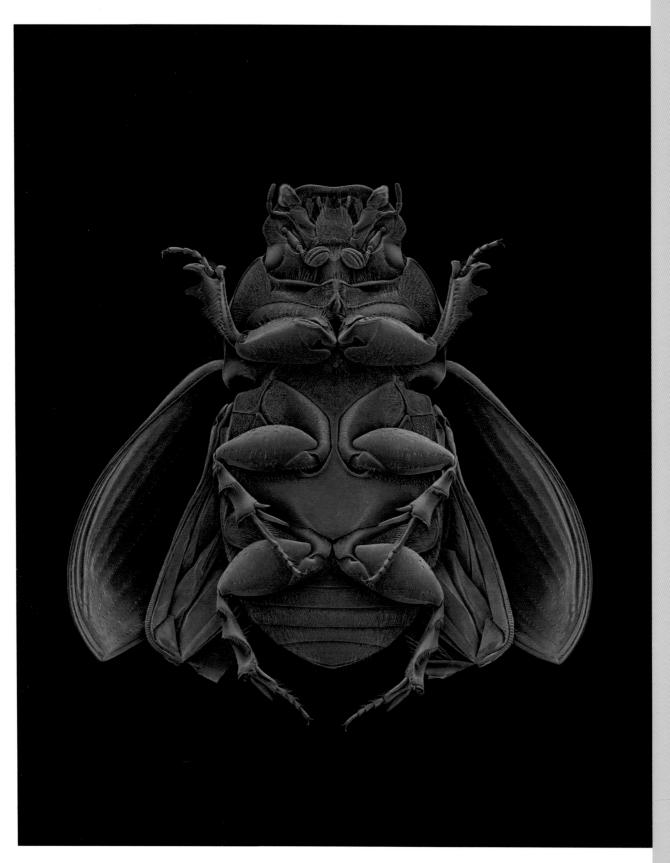

The power of photographs

With its terminology of shooting and capturing, photography seems to offer the possibility of excitement and adventure. Photographs can be remarkably powerful tools. They can melt taboos, sway public opinion and even impact explosively on governments to cause real change.

The flicker of the television picture is ephemeral compared to the fixed image of the photograph, which provides a tangible, permanent visual experience. Photographs get straight to the heart of an issue and can crystallize instantly an event or personality. They have the power to be hugely eloquent: a great photograph can be worth tens of thousands of words.

'Photography has image impact – a single image can say things beyond words, carrying meaning and feeling.' Vincent Lee, photographer.

Alison Jackson observed how photos have this spellbinding effect on viewers. 'If you take a photograph of someone, and put it beside them, you want to look at the photo, not the person.' Moreover, cameras not only create powerful images but are also empowering: We are empowered by the camera. Depending on whose hand it is placed in, the same camera can be a tool for coldly and impartially recording a scene or for creating fantasies. The same camera can be a simple note-taker or offer a deeply personal means of expression, allowing the photographer to communicate his or her emotions. Unlike the spoken or printed word, photography is a universal language everyone can understand – nothing is lost in translation.

Photographer Nick Knight describes the camera as a 'ticket in', explaining: 'I've been accepted into a whole bunch of situations that otherwise I would never have got near.' As well as granting you access to places and events that you might not otherwise be invited to witness, the camera gives you a licence to behave in a certain way – to talk to strangers, to control situations, to actively seek to get a different view and to ask for things in a way that you would never usually do.

'Having a camera around your neck gives you a good excuse to be nosy.' Martin Parr, photographer.

The camera gives you the ability to take something permanent and satisfying from every encounter.

Giles Revell, Scarab, 2002

The camera can see many amazing things that are beyond the power of our eyes to perceive unaided. Revell's startling and beautiful pictures of insects (opposite) are created by painstakingly combining and enhancing many hundreds of images from a scanning electron microscope. After training as a geologist, Revell turned to photography. He exhibits the insect pictures at a massive size of up to 8 feet high.

How does film-based photography work?

Black and white

- If you forget to polish a silver trophy or granny's silver teapot, you will
 notice that it turns black. The same chemical reaction holds the key to
 making photographs.
- Silver is sensitive to sunlight: the more it gets, the blacker it becomes. Black-and-white photography works by harnessing this reaction.
- Film and paper are coated with tiny bits of silver; when they are then
 exposed to light, the silver darkens according to the amount of light
 that falls on it, the effects being amplified by the use of chemicals.

Colour

- Film-based colour photography also makes use of silver's sensitivity
 to light, coupled with the fact that you need just three basic colours to
 recreate any particular shade of colour you can see.
- Scientists established long ago that by mixing red, green and blue in different proportions, you can create all the colours of the rainbow.
- Colour film has three different coats of silver similar to those used in blackand-white photography, but layered one on top of another. Each layer is designed to record one of the three essential colours – red, green or blue.
- During an exposure each layer darkens according to the amount of light of the corresponding colour that has fallen on its surface.
- In development each layer then absorbs a dye of one of the three colours again in proportion to the amount of light.
- A bleach removes all the silver, leaving a colour image created by layers
 of dye left on the film, which together recreate the numerous colours
 seen through the camera lens by the photographer.

How does digital photography work?

- Digital pictures are made up of millions of pixels which form a believable image when our eyes merge them into continuous tones. Each pixel is a solid block of colour. The word pixel is short for 'picture element', each pixel being a tiny element of the whole picture.
- When you take a picture with a digital camera, the image is divided into these tiny coloured building blocks by the camera's sensor, which matches every part of the image with one of the many millions of different colours it can sense. This is a bit like making a painting-by-numbers picture, but with millions of different pots of paint available. You can view the pixels in digital pictures by enlarging an area until the blocks are clearly visible.

Is film dead?

This book embraces the whole spectrum of photography. It is wrong to say that there is 'digital photography' and 'film photography' – there is only photography.

- Every single pixel's individual colour is recorded as a number or digit, hence 'digital photography'. Collectively, all these numbers are used to store, show and recreate the image by rebuilding all the blocks of colour in the same sequence to reform the original image.
- Once an image has been digitized, you can change any of the pixels to alter colour, brightness and contrast. This manipulation is achieved by changing the number of each pixel on a computer. As well as enhancing existing photographs, totally new images can be created and built by manipulating groups of pixels. Photos can be combined, colours boosted or muted and edges sharpened or softened.

There is no boundary between film-based and digital photography. Photographers combine the two in numerous ways.

'I like combining things, taking images created with the Lomo camera and the multi-lens camera that have been made on film and then using the latest technology – it lets you bake things together, overlay things and add things.'

Fabian Monheim, photographer.

Where have digital cameras come from?

Digital cameras evolved from the technology developed to record television pictures. By the early 1950s scientists had created the first video recorder, which could save live images from TV cameras by converting them into digital information and storing it on tape.

Digital images are made from millions of tiny coloured blocks which become visible when an image is greatly enlarged.

British artist Mat Collishaw is one of the many people who have been inspired by the beauty of the patterns of pixellation. He has created huge ceramic artworks out of small bathroom tiles in imitation of the way digital images pixellate. American artist Chuck Close used blocks of flat tone to examine the surface of the human face in paintings that predate the pixel.

The eye and the camera

The view we see with our two eyes is roughly ovoid, with the periphery of our vision blurring the shape towards the edges. The camera lens, by contrast, produces a circular image, but the camera has been designed to select a square or rectangular section.

Our eyes and cameras have a lens that focuses the light reflected from objects. Like the camera, the eye also has a shutter – the eyelid – and a variable aperture – the pupil. Both the eye and the camera work with light-sensitive surfaces: the eye has the retina, which is covered with a multitude of light-sensitive cells, while the camera uses film or a CCD sensor.

We see in stereo. Our eyes capture slightly different views, which our brains then unify into a single whole. The tiny difference in viewpoint of each eye allows us to perceive three-dimensional depth. This is called binocular vision. Photographs are two-dimensional representations of what we see through the camera. Three-dimensional depth can be replicated with stereoscopic photographs, which are viewed through binocular viewers, and anaglyphs, which are viewed with red and green '3D' glasses.

As we look around a room our eyes instinctively change focus to concentrate on the object we are looking at, giving us the impression that our eyes are never out of focus. We see selectively: when looking at an object, whether near or far, our eyes focus on it to the exclusion of everything else. The camera can focus like this but it can also give a view with everything in its vision sharply focused, from near to far – a view we can never have with our own eyes. The closest distance at which the human eye can focus is about 8 inches or 20 centimetres. The focusing range of a camera lens has no lower limit.

Our eyes have evolved to cope with incredible contrasts of bright light and deep shade. Hence, we can see everything with great clarity on the brightest of days and our eyes adjust instantly when we move from a darkened room into bright sunlight. The pupil of our eyes reacts instantly to maintain the level of light falling onto the retina, whereas the photographer must either manually or automatically vary the aperture of the camera to darken or brighten what he records. Cameras can also register events or objects that the eye cannot by using exposures of fractions of a second or many seconds, minutes and even hours.

Katrin Geilhausen, Eye (Close-up), 1995

Many photographers create their own palette of colours, as German-born photographer, illustrator and animator Geilhausen has done here (opposite). 'The image was shot on slide film, which was then processed and used as a negative. The eyelashes of the model were painted white so that when printed in negative they would look positive. I love spending hours in the colour darkroom – it's a slow process with lots of time in the pitch black during which new ideas stream into your head like big rainbows.'

Colour and black and white

Although the eye can see a wide range of colours, the photographer has a much broader palette and can create images in colours not seen in the real world. By selecting a particular kind of film or manipulating digital images, the photographer can create pictures of great subtlety or vividness in their use of colour; alternatively, they might be in black and white. Scientists say the only time we see in black and white is when we are in extreme danger – when the body shuts down all unnecessary functions to concentrate all reflexes on the immediate crisis.

The human eve can only distinguish colour if there is sufficient light. Colour appears clearly to our eyes in bright light and increasingly as shades of grey in low light. The camera can retain colour to a greater degree than our eyes in lower-light conditions. Our brains have evolved to compensate and homogenize what we see in various ways. The image we see, for instance. is inverted by the brain, which also overrides changes in the colour of light. We see - or imagine we see - many light sources as white. Tungsten light, sunlight, candle light, strip light and the light from household bulbs all appear to us as white. Film, on the other hand, is very sensitive even to minor colour changes in light and will always record them.

Hiroshi Sugimoto, Cabot Street Cinema, Massachusetts, 1978

Photography can extend our vision. Sugimoto's picture was taken with an hour-and-a-half exposure during the entire length of a movie. The photograph sees neither the movie nor the audience, whose passing is too fleeting; only the solidity of the building is recorded. Sugimoto uses a 10x8 plate camera anchored on a tripod to take very long exposures that record things that can only be witnessed through photography. Sugimoto's work is discussed in The landscape, p. 58.

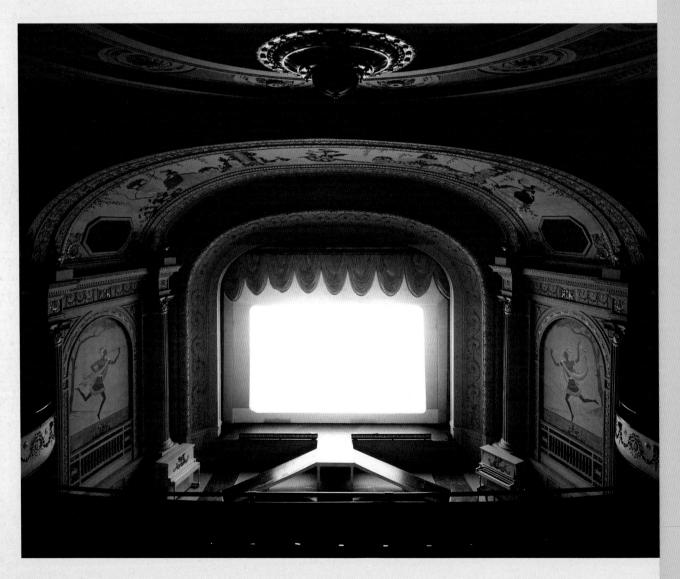

Where has photography come from?

The ingredients of photography

Cameras today use exactly the same ingredients that the pioneers of the medium worked with – a black box with a hole in it to let in the light, a lens and materials that are sensitive to light. These elements had been experimented with for centuries before finally being successfully combined to create photographs.

Over 500 years ago, during the Renaissance, people understood that a small hole in the wall of a darkened room could act like a lens and project images of the scene outside on to the opposite wall. This effect was named 'camera obscura', which means dark room. This is how the camera got its name. There are many working room-sized camera obscuras in existence that can be visited today, such as in Greenwich in London. In the United States there is one called the Giant Camera, which overlooks the sea in San Francisco.

The lens and the magic black box

The light-bending power of a lens had been known in many ancient cultures. In ancient Rome, scholars with poor eyesight found they could read text by peering at it through glass globes.

Segments of a glass sphere, known as 'reading stones', were found to magnify letters when placed against books. By 1300 such magnifying glasses were in common use. Craftsmen in Venice – one of the centres of glass grinding and polishing – began making small discs of glass, convex on both sides, that could be worn in a frame. These were the first reading glasses. As these little discs were shaped like lentils, they became known as 'lentils of glass', from which we get the word 'lenses'. The earliest illustration of these glasses dates from about 1350.

In Naples at the end of the sixteenth century a scientist and writer called Giovanni Battista della Porta experimented by placing a lens in the hole in the wall of his camera obscura. He found that the lens cast an upside-down image on the opposite wall and that it both sharpened and brightened the image. He invited friends into his camera obscura for a show. When they were seated in the darkened room he uncapped the lens and a troop of actors began to perform in the sunlight outside. On seeing tiny figures cavorting upside down on the wall, della Porta's guests fled in panic. He was brought before the Pope's court on charges of sorcery. Fortunately, he was able to talk his way out of it.

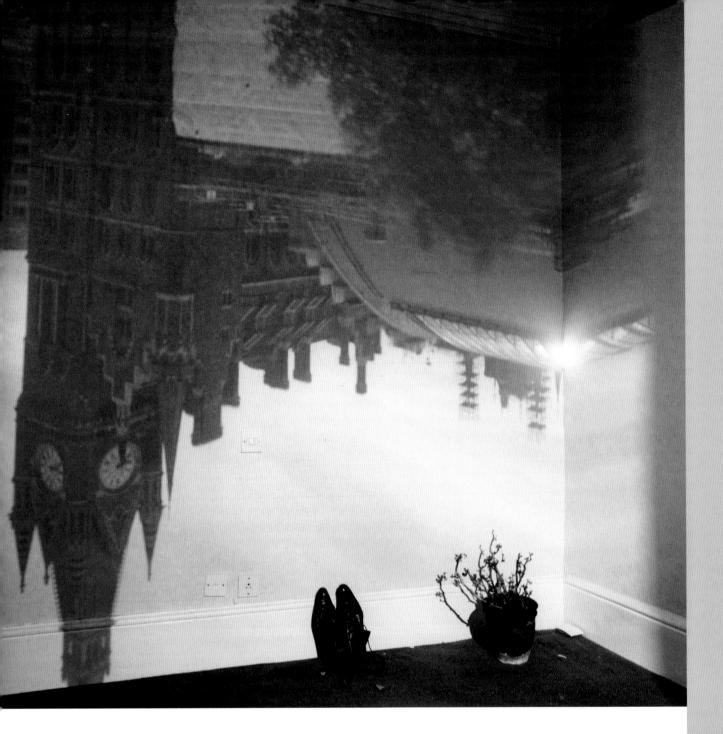

Minnie Weisz, Norfolk Suite Camera Obscura

Minnie Weisz uses the principle of the camera obscura to create images on the interiors of rooms that she has sealed from light with the exception of a small hole, thus producing an inverted image of the outside view. Even in today's visually exciting times, the experience still amazes those who witness it.

Light-sensitive materials and the silver rush

It had been known for many centuries that silver salts blackened in sunlight and might hold the key to preserving images made in a camera obscura. By the early 1800s many scientists, inventors and businessmen were competing to find a formula. Some were seeking scientific and creative discovery, others financial reward. There was a desperate rush to be the first to succeed.

After much trial and error, silver chloride was found to darken in the light and silver nitrate could be coated on paper or leather to imprint the shadows cast by objects. Despite these discoveries, 'fixing' these images still proved impossible as they continued to react to light until the whole surface darkened and the picture was lost.

The world's first photograph

After experimenting unsuccessfully with silver nitrate-coated paper inside a camera obscura, the French lithographer and inventor Joseph Nicéphore Niépce tried coating sheets of pewter with bitumen of Judea, a substance known to harden when exposed to light. One summer's day in 1826 he slotted a pewter 'plate' into his camera obscura and propped it on the ledge of his attic window overlooking the rooftops, a pear tree and a pigeon house. After leaving it there for eight hours he tried washing the plate with lavender oil and found he was able to remove the soft areas that had received less light. The resulting image was fuzzy – in the eight-hour exposure period the shadows had moved across the picture with the movement of the sun – but the scene was nonetheless clearly visible.

Niépce had created a direct positive image – a photograph without a negative – which he proclaimed as 'the first picture copied from nature'. This was the world's first permanent photograph, in Niépce's terminology a 'heliograph', or sun drawing.

The daguerreotype seizes the light

Niépce teamed up with the Parisian Louis-Jacques-Mandé Daguerre to refine his process, finding that polished silver plates gave a better picture quality. Daguerre worked in Paris running a diorama, a thrilling and ingenious venue where, using magic lanterns, painted backdrops and sound effects, he created dramatic dissolving views, illusions of sunrises, sunsets and storms complete with thunder and lightning.

After Niépce died suddenly in 1833, Daguerre continued to experiment and develop their work, finally arriving at a practical process that he named the 'daguerreotype' - somewhat forgetting M. Niépce's contribution. Daguerre declared: 'I have seized the light, I have arrested its flight.'

The process worked as follows. A silver plate was placed in a closed box containing iodine. The fumes of iodine fused with the silver, creating light-sensitive silver iodide. The plate was then fitted in a camera obscura and exposed for up to thirty minutes. After this it contained a latent image an image that is registered on the silver surface but isn't yet visible.

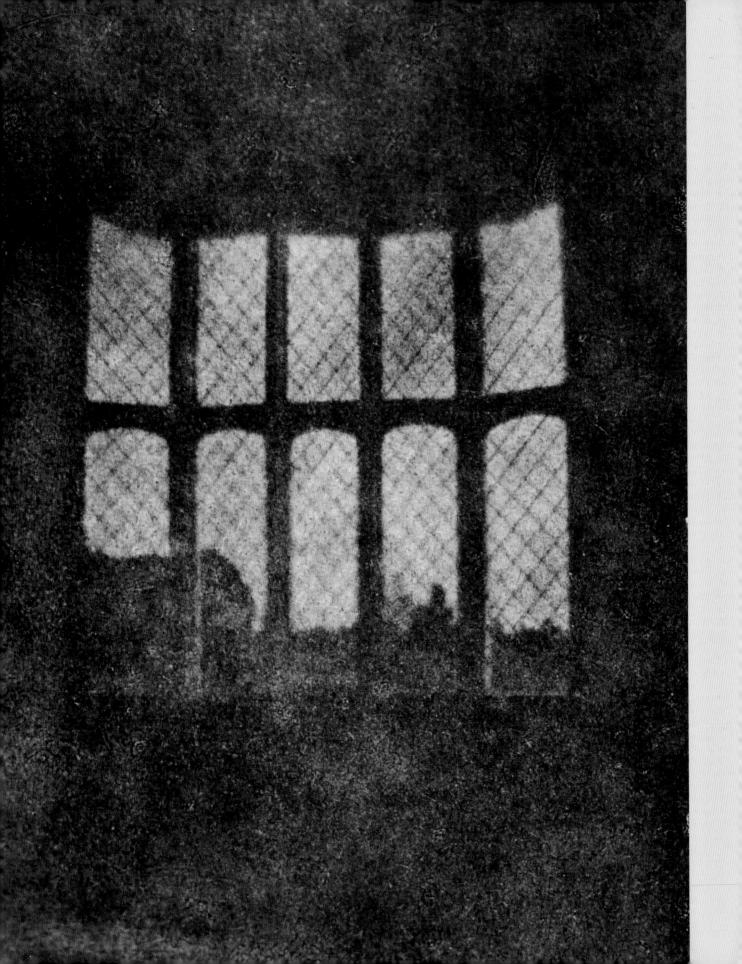

Daguerre found he could 'develop' this image with mercury fumes so that it could be clearly seen and that common table salt would stop the plate from continuing to react and thereby 'fix' the image. The process created pictures that were mirror images of the scene they recorded. As no negative existed, each daguerreotype was a unique, non-reproducible picture.

Daguerreotypes have a beautiful clarity and are surprisingly sharp, revealing great detail. The silvered surface creates an elusive image that can only be seen from certain angles. It also acts as a mirror at other angles so that viewers can see their own reflection. The daguerreotype became known as 'the mirror with a memory'. All of this added to its magic. In 1839 Daguerre caused a sensation when he opened the doors of his studio to an excited Parisian public keen to view his photographs. He published his techniques in a seventy-nine-page manual which was an instant hit – within hours chemists and opticians shops were stormed by would-be photographers seeking the magic ingredients of photography. Daguerre was acclaimed for giving the world the knowledge of how to successfully create photographs and was granted a government pension by way of reward. Daguerreotypes continue to be created today.

Cameras travel around the world

The daguerreotype and Daguerre's camera design became incredibly popular despite the crudity of the lens and the clumsiness and complexity of the developing process. A year after the launch, in 1840, Josef Max Petzval, a maths professor at the University of Vienna, solved some of these problems by calculating how a new type of lens could be constructed. Working with telescope-maker Peter von Voigtländer, they created a lens that admitted nearly sixteen times more light into the camera than Daguerre's. At the same time they also made an attempt to build the first purpose-built camera – not just a modified camera obscura. It looked like a short, fat brass telescope and took circular pictures. Petzval's lens design was to remain in use for sixty years. Thousands of lenses were produced and their design was copied throughout Europe and America.

In those early days exposures were still made by removing and replacing the lens cap, and long exposure times meant a tripod or stand was needed to keep the camera steady.

Soon the daguerreotype process had become widespread. Wealthy amateur explorers started bringing back pictures of people and landscapes from all over the world, and news pictures were being taken for the first time. Every town and city soon had its own 'Daguerrean artists' – the first professional photographers. By 1850 New York had seventy-seven.

Daguerreotypes were kept under glass and presented in richly decorated frames, often lined with satin, with a hinged cover and a clasp to protect the image. Daguerreotypes were often signed by the photographer as a painting would be by an artist.

William Henry Fox Talbot, Latticed Window at Laycock Abbey, 1835

Although Niépce had created the first photograph, it was Fox Talbot who discovered that images could be reproduced by creating a paper negative using silver-based chemicals. From this beginning, photography continued to depend on silver and the use of negatives for the basis of the photographic process, until the advent of digital technology in the late twentieth century.

Positive and negative

While Niépce and Daguerre had been experimenting with camera obscuras in France, the scientist William Henry Fox Talbot was making his own photographic discoveries in England. In 1841 Talbot announced his own process, which worked by creating paper negatives. His first successful picture was a famous postage stamp-sized photograph taken through his library windows. Talbot made his discovery by experimenting with primitive cameras he nicknamed 'mousetraps' - tiny wooden boxes with lenses in the front made by his village carpenter - loaded with light-sensitized paper. Talbot patented his process, calling it the Calotype – from the Greek kalos, meaning 'beautiful picture'. Calotypes were waxed-paper negatives that for the first time allowed multiple prints of the same photograph to be made. The popularity of daguerreotypes began to wane owing to the complexity of the process and the non-reproducibility of the images. By the early 1850s the combination of the wet-collodion process glass negative and albumen prints evolved from Talbot's inventions – replaced the daguerreotype as the standard method of taking and printing pictures for most photographers. This negative/positive process became the basis of photography until the arrival of the digital camera.

Enlargers

The first enlargers were made in 1857 and were known as solar cameras. They used direct sunlight to project an image from glass negatives onto sensitized paper. Until then contact printing had been the only available method of printing. By the 1860s the first enlargers using electric light had been designed.

Bellows cameras

As cameras evolved in the 1850s and 1860s, flexible leather bellows became standard, allowing the camera's lens to be moved back and forth to focus more finely. Photographers viewed the scene through a ground-glass screen at the back of the camera, replacing it with a plate holder when they were ready to take their pictures.

Shutters

By the 1870s new types of photographic plates were being manufactured that were far more sensitive to light. However, photographers found they couldn't accurately cap and uncap the lens for short amounts of time and so now needed a 'shutter' device that could reliably open and shut the lens for fractions of a second.

The first shutters were fitted in front of the lens – they were like small guillotines – and contained a sliding board with a hole in it. When the photographer released the board, it slid past the lens, only letting light through to it for the instant that the hole passed by. Shutters such as these, rigged with elastic bands, allowed Eadweard Muybridge in 1872

Kodak: 'you press the button, we do the rest'

In 1888 Eastman – in a brilliant piece of marketing – launched the first camera to use roll film. He christened his small handheld box camera the 'Kodak', a snappy name that he felt could be pronounced anywhere in the world. He promoted the camera with the slogan 'you press the button, we do the rest'. The Kodak cost \$25 and came with enough film for 100 circular pictures. It was loaded with Eastman's latest invention – transparent celluloid 'film' coated with emulsion. After taking your 100 pictures, you simply mailed the camera to the Kodak factory, which printed the pictures and posted them back with the reloaded camera.

The Kodak was a huge success and was followed by a \$5 'pocket' camera and then, in 1900, by the

six-picture 'Brownie' camera which sold for just \$1. Eastman had totally transformed photography. For the first time it became accessible to tens of millions of people and a new era of picture-taking began.

The Kodak Brownie was originally designed for children, but – contained in a box decorated with images of happy mischievous imps – it was quickly taken up by adults as well. A once elitist and expensive medium had been put into the hands of everyone. It is possible that there are now as many cameras in the world as people, and certainly more pictures are taken every second than at any previous time in history. Cameras surround us more than ever before, offering fantastic creative possibilities.

The Brownie was revolutionary when launched, making photography accessible to the masses. The next revolution came in the late twentieth and early twenty-first centuries when digital capture overtook film as the primary photographic medium. What will the next photography revolution be?

The Kodak Camera

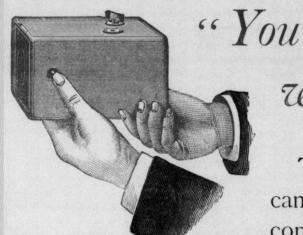

"You press the button,
we we do the rest."

OR YOU CAN DO IT YOURSELF.

The only camera that anybody can use without instructions. As convenient to carry as an ordinary field glass World-wide success.

The Kodak is for sale by all Photo stock dealers. Send for the Primer, free.

The Eastman Dry Plate & Film Co.

Price, \$25.00 — Loaded for 100 Pictures. Re-loading, \$2.00.

ROCHESTER, N. Y.

to photograph the movement of a horse in mid-gallop with shutter speeds of around 1/500 of a second. (See Sequence, p. 103.)

In 1878 the gelatin dry plate process replaced the wet plate negative. This freed photographers from the need to use wet plates, which had to be sensitized and developed on the spot. The exposure times needed for dry plates were very short so at last photographers could handhold their cameras.

George Eastman

Great progress in the technical and cultural development of photography was made by George Eastman, an inventor and industrialist who foresaw the commercial possibilities of photography and began manufacturing and marketing his photographic inventions on a massive scale.

Eastman's first success was a roll holder which adapted the conventional wooden plate camera to take a roll of sensitized paper of up to forty-eight exposures. This was another great step forward for photographers. The fragile and heavy glass plates or metal sheets that had to be carefully slotted in and out of the back of the camera could be replaced with a lightweight roll. Photographers could work with much greater ease and take numerous photographs quickly for the first time.

The portrait

Some photographers have a passion for people and a fascination for faces. Their natural subject is the portrait. We have a very powerful urge to see ourselves and people have always been the favourite subject of photography. We see pictures of people in every magazine and newspaper, in numerous books, galleries and museums. In central London the huge National Portrait Gallery is dedicated solely to pictures of the famous. But what makes a photograph of someone a portrait?

What is a portrait?

A portrait attempts to express the character of a person and pin down the sitter in the hierarchy of their world, socially and physically, showing status, authority and significance. A portrait offers insight into a person beyond the details of appearance, revealing unknown sides of his or her character or showing a fresh perspective on someone we know well.

To create a portrait you need more than someone just standing in front of your camera. Having someone framed in the viewfinder and clicking the shutter doesn't mean you've taken a portrait of that person. The result is often just a composition or a likeness revealing little other than features, location and outfit – though history can add weight to these images as places change, clothes become dated or the person famous.

Many things stand in the way of creating a portrait. When being photographed, most people have a self-awareness about the presence of the camera and present a habitual expression and pose to the lens that they know will look satisfactory. Despite our best efforts, though, it is impossible not to betray some small clues to our true identity.

To take a portrait the photographer must somehow search and penetrate beyond a sitter's guard. The photographer Eve Arnold said that the portrait photographer should 'get into the soul of the person'.

Photographer, sitter and viewer

There is always more than one person in a portrait: there's the sitter and the photographer. Together they create the portrait, it is a record of their encounter. But is it a meeting between equals?

'My portraits are more about me than they are about the people I photograph.'

Richard Avedon.

John Szarkowski introduced a book of portraits by saying that 'a portrait is a battle between two wills for the control of the sitter's soul', seeing taking portraits as a fierce wrestling bout. Some portraits do indeed reflect this battle; in others the encounter appears to be far more collaborative.

Alastair Thain, Richard Long, 1990

Finding himself dissatisfied with the quality of image he could obtain with a standard large-format camera, Alastair Thain decided to construct his own. In a single-minded mission to achieve photographic excellence, he built a series of massive large-format cameras with which to take portraits. He shoots on black-and-white, ultra-high-definition satellite reconnaissance film. This portrait of artist Richard Long (opposite) is from a series of pictures of artists, actors and musicians published in the book *Skindeep*. Thain photographed Long in front of one of his own mud-circle artworks.

Photography The Big Picture

In addition to the sitter and the photographer, the viewer is intimately involved in a portrait. The viewer completes a portrait. All prior knowledge of the sitter colours the viewer's vision. Everything known about the sitter is imprinted in the viewer's mind, including other images of the subject. Knowledge and the prism of history magnify photographs, changing how they are viewed. Viewers react to an incredibly simple photograph of a familiar face or famous person in a totally different way from the way they would to the same composition of someone unknown, seeing one as an insightful portrait and the other as merely a snap.

Great photographic portraits create a unique, unforgettable chemistry, formed by the relationship and interaction between the sitter, the photographer and the viewer.

Questioning photographic portraits

Does the photograph reflect a unique meeting of photographer and sitter, or could anyone have taken the picture? Who has the balance of power – the sitter or the photographer? Who's in charge?

Does a picture of a person reveal and give insight beyond the details of appearance? Is the sitter happy in their own skin? Do we see their essence? Are we offered an original view? Is the sitter unveiled or is the sitter merely flattered? Do we see the familiar or an unfamiliar face of that person? Is it possible not to pose? Is it possible to reveal nothing – is there such a thing as a 'blank expression'? Are we captivated, touched or moved by a photograph of someone? How much does it reward intimate and repeated viewing – how demanding is a picture?

A portrait preserves the subject and photographer for posterity. How will the sitter and the photographer be judged by a future audience – when both are long dead? Does a long-dead sitter speak to you across the years in their portrait?

The tools of the portrait photographer

The tools chosen by the photographer have a vital influence on the final image. Photographers choose to work with flash light, tungsten light or daylight, in studios or 'on location', and select particular cameras for the effect they will have on the image. Some photographers choose the fierce scrutiny of the large-format camera, others the Lomo camera. Some choose soft lighting, vivid colour or to manipulate pictures digitally after they have been taken. Great portrait photographers select a camera, light source and method of output for their inbuilt creative character, finding their own way of combining and using these tools to create a unique means of portraying people.

Curator, critic and writer on photography John Szarkowski was one-time curator of photography at the Museum of Modern Art in New York. He 'discovered' the seventy-year-old Jacques-Henri Lartigue in 1963, and exhibited the work of Diane Arbus, Garry Winogrand and Lee Friedlander at MOMA in 1967 in the 'New Documents' show. His staging of photography in place of painting in a major public art gallery was perceived as revolutionary at the time — a prelude to the acceptance of contemporary photography in art galleries and collections worldwide. Szarkowski has been called 'one of photography's important seers'.

Face value

Photographers approach the ceremony of portrait-taking in different ways – seeking revelation and intimacy. Many concentrate on the face, relying on the details of features and expression. 'Head shots' can have great intensity. If taken with a medium- or large-format camera, they give a striking level of detail about the landscape of the face. We seldom if ever stare at length at others – even loved ones; the head shot lets us do this, giving the viewer a great visual intimacy with the sitter's eyes, eyelids, mouth, hair and pores of the skin.

Canadian photographer Yousuf Karsh (see www.masters-of-photography. com) used a 10x8-inch format camera to take head shots that he then printed larger than life, making his sitters look powerful and monumental on a Mount Rushmore scale. American artist Chuck Close (see Chuck Close, Daguerreotypes [Alberico Cetti Serbettoni Editore, Italy, 2002]) revels in extraordinary human detail, creating huge close-ups using daguerreotypes, a process that was used for the very first portraits over 150 years ago. Their intense clarity gives the viewer the opportunity to examine his sitters' faces microscopically.

Details

Very telling portraits have been created examining key details of a sitter – the hands of sculptors and artists, the fists of boxers, and the feet of dancers and sportsmen. Bill Brandt photographed in tight close-up the eyes of visionary artists including Henry Moore, Max Ernst, Georges Braque and Alberto Giacometti. The ephemera of a person's life can also be very revealing.

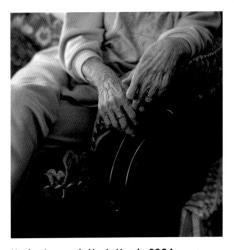

Hayley Leonard, Nan's Hands, 2004
'I set out to take a portrait of my grandmother that revealed her personality and character. I didn't want it to be posed and I wanted to retain the atmosphere of her cosy flat. I used available light together with one tungsten light that I bounced to add further soft lighting. The picture was taken with a Bronica medium-format camera, with the lens set to a wide aperture to gain a short depth of field.' Leonard is a photographer and designer working in Liverpool.

The plain-background portrait

Photographers often choose to photograph people against white or neutral backgrounds, a method of working used throughout the history of photography. The person stands isolated from his or her natural environment, allowing the viewer a closer inspection of pose, dress and face. Richard Avedon (see www.richardavedon.com) spent five summers creating a series of plain background portraits which were compiled in his famous book *In the American West*. Avedon shattered many myths and stereotypes with these images. There are no heroic cowboys; instead, he reveals an America populated with sinewy manual workers seen exhausted with toil, drifters and the unemployed, the disappointed and disenchanted.

Avedon took the *In the American West* pictures in different locations but always used the same methods. They were all taken with a Deardorff 8x10-inch format plate camera, on bright days but in the shade so that there are no direct or strong shadows.

Avedon kept a constant vision and stuck to the same working methods throughout his career, photographing the famous, the wealthy, the poor and the condemned in exactly the same way against white backdrops. The portrait of Ronald Fischer neatly echoes his portrait from twenty years earlier of walnut-faced poet W.H. Auden, who, similarly centred in the frame, stands on a bleached background of snow in a New York street, his face and body flecked with falling snowflakes.

Irving Penn (see www.masters-of-photography.com) also loved the simplicity of the plain-background portrait, feeling that its straightforwardness gave his pictures an honesty. Penn's photographs are lit solely by the daylight falling into the studio, or with studio lights arranged to ape the effects of his skylight. He pushed together two stage flats, giving his subjects a corner in which to compose themselves. It is a stark stage, with nowhere to hide, as Penn's camera traps them; he has them cornered.

The studio portrait

The studio offers the photographer great control of the mood of an image. Cecil Beaton created amazing and stylish studio backdrops in the 1930s from cheap materials – torn paper, cellophane and Bacofoil – predating Warhol's silver studio by three decades. Madame Yevonde and Angus McBean used the studio to stage fantastically idiosyncratic portraits. McBean created strange landscapes sculpted with sand in front of painted backdrops of stormy skies. His portraits are dreamlike pictures with odd confusions of scale, his subjects often appearing with their heads trapped in bell jars. Madame Yevonde photographed English society beauties in vivid colour wearing flowing Greek and Roman costumes, lit with great theatricality. Her aristocratic sitters appear more than happy to be seen as goddesses.

Richard Avedon, Ronald Fischer, beekeeper, Davis, California, May 9, 1981

© The Richard Avedon Foundation
There are few smiles to be seen against the empty
nowhere of Avedon's bleached white backdrop
used throughout *In the American West*, with many
of the people seeming prematurely aged. The
most famous of these pictures is of beekeeper
Ronald Fischer – a picture that was sketched
and planned meticulously before execution. The
beekeeper stares at us unflinchingly from the
centre of the frame despite the fact that some
of his swarm are crawling into his ears (opposite).

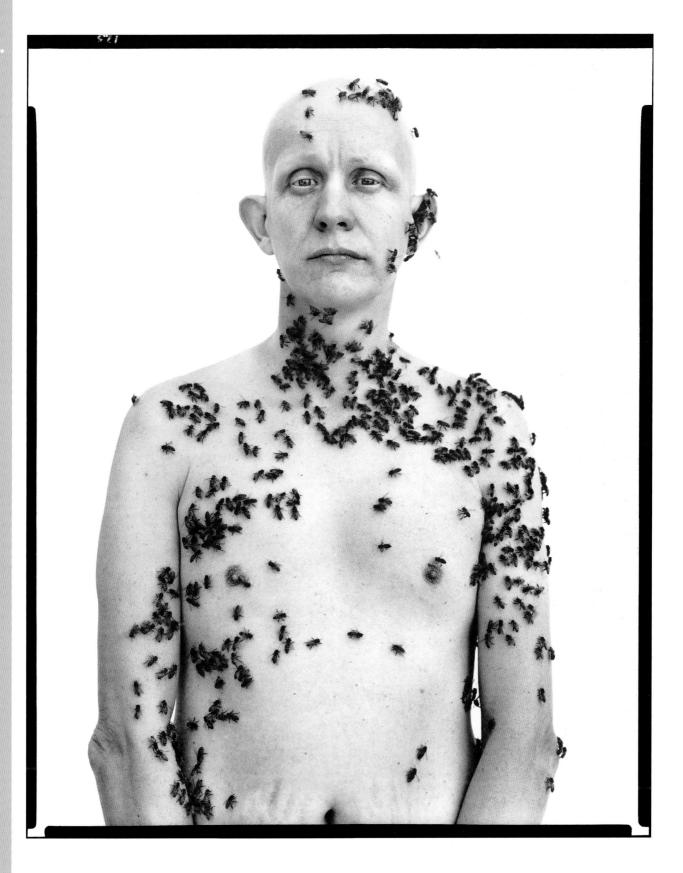

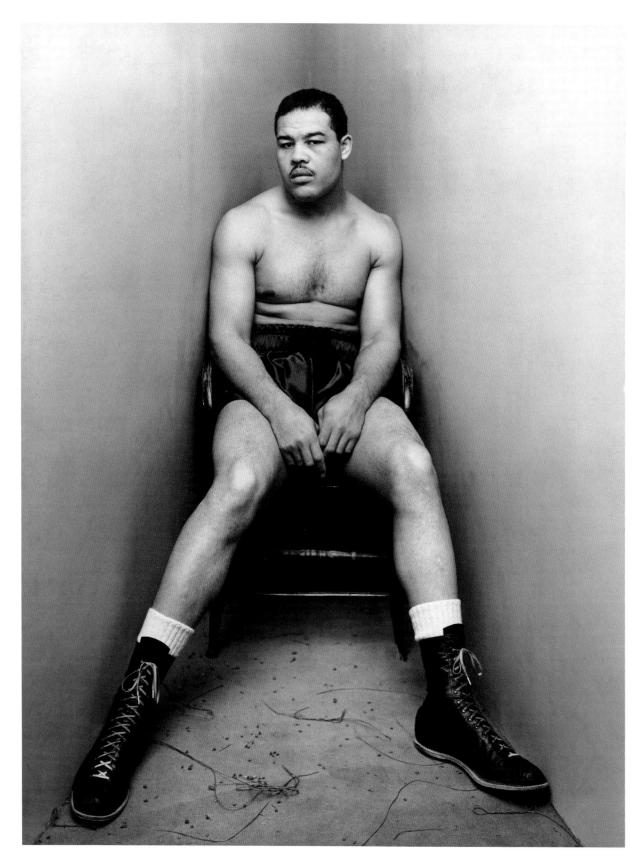

Robert Doisneau used the studio to give clarity and impact to an image of French comic actor Jacques Tati looking bewildered in a sea of whiteness, as he stands surrounded by the bits of a bicycle that appears to have just exploded from under him. The success of a portrait can come from the sitter reacting to a great idea, either inspired by something found on location or pre-planned and carried out in the studio, as with Doisneau's portrait of Tati.

Rineke Dijkstra, Hilton Head Island, S.C., USA, June 24, 1992

Dutch photographer Rineke Dijkstra finds plain backgrounds against which to photograph people singly, creating series of pictures of young clubbers, mums with their new-born babies and blood-spattered matadors fresh from killing. She used the sky as a backdrop in a series of pictures shot in Poland, Croatia, Ukraine, Belgium and Coney Island of adolescent girls standing awkwardly in swimsuits. The plain backgrounds intensify the strength of the pictures and magnify the straight-to-camera poses. This image (left) echoes Botticelli's The Birth of Venus and is lit with a mixture of flash and available light.

Irving Penn, Joe Louis, 1948

Having famously adapted his studio to create a stark, acute corner backdrop for his portraits, Penn shot world-famous and much-photographed celebrities, producing very revealing pictures. In his portrait of champion boxer Joe Louis (opposite), the boxer looks not only vulnerable but defeated. Was this Penn's intention: providing a way to see the inner child of a great athlete?

The ideal sitter

Salvador Dalí was an ideal subject for a portrait photographer. He was way ahead of his time in realizing the possibilities that photographic portraits offered to promote a sitter's career: the more dynamic the picture, the more often it would be published and the bigger it would be used. Dalí would react positively to the wildest ideas and suggestions from photographers. Where some famous people will only give photographers a small amount of time in which to take a picture, he would happily invest hours of his time to ensure photographers got what they wanted. He was the perfect collaborator, happily leaping time and again for Philippe Halsman, peering through a magnifying glass so that Peter Beard could photograph his face strangely distorted, and standing up to his neck in the sea with flowers in his moustache for Jean Dieuzaide.

Arnold Newman, Georgia O'Keeffe, Ghost Ranch, New Mexico, 1968

Georgia O'Keeffe (opposite) is framed by a blank canvas and a skull, on her ranch in New Mexico. O'Keeffe used the skull as a motif in her paintings. Arnold Newman was a master of environmental portraits, his images informed by his knowledge of art and a technical ability to work with large-format cameras. He was able to communicate with his sitters as if the camera was not there.

Philippe Halsman, Dalí Atomicus, 1948

Halsman suggested the idea for this picture (below) to Salvador Dalí after seeing his painting Leda Atomica in which everything appeared suspended in mid-air. Halsman suspended an easel, a stool and two Dalí paintings (including Leda Atomica itself on the right of the picture). Dalí's wife held the chair in the left of the photo, and on the count of three Dalí leapt while Halman's assistants chucked a bucket of water and three cats in the air. After half a day and twenty-eight attempts they had a perfect image, the product of an amazing collaboration.

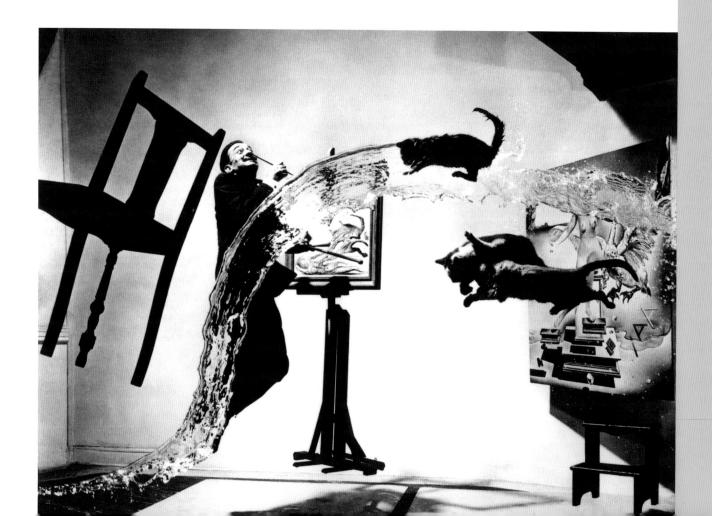

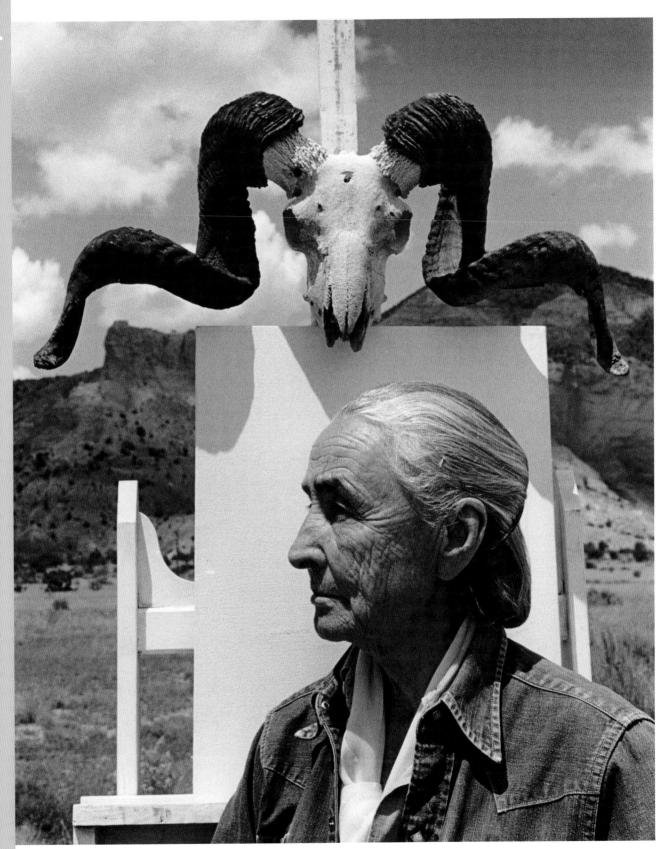

Portraits on location

A portrait taken 'on location' is one in which the photographer has gone to the subject's place of work or home, or taken him or her out into the street to do the shot. Locations offer photographers many things to work with in creating a portrait; the subject's possessions, environment and tools of work are great props to help give insights into the sitter's personality.

'Found' portraits

In many set-up pictures – such as those created in the studio – the subject is directed by the photographer and told where to look or which expression to give. This can lead to a sense of artificiality. Portraits are sometimes better when 'found' rather than manufactured, with the photographer melting into the background of a location and waiting for a revealing or intimate moment. Such portraits have been described as 'candid', a term coined by the art editor of *The London Weekly Graphic* in 1930 to describe Erich Salomon's revealing pictures of politicians. (See Scoop!, p. 84.)

Mugshot portraits

Mugshots are photographs taken as a record of people who have been arrested and brought into a police station; they are taken by police officers untrained in photography. The resulting pictures show people at a time of great worry and as such make for fascinating and revealing portraits. In some famous cases involving celebrities, the actor Hugh Grant looks sheepish and terrified, the Microsoft founder Bill Gates smiles, while actress and political activist Jane Fonda looks triumphant, raising a clenched-fist salute.

Portraits with the unseen camera

Walker Evans (see www.masters-of-photography.com) believed you could gain more insightful portraits when the subject was completely unaware of being photographed. Evans took his famous subway photographs by spending hundreds of hours riding the tube, his camera peering from between the buttons of his coat and the shutter cable release hidden up his sleeve. The passengers are photographed seated and close-up. Their expressions are totally private ones – completely different from those that people offer up to the camera when they know they are in its presence.

In pursuit of similar intimacy Paul Strand fitted a 45-degree prism to his camera so that he could take pictures while people thought he was looking in the other direction. In his series *Heads* Philip-Lorca diCorcia photographed pedestrians in New York, Tokyo, Calcutta and Mexico City without their knowledge. DiCorcia's camera was triggered as passers-by walked through a hidden set of flash guns. The resulting pictures show people completely absorbed in inner thought.

The celebrity portrait

The culture of celebrity power and image control has led to the phenomenon of celebrity photographers – a jetsetting elite as famous as their film- and rock-star sitters. Celebrity photographers include Mario Testino, Annie Leibovitz, David LaChapelle and anyone who has photographed Madonna. American fashion photographer Terry Richardson has taken this one stage further and has achieved a celebrity status comparable to that of many of his famous subjects, such as Lady Gaga.

The celebrity photographer is the celebrity's accomplice, trusted for being able to flatter and keep both the star and the magazines happy by presenting the celebrity in the right light – looking edgy and sexy, not shifty, dumb or trashy. It's understood that celebrity portraits will look fantastic hung on the walls of galleries, in the star's mansions and in record-company boardrooms.

Being photographed by a celebrity photographer indicates high-celebrity status or the arrival of a new star. Annie Leibovitz created what she has called 'concept' celebrity portraits, elaborate, stage-managed photographs realized with the assistance of platoons of assistants, make-up artists, stylists and set builders. Celebrity portraits are little more than advertising images – the products for sale being the celebrities themselves.

Portraits of presidents and royalty

Presidential and royal portraits are essentially public-relations events and promotion for the state and the monarchy. Today, royal families still release official photographs at certain times such as birthdays and christenings. In a recent publicity stunt a number of hip young photographers were commissioned to photograph Queen Elizabeth II; all failed to create anything at all revealing. Most royal portraits are chocolate-box photography.

The best-ever royal portrait is surely Hiroshi Sugimoto's picture of Queen Elizabeth II – a lifesize, pin-sharp, large-format, black-and-white picture of her waxwork, cheekily hung in the National Portrait Gallery in London among oil paintings of the royal family.

The first celebrity photos

Mathew Brady was the first nineteenth-century photographer to understand the attractions of the famous and the money-making possibilities in exploiting images of celebrity. Brady exhibited his pictures of famous people of the day – including Abraham Lincoln and Edgar Allan Poe – in the windows of his studio 'Brady's of Broadway'. The public flocked to see the photographs, to buy reproductions and to have their own portraits taken. Brady published the first book of celebrity portraits, *The Gallery of Illustrious Americans* (1850).

By the middle of the nineteenth century most celebrities had posed for photographic portraits. In Britain, Charles Dickens, Florence Nightingale and Alfred Tennyson were not only well-known names but recognizable faces. In 1860 Queen Victoria and her family were photographed for their own carte-de-visite and a cardomania craze broke out, with people collecting portraits of royalty and celebrities. Cartes-de-visite were traded in their millions – even creating cult followings for some mediocre talents, exactly as the tabloids do today.

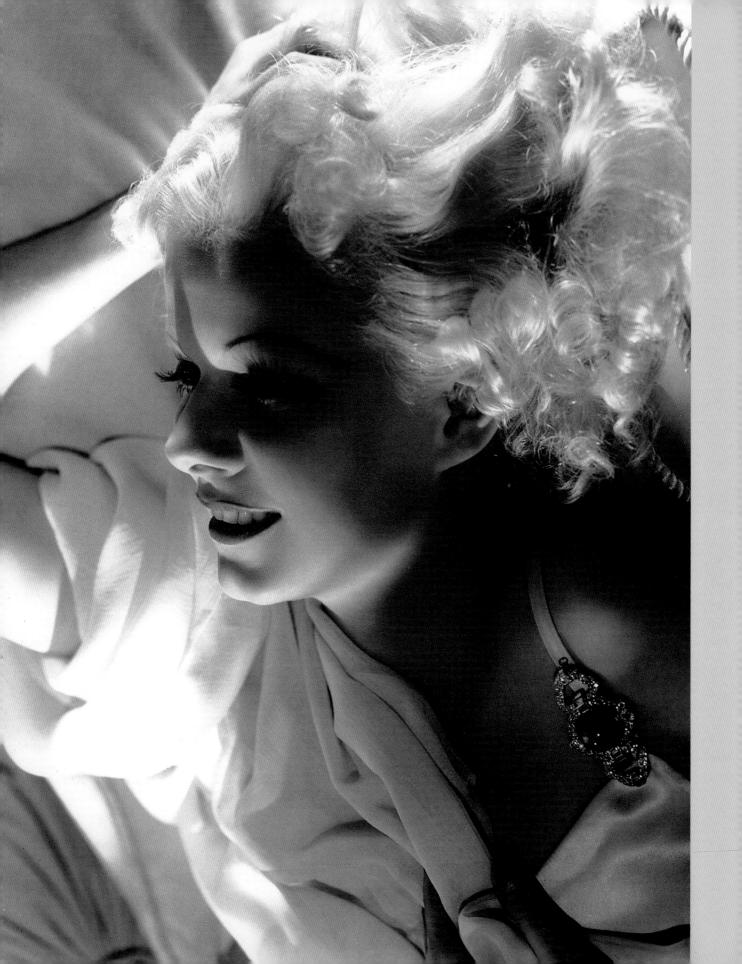

Portraits of a whole town or city

Many high-street photographers work in the same premises for decades, creating wonderful and historic portraits. Philip Kwame Apagya in Ghana, Malick Sidibé and Seydou Keïta in Mali, Ernest Dyche in Birmingham, England, Harry Jacobs in Brixton, London, Mike Disfarmer in the small town of Heber Springs in Arkansas and Hashem El Madani in Saida, Lebanon, all created portraits of entire communities over the passing years. Madani claimed to have photographed 90 per cent of his city's population in the course of his career. All these photographers found amazing subjects on their own doorsteps.

Their aim was simple: to make their customers look good. All offered props and a choice of plain or exotic backdrops. Apagya used amazing, brightly painted fantasy backdrops of cities and luxury apartments in his portraits.

Even the Taliban in Afghanistan, who banned all photographs except ones for use in passports, had their own secret portrait photographer. His hand-coloured pictures were discovered by chance after the fall of Kandahar.

Photographers being photographed

Photographers are often reluctant to come in front of the camera of others – often preferring self-portraits or not to be pictured at all, perhaps because they understand the power of photography. This is a pity, since portraits offer the chance of revelation, the discovery of aspects within ourselves that we may not otherwise have known to exist.

George Hurrell, Jean Harlow, 1935

With the invention of the focused spotlight, photographers working for film studios created the idols of the golden age of Hollywood. This highly artificial style produced powerful images that were more about glamour and escapism than insightful portraits. The style has been influential in fashion and beauty photography ever since and a new generation is now appreciating the technical virtuosity of the photographers who helped create the gods and goddesses of the silver screen.

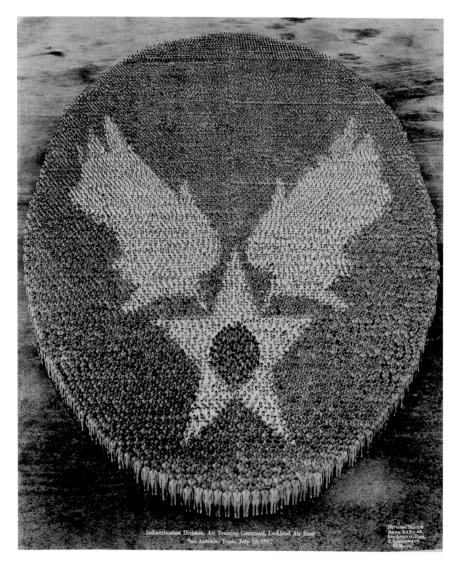

Eugene O. Goldbeck, Indoctrination Division, Training Command, Lockland Airbase, San Antonio, Texas, July 19th, 1947

Early in his career Goldbeck spotted that group photos could be very profitable, realizing that the more people there were in a picture, the greater the number of prints that would be sold. He specialized in large military groups (left).

Group portraits

Group portraits offer the challenge of trying to reveal the personalities of many individuals at once. Since this is very difficult to achieve spontaneously, photographers often engineer group portraits by carefully posing subjects to create strong compositions. This method was taken to extremes by Eugene O. Goldbeck and the partnership Mole & Thomas. They took enormous group portraits of tens of thousands of troops, Goldbeck creating pictures of regimental emblems while Mole & Thomas made a monumental portrait of President Woodrow Wilson using 21,000 soldiers.

The self-portrait

Put me in the picture

Self-portraits are likely to be self-commissions motivated by creative desire and free from commercial constraints. This often makes them elaborate and highly ambitious images. Photographic self-portraits are made with a shutter release cable or using a camera's self-timer. Alternatively, a collaborator can press the shutter at the photographer's instruction.

Self-portraits need not be constrained by the willingness and mood of the subject, the suitability of the location and the time and light available; they can be created exactly as the photographer wishes. This gives the self-portrait a quality not always present in other portraits.

Death, sex and race

The freedom of the self-portrait leads photographers to choose them to challenge traditions and explore monumental issues such as mortality, sexuality and race. Death is mimicked in one of the first ever photographic self-portraits, taken in 1840, in which the photographic pioneer Hippolyte Bayard poses as a drowned man – possibly as a comment on his personal devastation at being beaten by Daguerre in 1839 in the race to produce the first successful photographic process.

The work of Cindy Sherman is made up almost entirely of self-portraits examining and questioning the ways in which women are photographed. Sherman (who appropriately shares her first name with a plastic doll) dresses in costumes of the past; wearing masks and wigs and caked in make-up, she satirizes the poses of fashion photography, the pin-up and pornography. Introducing violence, horror and dark humour into her images, she sometimes pushes them to levels where they become gross and repulsive.

In her series *Untitled Film Stills* each picture appears to be snipped from a reel of cine film. With a great understanding of the potency of the film still, Sherman makes us imagine what might have gone before or what is to come. In *Untitled No. 122* she is power-dressed in the business-suit uniform of 1980s 'greed is good' Wall Street culture. Lit harshly from above, with a strong shadow cast on the white wall behind her and with dishevelled hair covering her face, she clasps her fists in rage.

In another series she dresses as a clown. In *Untitled No. 413* she appears against a brash background, rippled by digital manipulation to ape the vivid colours and presentation of commercial photography, transforming herself into a toxic, malevolent Ronald McDonald.

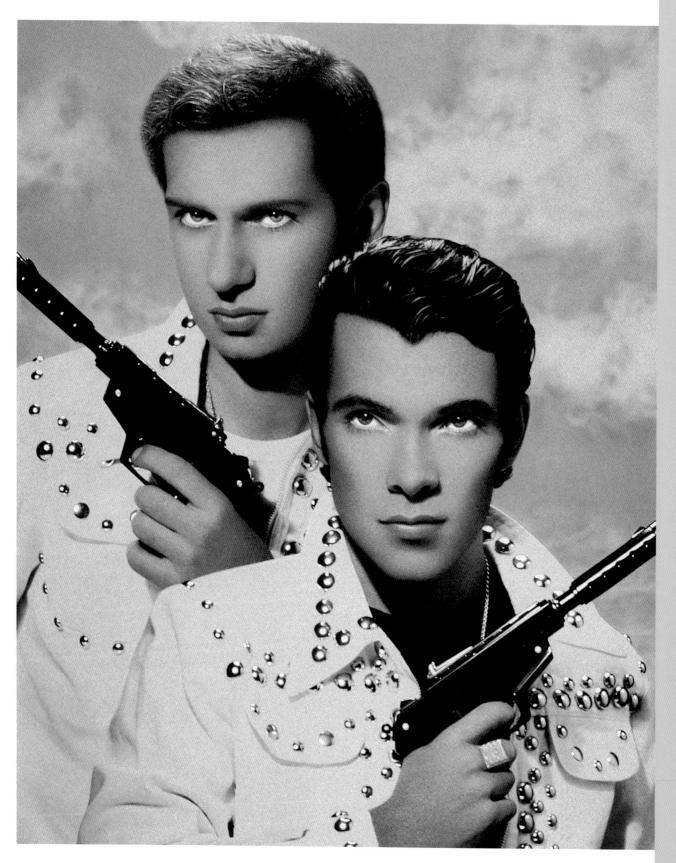

Like Cindy Sherman, Japanese artist Yasumasa Morimura has used the pin-up for a self-portrait. Reclining naked on vivid red velvet and recreating the pose of the world's most famous pin-up, Morimura becomes a man-Marilyn. This is a startling and unforgettable picture in which Morimura transforms both his sex and race.

Robert Mapplethorpe shows himself in a 1988 self-portrait withered and dying from AIDS. He grasps a cane topped by a small skull. It is the only one of Mapplethorpe's photographs in which every part is not fiercely defined by sharp focus. In stark, silvery black and white, the shiny detail of the skull is chillingly juxtaposed with Mapplethorpe's haunted face – floating out of focus, receding into the blackness.

Pierre et Gilles, Self-Portrait, 1988

The French duo Pierre et Gilles, who create amazing hand-painted photographs together, were inspired by a trip to India in making this self-portrait (opposite): 'The cinema, the temples, the sculptures, the thing of making the marvellous with nothing, with planks of wood and papier-mâché! They aren't afraid of artifice', they enthused. They appear in studded white Elvis suits holding shiny black revolvers against a bright blue sky backdrop with cotton-wool clouds. They pose as angelic gangsters with airbrushed faces.

Yasumasa Morimura, Self-Portrait (Actress), Red Marilyn, 1996 Japanese artist Morimura mirrors famous

Japanese artist Morimura mirrors famous pin-up photos in his self-portraits, transforming both his own sex and race in the process.

Peter Beard, 'I'll Write Whenever I Can...', Koobi Fora, Lake Rudolf, Kenya, 1965

Peter Beard's humorous Christmas card photograph finding him posing inside a freshly dead crocodile was taken on the shores of Lake Rudolf (now Lake Turkana), on the border between Ethiopia and Kenya. The photographer, artist, adventurer, playboy and environmental philosopher Peter Beard studied with Josef Albers and Richard Lindner as an art student at Yale University. His early friendship with Karen Blixen (the author of *Out of Africa*), encouraged his interest and future work in Africa. He developed close relationships with the painters Francis

Bacon, Salvador Dalí and Andy Warhol. Beard's oeuvre starts with his life's work: the diary, a daily routine of collecting and contributing material, method, technique and content to his artworks. Beard uses the photograph as his canvas on which he superimposes other photographs, ephemera, found objects and objects from nature, newspapers and magazine clippings further embellished with quotations, dates, names and named locales. These visual commentaries form a cogent narrative, which invites careful examination.

In his work, Beard is narrating and commenting on the past, the present, the moment. Whether his canvas depicts a known or unknown landscape, a personality or person, a historic event or the mundane, or the exotic other — it is never left to stand on its own, but forms the base of his commentaries on the meaning of space, temporality and the incongruity of humour and horror in our times.

More of Beard's work can be seen on his website www.peterbeard.com.

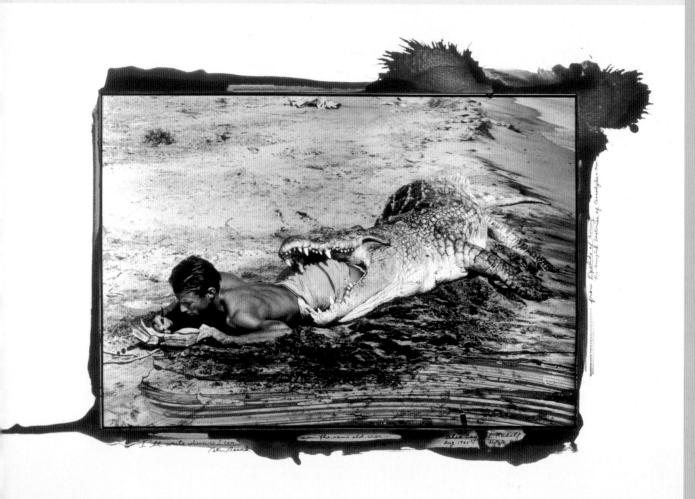

Self-definition

Self-portraits are often used to declare the creative identity of photographers and provide the viewer with a key to understanding their work and ambition. Edward Steichen posed as a painter in a self-portrait from 1902. He shows himself holding a palette and a paintbrush heavy with oil paint, the painterly feeling and brushwork of the gum-bichromate print adding to Steichen's self-definition as a moody master artist – Byron with a brush.

German-born photographer Helmut Newton photographed himself in a cheap hotel. Newton lies squarely on a bed covered by a partially clothed model who is embracing him, his face obscured by her hair and hands. One arm is stiffly around her, while the other depresses the cable release of the camera to take the picture of their reflection in the mirrored ceiling. The grainy black-and-white picture reveals both Newton's voyeurism and his cold and passive detachment; he's still dressed in a suit and has his shoes on. (See The body, p. 66.)

Self-portraits in the street

Self-portraits capitalize on the reflections or effects of the light that they've found by chance in the street. Nigel Henderson, Tommy Harris, Henri Cartier-Bresson and Eve Arnold have all made fractured, distorted and joyous 'hall of mirrors' images of themselves in this way. Saul Leiter and Louis Faurer capture more sinister reflections in the windows of New York.

The American Lee Friedlander is a street photographer who appears in many of his own pictures, often as only a small element – reflected in windows and mirrors and in shadows, most famously in a shadow falling on the back and sculpted hair of a woman passer-by. (See Seeing things, p. 120.)

The photo-booth

Everyone has taken a self-portrait in a photo-booth. The coin-operated machine was originally designed to take black-and-white passport photos delivered in a couple of minutes.

Photo-booths have proved a tool for cheap experiments and have been seized upon by many photographers, artists and art students, including Andy Warhol, Francis Bacon and Dick Jewell. Tomoko Sawada exhibited 400 photo-booth self-portraits showing herself undergoing numerous fashion crazes, but looking straight-faced throughout.

Richard Avedon used a photo-booth to create an extraordinary self-portrait in 1964. Seated in front of the white background, he holds a cut-out photo of the writer James Baldwin with whom he was collaborating on a book. Curling the picture to half-reveal and half-obscure his face, Avedon moved towards the camera, thereby throwing the whole picture out of focus. The faces of the writer and photographer merge, creating an image reflecting their creative partnership. It is a complex and potent picture produced for a few cents.

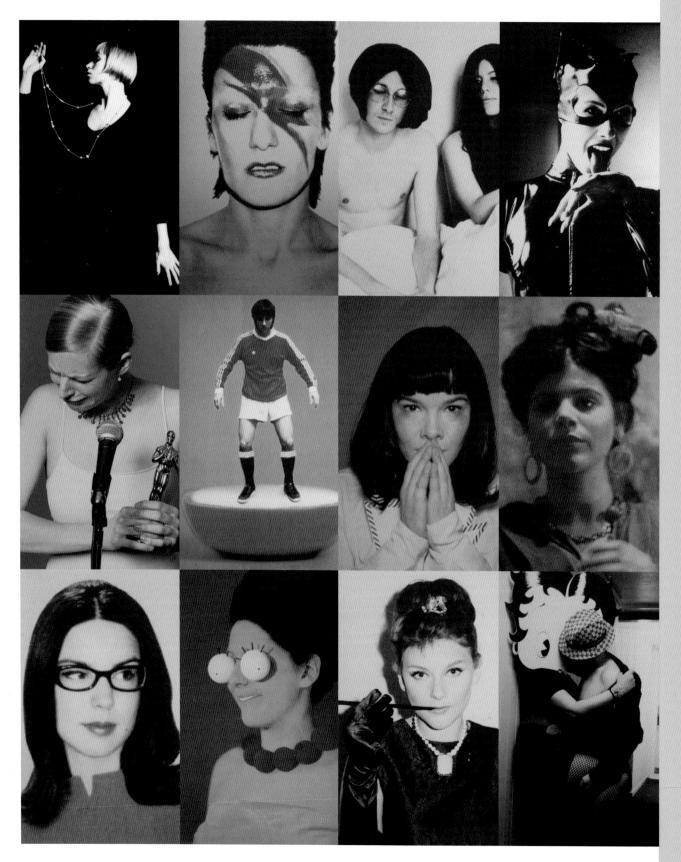

Heroic self-portraits

These student photographs were taken in response to a brief to create self-portraits in the style of their own heroes and heroines (opposite).

Brian Griffin, *Brian Griffin*, self-portrait, 1988

'This self portrait was taken at a time when it seemed like the whole world wanted part of me. In this image, I always thought I looked like a sea urchin for my human features are irrelevant because it is a photograph of a state of mind.'

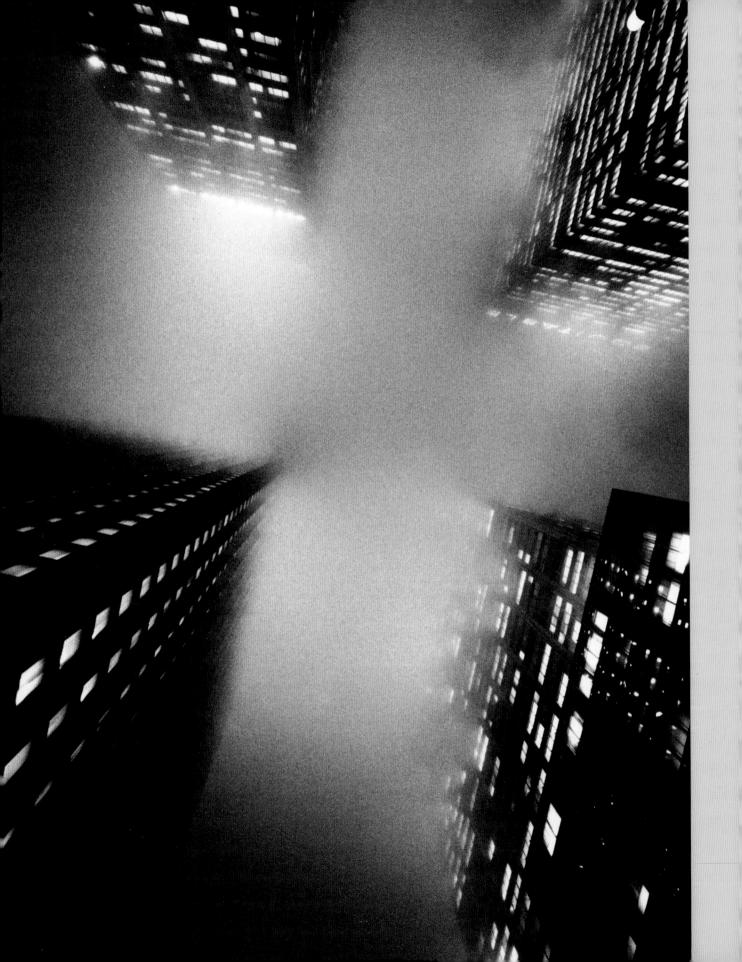

The city

Some photographers are obsessed by cities and the currents and undercurrents of urban life. They pace the pavements, watching, searching and waiting for chance meetings of sunlight and street, neon and nightlife, skyscrapers and street life. They seek extraordinary and ordinary happenings, wanting to picture the joy, intensity or malevolence of city life and to preserve scenes that might otherwise be lost forever.

Eugène Atget's Paris

In 1898 Eugène Atget picked up a camera for the first time and began to photograph Paris. With primitive equipment and no immediate prospect of either exhibition, publication or payment, he single-mindedly embarked on a project that lasted twenty years, producing about 10,000 prints. Atget's obsession was to photograph his vision of old Paris. Ignoring the newly constructed Eiffel Tower and the great boulevards, he focused on the narrow cobbled streets and alleyways, and areas due for demolition, photographing details such as shop fronts, signs, door knockers and streetlamps.

Robert Doisneau's Paris

From the 1940s until the 1970s Robert Doisneau strolled the streets of Paris, finding humour and warmth in city life. In his images, lovers kiss in crowded streets, a policeman passes a door shaped like a wide open mouth which appears about to swallow him whole, and workmen struggle to shift a heavy statue of a naked female figure, their hands pushing against her breasts. His pictures are gentle and witty, showing the city to be a place of pleasure and romance.

Roger Mayne's London

Roger Mayne photographed Southam Street in the North Kensington area of London for five years, 1956–61. He discovered the street by accident while exploring the neighbourhoods near his studio. Struck by its exuberance – family life spilling out into the streets, kids playing mass games of football and constructing swings tied to lampposts – he returned frequently to photograph the area. A gentle, quiet and shy man, Mayne blended into the background after his first few visits, taking wonderful and joyous pictures of the street as a playground and the focal point of community life.

Naoya Hatakeyama's Tokyo

In the 1980s Naoya Hatakeyama photographed the unseen structure of Tokyo. As millions crowded through the streets above, he waded knee-deep in stinking ooze photographing the toxic canals running in concrete culverts cut just below the surface of the city. Hemmed in by the ugly backs of offices and apartment blocks, the rusty, acid water reflects glimpses of the city's neon and fluorescent lights. Hatakeyama exerted tight control over the series of

Ernst Haas, The Cross, NYC, 1966

Haas was a stranger to New York when he first arrived there aged thirty. As such he was able to photograph the city through fresh eyes. Inspired by Edward Weston's ability to take photographs that transformed the real into the unreal, Haas found a crucifix among the skyscrapers. His pictures were published in *Life* magazine as 'Images of a Magic City'.

William Klein, Variation on Gun 1, NYC 1955, 2000

Maverick photographer William Klein is said to have won his first camera playing poker in the US army. Klein is a legendary figure, a self-styled revolutionary with a camera – he is so cool he can smoke and take photographs at the same time. Klein began his creative career as an abstract painter and designer. He has been a street photographer, fashion photographer, painter, sculptor, commercials maker, advertising

photographer, filmmaker, documentary maker, activist and satirist. His pictures of New York in the early 1950s have influenced every subsequent generation of photographers. This picture is from a series in which Klein recently reworked his city pictures. Klein now lives and works in Paris and has recently embraced digital photography.

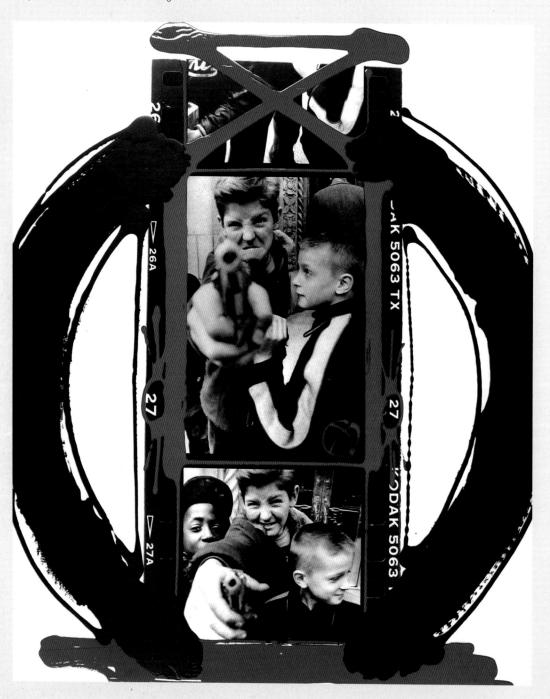

pictures, composing each image so that the bold horizontal line of the concrete lip of the canal wall runs exactly through its centre. The modern, brutal and ugly city seen in the top half of the picture is made eerily beautiful in its distorted reflection below.

Strangers to the city

Some photographers are passionate about their home town and make it their subject; others are strangers and see a city through fresh eyes. Brassaï, Weegee, Philip-Lorca diCorcia and Sirkka-Liisa Konttinen were all outsiders who became synonymous with the cities they photographed.

Brassaï's Paris

Brassaï was from Transylvania and created dramatic pictures of Paris in the 1920s and 1930s. Born Gyula Halász, he took the moniker Brassaï from the name of his home town, Brasso. Photographing only at night, he created an insomniac's view of the city, a perspective unseen by the vast majority. Brassaï's Paris is populated by gangsters, prostitutes, night-workers and down-and-outs. He used a Voigtländer camera and flash light from magnesium flash powder, taking his pictures on glass negatives that were so heavy he could only carry twenty with him at a time; as a consequence he had to be highly selective when picking his subjects. He also photographed the city's graffiti – drawings, carvings, scratchings, initials and love hearts, a theme later pursued in London by Gilbert and George. Brassaï's pictures reveal nocturnal Paris as a bittersweet place of tenderness and sex, loneliness, violence and melancholy.

Weegee's New York

Austrian-born Arthur Fellig took the name of Weegee and created unforgettable pictures of New York in the 1940s which contributed to the world's view of the city as a frightening place – the capital of vice and violent death. He was the archetypal grubby, hustling newshound: an ambulance-chasing, cigar-chomping news photographer, with his press badge stuck in his hat band. Chummy with both the cops and the criminals, looking for a scoop anywhere, anytime, day or night, he carried a constantly loaded camera.

Weegee was driven by the desire to be first to photograph the latest murder or fire in order to sell his images to the tabloids and wire services. He got his name after policemen and firemen became curious to discover how he got to murders and fires before them, asking him if he had a ouija board. This caught his imagination and in a play on the word he christened himself 'Weegee'. He had a police radio in his apartment and slept in his clothes, ready for action.

Fellow newshound Louis Liotta recalled: 'Weegee was smart. He had taken the police commissioner's daughter's wedding pictures, and the commissioner loved them. He took Weegee's press card and wrote a note behind it, so when he went on a story he would show his card, turn it around and the police would take care of him, giving him access to crime scenes. They undraped the body, put the gun in the right place and he got beautiful pictures.'

Weegee also used signs on buildings, advertising billboards and cinema hoardings in his pictures with black humour. In a photo of a blazing highrise building being hosed by fire trucks, a huge billboard centre-frame reads: 'SIMPLY ADD BOILING WATER.'

His first solo exhibition was called 'Murder Is My Business' and featured images of New York small-time gangsters, bobby-soxers, drunks, transvestites and thugs. Weegee died on Boxing Day, 1968, in Hell's Kitchen, New York. The rubber stamp used on the back of his photos read: 'CREDIT PHOTO BY WEEGEE THE FAMOUS.' (See The tools of the press photographer, p. 84.)

Weegee, The Critic (Opening Night at the Opera), 1943

In Weegee's most famous picture, *The Critic* (Opening Night at the Opera), two ageing society dames in tiaras (Mrs George Washington Kavanaugh and Lady Pell) arrive for a night at the opera, greeting the camera with smug smiles, clutching their tickets in bejewelled wrinkled hands. An unkempt passer-by – the critic of the title – scowls at them. The picture encapsulates the mutual contempt of people from opposite ends of the New York social spectrum. Weegee loved such juxtapositions.

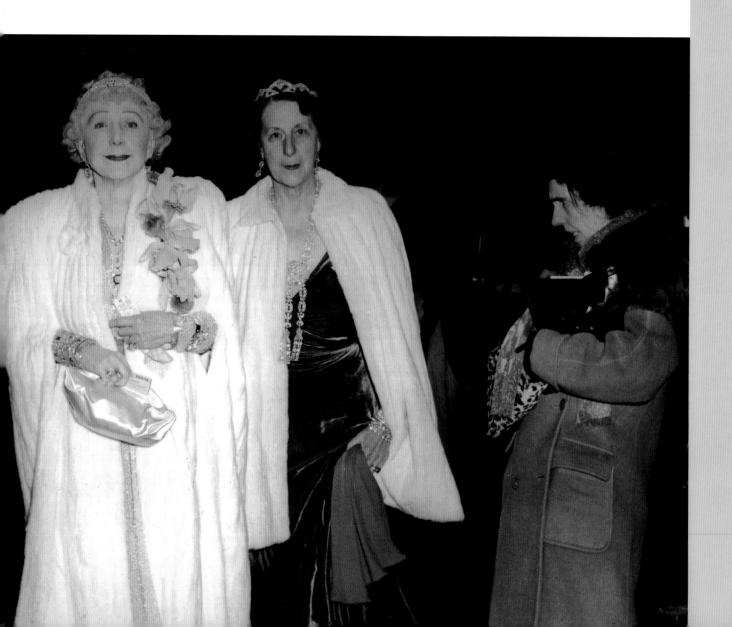

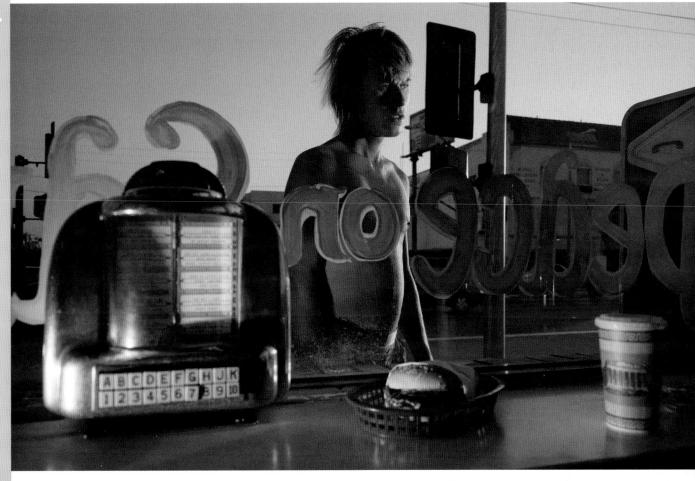

Philip-Lorca diCorcia's Tinseltown

Philip-Lorca diCorcia, from Hartford, Connecticut, photographed a hidden, twilight side of city life. On Santa Monica Boulevard in Los Angeles, he approached rent boys, drifters, hustlers and addicts, asking how much it would cost for a couple of hours of their time so that he could take their picture. After striking a deal, he then photographed each person in elaborately lit set-ups in the street, in diners and cheap motels, mixing flash light with street and fluorescent light.

Sirkka-Liisa Konttinen's Newcastle

Finnish photographer Sirkka-Liisa Konttinen spent much of the 1970s and 1980s photographing the Byker area of Newcastle: everyday life in the streets, in family homes, in the hairdresser's and the launderette, the bingo hall and the bowling club, finding a village in the inner city. Her pictures are tinged with great sadness; the entire area is about to be demolished for 'regeneration', the close-knit streets are about to be replaced by towerblocks.

Philip-Lorca diCorcia, Eddie Anderson; 21 years old; Houston, Texas; \$20, 1991

The titles of diCorcia's pictures record the subject's name, age and home town, together with the fee paid to pose. They show the sad underside of life in Tinseltown – isolation, sadness and homesickness. (See Portraits with the unseen camera, p. 36.)

Johnnie Shand Kydd: Naples

'To photograph Naples I moved there for three months. I arrived not able to speak the language and without knowing anyone. Naples is a great city that has a sense of otherness, it has huge humour, huge exuberance but at the same time is dark and sinister.

'To begin with you get totally seduced by the clichés of a city. This is a process you have to go through before discovering lower, more intriguing levels hidden beneath. The only way to do this is committing a lot of time to wandering the streets with a camera.'

Johnnie Shand Kydd is a self-taught photographer. In his first book, *Spitfire*, he photographed the explosion of Britart in London in the mid-1990s, photographing events as a participant at the centre of events. These photographs were taken in 2000 with a medium-format Mamiya twin-lens camera manufactured in the 1950s.

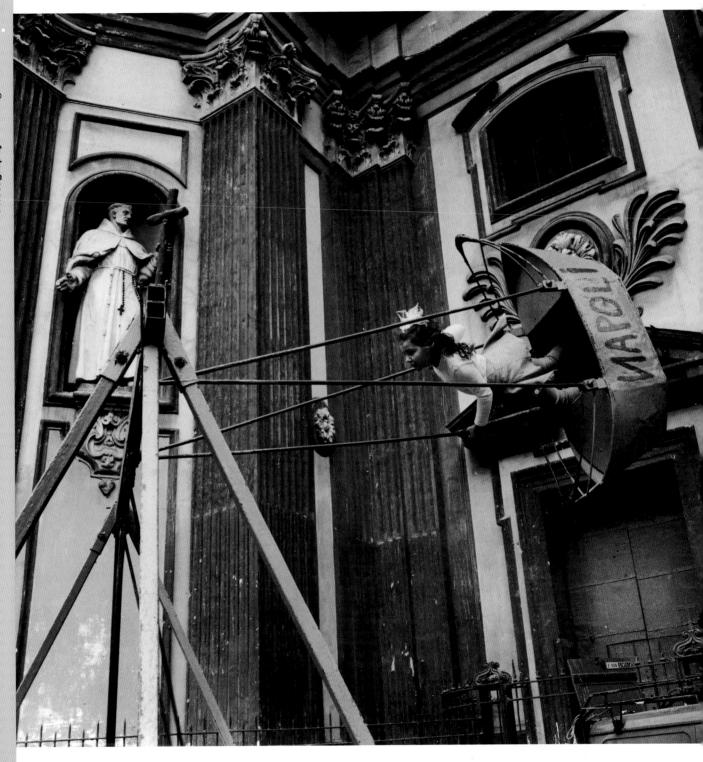

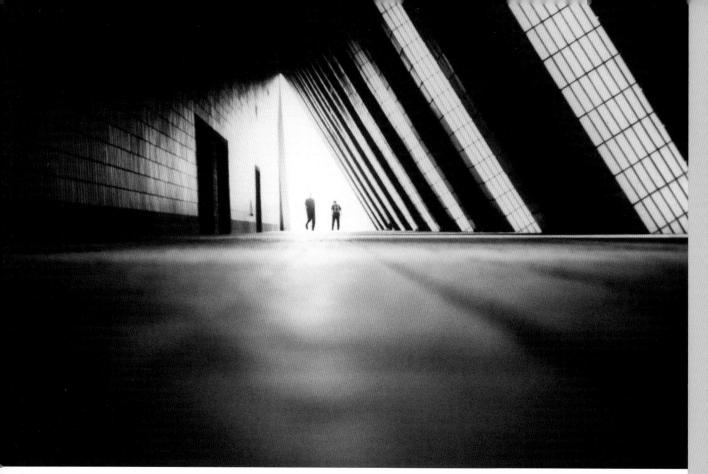

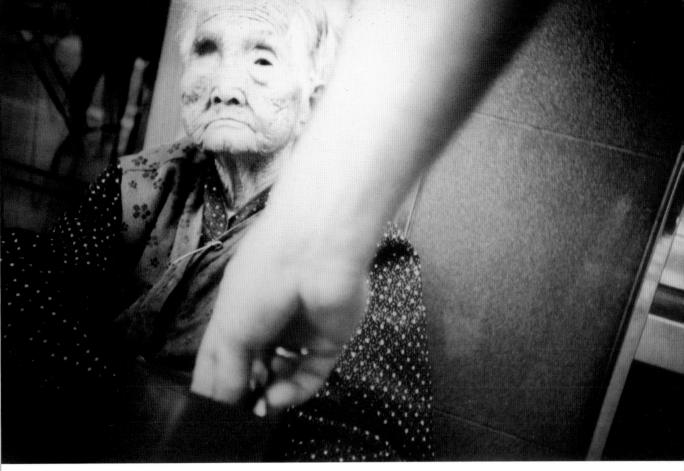

Fabian Monheim: Hong Kong
In 2004 Monheim chose to photograph Hong
Kong using a Lomo camera. 'When I visit a city
I never visit the tourist sites. One day I go north,
the next day I go south, the third day east and the fourth west, and I see what I bump into.'

The landscape

The beauty and power of nature have captivated many photographers. They have been stunned by the drama and vulnerability of the natural world – by the mountains, forests, trees, sky and sea – and have photographed the vastness of the landscape, its patterns, rhythms and rhymes, both ancient and modern, together with the fleeting effects of the elements – light, mist, wind, rain and storms.

Photographers of the landscape show us what they think of the world in their photos. Some are awestruck, some see a harmony between man and nature, others are fearful for the landscape's future.

Landscapes and cameras

To express the scale of nature, many photographers choose to photograph landscapes with large-format cameras. The large format offers razor-sharp clarity and great intensity of detail. Although photography is very good at honing in on things – such as examining details of faces and objects – picturing huge spaces is a very different kind of challenge.

When standing in the landscape, we don't look at details but instead experience a panorama. We use the whole of our vision, right to its edges, to experience the space. Photographers therefore began creating panoramas by joining together different photos taken from the same point. They started to build panoramic cameras that could take a broad view in a single exposure. From 1859 to 1866 French geologist and photographer Aimé Civiale made striking 360-degree panoramas that encompassed the beauty of the Alps in a single image. Hong Kong-born designer and photographer Robin Koh creates 360-degree panoramas made up of separate shots that have been perfectly merged on the computer. He mounts the images on the inside of thin, metre-wide circular drums which rotate slowly. Standing beneath, viewers can feel as if they are actually standing in the landscape.

The landscape as hero

Ansel Adams saw the landscape as paradise. The focus of his life's work was the incredibly beautiful Yosemite National Park in California. He took his first photographs of Yosemite aged fourteen in 1916 during a family vacation and returned to the same views for the next sixty years.

Adams' utterly distinctive pictures create beautiful order from the light falling on the mountains, canyons, trees and lakes. They show the epic grandeur and majesty of the American landscape and were immensely popular, making it possible for a public busy poisoning itself with consumer products to connect to a world of simplicity and heroic beauty. Obsessed by technical quality, Adams created the 'Zone' system, a method of ensuring his large-format exposures gave the viewer the largest amount of information possible about each scene.

Ansel Adams, The Tetons and the Snake River, 1942

Ansel Adams wanted to be a classical pianist, but his great skill as a photographer became his artistic calling. His understanding of light and his supreme technical ability combined to create landscape images that have become iconic views of the American wilderness. His photography and campaigning helped preserve many areas of the USA that have become national parks and are now forever protected from exploitation and development.

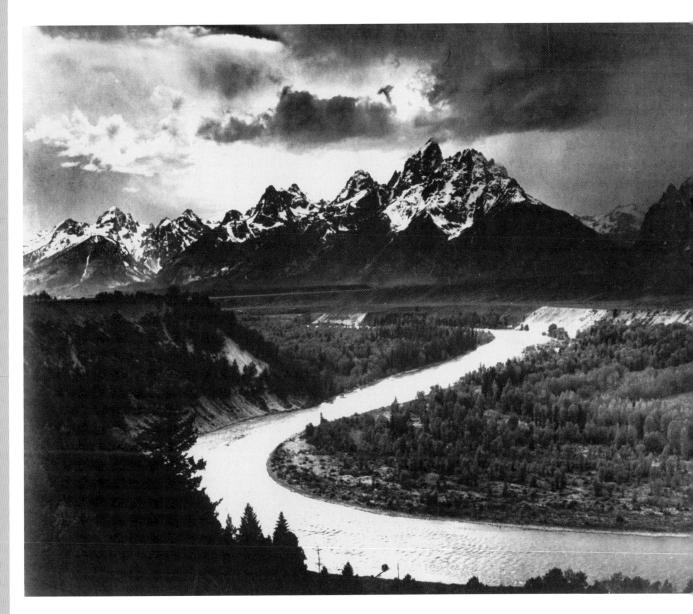

Andrew Watson, Figsbury Ring, 1994, and A303 and Tumuli, Salisbury Plain, 2002 Watson photographs man's imprint on the landscape both ancient and modern.

The creative power of nature

Edward Weston was driven by the desire to make perfect pictures expressing nature's power to create mysteriously beautiful forms. He photographed trees, rocks and sand dunes eroded, weathered and battered by the elements into beautiful shapes, photographing each subject again and again as it was altered by the light. His simply composed pictures of shells, roots, leaves and peppers look like monumental sculptures.

The precise line of the horizon bisects the exact centre of each of Hiroshi Sugimoto's black-and-white pictures from the 1990s of the world's oceans, taken using 10x8-inch-format Deardorff and Phillips cameras. His hypnotic pictures show the vastness of the sea and sky as stark and simple blocks of grey and black. His nighttime seascapes, taken with exposures lasting hours, are unreproducible, such is the subtlety of the contrast between the dark grey sky and the blackness of the sea. You have to view the prints themselves.

Starting in the 1940s, for the next fifty years William Garnett took photographs from the window of a small plane as he piloted himself above the earth. His pictures give an awe-inspiring new perspective on the beauty of the landscape, revealing the patterns of hills, gullies, sandbars and surf that would otherwise remain invisible to us.

'Nature is a great artist, the greatest. I've seen rocks and forms that put Matisse, Picasso and Brancusi to shame. You can't beat Mother Nature.' Brett Weston, landscape photographer.

Man's stamp on the landscape

Andy Watson's photographs show the great subtlety of some of man's imprints in the land. Taken from light aircraft, his pictures, of the Manger glacial valley in Oxfordshire, southern England, reveal a harmony between historic and modern marks on the land. In some pictures the traces of ancient settlements and enclosures blend in swirling abstract patterns with contemporary marks made by crops, tractors, trailers and combines; in others, the lines made by modern roads become absorbed into others many thousands of years old.

Richard Long (www.richardlong.org) photographs the marks that he has made on the landscape. He walks – often for many days – across tracts of uncultivated land, creating straight lines or circles. Long's pictures engage us with the power of nature to erase manmade marks – the pictures provide the only record of the walker's disturbance of the land since all trace of his presence will slowly be dissolved over time as wind, rain and tide reclaim natural beauty from man's footprints. See also the work by Aaron Siskind and Minor White discussed on p. 137.

The first aerial photographs were taken from tethered balloons in the 1850s. Pioneering photographer James Wallace Black used kites to take his camera to heights of up to 1,200 feet, opening the shutter by means of a long piece of string. Photographer Vik Muniz uses massive mechanical diggers to create huge earthworks on the scale of the ancient chalk drawings carved in hillsides, and then photographs them from helicopters.

See also the work of aerial photographers Marilyn Bridges, Yann Arthus-Bertrand and legendary Italian one-armed aerial photographer Filippo Masoero.

Canadian photographer Edward Burtynsky (www.edwardburtynsky.com) is enraged by man's abuse of our planet. Photographing in large format and intense colour, he documents the way we have scarred the landscape with huge oil fields, refineries, tips and tyre dumps. His pictures from the 1990s of massive abandoned mines and quarries look like gaping open wounds in the earth's skin. Burtynsky's most harrowing photographs show bright poisonous nickel-polluted rivulets seeping into the land or trickling out into the sea.

Edward Burtynsky, *Nickel Tailings No.34*, 1996

Burtynsky's work shows how man has ruined many landscapes and contrasts with Ansel Adams' images of an Arcadian sublime landscape. However, both are motivated to communicate through their work that we live on a beautiful planet and we should look after it; it's the only one we have.

The still life

'A great still life can unlock an emotional response to an object.'
Adam West, photographer.

For hundreds of years artists have made paintings of arrangements of bowls of fruit, food and drink, flowers and musical instruments. The term 'still life' was coined to describe these paintings of inanimate objects. Photography's first attempts at still life mirrored these compositions. Although the French call a still life 'nature morte', which literally means 'dead nature', the photographer wants to bring the objects to life.

The object as hero

Great still-life photographs can give us a deeper understanding of and new relationships with the things that surround us. They focus in on the qualities of an object. Unlike other forms of photography, still life offers photographers a subject that can be totally controlled, particularly in the studio. Lighting, cameras, lenses and focus are chosen to help find or enhance the beauty of objects.

'Still life is a very pure way of working. Nothing need be in a still life photograph that you don't want.'
Sandro Sodano, photographer.

To give an object a beautiful visual value, a still-life photographer requires strong ideas and an attention to detail. Still lifes created for magazines and advertising make objects look heroic. The photographer accentuates an object's qualities to capture it at its most luxurious, appetizing, refreshing or fashionable.

Some objects, such as plants, pebbles and shells, are naturally beautiful and have been the subject of many photographic still lifes. Man Ray, Nick Knight, Robert Mapplethorpe and André Kertész all photographed flowers, amplifying their beauty in different ways. Man Ray solarized his prints of lilies to show flowers ablaze with light. Nick Knight photographed specimens from the flower and plant collection at the Natural History Museum in London on vivid white backgrounds to accentuate their shapes. Robert Mapplethorpe photographed lilies in the studio to show their sensuality, while André Kertész photographed a melancholic tulip distorted like a Cubist painting.

Food is a frequent subject of still life. Irving Penn – a master still-life photographer – created a beautiful image of frozen vegetables straight from his freezer. His American Summer Still Life features a bottle of Coca-Cola, a stick of chewing gum, a baseball and a hot dog smeared in mustard. Perhaps Penn's greatest still life – an image of great simplicity and humour – is of massive diamonds, worth millions of pounds, pictured as if dripping from a household tap.

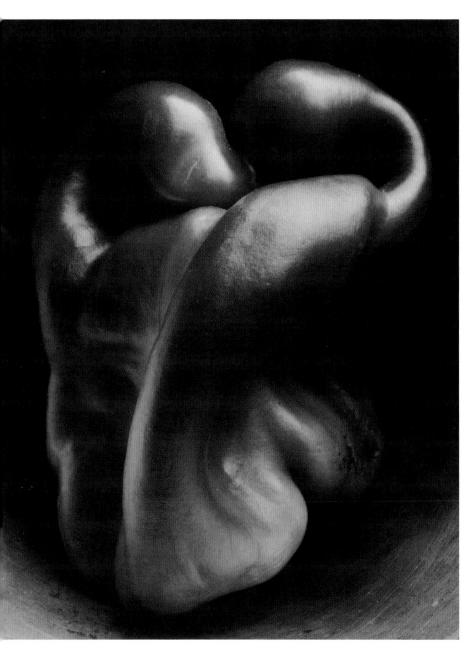

Edward Weston, *Pepper No. 30*, 1930
Still lifes can amplify the qualities of a particular object in surprising ways, as in this extraordinary view of a pepper by the great American photographer Edward Weston.

Photographers have found beauty in the overlooked, the discarded and the ugly, sometimes coming upon readymade compositions in the street or on their travels. Edward Weston photographed a cement worker's glove, crusty with dried cement. Chalkie Davis had a great still life presented to him on a plate – his airline meal on its tray. Irving Penn created an amazing series of photos of cigarette butts he'd picked up on the street, enlarging them to the size of posters and creating beautiful platinum prints that give each cigarette a strange sculptural elegance. The result is an identity parade of battered butts. Martin Parr even found beauty in the front seat of his car after it had been broken into, taking a still life of the gleaming tiny cubes of smashed windscreen glass sparkling like gems.

Sandro Sodano's still lifes of bags, 2000 Sodano makes his subjects – bags – appear heroic in these advertising still lifes. They were created in the studio by carefully controlling the lighting and exposure rather than using digital techniques.

The body

The human body has fascinated many photographers. They have created images of its contours and textures, its motion, its changes through age, and its strength, frailty and beauty.

Some photographers picture the body in order to show desire, sex and sensuality, to conjure up fantasy or as a means of persuasion in advertising. Some love the spectacle of the body seen at full stretch in dance and sport, while others use the camera to help us further understand how our bodies work.

The naked body

Images of naked and semi-naked bodies surround us, dominating advertising images selling clothing, beauty products, perfume and underwear.

Mainstream publications now regularly feature pictures that would once have been taboo. We live in an increasingly permissive culture, which allows more and more flesh to be seen without public comment. What were once viewed as sexually explicit images for private consumption only are now often splashed across billboards and openly perused in magazines by men and women in public.

The bodies shown in these images are more or less exclusively young, fashionably shaped and sun-bronzed. The Japanese photographer Manabu Yamanaka, however, creates far more challenging photos in his series of lifesize images showing naked old ladies, their skin deeply rippled and their bellies sagging. These are extraordinary pictures: the subjects are dignified and completely comfortable with their nakedness. They make us reflect on our obsession with youthfulness. In our world in which cosmetic surgery to tighten sagging flesh has become routine, the pictures remind us that aging is nonetheless unstoppable. Elliott Erwitt photographs the beach, a place where many of the normal social rules of behaviour are suspended. He shows the comedy of nakedness, creating witty and unexpected juxtapositions of the unclothed with clothed passers-by, of young with old bodies, and exploring the beach rituals of courtship, bathing and tanning.

Some photographers look at the beauty of the naked body. Robert Mapplethorpe photographed naked men and women posed like classical statues, studio-lit to display muscle and tone; in his work flesh becomes cold, solid stone. Edward Weston created harmony in the shapes of the naked body, his pictures lit by strong sunlight, making soft curves and throwing simple, dark pools of shadow.

Irving Penn chose fleshy and well-rounded bodies for his famous high-contrast pictures of naked women, finding beauty in obesity. The models he chose were the antithesis of the stylish and thin fashion mannequins he was photographing at the time for *Vogue*.

Manabu Yamanaka, *Gyahtei no. 7*, 1995 We are very used to seeing images of naked young bodies. But the Japanese photographer Yamanaka broke taboos in producing his series of dignified lifesize photographs of naked elderly women (above).

Robert Mapplethorpe, Lisa Lyon, 1982

© Copyright The Robert Mapplethorpe
Foundation. Courtesy Art + Commerce.
Beautifully crafted medium and large-format blackand-white images made Mapplethorpe a famous
(and, latterly, infamous) fine art photographer.
Mapplethorpe directed images of the body that
look like sculpture, which he then photographed.
Despite the classical influences that permeated
his work, as seen in this image of world champion
bodybuilder Lisa Lyon (opposite), some of his
more sexually charged photographs met strong
disapproval from audiences. Photography of the
naked body may go in and out of fashion, but
photographers will continue to photograph the
human form in many ways and styles.

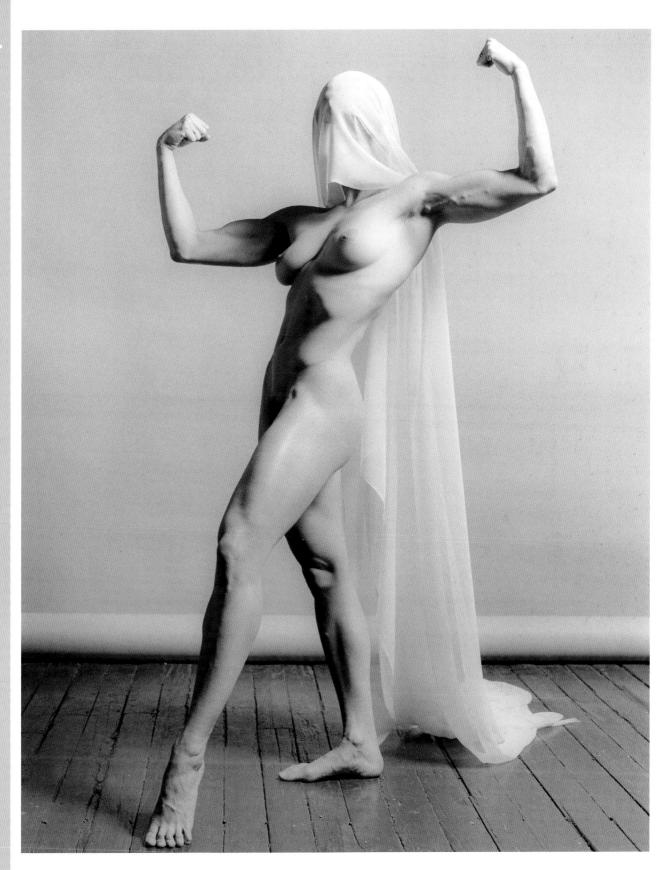

Hong Kong-born Lewis Morley created one of the most famous pictures of a naked woman, though in it the body is almost entirely unseen. Commissioned to photograph Christine Keeler, the woman at the centre of a 1960s sex scandal in Britain involving a government minister, Morley posed her astride a backwards-turned curvaceous wooden chair, her shoulders and hair echoing its shape. The photo has been frequently restaged but without ever recapturing the potency of the original. The strength of the image comes as much from the way it conceals Keeler's nakedness as from the way it reveals it – her torso is hidden by the chair and her arms, but tantalizingly glimpsed through the slot cut in the chair's back, towards which all the lines in the picture converge.

Natalie Loher shows 360-degree views of the naked body in huge pictures of her friends. They stand straight as the camera scans and scrutinizes every detail. In book form, Loher's pictures allow the viewer to turn the figure by turning the pages.

Naked abstraction and distortion

Photographers have experimented widely to create strange and sensual views of the body. Bill Brandt photographed naked models in stark black and white with a camera once used by the police. With an extreme-wide-angle lens, a fixed focus and no shutter, he created an amazing series of pictures taken in empty rooms. The lens distorts the model's limbs into elongated, sensuous white shapes, creating images evocative of both dreams and nightmares.

Hungarian photographer André Kertész experimented with photographing the naked body distorted by mirrors from a fairground sideshow. The results are brutal and disturbing, with the bodies twisted into tortured lumps like the damned in Breugel's paintings. Artist David Hockney created his *Photo Collage Nude*, 17th June 1984, of actress Theresa Russell from numerous close-up photos. The collage – influenced by Cubist paintings and the famous Marilyn Monroe pin-up – shows both Russell's front and back simultaneously.

Man Ray photographed the naked back of the famous Parisian model and muse Alice Prin, better known as Kiki de Montparnasse. Her shape and pose echo the curves of a stringed instrument. Ray painted the F-shaped sound holes of a violin onto the print on either side of her spine, creating an unforgettable image of a living musical instrument. He called the picture *Le Violon d'Ingres* (Ingres's violin) – as the naked Kiki, with her head wrapped in a cloth like a turban, looked like the subject of a painting by the nineteenth-century French artist Ingres, and as a joke since Ingres was an amateur musician. In France the phrase 'Le Violon d'Ingres' became slang to describe someone's hobby.

British photographer David Hiscock converted a photo-finish camera to produce scans of his body taken over several minutes. He called the strange distorted abstract colour images 'Transmutations'. They look like giant seismograms.

Natalie Loher, 360º Female Nude, 2004

'This piece is a photographic observation of the human form. Individual, factual shots taken every 30° of a female nude have been pieced together to create a new, bizarre 360° viewpoint of the human body, resembling a topography or landscape.' Loher took the pictures in a studio using a 5x4 Sinar camera. The model was positioned on a turning platform. German-born Loher trained at the Parsons School of Design in New York and at Central Saint Martins in London. Her website is www.natalieloher.com.

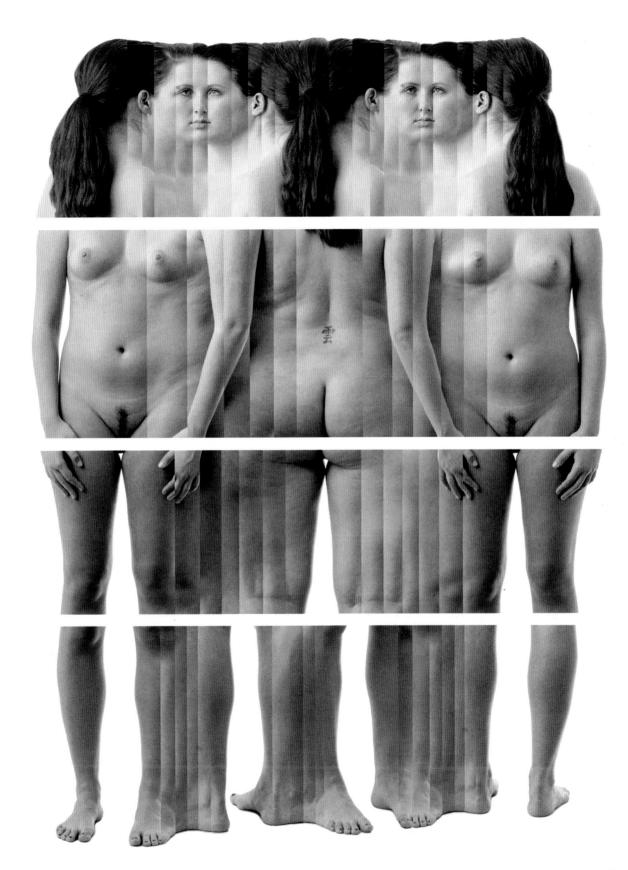

The pin-up

People put pictures on their walls to tell others who they are. Many put up pin-ups – reflecting their hopes, dreams and aspirations. Pin-ups are joyful images of semi-nudity that offer the false promise of sexual availability. They are stuck with drawing pins or Blu-Tac to the bedroom walls of millions of young women and men.

During World War II Hollywood studios issued millions of free celebrity pictures to boost the morale of far-from-home Gls. The pin-up of actress Betty Grable adorned more lockers than any other. Grable, famous for having her legs insured for a million dollars, now looks strangely proportioned in the picture – as though she has an over-large head. Part of the appeal of the shot may have lain in her ankle chain – tantalizingly exotic for the time.

In the 1950s the colour pin-up, shot from above, of Marilyn Monroe lounging on a sea of red satin launched *Playboy* magazine. The picture was used by Yasumasa Morimura as the basis of a self-portrait. (See The self-portrait, p. 41.)

Spencer Rowell, Man and Baby (L'Enfant), 1987

A staged pin-up image that found its way onto thousands of bedroom walls as a commercial poster (opposite). An image of its time, it captured the fantasy of many young girls of the 1980s.

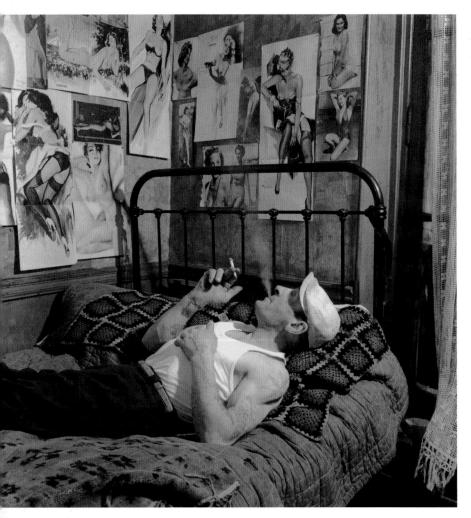

Robert Doisneau, *Dreams of a Tattooed Man*, 1952

The pin-up offers the dream of availability, as reflected in this classic image by French photographer Doisneau (left).

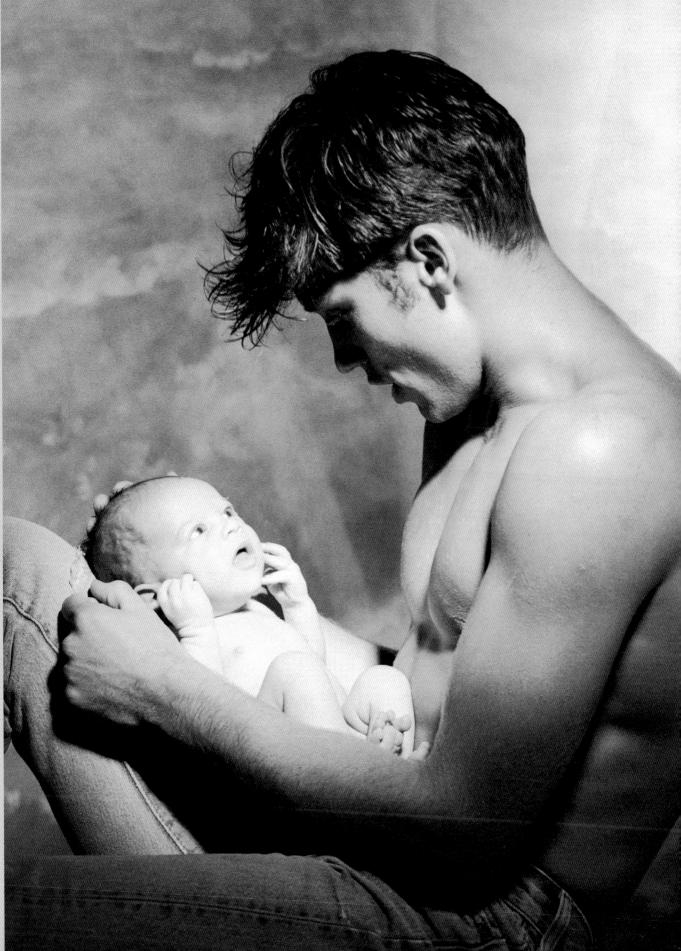

In the 1970s the pin-up of Farrah Fawcett by Bruce McBroom sold a staggering twenty-million copies. A black-and-white Athena poster of a bare-chested man cradling a baby sold in the millions to teenagers in the 1980s. The latter image successfully encapsulated the dream of a perfect father and a perfect child, with the man appearing to look simultaneously both caring, vulnerable and sexy.

Pin-ups are very indicative of the tastes of their times. As such, they quickly become dated and are easily and frequently pastiched.

Pornography

Pornography shows the body purely for sexual reasons. Pornographic photos have evolved their own set of poses, expressions, locations, colours and lighting, which have been satirized and explored by photographers and artists including Dick Jewell, Cindy Sherman and Yasumasa Morimura.

In a series of photo-collages Dick Jewell looked at the gesture in which the model raises her arms behind her head, a pose used throughout the history of porn and pin-ups to indicate availability and sexual abandon. Jewell found that this raised-arms pose had been assimilated into mainstream photography and was frequently to be seen in modern fashion, pop and advertising photography.

Helmut Newton brought mild pornography down from the top shelf of the newsrack and onto the coffee tables of cosmopolitan homes. One of his pair of pictures called *They Are Coming* famously features four supremely self-assured naked models striding towards the viewer. In one shot they wear expensive clothes, in the other they are naked except for high heels – though one model has forgotten which foot should be on the ground. Newton saw all photographers as voyeurs, spending their days 'looking through a little hole'.

The inner body

In 1907 William Morton used X-rays to create an amazing complete picture of the body of a young woman. Details of her necklace, the buttons on her boots and a hat pin add to the strangeness of the image. Helmut Newton echoed this use of X-rays seventy years later in advertisements for wildly expensive diamond jewellery. (See X-rays, p. 206.)

The camera has been attached to the microscope and endoscope by photographers to help doctors and scientists discover how our bodies work. In the 1960s Lennart Nilsson used revolutionary techniques to photograph a baby at different stages of growth inside its mother's womb. The foetus appears as if floating in outer space.

The body in motion - dance

Many photographers have created pictures of dance that record great athleticism and strength or that show the body at its most graceful.

Photographers have looked at dance backstage, from the wings, in performance and in rehearsal. Art director and photographer Alexey

Brodovitch created magical, experimental, grainy and blurred pictures of dancers, published in his book *Ballet*. Taken in the 1930s, the pictures had a huge influence on many photojournalists and fashion photographers in the following decades. Dancers swirl and rush before the camera. Brodovitch takes the viewer in among the performers on the stage.

Lois Greenfield photographs dancers at their most acrobatic. In her pictures dancers appear airborne, frozen in mid-leap. They are photographed as 'cut-outs' against a white backdrop, on a stage created in her studio rather than in the theatre.

The body in motion - sport

Sport features the human body in motion and at speed. The whole human experience can be encapsulated in a sporting event; the entire spectrum of emotions – from the exhilaration of winning to tears of defeat – occurs in front of the photographer. The extremes of man's basest desires and fears are witnessed in sport and in some events – such as Olympic sprints – they are condensed into the few brief seconds of an extraordinary explosion of human energy. The body is seen stretched to its limits.

Most sports photographers look at the action, but some of the most telling pictures don't even feature the game or event in progress. Chris Smith brilliantly caught boxer Barry McGuigan in tight close-up in his corner just before the final round of his World Championship bout. His trainer gently cradles the fighter's head in his hands to whisper instructions in his ear, but you can tell it's too late: McGuigan is already defeated and broken. His eyes are dead, his shoulders slumped as all the strength and energy has seeped from his body. It's a heartbreaking picture.

Garry Winogrand photographed American football pitch-side using a wide-angle lens. In one great picture every single player on both teams is visible mid-play. Robert Davies took sports photography from the back pages into the gallery arena with his series entitled *Epiphany*. Davies rephotographed key moments in world sport, pausing video recordings at the exact fraction of a second at which they occurred, then enlarging the images to a huge scale, revelling in the rich coloured abstraction of the screen image. Other must-see sports photographers include Neil Leifer, Gerry Cranham and Eamonn McCabe. (See So you want to be a sports photographer?, p. 234.)

Fashion

Fashion photography allows photographers' imaginations to run wild. Fashion photographers have creative licence to assemble extraordinary fantasies from beautiful ingredients – expensive clothes, amazing locations and models at the peak of human beauty.

Fashion photography moves forward more quickly than other facets of photography, constantly seeking originality and impact. Yesterday's look is immediately forgotten.

'It's a very dynamic medium. It's based by its definition on change. It's about that quick chop-change – in today, out tomorrow.'

Nick Knight, interviewed in Dazed & Confused magazine.

Fashion magazines

Fashion magazines provide the venue for fashion images. Magazines compete fiercely every month to produce the most exciting and innovative pictures. The editorial fashion images often outshine their advertising pictures.

Fashion magazines use the best 'glossy' paper, their covers often printed with extra colours to stand out on magazine racks. Huge attention is given to ensuring the photographs are fantastically reproduced.

'The best fashion magazines just drip in gloss. I love how fat and heavy the issues are. They promise so much. They even smell amazing thanks to all the perfume advertisements.'

Emma Wright, journalist.

The price of the magazine is the entrance fee to a world of fantasy and inspiration that most readers know is way beyond their budget and expectations. Fashion photos are seductive; they offer temptation and promote beauty, luxury and glamour.

Fashion photography is often about creating the illusion of perfection. An apparently simple photograph of a physically perfect model wearing beautiful clothes in a magnificent location is the result of hours of preparation, styling, hairdressing, make-up and lighting, followed by days of computer retouching.

'We like to be seduced by fashion photos.' Lee Widdows, art director and teacher.

Series of fashion pictures are called fashion 'stories', a name reflecting that they are make-believe rather than real. No idea or location is out of bounds in telling such stories. Stately homes, fairground rides, the pyramids of Egypt and the Taj Mahal in India have all been hired, together with the world's most beautiful models, troupes of dwarves and herds of wild animals – and all to create amazing fashion photographs.

'Fashion photography is about fantasy. The fashion pages in magazines are thirty pages of big pictures where the reader can be indulged.'
Stuart Selner, creative director, Marie Claire.

Great fashion stories can offer insights into life at the time the pictures were created. Through fashion photographs we can see how society has evolved, the changing worlds of work and leisure, and the obsessions and influences of different eras.

Elaine Constantine, *Girls on Bikes*, 1997
This is a wonderfully fresh and joyous fashion picture, created by Constantine using perfectly cast models, a great location and great props – three retro bikes. The stylist was Polly Banks.

The fashion team

Fashion photography is always collaborative. There is always a team working with the photographer, including a fashion editor, stylist, hairdresser make-up artist and models.

When a photographer creates a team of talented people that they trust there can be great camaraderie, with ideas coming from everyone behind the camera on a shoot. David LaChapelle calls his team 'the family'.

This year's model

Models are chosen for their ability to 'light up' a fashion photograph, in the same way that film stars are said to light up the cinema screen. They are totally comfortable in front of the camera and look amazing no matter how they are lit or posed.

Female and male models are employed for possessing the physical attributes of shape, colouring and height that are deemed by fashion editors and art directors to mirror public aspirations or represent the look of the near-future.

'Models have to express the mood of the times.'
Lee Widdows, art director and teacher.

Great models can have a much broader influence on culture than just being passing clothes horses seen by the magazine-consuming public. Some, such as Jean Shrimpton, Twiggy, Cindy Crawford, Elle Macpherson and Kate Moss, have had very long careers and become universally known, their own looks and style influencing generations of women more than the clothes they are paid to wear.

Although the conventions of fashion photography dictate that clothes should only be seen on the slim, young and beautiful, occasionally photographers break these rules. Nick Knight, who has created consistently brilliant fashion photographs since the 1980s, pioneered using normal people as models, photographing stories with older models and people with disabilities.

Fashion stories also use shock for effect. When clothes are considered too extreme or revealing, or the models appear too thin, too young, too 'druggy' or too aggressive, the shock factor can generate huge publicity and sales for fashion magazines.

The first fashion pictures

The first fashion pictures were of society women in their latest clothes. Readers were expected to look up to them as an example of what was fashionable. After *Vogue* and *Vanity Fair* hired full-time staff photographers in the 1920s, professional models began to be used to show off the clothes.

In the 1920s and 1930s Cecil Beaton, George Hoyningen-Huene and Horst P. Horst photographed their models to look like goddesses. The latter pose in elegant flowing dresses with distant expressions on their faces, framed in dramatically lit classical sets, in images inspired by Hollywood films. In the mid-1930s Martin Munkácsi caused a sensation when he began to take pictures that were the complete opposite of these studio-crafted images of cold elitism. He photographed his models outdoors, in light summer clothes, running across beaches and dunes, expressing spontaneity and carefree joy. Fashion photography has since often veered between these two styles – between high elegance and a look of immediacy that echoes real life.

Juergen Teller, Burning Jacket, 1999

A picture from Teller's campaign for Jigsaw Menswear – an unforgettable fashion picture, styled by Paul Frecker and art-directed by Phil Bicker.

Fashion and Surrealism, vanity and vertigo

In the late 1930s Surrealism became influential in fashion photos. Photographers began to compete with each other to find the most adventurous settings in which to create unexpected and shocking juxtapositions. Erwin Blumenfeld placed models teetering on the iron girders at the top of the Eiffel Tower and Toni Frissel photographed a model drifting gently underwater in evening dress while her date – in full diving suit and helmet – looms in the dark ocean behind her. This partnership between art movements and fashion has thrived ever since.

Colour pictures regularly appeared inside fashion magazines from the 1940s. Exploiting the new possibilities of colour, Erwin Blumenfeld created inventive and graphic fashion pictures using mirrors, veils, rippled glass, projections, back lighting, solarization, multiple exposures and darkroom experiments that combined negatives and positives.

Elegance and elephants

In the late 1940s the hugely influential Irving Penn and Richard Avedon photographed the new extravagant styles that returned to female fashion after the war. Both men had incredibly long careers, undertaking a huge variety of assignments across more than half a century.

Penn created bold, pared-down, highly controlled studio images using high-contrast lighting and elegant and sophisticated models, sexily smoking. His tightly cropped pictures were revolutionary. By cutting off models' elbows, legs and the tops of their heads, the images seem magnified and intensified on the page. Avedon chose to photograph on busy city streets and in quirky locations. His famous picture *Dovima with Elephants* shows a model in an evening dress gracefully stroking two huge elephants.

In the 1950s William Klein stumbled into fashion photography with little knowledge of its traditions or history, after the raw pictures of street life he had taken in New York had been spotted by Alexander Liberman, the art director at *Vogue*.

Klein shot fashion stories in fantastically bizarre locations – waxwork museums, graveyards, ancient ruins and halls of mirrors. His pictures are incredibly exciting and imaginative. Never repeating an idea, he tried wide-angle lenses, multi-exposures and even roughly painted out the faces of a mass of onlookers who had crowded behind a model on a shoot in the middle of Paris. He was equally inventive in the studio, building false-perspective sets, employing eccentric-looking extras, outlining dresses with streaks of coloured torchlight and photographing models against massive blown-up backdrops of neon-lit streets.

David LaChapelle, 'Giving birth to a shoe' story, New York, from Paris Vogue, 1995
This is a wonderfully original way to show a pair of shoes (opposite).

In Britain in the 1960s three spunky chancers – David Bailey, Brian Duffy and Terence Donovan – shook up the fashion establishment. Donovan photographed men's fashions like stills from a James Bond spy movie; Duffy worked for *Nova* magazine, creating images of model Amanda Lear stripping that readers could then cut out to make into a do-it-yourself flick book; while Bailey was copying Irving Penn. The dynamic trio gained celebrity status and were as well known as the people they photographed, their lifestyles inspiring the film *Blow-Up*.

Lust, camp and colour

In the 1970s Guy Bourdin and Helmut Newton created compelling and unsettling colour images of lust, fantasy and desire. They brought cruelty and imagined murder to fashion photography – their models sometimes appearing as if slain in some terrible crime. By way of contrast, Paolo Roversi and Sarah Moon created soft romantic pictures in muted and mottled colours, Roversi taking unique large-format Polaroids.

Bruce Weber takes models and clothes to great locations – country houses, film sets and pools full of inflatable animals – then takes pictures as his human subjects dress up, fool around, hang out and make out. His pictures are witty, youthful and camp. He creates images that look like those in a family album – except that everyone is paid to be there and is young and beautiful.

Nick Knight, Snakes, 2010

Nick Knight is a great innovator who uses digital photographic post-production techniques to create impossible images that look real. This shot was created for Alexander McQueen's Spring–Summer collection of 2010.

Weber's playful snapshot style of fashion photography influenced the much rawer fashion snaps created by Juergen Teller, Wolfgang Tillmans and Terry Richardson. (See The snapshot, p. 157.)

David LaChapelle creates tight room sets packed with models and oversized props, and shoots in theme parks, drive-ins and at rocket launch pads. His pictures are bursting with detail, screaming colour, burning cars and naked flesh. LaChapelle's fashion pictures are full of great ideas and humour: a baby is born to smiling doctors in a delivery suite, while mum is still wearing the very latest golden high-heeled shoes.

Fashion in the digital age

As well as being an amazing tool for retouching pictures to create perfection, digital photography gives fashion photographers a powerful new means of expression. Nick Knight melts models into abstract swirls and pools of sensual colour, while Sølve Sundsbø reduces the body and clothes to tight wire grids. In another unique approach to fashion photography, Fabian Monheim explains, 'I had a model turn up who was really hungover and impossible to photograph, so I gave her the camera and told her to take the pictures. She really enjoyed it, and they were the best shots of the whole shoot.'

The perfect figure does not exist, but it is now possible using CGI to create models with perfect bodies, flawless skin and impossible proportions. However, fashion photography must always consider the impact that images of unattainable figures can have on its audience. On the catwalk, in contrast to the extremes of CGI makeovers, some fashion designers are demanding models with realistic and healthy bodies as a reaction against the dangerous size 0 trend that prevailed amongst the top fashion houses. Fashion by definition requires change, so maybe the next trend will be real people in a real world? But that would only be fashionable for a season, right?

Telling a story with photos

Many photographers are driven to tell stories with their pictures. News photographers, photojournalists, reportage photographers, documentary photographers and war photographers strive to find moments of visual eloquence that will make the stories they tell unforgettable. More than any other kind of photographers, they want to influence and change the world we live in by taking pictures that make a difference. Great photographers working in these areas are able to reveal the unseen and unknown, and to transport us to new worlds by creating powerful and indelible images. Some want to create photographs that ask great questions of their viewers – and are even prepared to risk their lives to do so.

Different ways of telling a story

'Photojournalism', as the word suggests, is the fusion of photography and journalism. The French word 'reportage' is also commonly used to describe this kind of work in which a photographer is present at an event to make a report in the form of a sequence of pictures.

'Being a travelling photojournalist is utterly remarkable; the idea that you can enter people's lives and the most extraordinary situations that are so far removed from your normal experience and share in and in some ways communicate that experience to others.'

Chris Steele-Perkins, photographer and member of Magnum.

The term 'documentary photography' implies that a photographic record is being created for posterity, to be viewed later in exhibitions and books; photojournalism, on the other hand, involves the creation of images for a contemporary audience that are taken by photographers commissioned by the picture desks of magazines and newspapers. News photography is a facet of photojournalism and is for immediate use in newspapers.

Different photographers have different approaches to each of these areas; some are impartial observers of events, others take sides and are crusaders with cameras.

The news photo

The job of a news photographer is to capture the essence of a whole story in a single image – a moment of truth giving the sensation of what it was like to be present. He or she has to find that fraction of a second that says it all in a stand-alone image – the storytelling moment – rarely being given the luxury of a sequence or series of pictures in which to unfold a narrative. Frequently the photographer will have no idea of the final outcome of the story, having to photograph constantly and react to unfolding events.

Hold the front page

- Buzz Aldrin stands on the Moon, photographed by fellow astronaut Neil Armstrong, 1969.
- · The soldier returns from war.
- · Mount Everest is climbed, 1953.
- A Sailor's Kiss, Times Square by Alfred Eisenstaedt – sailor and girl embrace during the joyous VJ celebrations in New York in 1945.
- The Falling Man 9/11 photographed by Richard Drew, 2001.
- Hooded Iraqi prisoners abused by troops in Abu Ghraib prison, 2004.
- Pro-democracy demonstrator halts tanks in Tiananmen Square, China, photographed by Stuart Franklin, 1989.
- · Concorde crashes, 2003.
- The atomic bomb explodes, 1945.
- The Hindenburg explodes, photographed by Sam Shere, 1937.
- Jack Ruby shoots John Kennedy's assassin Lee Harvey Oswald, photographed by Bob Jackson, 1963.
- The street execution of a Vietcong prisoner, photographed by Eddie Adams, 1968.
- Death of an anti-war protestor at Kent State University, 1970.
- French customs take a massive X-ray image of a container lorry, revealing it to be packed with asylum-seekers.

Front-page photographs - moments of truth

Newspaper photographers aspire to having their pictures on the front page, where their work will be seen by the greatest number of people and create the maximum impact. Such pictures are chosen by picture editors for their ability to tell the whole of the biggest news story of the day. Technical quality is not an issue here; impact is what matters. A news photo can be unfocused, grainy and even poorly composed so long as it brilliantly encapsulates an event. Content – not quality – is king.

The history of news photography

Since the beginning of photography there had always been great news pictures that, had the technology been available, would certainly have been splashed across newspaper front pages. There are incredible pictures of the ruins of Hamburg after the great fire of 1842 and of the barricades of the Paris uprising in 1848, but newspapers had to make do with publishing drawings copied from the photos.

It was not until the 1870s that printing techniques were discovered that meant newspapers could finally reproduce photographs. By rephotographing a picture through a fine screen, the image could be reduced to many tiny fine black dots, which could then be printed on newsprint paper. This was a technique known as half-tone printing and it is still used today.

The New York Daily Graphic was the first newspaper to publish a half-tone photograph in 1880. By 1900 half-tone pictures appeared in most daily papers as publishers and editors realized they could boost sales with great news pictures. Newspapers began looking for news rather than waiting for it to happen and despatched the first full-time professional news photographers around the world to places where stories might occur. Great rivalry grew between newspapers for access to original and exclusive front-page photos. The wish of every news photographer today continues to be to have his or her work partnered by the banner headline 'EXCLUSIVE!'

The birth of the news agencies

The early 1900s saw the rise of many news-service agencies, supplying news photographs to subscribing newspapers and saving editors the expense of having to send staff photographers to cover every story. Famous agencies include Corbis, Associated Press (AP) and its great rival United Press International (UPI). Many famous photographers have worked for these agencies, including Pulitzer Prizewinners Joe Rosenthal and Nick Ut. Large news services offered a huge network of news coverage by having many of their own photographers and by buying in pictures from freelancers and regional papers, distributing the photos to their clients as speedily as possible by plane, train and boat. However, in 1906 it still took eight days for pictures of the San Francisco earthquake to make it onto the front pages of papers on America's East Coast.

Despite the thousands of images available, many picture editors chose identical images for their front pages.

Tabloids

Tabloid newspapers developed rapidly between the world wars, featuring pictures of sensational crimes and disasters, telling their stories quickly by using large pictures and short captions. The tabloid *New York Daily News* launched in 1919. It called itself a picture newspaper, and had a logo of a camera with wings, indicating the speed with which its photographers could tell the news. The new tabloids' thirst for sensation meant that news photographers were encouraged to get images by whatever means possible. For example, blurred pictures of the death of murderers in the electric chair were taken secretly with hidden cameras.

Scoop!

The photos of Dr Erich Salomon in the 1920s and 1930s were some of the first scoop pictures – sensational news photos – taken, for instance, in secret at a trial and sold for a huge fee. Salomon trained in Germany as a zoologist, engineer and lawyer before realizing that he could sell the pictures that he had secretly taken in the courtroom for the equivalent of two months' wages. Salomon became famous by using his Ermanox camera, which was marketed with the slogan - 'what you can see, you can photograph'. With a huge lens and a very wide aperture, it could take pictures indoors in poor lighting, but it only took one sheet of film at a time before having to be reloaded. Elegantly dressed in dinner jacket and bow tie, Salomon had the gift of being able to mix with the rich and famous without being noticed. He would gatecrash political and diplomatic gatherings, quietly placing his camera where it could view goings-on. On seeing the key moment, he would press the shutter with a long cable release, before exiting with his picture. The term 'candid photography' was coined to describe Salomon's revealing pictures of world leaders caught vawning and snoozing at summit meetings.

The tools of the press photographer

The Speed Graphic camera was launched in 1912, becoming the original news photographer's tool. Although it was heavy, it could be handheld by a leather wrist strap and was designed to use 5x4-inch sheet film loaded in darkslides. The large format was perfect for editors on a deadline, as they could publish contact prints made straight from negatives. This was Weegee's (see p. 51) choice of camera, with which he stalked New York, photographing murders, fires and other sensations. He fitted his camera with a huge flash gun, using newly invented flash bulbs for night shooting. Weegee was the most famous news photographer in the world but was also notorious among the press pack for repositioning dead bodies in order to get a better shot.

The Speed Graphic was very cumbersome: focus often had to be guessed in the speed of the moment and the photographer had to ensure he got the shot in one, especially at fast moving events – as it took so long to load the next darkslide and change the flash bulb.

The invention of the lightweight Leica camera and its rival the Graphex in the 1920s totally revolutionized news photography and photojournalism. The Leica was invented by Oscar Barnak and was launched in 1925, and was the first camera to use sprocketed film like today's 35mm film. Barnak worked for the cine-camera manufacturer Leitz. He had the idea of creating a camera that used cine film instead of conventional photographic roll film. It was christened the Leica, short for Leitz and camera. The Graphex also used 35mm-type film and was the first camera to have an internal mirror allowing the photographer to see the scene through the lens. These two dynamic new cameras were miniature in comparison to the Speed Graphic and revolutionized how photographers worked. For the first time they were freed from the constraints of big cameras; they could work unobtrusively and take pictures very quickly, accurately and continuously.

Wire photos

In the 1930s photographs could be transmitted down the telephone by scanning a picture and translating it into electrical impulses. Wire photos, as they were known, could be sent from one machine to another anywhere in the world; the receiving machine converted the impulses line by line back into a photographic copy of the original.

News agencies saw the great possibilities of wire photos for news stories. Pictures could be sent to many receivers simultaneously, making the distribution of images to newspapers much quicker. The first wire photo to hit the front pages – of a plane crash – was published in twenty-five cities at the same time. The wire photo became the dominant form of news-picture distribution until the 1970s. Early wire images had a very raw quality, like a photograph copied on a fax machine. This gave them the appearance of great drama and a sense of you-are-there immediacy.

The bloody news

Enrique Metinides worked for the Mexican tabloids known as the *nota roja* – the 'bloody news', whose obsessions are car, bus and plane crashes, violent death, catastrophe and suffering. Beginning in the 1940s he specialised in pictures of death and destruction, taking his first front page at the age of twelve, earning him the nickname El Niño – the kid. Using flash in daylight and later colour, Metinides became famous photographing carnage and slaughter for five decades.

Hold the back page

In the 1930s New York newspapers and news agencies tried to beat deadlines by using carrier pigeons to transport photographers' films back from assignments. One bird, nicknamed 'the Champ', worked for Acme News and could fly the half-dozen miles from the Belmont racetrack to the Acme offices on 8th Avenue in under nine minutes.

A red-colour news soldier

Li Zhensheng was a news photographer for the Chinese *Heilongjiang Daily*. He photographed the internal war that raged across China from 1966 to 1976 known as the Cultural Revolution. This was a period in which tens of thousands of young people joined the Red Guards, driven by revolutionary zeal. Children turned against their parents and pupils denounced their teachers. Countless numbers of people were executed, imprisoned or sent to work camps, accused of being enemies of the people.

Li photographed this time of madness, the denunciations, show trials, mass demonstrations and executions, winning recognition for his work from Chairman Mao who sent him an armband inscribed 'red-colour news soldier' – meaning 'revolutionary news photographer'. Li fell victim to the bitter political infighting that ensued and was himself denounced and exiled to a desolate part of rural China for two years. Despite the risk of punishment by death, he decided to hide all his negatives under the floorboards of his house. His pictures today are the only known record of the period, providing a unique and terrifying record for the world.

The Pulitzer Prize for news pictures

The Pulitzer Prize, named after the publisher Joseph Pulitzer, is a prestigious American award given every year since the 1940s for outstanding news photography. The dream of news photographers is to win this award, which has in the past gone to photographers whose pictures are among the most famous of all time. Winners include Malcolm Browne for a picture of a burning Buddhist monk in Saigon; Joe Rosenthal for his picture of American troops raising the flag in Iwo Jima; Nick Ut for his picture of children fleeing a napalm attack in Vietnam; and Kevin Carter for his picture of a starving child stalked by a vulture in the Sudan. (See The World's Best-Known Pictures, p. 148.)

9/11

Associated Press news photographer Richard Drew photographed the attacks on New York's World Trade Centre on September 11, 2001. Drew focused on the horrific sight of people leaping to their deaths from the top of the towers. One photo, now known as *The Falling Man*, shows a young man in a white jacket, dark trousers and black boots, framed against the steel stripes of the twin towers. Astonishingly, as he plunges head-down, he seems relaxed, casual, arms by his side, his left leg raised at the knee – offering a sliver of hope, where there was none.

On first seeing the picture on the computer screen at his agency's offices, Drew knew that from amongst the many thousands of pictures of 9/11 this would be the one to be front-paged. 'You learn from photo editing to look for one frame, you have to recognize it. That picture just jumped off the screen because of its verticality and symmetry. It just had that look,' he said. *The Falling Man* appeared in the majority of newspapers around the world the next day. The picture ran once and once only. Newspapers were forced to defend

themselves against accusations of exploiting the man's suicide. *The Falling Man* has become taboo following public resistance to the fact that people had chosen to leap from the towers. There are some events to which readers wish to close their eyes.

News photography now

Today's newspapers employ only a small number of staff photographers to cover major news stories, together with a network of nationwide regional freelancers to be called upon should a story occur in their district. The majority of news pictures printed now come from news agencies.

Photographers use the very latest equipment – cameras that can autofocus quicker than hand and eye can, with flash guns programmed to give perfect exposures, ensuring that photographers usually get the shot no matter how quickly an event occurs. Their digital pictures can be sent straight to computer screens at news desks while an event is still taking place. For the first time a photographer can tell a story in pictures quicker than a reporter can deliver copy. (See So you want to be a news photographer?, p. 233.)

Photojournalism and reportage

The news photographer is expected to communicate an event in a single picture. The photojournalist, in contrast, embarks on an assignment knowing he or she is going to tell a story through a series of pictures that will be viewed together and will cumulatively tell the story in a photo essay.

During the 1920s there was a huge public appetite for newspapers; every large city boasted many rival morning and evening papers. Publishers began to launch magazines full of large photographs, as they saw the possibility of creating popular titles that covered broader topics than the daily news. Printing techniques had improved and these picture magazines could now reproduce photos excellently.

The most dynamic titles came from Germany and included *BIZ* (the illustrated Berlin newspaper) and *MIP* (the Munich Illustrated Press), featuring work by a new breed of photographers including Alfred Eisenstaedt, André Kertész and Martin Munkácsi. They all used the new smaller, faster, lightweight cameras.

The editors of *BIZ* and *MIP* wanted to put their readers in the midst of the action. Rather than using single pictures to tell stories, they pioneered the photo essay. *MIP*'s editor Stefan Lorant said, 'I didn't think the single picture was enough.' Ordinary people were photographed at work or play, often as 'a day in the life', with each story laid out over a number of pages. The magazines were designed by a new wave of brilliant graphic designers whose dynamic covers and layouts redefined how pictures could be used. With the coming together of these exciting talents, the word 'photojournalism' entered the language to describe this new way of telling a story.

A classic photo essay
This photo essay from a 1939 issue of the *Picture Post* takes a humanistic approach to telling the story of a day in the life of an unemployed man.

By the 1930s many countries had outstanding picture magazines, including *Life* and *Look* in America, *Picture Post* in Britain and *Vu* in France. All of them surveyed the whole spectrum of society and treated the commonplace aspects of daily life as worthy of attention.

Life magazine was founded in America in 1936, following the model of the German picture magazines, with the manifesto 'To see life; to see the world; to eyewitness great events.' Picture Post launched in Britain in 1938 under the direction of Stefan Lorant. It was incredibly popular at its peak in the 1940s, selling nearly one and a half million copies a week.

The period after World War II until the mid-1950s was the heyday of the picture magazines. Photographers worked freely on the street and the camera was welcomed into people's workplaces and homes. Unlike the paparazzi of today, photojournalists treated people with respect and equality – photographing without intrusion – whether picturing the celebrity or the man in the street. Some of the twentieth century's greatest photographers worked in this period, including Henri Cartier-Bresson, Robert Doisneau, Margaret Bourke-White, Bill Brandt and Bert Hardy.

Magnum, the legendary independent photo agency, was formed in 1947 to protect the integrity of photojournalists' work. The world's most famous collective of photographers was created with the idealistic aim, unheard of at the time, of wanting to protect the copyright ownership of their pictures and control how their work was used in newspapers and magazines. Before Magnum a photographer's work was considered to be the property of the publication for which it was originally shot, and pictures could be cropped, retouched or captioned without a photographer's prior knowledge or permission and reused or resold with no fee given to the photographer.

Magnum is still run as a co-operative, sharing the profits between members. Its photographers are still at the forefront of photojournalism today. They include Chris Steele-Perkins, Donovan Wylie, Steve McCurry and Nikos Economopoulos. Magnum has declared its studio to be the world.

Henri Cartier-Bresson and Magnum

Henri Cartier-Bresson has been described as the father of photojournalism and was one of the four founding members of the Magnum agency. He began his creative life wanting to be an artist, but after being inspired by the work of Martin Munkácsi he bought a Leica camera and photography replaced art as his obsession.

His photographs are beautifully judged compositions, taken with masterful timing He was an obsessive purist, always using the standard 50mm lens, never cropping his pictures or using colour or flash. He was difficult to work with for picture editors, since he was quite prepared to come back empty-handed from an assignment if he didn't find inspiration not a course of action recommended to young photographers.

Cartier-Bresson travelled to wherever he saw the world was changing and often had the astonishing ability to be in exactly the right place at the right time to tell the story. He witnessed the Civil Wars in Spain and Mexico, Mao's Communist revolution in China, and he was the last photographer to take pictures of Indian leader Mahatma Gandhi, fifteen minutes before his assassination in 1948.

After being taken prisoner by the Nazis in 1940, Cartier-Bresson escaped at the third attempt disguised as a funeral mourner. He was wrongly reported dead, which led to the staging of a 'posthumous' exhibition that he was able to attend. In 1952 a collection of his photographs was titled Pictures on the Run and published in America as The Decisive Moment, a phrase that became synonymous with his name and style of pictures. While working, he made his guick and quiet Leica camera as inconspicuous as possible by covering over the shiny parts with black tape and keeping it hidden under his coat but tied to his wrist for instant use, often using a rubber jamjar lid instead of a fiddly lens cap. For the last thirty years of his life he returned to his first love - painting and drawing.

Cartier-Bresson died in 2004, aged ninety-five. His death made the front pages of many newspapers around the world. The Fondation Henri Cartier-Bresson in Paris exhibits his work, www.henricartierbresson.org.

Henri Cartier-Bresson, Behind the Gare Saint-Lazare, 1932

Cartier Bresson's ability to capture 'the decisive moment' set him apart; this early image freezes an action that, a micro-second before or after, would not have been so perfect.

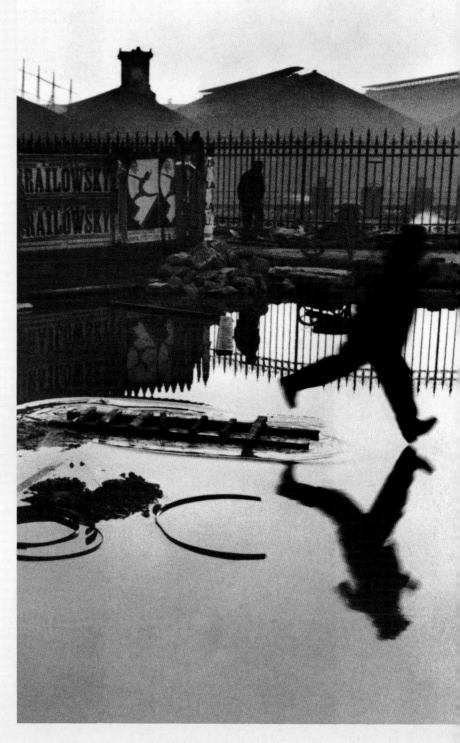

Documentary photography

To call a photographic project 'documentary photography' implies that photographs are taken to create a valuable, visual record. Documentary photographs create a historical document or something that will become one. The word 'documentary' was coined in the 1920s to describe the new kind of films being shown in cinemas about the exploration of the world and the lives of little-known people.

Documentary photography now describes long-term photographic projects that are self-initiated: a photographer commits a number of months, years or even decades to a story, driven by his or her passion and obsession rather than a commission, and often funded by other commercial work or by grants and awards. There is the tradition that documentary photographers live with their subjects, immersing themselves in their culture and lifestyles, sharing their experiences, and that the pictures are taken with the full trust of the subjects.

'For me documentary photography is less a matter of subject and more a matter of approach. The important thing is not what is photographed but how.'

Dorothea Lange.

Many documentary photographers stay in touch with their subjects long after their projects have been completed, returning to visit the friends they made and rephotographing the continuing story. Some photographers choose to photograph as if they were an invisible observer; others photograph as a participant in events.

Opening the eyes of the world

Shortly after the invention of photography, governments came to regard photographic records as a valuable addition to written records. Photography became routinely used in police work. Mugshots of offenders were taken to establish criminal records, full face, right and left profile becoming the standard. Soon social reformers saw the possibilities of photography as a means of educating people about poverty and exploitation, realizing that photographs offered proof of conditions hidden from the public eye.

In 1890 a book of flash-lit photographs called *How the Other Half Lives* focused on the appalling living conditions of Manhattan's Lower East Side. Produced by Danish-born photographer Jacob Riis, the publication of the book caused public outcry and was the catalyst for social change. Whole city blocks were torn down to be replaced by public parks and playgrounds.

Lewis Hine also believed that published photographic evidence could effect change. He photographed the wretched working conditions of the poor across the whole of America in the early 1900s, in particular child labour in factories. He was sponsored in his efforts by public and private organizations

Must-see documentary photography

- Bruce Davidson's Brooklyn street-gang project and subway series.
- · Farm Security Administration photographs.
- Roger Mayne's pictures of street life in the North Kensington area of London.
- · Chris Steele-Perkins's pictures of 'Teds'.
- · Oscar Marzaroli's pictures of Scotland.
- · Danny Lyon's motorcycle-gang pictures.

Chris Steele-Perkins, *The Teds*, 1976
Documentary photographers often focus on subjects that are not the stuff of headlines.
Chris Steele-Perkins spent three years photographing the English Teddy Boy scene in a project later published as a book.

concerned with the welfare of the poor. The rubber stamp used on the back of his pictures read 'Lewis W. Hine/Social Photographer'.

The term documentary photography came into common use after pictures taken by photographers working for the Farm Security Administration were first published in America in the 1930s. The FSA, a division of the US Department of Agriculture, hired a dozen photographers – including Walker Evans and Dorothea Lange – to provide a stream of potent photographs that could be distributed to newspapers nationwide, which showed the lives of the rural poor at the height of the catastrophic drought that had hit the Southern states during the economic depression of 1929. The FSA project, which lasted over five years, was conceived as 'a pictorial documentation'. It successfully used photography to open the eyes of the American people to the plight of the people pictured.

In Britain a project known as Mass Observation took place between 1936 and 1947. It was the largest ever investigation into the culture of one country. Fifteen-hundred observers were sent all over Britain to document the minutiae of everyday life. Mass Observation looked at normal people doing the things they do each day - going to work, spending time with their families and socializing. The aim was both to reveal and preserve for a future audience the daily rituals of people who are never interviewed, written about or make the news, and to educate by contributing 'to an increase in the general social consciousness'. The photographers working for the FSA and Mass Observation paved the way for modern documentary photography.

'I believed that pictures should disclose the unacceptable: poverty, bad housing, hunger and that my pictures would help eventually to make the world a better place.'

Humphrey Spender, photographer for the Mass Observation project.

Giving voice to the unheard

Documentary photographers often have a mission to educate and enlighten, choosing to look at issues that are typically not the stuff of headlines but instead daily life, creating indelible images of subjects that are at the periphery of our vision. Their photos reach a wide audience through publication in books or in exhibitions.

The Brazilian Sebastião Salgado exemplifies this approach. His images give a voice to his subjects' stories - some of which had rarely if never before been heard, opening the eyes of the world to the daily toil and struggles of his subjects. Salgado has photographed in over sixty countries, focusing mainly on people who survive from day to day, labourers, refugees and famine victims. His extraordinary series of pictures taken in 1986 of the lives of the open-pit goldminers in Para, Brazil, showed a vision of hell. Massive, muddy pits swarm with ragged workers, some of them children. Some climb huge homemade ladders, burdened with sacks of earth, others dig by hand, all under the eye of uniformed armed guards. This self-initiated assignment,

Documentary films

Before there was even a word for it, photographer and filmmaker Frank Hurley made one of the world's first documentaries, taking as his subject Australia's first Antarctic expedition. When the party became stranded by winter storms, Hurley filmed the extreme blizzard conditions, telling the story as a heroic battle between man and nature. He went on to produce the extraordinary photographs of Shackleton's later Antarctic trip. Many photographers have made documentary films, including William Klein, who made them about the boxer Muhammad Ali and the singer Little Richard.

Martin Parr, Sedlescombe, 1998

Martin Parr brought vivid colour to documentary photography in his medium-format, close-up photographs of Britain's daily social pageants and ceremonies. The activities of drinking tea, Tupperware parties, seaside holidays, suburban DIY, Union Jack flags and '99' ice cream cones are photographed larger than life, sometimes with ring-flash, enlarged to billboard scale for exhibition.

Parr mostly photographs with sly, knowing humour, tongue firmly in cheek. Sometimes his vision is a cruel one, the opposite approach to that of many documentary photographers. On applying to join Magnum – a process Parr described as being akin to trying to join the Freemasons – he found himself denounced as a fascist by veteran war photographer Phillip Jones Griffith for mocking the people he photographed. Parr scraped in by one vote; he is said to be Magnum's biggest current earner.

Where Robert Frank (see Telling a Story in a Book of Pictures, p. 100) looked at the iconography of American life in black and white – jukeboxes, cars, bars, and the Stars and Stripes flag – the English photographer Parr uses throbbing colour in his dissection of British iconography. Parr is an obsessive collector and former trainspotter and birdwatcher. He collects examples of the ways in which pictures can be used – postcards, mugs and plates with photos on, prostitutes' cards found in phonebooths, and even crisp packets.

In his book *Autoportrait*, a series of portraits of Parr taken in theme parks by street photographers from around the globe, he appears as the Mr Bean of photography, a weedy nerd in spectacles bewildered by the world.

His books include Sign of the Times, The Last Resort and a black-and-white series, The Weather. He has also compiled a strangely compelling book entitled Boring Postcards.

If you like Parr's work, have a look at John Hinde's postcards and the photographs of William Eggleston.

carried out over a month-long period, shook viewers, who could not believe that such barbaric conditions could exist in the late twentieth century.

Bruce Davidson spent two years, 1966–68, photographing people living in Harlem's East 100th Street in New York, having initially approached the local citizens' committee with his idea for the project. He deliberately chose what was known as the worst block in the city and photographed in black and white with a large-format view camera. Davidson produced a wonderfully intimate series of gentle, dignified pictures of people struggling in poverty. He photographed not as a stranger with a camera, but as a trusted friend welcomed into people's homes.

Roger Ballen (www.rogerballen.com) spent almost two decades photographing life in the small villages of rural South Africa. He revealed the unknown poor in troubling and provocative pictures which evoke the barrenness and emptiness of the South African countryside and the mindset it has helped to create in its inhabitants. His pictures are square and black and white, taken with a medium-format camera, often with vivid flash. Ballen created each picture in partnership with his subjects, viewing the small, claustrophobic square of space that he'd selected through the lens of his camera as a theatre stage on which he invited the people to perform, with their pets and children.

After taking grainy and grim pictures of his own adolescence, followed by time in jail, Larry Clark was able to talk himself into getting a grant to photograph the lives of young American teenagers. Although by then over twice their age, he photographed them as if one of their gang, saying, 'They're living for the moment, not thinking beyond that, and that's what I wanted to catch. And I wanted the viewer to feel like you're there with them.' His disturbing snapshot pictures are shockingly 'there with them', exposing the reality of teen lives that are casually entwined with hard drugs, sex and guns. (See The snapshot, p. 157.)

Telling the story of war

'Believing that one picture is worth a million words, it is the task of the still photographer to try to expose the injustices that humanity perpetrates on itself. Images of the agonies and ecstasies of war must still have the ability to shock and, one hopes, to sway public consciousness.'

Tim Page, war photographer.

Although the language of photography seems suited to fighting – with flash guns, shots, loading, aiming and capturing – there are only a few brave photographers who have a mission to tell the story of war. They choose to bear witness for us by photographing the victors and victims, looking unflinchingly at horror and death, often showing remarkable courage.

War photography has been approached as news photography, photojournalism and documentary, with each photographer striving to create pictures that force viewers to choose sides. There isn't a no-man's-land in war photography.

Victors and victims: Roger Fenton and Mathew Brady

The first front-line war photographer was the Englishman Roger Fenton, who was dispatched to the Crimean War in 1855, under strict instructions to bring back a positive view of the war that would calm fears at home. He seems to have done a good job. Instead of photographing the suicidal Charge of the Light Brigade, Fenton produced stately scenes of soldiers in mock-heroic poses and battleground landscapes with biblical titles which were then reproduced as wood engravings for publication. He took over 300 pictures, not one showing the rotting corpses he mentioned in his letters.

Fenton's work was widely exhibited and inspired Mathew Brady to embark on ambitious campaigns to photograph the American Civil War, 1861–65. Brady ran a portrait studio and gallery on Broadway in New York City, across the road from Barnum's Gallery of Freaks. Known as 'Brady of Broadway', he rarely took pictures himself, instead employing 'operators'. Brady sensed pictures of death could be good for trade. When he created a corps of photographers to cover the war, the announcement of his plans made national news.

Brady seems to have spent most of his time hobnobbing with generals rather than on the battlefields where his operators were photographing. Their pictures show smashed and bloated dead bodies strewn upon fields and lying in ditches. The photos were exhibited, with no attempt made to censor their horror. The show caused a sensation amongst the New York public who fought to pay to see the pictures. Brady's project had paid off. Reproductions of the pictures of the dead, sized for the home album, sold particularly well.

The first living-room war

The Spanish-American war of 1898 fought in Cuba became the first war to be reported with printed photos in newspapers, although these were published weeks after they had been taken, having been transported over sea and land from the front line. This war has been labelled the first living-room war as the impact of photographic images of death could reach into every home of a fighting nation for the first time.

At the outbreak of World War I press photographers were allowed to follow the British Army in France with little hindrance. The newspapers were patriotic supporters of the war and all images published were positive ones. A year into the war, as men were beginning to be conscripted to fight, morale in the country began to drop and the government saw the need to bolster confidence that the war could still be won by a war-weary nation. Photographs began to be censored and suppressed, so that only images that gave the impression that the war was being won and everyone was behind the war effort were published, despite strikes and a growing anti-war movement.

No photos of dead allies are found in British newspapers or magazines of World War I, although there are many of the enemy dead. Official photographers were discouraged from picturing their own dead troops, as were official war artists. Photographers were eventually banned from the Western front, as was any photography taken by the troops. The few snapshots that survive – taken by soldiers risking court martial – show the total devastation caused by warfare, the miserable life in the trenches and the blind terror of going 'over the top' to fight.

Roger Fenton, The Valley of the Shadow of Death, 1856 (taken in 1855)

Roger Fenton was sent to the Crimean War by the Illustrated London News magazine, with the blessing of the British War Office, complete with a horse-drawn wagon to carry his cameras, glass negatives, developing lab and two assistants. He was a strange choice to photograph the horrors of the battlefield, as he had previously worked as a landscape photographer. This battleground shot, given a heroic biblical title, carefully omits and signs of death or violence - true to the selective brief Fenton was given.

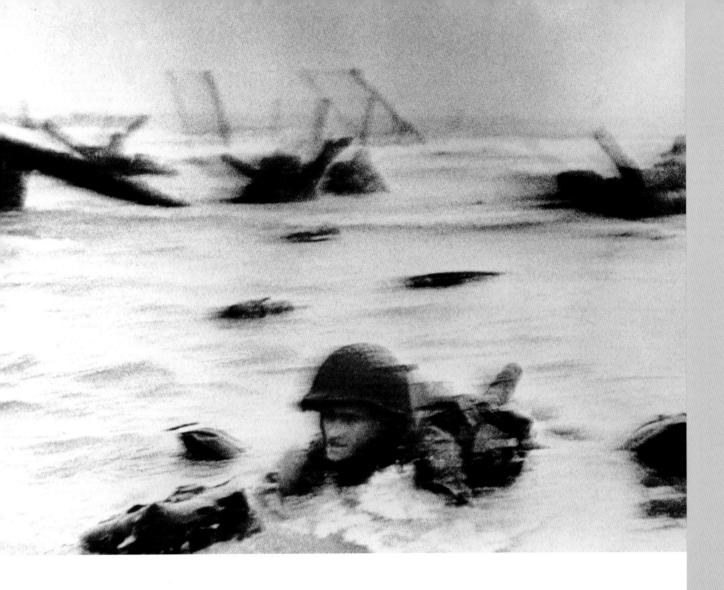

'The greatest war photographer in the world': Robert Capa

The original hard-drinking, hard-living war photographer, striding through the world's theatres of war in the 1930s, '40s and '50s – Spain, North Africa, Sicily, Anzio, D-Day, Israel and Vietnam – Robert Capa was driven by a mission, always travelling to the front line. Expressing in his pictures the panic, anxiety and tragedy of war, he saw his camera as a weapon against totalitarianism.

Born Endre Friedmann in Budapest in 1913, he moved to Berlin and became an errand boy in a photographic agency, graduating to darkroom assistant before being given minor photographic assignments. In 1932 he sneaked into a lecture given by Trotsky; the resulting pictures were his first great success.

He relocated to Paris in 1933 and befriended André Kertész and Henri Cartier-Bresson. Finding himself short of assignments, he followed his girlfriend's suggestion and reinvented himself with a clothes makeover and a change of name, choosing the name Robert Capa as he thought it sounded American and professional.

Robert Capa, *D-Day landings*, 1944
Many of the images from this historic shoot of the D-Day landings in 1944 were lost due to poor processing, but those that survived are a powerful visual document of a decisive event in world history seen from a human perspective.

Capa took one of the most famous and controversial war photographs in 1936 during the Spanish Civil War, aged just twenty-two. The picture is now known as *Death of a Loyalist Soldier*, *Soldier at the Moment of Death or The Falling Soldier*. A man dressed in a white uniform falls under gunfire, tossing his rifle hopelessly away, an image of the heroic stand against the fascists. The photograph was first published in France's picture magazine *Vu*, then picked up by *Life* and *Picture Post*. Questions were asked about the picture's truth and authenticity. Why was Capa in front of the soldier? Why is there no sign of a wound? Capa's photo is thought to be of the death of Federico Borrell García on the Córdoba front on September 5, 1936, an image that is still a powerful symbol of sacrifice. *Picture Post* carried eleven pages of Capa's Spanish Civil War photographs and proclaimed him 'the greatest war photographer in the world.'

In 1938 Capa took pictures on colour slide film of the aftermath of a Japanese bombing raid. These were printed in *Life* magazine which, persuaded by their strength, made an exception to its policy of publishing only black-and-white photos. Capa's photographs of the D-Day landings in Normandy on June 6, 1944 portray the panic and chaos of war more than any others. Capa, complete with a Burberry raincoat, found himself booted into the freezing water behind the American soldiers when his picture-taking from the landing craft was mistaken for a hesitation to leap. Only a third of the first wave of troops reached dry land.

After a few minutes on the beach, under heavy fire, shaking with fear and having run out of film in his two Contax cameras, Capa scrambled back onto a barge retreating to England – by which time the sea was stained red with blood, according to surviving soldiers. In haste to get the pictures printed, the darkroom assistant nearly destroyed the negatives by turning up the drier too hot, which melted the film's emulsion; of over a hundred pictures only eight survived. The heat-blurred pictures are etched with a raw texture; they give the sensation of the intense danger, confusion, panic and fear of the aborted landings. The pictures are the inspiration for the look of many sequences in modern war films, including the first half-hour of *Saving Private Ryan*.

His famous advice to others, 'If your pictures aren't good enough, you're not close enough,' was the death of him, when on May 25, 1954, still in pursuit of the action, he stepped on a landmine in the Red River delta in Vietnam. Capa's autobiography, *Slightly out of Focus*, is a must-read.

Cecil Beaton, Broken German Tanks at Sidi Rezegh, 1942

Beaton was a most unlikely war photographer. Known for his glamorous fashion pictures and portraits of the rich and famous, he found himself attached to the Ministry of Information in World War II with the task of promoting the war effort. One picture of a heavily bandaged girl – the victim of a bombing raid – sitting up in her hospital bed made the cover of *Life* magazine. It is said to have galvanized US opinion in favour of joining the war. In the image reproduced here, Beaton finds brutal beauty in twisted metal.

Haunting Hiroshima

Photographs of the atomic bombing of Hiroshima and Nagasaki in August 1945 were taken from the planes that had dropped the bombs as they flew home from their missions in which a quarter of a million people had died. The images of the skull-like mushroom clouds were to haunt the public's imagination for the next decades, while all images of the victims of the bombs were censored in America for being too shocking.

The battle with censorship

W. Eugene Smith photographed American troops in the Pacific in 1944–45, concentrating on the physical and emotional experiences of front-line soldiers, photographing with sympathy and compassion, getting so close to the action that he was seriously wounded in Okinawa. His way of telling the personal stories of war is echoed in the photos of Vietnam by Larry Burrows and Don McCullin, who concentrated on taking powerful and immediate pictures of the daily lives and suffering of ordinary soldiers far from home, fighting in dreadful conditions and frequently experiencing the death of friends. Burrows' 1966 colour picture, known as *Reaching Out*, shows an injured black GI instinctively turning to help his severely wounded white comrade rather than be evacuated for treatment. Burrows was killed in 1971 when the helicopter he was in was shot down over Laos. A 1968 picture by McCullin shows a shell-shocked soldier during the Tet offensive clenching the barrel of his gun, a hollow, dazed and defeated Action Man.

Vietnam was the first and last time in which the press was given the freedom to roam at will across the theatre of war. Photographers were able to travel to wherever they could hitch a ride by helicopter or truck. Their horrific pictures of the conflict swayed public opinion against the fighting and contributed to America losing the war. No government would take that chance again. During the Falklands War of 1982 the British government prevented access to the conflict by picking just two photographers to supply all the images to be published back home – one from a pro-government newspaper and one from a news agency. This level of censorship was repeated in the first Gulf War of 1990-91, though an extraordinary picture of a charred Iraqi soldier incinerated in the moment of trying to escape his tank – his head seeming to be about to crumble to ash - was taken by Kenneth Jarecke on the road to Basra. He had somehow avoided the net of press restriction to take the picture. Jarecke was shooting for TIME magazine, whose editors killed the picture, considering it too shocking. It was also censored by most newspaper editors. Jarecke reflected that 'no one would touch my photograph.'

By the second Gulf War of 2003–04, American and British governments exerted a total stranglehold on the media by allowing access to the war only to a chosen few photographers and journalists who were 'embedded' with sections of the army, meaning that all their movements and activities were firmly controlled. All other members of the press were corralled at a media centre, many hundreds of miles from the front line, where the only information available was from the army's media spokesmen.

Censorship extended to a Pentagon ban on the publication of any photos of American war dead, broken by the publication on the internet of a photo taken by a cargo handler of an American plane full of coffins draped in American flags. By far the most potent image to emerge from the invasion of Iraq is the haunting image of the terribly injured young boy Ali Ismail Abbas, whose arms had been blown off during one of the bombing raids described by the military as 'surgical strikes'.

Telling a story in a book of pictures

All photographers want to see their work published in books. A few, including Diane Arbus, William Klein, Henri Cartier-Bresson and Robert Frank, have produced incredible books that continue to inspire new generations of photographers, as have Nick Knight and Richard Billingham more recently.

In turning the pages of a book of photographs you can intimately view and review the imagery, sequences and rhythms of a photographer's work. Photographers are collectors and to possess a selection of your favourite photographer's work in one book is a wonderful thing. Photography books both preserve the work of photographers and enable them to gain very wide audiences.

The history of photography books

William Henry Fox Talbot is credited with creating the first book of photographs – *The Pencil of Nature*, which was published in six parts between 1844 and 1846 using prints from his Calotype negatives. Around the same time Anna Atkins created an amazing book of cyanotype pictures of flowers. (See Where Has Photography Come From? in Loading.)

Self-published books

One of the benefits of the digital age is that publishing your own book is very easy. Adding photos, artwork and text to a story or document can be done using online publishers. Creating a self-published book is very satisfying and the process of telling a story in pictures can create a powerful body of work that can become a collectable book in its own right. A self-published book is a way of presenting your work and bringing you to the attention of those who commission photography. Online publishers such as Blurb, Lulu and Bob Books enable you to sell your book via the internet directly to your target audience or, by using print on demand, to distribute the book yourself through specialist outlets such as art shops. Collectors of photo books are always looking for exceptional new photographers and buying a first edition from a photography books are purchased.

With the change to online publishing, traditional paper-based book publishers and others are exploiting digital platforms and providing ephotobooks, as Apps or in downloadable formats. The future of publishing is undergoing great changes, but the traditional printed photo book is likely to remain for many years. A well-printed, beautifully designed book cannot be replaced by screen-based publication – the reader's experience in handling it is both tactile and visual, and long may that be the case. If you have the talent, a great project and a good deal of luck, a publisher may get involved and finance a small edition. However, most photographers do not make a great financial return on book publication, but they can benefit from the kudos and the exposure that a book provides in helping to promote their career.

Specialist dealers

Specialist dealers have sprung up as collectable monographs and rare first editions can command significant figures. In this digital age, small limited-edition books can be created without compromising on quality, allowing emerging photographers to come to the attention of curators and collectors.

The patched American flag: Robert Frank

Robert Frank's book *The Americans* is pivotal in the history of photography. It is a benchmark for the huge impact a story told in a book of pictures can have. Each image in the sequence of only eighty-three black-and-white pictures, beautifully printed in a small black bound book, stands alone opposite a blank white page. The pictures were selected from over 28,000 Frank took during a meandering journey across the breadth of America in a battered Ford in 1955 and 1956. The photos express alienation, sadness and bewilderment, a sequence stitched together with images of the stars and stripes of the American flag, appearing sometimes threadbare and patched, often sliced by the framing of the pictures. Gas stations, jukeboxes, drive-ins, coffins and crucifixes also feature in the layers of imagery that journey through the book. You feel as if you are travelling with Frank, looking from his car window.

Upon its publication in 1958 *The Americans* caused outrage. Critics called it warped, sick, neurotic and joyless, offended by the audacity of the title, regarding it as an attack on American values and way of life. Frank had perfectly captured a nation on the cusp between the dying optimism of the early 1950s and the radical changes to come in the 1960s.

The Americans is still in print today and Frank's pictures have influenced every succeeding generation of photographers. The Americans is photography's version of Jack Kerouac's On the Road, a sad Beat poem for a changing country. Kerouac even wrote the introduction.

Robert Frank was born in Switzerland in 1924 and emigrated to America aged 23. He abandoned work as a fashion and advertising photographer in the early 1950s to travel to South America and Europe, and then roamed America supported by a Guggenheim Fellowship. Frank sometimes made little attempt to compose his pictures, randomly shooting without looking through the viewfinder. The image of the US flag, seen so often in *The Americans*, was to become a key element of Pop Art. Frank's pictures predate Jasper Johns' iconic American flag painting.

Shortly after the publication of *The Americans*, Frank stopped taking photos to concentrate on filmmaking, bringing his photographic approach to moving images. His films are mainly created with hand-held cine cameras and include *Cocksucker Blues*, a documentary on the Rolling Stones' 1972 tour. The band used a detail of a Frank picture on the cover of their album *Exile on Main Street*. *Cocksucker Blues* is a messy masterpiece; much of the grainy footage is etched with light that had leaked into the film magazine – a 'fault' that Frank refused to get fixed. The Stones banned the film from being shown – except in Frank's presence – and it has become a highly prized bootleg video.

Returning to photography in the 1970s Frank began creating collages and sequences of pictures, some from images featured in *The Americans* onto which he boldly scribbled deeply personal text reflecting the tragedies that have peppered his life. These formed his book *The Lines of my Hand*.

Frank, though never a household name, nonetheless gathered a huge cult following of people who admire his images before all others.

Loneliness, strangeness and sadness: Diane Arbus

'Giving a camera to Diane is like putting a live grenade in the hands of a child.'

Norman Mailer, American novelist.

Diane Arbus's groundbreaking book was first published by Aperture in 1972. The pictures are unforgettable silvery, black-and-white squares with smudgy edges that tell intense and compelling stories of loneliness, strangeness and sadness. Each picture is displayed on the right-hand page, accompanied by a simple and strange title on the left. In some pictures we see people in ordinary surroundings, refusing to live ordinary lives. Tattooed men, transvestites, strongmen, circus performers, men in drag and a lady nursing a baby monkey that is dressed as a child are all examined by the harsh cruelty of the exploding raw flash bulb. In other pictures passers-by, stopped in the street, on the beach or in the park, look straight at the camera, posed symmetrically in centre-frame, seeming drained by life. Of all the pictures in the book, the final few photographs of the disabled, wearing masks and playing games, are the most uncomfortable to view and impossible to forget. Taken in 1970–71, they are now known as *The Untitled Series*. The book, which is still in print, has sold over a quarter of a million copies.

A tabloid gone berserk: William Klein

William Klein created four legendary self-designed books, *New York: Life Is Good and Good for You in New York: Trance Witness Revels* (1956), *Rome* (1960), *Tokyo* (1964) and *Moscow* (1964). The New York book had a very bold design and was hugely influential. Klein wrote: 'I saw the book as a monster big city "Daily Bugle", with its scandals and scoops, that you'd find blowing in the streets at three in the morning... I saw the book I wanted to do as a tabloid gone berserk, gross, grainy, over-inked, with a brutal layout, bull-horn headlines.' Klein's pictures are full of energy, distortion and blur. Printed in stark black and white with no midtones, the images rush at the viewer like TV pictures fast-forwarded with the contrast turned up full. (See Elegance and elephants, p. 78.)

Fighting and making up: Richard Billingham

Richard Billingham's book *Ray's a Laugh* (1994) contains no text except for half a dozen lines on the back cover and a few words from Robert Frank. The photographs detail in raw, full-bleed colour the daily life of Billingham's mum, alcoholic dad and brother in their claustrophobic flat overrun with pets. The Billinghams' life consists of drinking home brew, fighting and making up, smoking, feeding the cats and doing jigsaw puzzles. The book puts you in the centre of the family's chaos – the dad's staggering drunkenness, the haze of hangovers and nicotine – with glimpses of affection and happiness. You can smell the stench of the flat

Diane Arbus and Richard Avedon came from the same background: both were children of prosperous families who owned Manhattan department stores. Her family owned Russeks on Fifth Avenue and she grew up in a privileged world of nannies, maids and chauffeurs. After studying painting, she turned to photography and attended classes by Berenice Abbott, Alexey Brodovitch, Lisette Model and Bruce Davidson. In 1951, aged eighteen, she married Allan Arbus, a fashion photographer who worked for the Russeks advertising department. They began a commercial photography business together, with Diane developing the ideas and styling the shots while Allan took the photos.

By the 1960s Arbus had begun to pursue her own assignments and personal work using a 21/4 format Rolleiflex carnera. These pictures are mesmerizing. She interacted with her sitters during each shoot; on one contact sheet of portraits of a young couple Arbus herself suddenly appears in one frame, naked, replacing the girl, who had become the photographer.

Diane Arbus took her own life in 1971. Some see her personal work as one long suicide note composed using a camera.

If you like work by Diane Arbus, see work by August Sander, Lisette Model, Weegee, Martin Scorsese's film *Taxi Driver* and Todd Browning's 1932 movie *Freaks*.

Sequence

Some photographers are not satisfied with creating single images and choose instead to express their vision in sequences of pictures. Sequences can intensify a view and greatly develop ideas, creating a greater impact than individual pictures.

Early sequences

In the 1850s cameras were designed with a series of lenses so that a photographer could take a number of portraits – either four, eight or twelve – on the same photographic plate. These were the cameras that sparked the carte-de-visite craze. They greatly reduced the expense of having your portrait taken, which led to a huge increase in the popularity both of a trip to the photographer's and of collecting photos. Contact prints were made from the plates which were then cut up for presentation. The uncut pictures create a jerky, stop-start record of photo sessions, showing the sitters as they slightly alter their poses and expressions. These series look very similar to Eadweard Muybridge's studies of movement made thirty years later, the difference being that Muybridge precisely controlled the time between the taking of each picture.

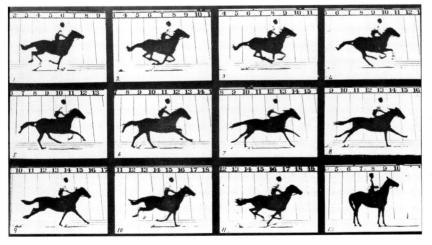

Eadweard Muybridge, The Horse in Motion, 1878

In 1872 a wealthy railroad tycoon with a large stable of racehorses hired Muybridge to settle a bet - reputedly for an astonishing \$25,000 between himself and a trainer as to whether there is ever a moment when all four of a horse's hooves are off the ground at the same time. Muybridge set up a series of cameras side by side at a racetrack so that he could photograph a horse galloping across their path. To each camera's shutter he attached a taut thread which would be broken as the horse passed, causing each shutter to snap in sequence. A horse called Occident sped past, tripping the shutters and settling the bet. Muybridge's pictures provided incontrovertible evidence that all four legs were off the ground at one point.

The weird world of Eadweard Muybridge

Muybridge lived an extraordinary life. Following a severe bang on the head in a stage-coach crash, he changed his name and career. From being Edward Muggeridge, unsuccessful book dealer, he became Eadweard Muybridge, brilliant and very innovative photographer.

As well as creating nearly 800 famous sequences showing the movement of horses, zoo animals and people, he developed the camera shutter and invented a projector that could show his sequences in motion – a forerunner of the cinema. Muybridge also found time to hunt down and murder his wife's lover – a crime of which he was acquitted in a sensational trial.

Etienne-Jules Marey

Like Muybridge, the French photographer Etienne-Jules Marey was obsessed with photographing movement. After seeing Muybridge's pictures of horses running, Marey became determined to photograph the movement of birds in flight. He invented a photographic gun with a rifle sight and a clockwork mechanism which, when the shutter was fired, made a rapid sequence of twelve exposures. Marey called his pictures 'chrono-photography', which means time-photography.

The power of sequence

The power of the repetitive image is known to every fruitseller who has ever created displays of boxes of oranges or apples, and to every supermarket manager who employs shelf-stackers to pile tins of peas or beans. Repeated images stimulate the eye. Andy Warhol saw these commercial displays and adopted their methods to produce silkscreened paintings of soup cans and Brillo boxes.

Peter Beard uses sequences to amplify the experience of being present at an event. His serial pictures of a matador killing a bull and of a charging lion offer the viewer a much more intense experience than any one of the pictures could on its own.

The humour of sequence

Elliott Erwitt creates humorous sequences of pictures, often with unexpected endings. He makes observations and tells great jokes in pictures – like a flick book or a photo cartoon strip. Robert Doisneau created a joyous sequence of pictures – taken with a hidden camera – of different people as they stopped to look at a nude painting on display in a gallery window. The expressions of the people vary from outrage to envy and pleasure.

Staged sequences

Duane Michals stages sequences of photographs using friends and models, room sets, double exposures and props. His sequences create a dream-like poetic world in which strange and puzzling things happen; characters disappear into bright light, spirits leave the body and flowers grow on people as though in a time-lapse movie.

Harold Edgerton experimented in a studio with rapid bursts of flash light to photograph sequences of fast-moving action, including tennis players serving and golfers striking the ball.

Collections

Some photographers use collections of similar images for impact. Photographers love collecting images, both with their cameras and by finding photos. Sequences occur or are built, gaining potency and connections by repetition.

For forty years the German photographers Bernd and Hilla Becher have meticulously and systematically photographed industrial architecture. They shoot water towers, cooling towers, blast furnaces and gas tanks. The Bechers precisely compose and carefully correct the perspective of each image using their large-format camera. All the vertical lines run parallel in the pictures, creating a flat-on, deliberately bland view. Grouping the photographs in categories, they display them in tight grids of images, reinforcing the buildings' strange brutal beauty and symmetry. Artist Idris Khan reinterprets the Bechers' pictures by superimposing entire sequences to make a single image, which Khan enlarges to a massive scale.

The artist Dick Jewell collects and reworks sequences of photos from newspapers and magazines. He created a massive mural from every photo he could find of the famous Olympic race between Zola Budd and Mary Decker in 1984. Jewell's picture offers a view of the famous incident in which the racers collided that was impossible for any single spectator present at the actual event to see. It shows the key moment from all angles of the arena by combining pictures taken by different photographers all around the track, together with others he found published that had been taken by people in the crowd. Jewell completed the picture by adding his own photos taken from TV footage of the race.

The slide-show sequence

Magic-lantern shows predate photography and were a very popular form of entertainment. Comic stories, adventures, stories from the Bible and morality tales were told through sequences of projected hand-painted or printed slides. Some projectors could show up to three images at once through different lenses and were used to create startling effects.

The invention of photography introduced glass photographic slides and soon the photographic slide-show entered many Victorian front rooms, where the first of many generations of young children were to be bored senseless by family photos of faraway places.

Elliott Erwitt, Not That Naïve, New York City, 1990

Erwitt is a photographer who can tell great jokes with photographs, in this case using a sequence shot in Central Park. 'Erwitt has the wonderful ability to anticipate scenes that most photographers wouldn't even notice', says picture editor Tony McGrath. Erwitt has created many pictures of dogs, published in his books Son of a Bitch and To the Dogs. If you like Elliott Erwitt's photography, see also the work of William Wegman.

Duane Michals, I Build a Pyramid, 1978

Self-taught photographer Michals stages scenes to create sequences of up to twenty pictures exploring big themes such as mortality and desire (opposite).

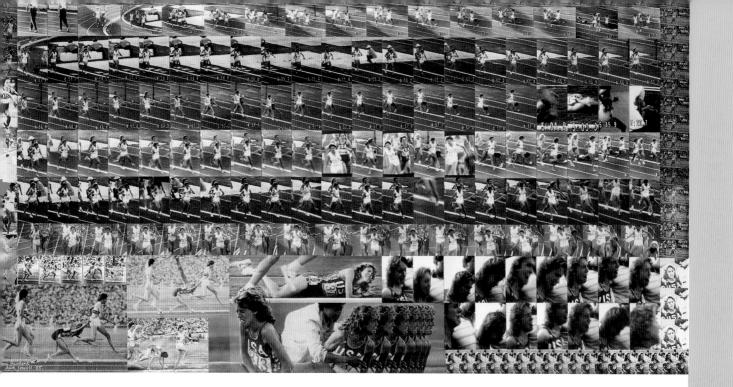

Sequences of projected images are used by many photographers and artists today. The projector offers the photographer an inexpensive way to display photographs at a large scale and in high quality when used in a darkened room. Nan Goldin first showed her photographic work as projections in nightclubs in the 1980s.

Jacques-Henri Lartigue's life in pictures

Jacques-Henri Lartigue recorded his life in a sequence of wonderful pictures. He created 130 large photo albums, packing their 14,500 bulging pages with beautiful pictures. Each page is carefully composed, with notes of time, place and participants. The albums are all of similar size and Lartigue stored them on specially made shelves. Today the photos are exhibited chronologically in their albums – a sequence of tens of thousands of pictures.

Lartigue is photography's child genius. Before being given a camera as a seven-year-old in 1901, he imagined you took pictures by simply blinking quickly three times! Although his first camera was taller and heavier than he was, he was able to take pictures that still appear fresh, joyful and spontaneous today. His father was among the richest men in France, and young Lartigue grew up surrounded by servants who became the willing subjects of many early pictures, along with his older brothers Zissou and Maurice.

Lartigue's family loved the excitement of motor-car races and joined the crowds that flocked to see early attempts at manned flight. Lartigue photographed these events with the camera he nicknamed an 'angeltrap', experimenting with ways of photographing the speed and energy that he witnessed. These pictures of the movement of cars and planes look like dynamic Futurist paintings.

Dick Jewell, The Olympic Incident, 1985

Artist Dick Jewell uses a huge sequence of images to amplify an event. Feeling the world's media had unjustly accused the runner Zola Budd of tripping Mary Decker, he used every picture available to analyze and clarify what had actually happened. Jewell studied at the Royal College of Art in London. Publications of his work include the books Found Photos and Hysteric Glamour.

As a teenager Lartigue became fascinated by the stylish Parisian women he saw strolling around him in the latest dresses and hats, and began to photograph them with a passion. These images – and in particular one of a woman wearing black-and-white stripes - became the inspiration for Cecil Beaton's designs for the film My Fair Lady.

As he grew older Lartigue simply continued to photograph constantly – his loves, travels, family and everyone he met, living a life of pleasure, untroubled by the changing world or the need to work. In 1963, following a chance encounter with John Szarkowski, director of photography at New York's Museum of Modern Art, he was offered an exhibition there. As a consequence Lartigue went overnight from being totally unknown to becoming an internationally famous photographer. The Peter Pan of photography – the boy who refused to grow up – became a professional photographer at the age of seventy and continued to create enchanting photographs full of youthful glee and wonder until his death in 1986.

Jacques-Henri Lartigue, Bichonnade Leaping, 1905

Taken at the tender age of ten, this shot encapsulates the playful, lively spirit of Lartigue's work. Lartique enjoyed a charmed life and the joy of living is evident in his photographs, shot over many decades.

Persuasion

Advertising campaigns and political campaigns

Some photographers are passionate about advertising, seeing it as the peak of professional photography. They are thrilled by the idea that their work may be seen at massive scale by huge audiences.

Advertising photographers love the collaborative aspect of putting together a campaign. There are many other creative people involved in advertising shoots – art directors, copywriters, stylists and set builders – and their partnership brings ideas to life. The job of the advertising photographer is to stir the appetites of the viewer by creating images that not only show a product but give it added value and resonance through the way it is presented.

Propaganda has the same purpose as advertising – to change the public outlook. Advertising is used for commerce, propaganda for politics. Propaganda spreads a message and propagates ideas – aiming to plant thoughts and images in the viewer's mind that assist or damage a political or social cause.

Creating desires

Advertising and propaganda images have a tremendous directness, simplicity and purity. Nothing appears in them by accident. They work through the same methods – claiming attention and creating desires through viewers' identification with the people featured, their feelings towards the well-known person photographed or the image's humour or shock value. Successfully creating these images of persuasion is a fascinating creative challenge.

Impact

'You have to visually arrest people. It's your job to stop them in their tracks. You have to shout louder than the cacophony of visual noise in the street.' Francis Glibbery, art director.

Advertising and propaganda images have to give a message to a viewer who isn't looking for it. These messages have to stand out on hoardings and billboards from the visual chaos of the street. Images have to arouse the viewer's curiosity as well as demand and reward a second glance.

People buy magazines for the editorial content, not the ads, so the advertising images must be more visually striking than the editorial material that surrounds them or they will be ignored.

Great images of persuasion

- F.H.K. Henrion's anti-nuclear poster 'Stop Nuclear Suicide'.
- The pregnant man 'Would you be more careful if it was you that got pregnant?' – photographed by Alan Brooking.
- 'It takes 40 dumb animals to make a fur coat but only one to wear one' – advertisement for Greenpeace photographed by David Bailey.
- · Posters advertising the film Trainspotting.
- · Oliviero Toscani's Benetton campaigns.
- The vending machine filled with guns –
 'This is how easy it is to get hold of a gun in South Africa' photographed by Wayne Rochat.
- Sophie Dahl perfume ad by Nick Knight; pastiched by artist Angus Fairhurst.
- · David LaChapelle's Lavazza ads.

'You don't want to see ads. You don't buy magazines for the ads – an ad by definition is a waste of your time. A great ad sneaks up on you when you haven't asked it to. By the time you've engaged with it, it has left you with a warm feeling. It steals your brain.'

Clive Challis, art director and teacher.

To command our attention, bold vivid colour, huge scale, dynamic design and the impact of 'cut-outs' – in which a figure or object is seen 'cut out' against a bright white background – are all used. Cut-outs are used to pare down the visual to its essence.

Ideas, ideas, ideas

Images of persuasion are carefully designed to speak directly to viewers. They are generally partnered by a few words in support of the picture. The viewer is challenged to decode the idea the picture and words create. For advertisements to be successful, ideas have to be fresh, new products

Nick Georghiou, *Maasai*, Landrover Freelander advertisement, 2003

As the product – the car – is absent, the picture calls upon the viewer to unwrap the message – a brilliant idea, brilliantly executed. Georghiou, a graduate of the Royal College of Art in London, works exclusively in advertising. He has created images for numerous campaigns for global brands including Adidas, Sony and Vodaphone. More of his work can be seen at www.nickgeorghiou.com. This ad was dreamt up by writer Mike Boles and art director Jerry Hollens.

have to be seen as instantly desirable and established products have to be seen in a new light. This is an exciting challenge. Advertising photographers are given the essence of an idea and asked to make it work – by creating photographs that are both visually wonderful and that deliver the idea with maximum impact.

'You have to crop everything down to concentrate the viewer's mind. The more extraneous stuff there is, the more you lose sight of the idea.' Clive Challis, art director and teacher.

No advertising idea is considered too extreme or unrealizable. Photographers often have the luxury of a large budget – huge sets can be constructed, lavish locations hired, teams of models and extras cast, elaborate props built, outfits designed and the latest expensive technology harnessed – all to help make an idea come to life.

Advertisers have always striven to be in the forefront of modernity and technology, commissioning the most innovative and creative photographers to produce their campaigns from early greats like László Moholy-Nagy and Irving Penn in the 1930s and 1940s, through Robert Frank and Garry Winogrand in the 1950s and 1960s, to Nick Knight and David LaChapelle today.

Propaganda photojournalism

Many world leaders have employed photographers or used photography as a way of controlling their public image. Presidents, prime ministers and royalty allow carefully vetted photographers access to them so that the public can be supplied with a highly controlled peek into the inner sanctum of power. The pictures are choreographed by public-relations managers to ensure those photographed always appear in a positive light.

Hou Bo worked for the Communist Party in China, taking propaganda pictures of Chairman Mao. Her pictures were widely distributed by the Chinese authorities, who used them to spread the message of the people's love for their leader and his heroic deeds and of the great progress of the revolution. When Mao was reported to be dying, her pictures of the seventy-three-year-old happily splashing about in the Yangtse River were used to quash the rumour. In 1959 Hou Bo photographed Mao surrounded by adoring young pupils on the steps of Shaoshan school. Millions of posters of the retouched and hand-coloured image were distributed throughout the whole of China. When Hou Bo was later accused of taking unflattering pictures of Mao, she was imprisoned in a labour camp.

Shock and subversion

Oliviero Toscani's advertisements for the clothing company Benetton in the 1980s featured a cast of multiracial models in brightly coloured jumpers under the slogan 'All the world's colours'. The campaign was developed by juxtaposing warring nations united in harmonious woollen clothes: an English model with an Argentine, an Iranian with an Iraqi, and an Arab with an Israeli.

With each successive campaign Toscani decreased the visibility of the products being promoted, before discarding them entirely. Keeping the same 'cut-out' photographic style, he increased the shock value of the images. Soon priests kissed nuns, a black woman breastfed a white baby and a newborn child cried while covered in blood. Each new campaign was eagerly anticipated, though as soon as the shock value waned Toscani was replaced and the company refocused itself on 'cash for cashmere'.

The Canadian-based Adbusters Media Foundation (www.adbusters.org) creates subverts instead of adverts and uncommercials instead of commercials. It uses billboards, magazines, TV and the internet to try to pick apart advertising campaigns and prick the balloon of consumerism. Employing the same visual and copywriting language as the multinational corporations it so loathes, Adbusters uses the power of great ideas and photography as a weapon against consumer culture and mass merchandising.

The artist Barbara Kruger uses the intense punch delivered by advertising photography in conjunction with brutally direct copy. Her larger-than-billboard-sized images are overpowering and demonstrate a total mastery of the art of persuasion. Kruger uses very tightly cropped, stark black-and-white photos and dynamic design so that words leap out at the viewer together with the bright, blood-red colour associated with McDonald's, KFC and Coca-Cola. Her startling images address us accusingly: 'Your life is a perpetual insomnia'; 'Who is bought and sold?'; 'How dare you not be me?' You feel as if the words are being rammed down your throat.

Manipulation

To manipulate literally means 'to use the hand'. Some photographers ignite our imaginations by creatively manipulating photographs in collages and photomontages. Manipulation allows the impossible to happen; objects of hugely different scales can interact, fantasies can be visualized and the totally unexpected and ridiculous can be made to occur.

Tetsuya Tamano, Untitled, 2000

While on a residency at Fabrica – the Benetton-sponsored communication research and development centre in northern Italy – Tetsuya Tamano was asked to create images that reflected his view of contemporary society. This is one of the series created using digital technology. He went on to become the art director of *Colors* magazine.

In the process of manipulation photographs are cut up and used as raw material. They can be juxtaposed, rearranged, added to, cannibalized and 'sampled' in the same way that contemporary musicians now sample music.

'Life is a cut-up; as soon as you walk down the street your consciousness is being cut by random factors. The cut-up is closer to the facts.'
William Burrows, writer.

Prior to digital photography, pictures were manipulated using scalpels, scissors, glue, paint and airbrushes. Today many photographers use the computer programme Photoshop instead of the more traditional physical tools. Photoshop has reawakened the art of manipulation.

Collage - recycling images

'Collage is the greatest idea of the 20th century.'
Damien Hirst, artist.

Many photographers and artists keep everything visually interesting that they see in newspapers, magazines and in the street. Collage is a brilliant way of recycling these materials to make new images.

The word 'collage' comes from the French verb *coller*, which means 'to stick'. Collages are composites of photographs, paper, fabric and other found images stuck together, sometimes combined with painting. Pablo Picasso first used collage in 1912 in a painting called *Still Life with Chair Caning*, in which he glued a piece of wallpaper printed with bamboo cane onto his painting.

'I think collage comes somewhere between photography and film. As soon as you put two images together they begin to tell a story. When you put multiple images together the story gets really exciting.' Fabian Monheim, photographer.

Different photographers and artists have used collage in different ways and created collages from different materials. Max Ernst cut up catalogues and magazines in the 1920s to create images that the art critic Robert Hughes has described as 'edgy visual poetry distilled from everyday things'. The artist Brion Gysin chanced on a wonderful collage technique after creating accidental juxtapositions when he sliced through several layers of newspaper while cutting a picture mount. Vik Muniz (www.vikmuniz.net) creates collaged faces of movie stars, singers and friends made from confetti-sized bits of coloured paper torn from magazines; the eye blends them together to make photographic portraits. Peter Beard combines his photographs with found animal bones and skulls, drawings and jottings and pictures torn from tabloids. See also work by Peter Blake, Jake Tilson, Kurt Schwitters, Richard

Hamilton, Robert Motherwell and Nigel Henderson. Joseph Cornell's treasure boxes are amazing little theatres of memory, and David Hockney's photo collages are named 'joiners'. (See The camera in the hands of artists, p. 134, and What makes a great photographer?, p. 146.)

Photomontage

Photomontage is the name given to the technique of combining photos in such a way as to produce images unseen in reality. Pictures made in this way can possess an extraordinarily immediate visual impact and illustrate ideas very clearly and powerfully through unusual, perhaps absurd or satirical juxtapositions and the use of humour. As a result, photomontage has frequently been used in social and political campaigns. Photomontages use original photographs, pictures found in newspapers and magazines or advertisements. Hannah Höch, El Lissitzky, Aleksandr Rodchenko, Max Ernst, Erwin Blumenfeld, Linder Sterling, Cat Picton Phillipps and John Heartfield have all produced must-see photomontage.

The origins of photomontage

When photos of faces, actions and products are removed from their intended backgrounds, they take on a new power. When these cut-outs are combined in new ways, they can create fresh images with quite different meanings. This way of working was developed in the 1910s as photographers, designers and poster-makers searched for new ways of creating instant impact with their work. Designers during the Russian Revolution of 1917 used the technique to produce potent propaganda posters. They enlarged pictures of the heads of politicians to massive size and juxtaposed them with crowd scenes in dynamic perspectives to convey the message that their leaders were powerful and heroic, and that the people were utterly united behind them.

Around the same time, artists of the Dada movement began creating anarchic montages for their exhibition posters and for the covers of their manifestos and magazines. They chose images of modernity such as pictures of planes, record players and machine parts, which they then frequently joined to photos of their own heads. The Dadaists wanted a new name for this work to distinguish it from the Cubist artists' use of collage. They chose the word 'montage', which means 'fitting' or 'assembly line' in German.

The leading Dada artist working with photos was John Heartfield (originally Helmut Herzfeld), who was nicknamed 'monteur', meaning 'mechanic'or 'engineer'.

Photomontage as a weapon

Where many Dada artists used montage to create works of art, Heartfield later used it to create highly eloquent anti-Nazi propaganda images, which were published in German newspapers in the 1930s, often as their front pages. A slogan at the entrance to a show of his work proclaimed 'Use Photography as a Weapon'.

John Heartfield, The Spirit of Geneva, 1932
An example of John Heartfield's biting political commentary, created using effective photomontage. Here the dove of peace is shown impaled on a bayonet, in protest against the shooting of demonstrating workers in Geneva, the home of the League of Nations and symbol of peace amidst growing facism in Europe.

BEFORE AND AFTER A NOSE OPERATION IN THE 1920'S NASAL LOSS DUE TO DOG BITE FITTING HAIRPITCE POSITIVE AND NEGATIVE WINDTUNNEL TEST BEFORE AND AFTER PUTTING PROTECTIVE HOOD ON KUNG FU SALUTATION UNWRAPPING WRINSING DRYING AND COMBING REMOVING HAT AND MOUSTACHE A CAREER AND THREE MARRIAGES FEMALE IMPERSONATION POSITIONING OF DENTAL BRIDGES TWIN BROTHERS MIRROR IMAGE BEFORE AND AFTER HALLE A SECOND ON ADMISSION AND ON CONCLUSION OF TREATMENT FROM BENGH TO SHORE HIGH MISSYCAT MORE TIGHE LADY BEFORE AND AFTER REMOVING HERCKLES PREPORTED AND AFTER REMOVING FREEKLES PREPORTED AND AFTER REMOVING FREEKLES PREPORTED AND AFTER SENSATIONALLY DRAMATIC RESULTS WIG AND FALL BEFORE AND AFTER A PERFORMANCE MIRRACULOUS SEVEN DAY LLOW AFTER 24 HOURS AND AFTER A PERFORMANCE MIRRACULOUS SEVEN DAY LLOW AFTER 24 HOURS AND AFTER A PERFORMANCE MIRRACULOUS SEVEN DAY LLOW AFTER 24 HOURS AND AFTER A PERFORMANCE MIRRACULOUS SEVEN DAY LLOW AFTER 24 HOURS AND AFTER A PERFORMANCE MIRRACULOUS SEVEN DAY LLOW AFTER 24 HOURS AND AFTER A PERFORMANCE MIRRACULOUS SEVEN DAY LLOW AFTER 24 HOURS AND AFTER A PERFORMANCE MIRRACULOUS SEVEN DAY LLOW AFTER 25 HOURS AND AFTER A PERFORMANCE MIRRACULOUS SEVEN DAY LLOW AFTER 25 HOURS AND AFTER A PERFORMANCE MIRRACULOUS SEVEN DAY LING BRYLCREEMED GREECED DID HOURS AND AFTER A PERFORMANCE MIRRACULOUS SEVEN DAY LING BRYLCREEMED GREECED DID HOURS AND AFTER A PERFORMANCE MIRRACULOUS SEVEN DAY LING BRYLCREEMED GREECED CHANGE IN YOUR CENTURY OF THE AFTER AFTER AFTER A PERFORMANCE MIRRACULOUS ASSETTING AND AFTER REMOVING PROMISED AND AFTER REMOVING PROMISED AND AFTER REMOVING PROMISED AND AFTER REMOVING SEVEN DAY AND AFTER MEMOVING SEVEN DAY AND AFT

Carefully choosing famous quotations from leading politicians, Heartfield undermined their intended messages by creating skilful, witty visual juxtapositions using press and specially commissioned photos. When Hitler boasted 'millions stand behind me', showed a bloated plutocrat passing a backhander into the Nazi leader's saluting hand, thereby showing Hitler to be nothing more than a puppet, bankrolled by industrialists' millions. Heartfield was eventually forced to flee from Germany to escape Nazi persecution for his campaigning.

Peter Kennard created startling images for the Campaign for Nuclear Disarmament (CND) in the 1980s, including a photomontage of a massive nuclear missile being sliced by the sharpened edge of the CND logo. On his website Kennard explains that he wanted to 'break down the image of the all-powerful missile, in order to represent the power of the millions of people who are actually trying to break them'. Kennard's montage has been used with great impact at all sorts of scales - on billboards, posters, placards and even on tiny badges.

Dick Jewell, A Change of Face, 1977

Artist Dick Jewell created this photocollage from pictures found in books, newspapers and magazines. 'It was prompted by finding many instances of photographs that had been taken to accompany an existing or prior photo. Jewell printed the collage as a photo-lithograph and flyposted copies around central London. His work frequently features found imagery. 'Photomontage allows you to pick the aspect of a photograph you really want to maximize. You cut it down to purely that bit you're interested in and chop out the distractions. When you then join that piece with other pure bits, it then really starts to have power.' Dick Jewell, artist.

Manipulation in the digital age

Where once viewers could see immediately that a photomontage or collage was the result of manipulation, today it is impossible to tell whether an image has been radically altered in Photoshop. Computers allow images to be combined seamlessly. Although Photoshop can be a very exciting creative tool, it has brought about some developments with worrying implications for the medium of photography.

In 2004 a photograph was issued to the press that appeared to show presidential candidate John Kerry sharing the stage with actress Jane Fonda at an anti-war rally in the 1970s. The picture was publishing dynamite. Coming to light in the middle of the campaign for the White House and at the height of the debate about the US presence in Iraq, it was immediately put on the front page by many national newspapers, potentially swinging public opinion against Kerry. It turned out, however, that the picture was a fake, carefully 'photoshopped' from two separate images and created as part of a smear campaign against the Democratic politician.

Fashion pictures in particular endeavour to hide manipulation. A mouth or eye from one picture can be added to the face from another. Bodies can be exchanged and smoothed by specialist retouchers known in the fashion industry as 'the skin guys' – without us being any the wiser.

Instead of meaning 'to use the hand', manipulation now means 'to use sleight of hand'. The manipulation is not just of images, but of us, the viewers, too. (See In the digital age, p. 140, and Trusting photographs, p. 154.)

Photomontage and humour

Satirical magazines frequently use photomontage as a means of savaging the pompous and hypocritical, often employing Heartfield's technique of reinterpreting a soundbite in a comic way.

Joke photomontages are regularly sent as email attachments – the best can be seen swiftly by huge audiences as they are forwarded around the world.

This Photoshop photomontage of footballers lining up to face a free kick during the World Cup in Japan and Korea, 2002, was seen by millions after it had been spread by email within hours of the game.

5

Finding inspiration

The word inspiration comes from the Latin word meaning 'to breathe life into'. Inspiration breathes life into our ideas. Inspiration comes from a well-fed imagination. We all need to feed our imaginations by exposing them to the creative work and culture of others.

'Take inspiration from everywhere. Be aware of everything, take inspiration from the street, from popular culture, from music and from comedy.'

Lee Widdows, art director and teacher.

Be inspired by cameras

Be inspired by cameras and technology. Cameras surround us – look at their fantastic creative possibilities. As well as digital cameras and cameras that use film, you can create and be creative with images from photocopiers, scanners, webcams, X-ray cameras, satellite cameras, infrared and night-vision cameras, CCTV, speed cameras and security cameras. Each has its own unique creative character.

Be inspired by the history of photography

Find out as much as you can about photography. With photography you never stop learning – there is no end to how much you can know and absorb.

Be inspired by looking at other photographers' work

Seek it out in photography bookshops, libraries, magazines and on the internet. Collect great pictures and try to work out why you like them. Go and look at some original photographs in galleries and museums, and handle prints. Seek out films and documentaries about photographers. Assist an established professional photographer. (See Being an assistant – the sorcerer's apprentice, p. 243.)

Be inspired by the process of photography

Some photographers are inspired by particular photographic processes and become passionate about evolving them in their own way and discovering new ways of using them. Visit photo labs and darkrooms and witness the processes of photography.

Be inspired by old black-and-white movies

Richard Avedon was inspired by the tight close-ups, radical crops and stark white backgrounds in the 1928 film *Joan of Arc*. William Klein learnt from the films of Fritz Lang and Erich von Stroheim, while Bill Brandt was inspired by Orson Welles' *Citizen Kane*. Henri Cartier-Bresson learnt about composition by assisting film director Jean Renoir and the great potency of film stills was exploited by Francis Bacon and Cindy Sherman. Be inspired by film lighting, in particular the lighting used in film noir, a term used to describe the great

'To physically handle the prints of any photographer's work is a much greater experience than viewing their work in any other way. It's as close as you can get – your vision with their vision – one degree of separation from what they saw.'

Alan Latchley, photographer.

movies made in the late 1940s and early 1950s that were dramatically lit in high-contrast black and white, and had dark, brooding, doom-laden plots. Films such as Billy Wilder's *Double Indemnity* and Charles Laughton's extraordinarily inventive *The Night of the Hunter* can be a fine source of inspiration.

Be inspired by colour movies

Some films have used colour in an amazingly dramatic way. Particularly outstanding are the films created by Michael Powell and Emeric Pressburger including *The Red Shoes*, *A Matter of Life and Death* and Powell's *Peeping Tom*. Victor Fleming's *The Wizard of Oz* is another good and familiar example.

Be inspired by painting

Be inspired by painters, particularly those obsessed by colour and light and who have created their own distinctive palette of colour.

Be inspired by locations

Be inspired by places you find that possess a special quality created by nature, architecture or light.

Be inspired by your mistakes

'It's only a mistake if you tell someone it's a mistake.' Kitty McCorry, photographer.

Making mistakes can lead to great creative discoveries. Mistakes happen to every photographer, when film or paper is incorrectly exposed or processed, for instance, or when errors are made in scanning or printing images. These accidents can create great results or reveal a previously unthought-of process that can be built upon. Photographers need to possess the awareness to capitalize on creative mistakes and exploit them.

Great innovations in photography have been discovered by accident and great pictures have even been created by photographers who have been inspired by images created by malfunctioning equipment.

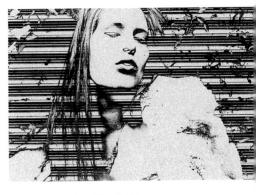

Daniel Alexander, Kim, 2005From a series of images created using a broken photocopier.

Seeing things

Photographers are keenly observant and constantly seeking visual treasure on their daily travels. They search for juxtapositions, sequences and new viewpoints, and look out for reflections, refractions, symmetries and shadows.

They experiment widely with cameras new and old, with film stock and printing, with focus, long exposures, double exposures and light. This section looks at photographs that are the product of this creativity.

Seeing things - shadows

Seeing things - from a new viewpoint

'When I was commissioned to take pictures of these dresses [below] I talked to the designer of the clothes who described how they were layered and how he wanted them to move on the body. When I saw them on the clothes rail they were just hanging flat and straight and the challenge was how we could make them come alive photographically. I thought of the idea of putting the models underwater and I went out to find a purpose-built tank for working photographically.'

Sandro Sodano, photographer.

More of Sodano's work can be seen at www.sandrosodano.com

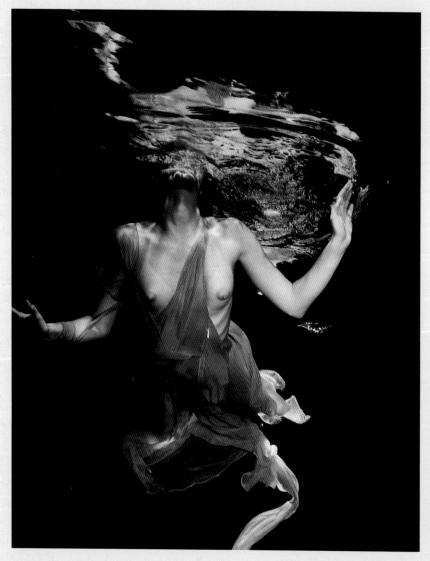

Jazz band The Happy End dynamically viewed from below (right).

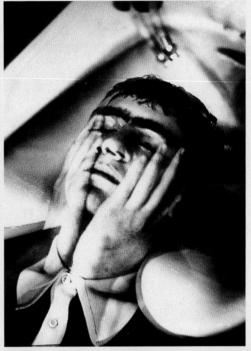

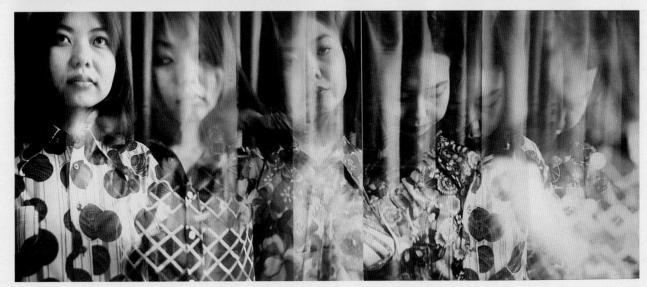

Seeing things - at night

Ted Croner, Central Park South, 1948By moving the camera during a long exposure,
Croner creates an image that reflects the energy
of New York (below).

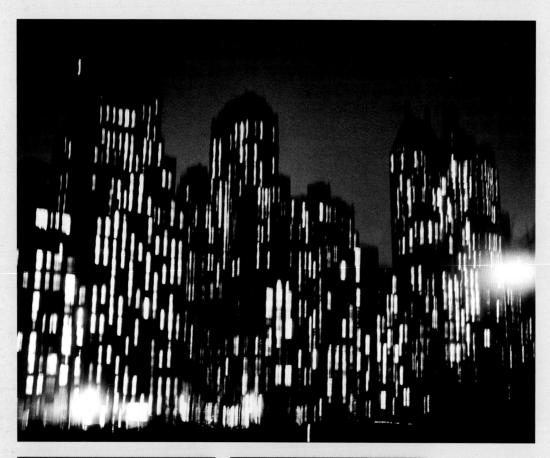

Seeing things - reflected and refracted

Lee Friedlander, Hill Crest, NY, 1970Friedlander's pictures often feature fractured images seen in mirrors and shiny surfaces. (See The self-portrait, p. 41.)

Seeing things - silhouettes

Silhouettes can be created by controlling exposure.

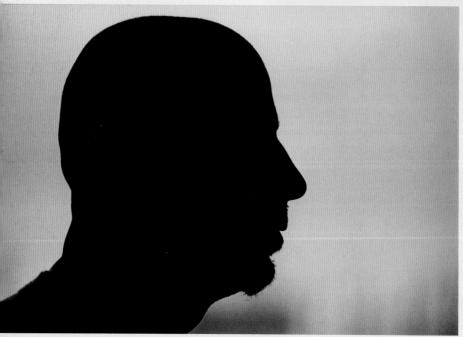

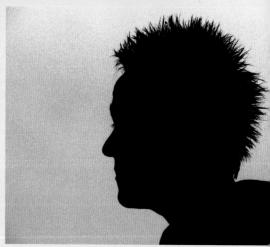

Seeing things - in sequence

Creating your own projects

'Photographers need a mission, there must be a reason or agenda why you take pictures, you must want to communicate something. The hardest thing is finding that thing that you want to photograph.'

Dave Hendley, photographer.

Many leading photographers have established their reputations through self-driven projects. They begin with a passion for a subject rather than a commission. Self-driven projects can lead to work being published and exhibited. You can create your own projects with subjects that are easily accessible, perhaps even on your own doorstep. Young photographers often focus on things that surround them, such as youth culture, fashion and music.

Kjell Ekhorn: Classmates project

Ekhorn decided to photograph everyone in his class at art college. Shown on this page are two of the resulting pictures. Ekhorn explains: 'I was seeking an original way of taking pictures. I photographed people on white backgrounds and then put the negatives onto a light box and masked out areas before reshooting them in a series of exposures which allowed me to emphasize different things in each picture. I love the accidental possibilities of multiple exposures -I sometimes use up to fifteen exposures on one frame. You can do all the planning and calculations but by just tilting something just a little bit more out of focus all of a sudden something happens which when you pick up the film has created something unexpected, lively and fresh. These pictures were the pinnacle of my pushing multiple exposure in portraits and created something that really looked like my own work."

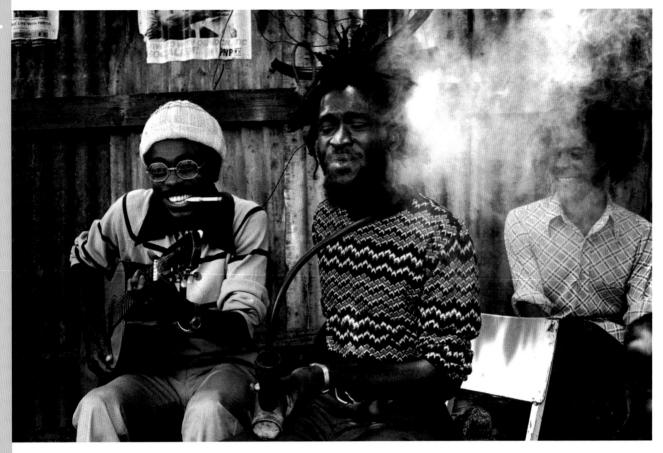

Dave Hendley: Jamaican roots reggae project

Hendley's passion for reggae records led him to make a series of visits to Jamaica to seek out the performers behind the music. His great interest and appreciation of the then-underground scene caused many doors to be opened to him and his camera.

Hannah Stanton and Vanessa Marisak: Photographic behaviour project

Stanton and Marisak are partners in a project that examines photographic behaviour in which they photograph themselves in different guises – as macho fighter pilots, meat porters and mechanics, grieving widows, teenage mums, tourists and even babies.

Steve Harries and Mel Bles: Locations project

Steve Harries and Mel Bles traced the locations used in the making of famous 1970s films – including *Taxi Driver*, *The Godfather* and *The Last Picture Show* – and then photographed these places which, owing to their appearance on celluloid, have been strongly imprinted in the minds of millions of moviegoers. They shot on Kodak colour negative film using a Mamiya 6x7 medium-format camera. More of this project can be seen at www.steveharries.com.

Will Brook: Pinhole project

Will Brook pushed pinhole photography into new territory when he built a very large curved multi-hole pinhole camera. It can take over 100 pictures of the same scene from different angles.

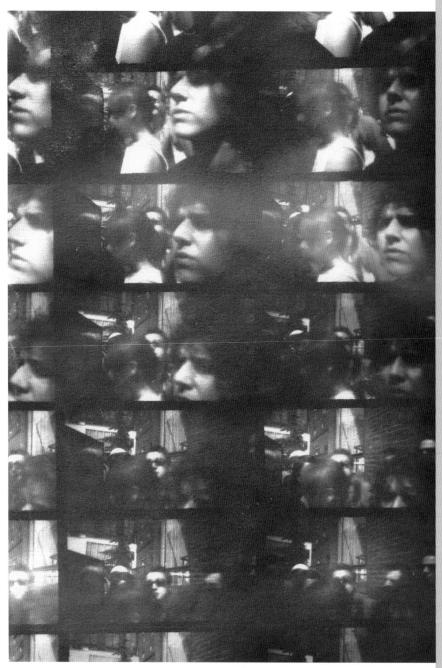

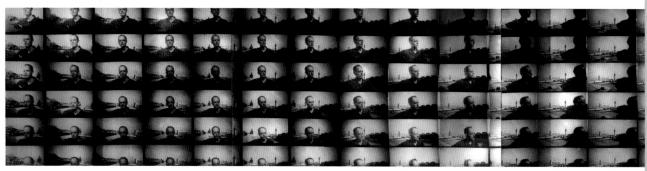

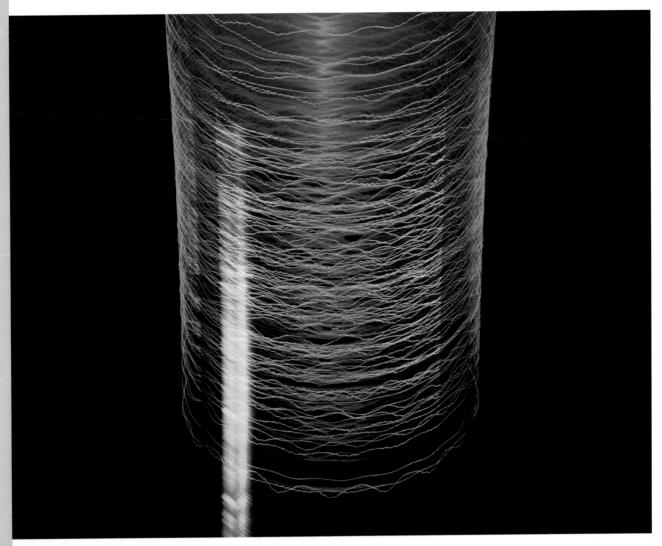

Jamie Dobson: Sound project

Jamie Dobson is fascinated with the ways in which photography can be used to portray sound. His experiments include building machines that interpret music into waves written in light that can be photographed, and picturing frequencies inaudible to the human ear as they cause liquid to vibrate – he then photographs the pattern formed by a spinning laser that projects a circle of light onto the surface of the fluid. Dobson uses cameras steadied on tripods and long exposures in order to create his work. More pictures can be seen at www.jamiedobson.com.

The camera in the hands of artists

By calling yourself an artist, you are declaring that you are answerable to no one but yourself, fearlessly following your own vision and passion, deciding on your own subject matter without commission or client, and earning a living through the sale of your work. Artists have greatly broadened the reach of photography and today it is common for them to use the medium to express their vision in the way that they once did by creating paintings or sculpture.

Artist/photographer, photographer/artist

Many modern artists who choose photography as their medium are frequently described as 'photographers'. The word 'photographer' has now come to embrace those artists who use cameras, as well as those who take pictures commercially or for pleasure.

The exciting work produced by artists using cameras and the wholesale acceptance of photography by galleries and collectors have created great opportunities for all. As well as creating their own self-driven work, many artists undertake commercial commissions that once would have been the territory of photographers, while photographers are finding new audiences for their work beyond the commercial arena by exhibiting it on the walls of galleries. (See Exhibiting, p. 251.)

Bohnchang Koo, *In the Beginning* #10. 1995-96

Bohnchang Koo creates gallery installations made from hundreds of photographic prints stitched together. The son of a tailor, he discovered this method of working after he had been unable to obtain large sheets of photographic paper. To solve the problem, he took his father's sewing machine into the darkroom and used it to stitch together many smaller sheets. He leaves the cotton threads hanging from the surface of his work. Bohnchang Koo is one of Korea's leading modern artists; his work has been exhibited widely in East Asia, Europe and America.

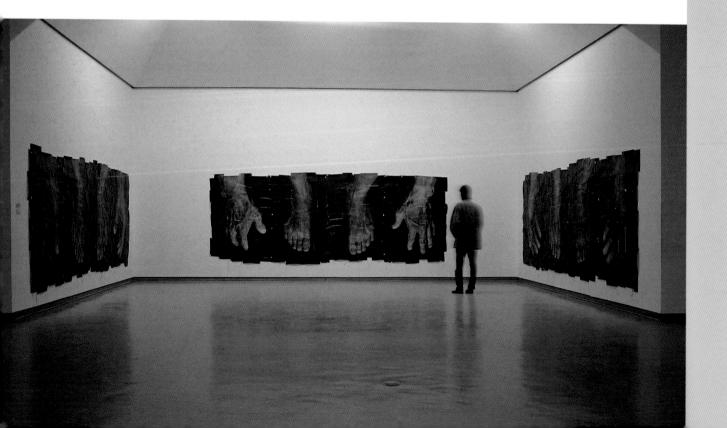

Seeing photographs in a gallery

History and the passage of the years can give pictures a value unforeseen at the time of their taking. A photograph can gain special meaning when printed tiny or at giant size, by being framed, placed in a sequence, displayed in a gallery or by having text or sound added to it.

Framing a photograph tells the viewer that it should be taken seriously as an image, that the photographer considers it a successful and meaningful picture worthy of scrutiny and exhibition. Showing photographs in a whitewalled gallery can give pictures an impact unobtainable in other arenas. The pristine gallery environment, coupled with viewers' expectations that what they are seeing will be worthy of their attention, causes the content of pictures to be amplified and focused.

The partnership between art and photography

Ever since the invention of the medium, there has been a mutually inspiring partnership between art and photography. From as early as 1850 artists commissioned daguerreotypes as studies for their paintings, while the first photographic portraits, still lifes and nudes aped the composition of paintings.

Many painters have been inspired by the new vision of the world achieved through photography. Marcel Duchamp used Etienne-Jules Marey's photographic studies of movement in the composition of his famous painting Nude Descending a Staircase (1912), and Muybridge's pictures of humans and animals in motion have influenced countless artists, including Francis Bacon, who used photographic studies of wrestlers as source material for his paintings of violent sexual encounters. Bacon also used film stills as a source: he reworked a close-up of a screaming mouth from the film Battleship Potemkin in his series of paintings of screaming popes.

Many famous photographers trained initially as painters, including Diane Arbus, Henri Cartier-Bresson and William Klein, and many artists best known for their paintings have experimented widely with photography, for example, David Hockney and Chuck Close. Picasso used fashion photographs as a canvas for wonderful drawings.

Many art movements have inspired photographers – in particular Surrealism, which stressed the role of unexpected juxtapositions, chance effects and the power of the images we see in our dreams. Photographers who have created Surrealist images include the Hungarian André Kertész, whose pictures featuring visual coincidences parallel the paintings of René Magritte. The influence of Surrealism is still prevalent in advertising and fashion photography, where the use of startling and unusual juxtapositions can be very effective.

Pioneering artists with cameras

Julia Margaret Cameron was a pioneering creative photographer who considered herself an artist who made photographs, rather than a photographer. Born in 1815, at age twenty-three she married a man twice her age and then settled into a comfortable life as a colonial wife in India, where her husband was one of the ruling British elite. On his retirement, the couple came back to Britain where Cameron, her children now grown up, found herself with time on her hands. Looking around for a hobby, she took up photography at the age of forty-eight. After months of experimentation she mastered the cumbersome equipment and processes, converting her glass henhouse into a studio and her coalbunker into a darkroom. With joyous enthusiasm Cameron cajoled her family, servants and friends into acting as her models. Using rugs and hanging velvet as backdrops and with a huge array of home-produced props, she created beautiful photographs influenced by Pre-Raphaelite painting, biblical art and romantic myths and legends. Within a year she was showing her work in major exhibitions.

In the 1890s a group of photographers sought to elevate photography to an art form with a capital A. They decided to define themselves as a 'movement' and called themselves the Pictorialists (see work by Frenchman Robert Demachy and American Frank Eugene). Influenced by the Impressionist painters, they created soft-focus pictures, clouded in mists, shadow and texture. Using techniques including gum-bichromate printing, platinum printing and photogravure, they created images that look like etchings or drawings.

At this time many different groups, societies and camera clubs sprang up in major cities – some calling themselves by grand names and all organizing exhibitions and making proclamations of their aims. Members often moved between the groups, which followed a typical cycle of flourishing briefly before subdividing and finally collapsing. One group that thrived was an American offshoot of the Pictorialists, who formed in 1902 and called themselves the Photo Secessionist movement.

Members included Alfred Stieglitz, Edward Steichen and Clarence White. They had grown frustrated by what they saw as the poor standard of American photography exhibitions and founded a gallery at 291 Fifth Avenue, soon known as simply 291, where for the first time photography was exhibited alongside works by leading painters including Matisse, Picasso and Cézanne. In doing so, photography allied itself with the creative avant-garde for the first time.

Julia Margaret Cameron, Sir John Herschel, 1867

Although she was criticized at the time, Julia Margaret Cameron renounced the accepted technical standards of photography as an interference and hindrance, transcending the limitations of the medium under the influence of the Pre-Raphaelite painters – many of whom she photographed. Cameron preferred to use exposure times of up to ten minutes in order to achieve her wonderful dream-like pictures. Her subjects included celebrated Victorians such as Lord Tennyson, Charles Darwin and Sir John Herschel (above), mathematician and astrologer, who was a major contributor to the early development of the chemistry of photography.

Group f64

'Photography is the strongest way of seeing.' Edward Weston, artist.

Another famous group of artist photographers was Group f64, which included Ansel Adams, Edward Weston and Imogen Cunningham. They first exhibited together in 1932, taking their name from the smallest aperture available on the lenses of their large-format cameras. The name was intended to indicate their passion for the clarity of image given by this tiny aperture, which created pin-sharp photos focused from the foreground all the way to the horizon.

Group f64 were pioneering artists with cameras who contributed to major gallery exhibitions in large museums. They earned a living by selling their prints to collectors and by the support of fellowships, grants and awards. Each member pursued personal artistic growth rather than commerce.

Andy Warhol's work has inspired many people, including this group. This photograph was found by the author in a photo album discarded in a rubbish skip in New Orleans.

Man Ray - wizard of invention

Man Ray was a great experimenter who worked as a painter, filmmaker, and photographer. Born Emmanuel Radnitzky in 1890 in Philadelphia, he studied art and design before setting off for Paris - then the world capital of art - without speaking a word of French. As he was totally unknown, he began to work as a commercial photographer to subsidize his career as an artist. A wizard of invention, Man Ray was determined to create pictures that looked like no others. He broke new ground, creating experimental portraits, fashion photographs and nudes including the extraordinary images Glass Tears and Le Violon d'Ingres. (See Naked abstraction and distortion, p. 68.) Ray also experimented widely with photograms made using 3D and opaque objects and with solarization, a technique he embraced for its unpredictability.

In the late 1940s and 1950s Aaron Siskind and Minor White took close-up photographs of details of nature and crumbling buildings – weathered boards and stones, peeling paint, crystals of ice and swirls of surf. In the process they created abstract works as powerful and moving as those of the Abstract Expressionist painters working at the same time, who included Mark Rothko and Willem de Kooning.

Found photos provided inspiration for artists Andy Warhol and Robert Rauschenberg. They took photos from newspapers – the same ones that readers looked at then threw away – and turned them into provocative and still-potent works of art. Warhol tore pictures of car crashes, riots, executions and appearances by film stars and pop stars from the pages of the tabloids.

After enlarging them, he boldly silkscreened each image repeatedly in muted, acidic colours and the brash colours of cheap advertisements, leaving any accidents caused by overprinting or clogged screens to add further rawness to the images.

Rauschenberg blew up news photos of presidents, astronauts and soldiers, and roughly collaged them with iconic American images of the Statue of Liberty, skyscrapers and the American eagle. He smudged, overlapped and painted over the images to create pictures the size of billboards.

David Hockney

British artist David Hockney has experimented with photography, as well as the photocopier and iPad, in his work. He came to photography by chance after a visiting curator left some Polaroid film at his California home with which he took some pictures of the building. He glued sequences of the images together to create a larger picture. Beginning with this thirty-picture collage, he continued to experiment, creating full-length portraits of friends and family members, including one of his mother at home which used over 100 close-up Polaroid prints. Each large picture is bound together by the strong white grid created by the borders of the individual prints. He called these pictures 'joiners', referring to the first exhibition of these photo-collages as 'Drawing with the Camera'

Hockney also created collages of groups of his friends using colour photos taken with a 35mm camera, processing his pictures cheaply at a local one hour lab. Rather than joining the prints edge to edge, he overlapped them, collaging many pictures of the same person taken at different moments and angles. The results echo the Cubist paintings that Hockney loves while at the same time breaking the convention that photographs should be rectangular – the final collages are disjointed blocks that spill towards the viewer.

The culmination of Hockney's photographic experimentation is a massive collage entitled *Pearblosson Hwy., 11–18th April 1986.* Using a 35mm camera, he photographed the highway for a period of eight days in order to create an incredible, massive 'joiner' image with every inch in sharp focus – a depth of field that would have been the envy of Group f64 – from the crushed Pepsi can at the front to the mountains on the horizon.

David Hockney, Pearblossom Hwy., 11-18th April 1986

Hockney created this incredible collage using hundreds of photographs taken from many positions and angles during an eight-day shoot.

Modern artists using photography

Many modern artists combine photography with other media and working methods. For instance, the British potter Grayson Perry fuses pottery, drawing and photography; the Chapman Brothers, best known for their sculptures, sold rolls of exposed but unprocessed film at a gallery show of their work; and British artist David Hockney has used computer-tablet painting applications to create artwork for a gallery exhibition.

Iranian-born artist Shirin Neshat creates unforgettable photographs of veiled women which are symmetrically composed on white backgrounds, and lit and tightly cropped like advertising and magazine cover images. Her aim is to express the spirit and strength of contemporary Iranian women. Neshat draws onto her images with black ink, tattooing the faces with Arabic calligraphy. The texts she uses are by women novelists and poets banned in Iran.

Catherine Yass uses intense colour effects in her work. For her series *Descent* she took photographs from the top of a high building in Canary Wharf in London. Focusing on the office blocks opposite, she panned her camera down the length of the buildings during long exposures. In the pictures the buildings disintegrate in urgent abstract trails of light, giving the disorienting sensation of falling out of control. Yass presents her pictures as huge transparencies lit by the beautiful, soft luminosity of light boxes.

Artist photographers

Artist photographers have traditionally produced photographs using fine-art methods and were able to cite the quality of individual or small-edition prints that cannot be perfectly matched, so adding value because of the work's unique quality. Other fine-art photographers have embraced the digital process, creating images that would be impossible without postproduction retouching, often of many exposures. Gregory Crewdson is someone who employs a production team, including retouchers, to combine his complex images, producing work of great intrigue.

Andreas Gursky

German-born Andreas Gursky creates massive large-format colour pictures in which humans are dwarfed by the commercial environments we have created for ourselves – supermarkets,

stock exchanges and offices. Gursky uses subtle digital manipulation to strengthen the flat compositions and enrich the colours

Andreas Gursky, Rhein II, 1999

In 2011, a print of the Rhine from a limited edition of six by Andreas Gursky sold for \$4.3m (£2.7m) at Christie's in New York. Photography has become the new darling of collectors and is seen as a good investment. This is possibly a reaction to the astronomical prices of other art forms such as painting, and the long-awaited recognition of photography as an art form.

In the digital age

Digital photography has changed photography forever

Photographers have always embraced the innovations that camera, film and paper manufacturers develop. However, for the generation of photographers who only knew film and the chemical process, the transition to digital photography has been a very difficult one. Photography shot on film worked so well for over a hundred years, so why change now?

Digital photography now dominates the way pictures are captured, the way they are stored, the way they are printed and the way they are displayed. From a camera on a smartphone to the most sophisticated professional camera, the digital revolution has taken over and only a small but important minority of photographers continue to use film.

The ever-present camera

With smartphones, compact cameras and DSLRs becoming more popular, the way people react to cameras is changing. Many more people are unconcerned when a camera is pointed at them, but others see a camera as an invasion of their privacy, and the reaction of subjects can be anything from a welcoming smile to outright aggression.

Digital photography has changed professional photography

The professional photographer today has either changed to digital or ceased working in a commercial arena; there are very few exceptions. Today's professional photographers have to follow the digital process, from the commission to the delivery of the completed work. Every process is digital, as clients require their images in a digital format – even the exceptional photographer who shoots film will have his images scanned and converted to a digital file so that it may be distributed or used to print from.

Digitization has empowered photographers, who can now create incredible images that are only limited by the imagination and Photoshop skills of the individual. No longer do they have to wait hours for film to be processed before finding out whether they have got the shot. The great skills that traditional film photographers had are no longer required; now instant exposure checks and point-and-shoot cameras ensure that a result is captured. This also means that there are many more people who call themselves 'professional'. To survive and make a living today, a professional needs additional skills in computer and digital applications, as well as a practised and creative eye for a shot.

Marketing in the digital age

As with all businesses, it is easy to have a web presence and to declare yourself a photographer. Google lists 250 million sites. Websites such as Flickr offer image hosting, free photo and video sharing, with billions of photos uploaded from all over the world. To shine through the fog of web

Digital cameras have changed the rhythm of photography – images can now be viewed on screen and instantly reviewed.

content, photographers have to work hard at marketing themselves. It is essential for photographers to have a website showcasing their work and to create a digital portfolio that can be viewed on a variety of platforms such as smartphones and computer tablets. These days it is not enough to wait for users to land on your web page; marketing your work through social media sites such as Facebook and micro blogs such as Twitter has become a matter of course. At the end of all this, however, producing great photographs will always be the path to success.

Good enough - in the digital age

Basic digital cameras and even phone cameras produce images that are good enough to be used on websites and computer screens. With assistance from digital post-production software such as Photoshop, images can be prepared for use in magazines and the press. This has given non-professional photographers the opportunity to supply material direct to the media market. While opening up opportunities for non-professionals to sell their work, this relatively recent development could be seen to undermine the photographic industry by driving down prices. 'Good enough' has become an expression meaning 'not to a professional standard', but the images are used regardless.

The impossible is possible

Computer-generated images (CGI) have made many areas of photography redundant. Car manufacturers often produce their advertising photographs using computer-aided design (CAD), a design and computer modelling software that can create cars in locations that do not exist. This is highly technical and very expensive work, but compared to making a prototype car and transporting it around the world, it is a much cheaper option and has now become commonplace.

Deletion – an option radically at odds with photographers' traditional desire to preserve what they see.

Digital fog

With millions of images being produced every day, it is very difficult to see through the fog to find good photography. Even with great ideas and lighting, images have to be exceptional to grab the viewer's attention and to be visible to potential clients. Self-promotion and presentation can often be key to getting your work noticed.

Convergence

As technology develops, it has become possible to produce broadcast-quality HD video using a DSLR. This has impacted the way photographers work, as clients – from publishers to advertisers – now expect a photographer to produce moving stills or mini movies as well as the photographs they require. It is almost as cheap to display moving images as it is to show a still image on a website, so the two disciplines are converging in commercial photography output. Creating audiovisual material for many applications, such as website or social-media adverts, offers exciting opportunities for photographers.

Digital photography has changed the control of photographs

Photography and design have become more closely intertwined. Designers use various software programs such as Flash and Photoshop to integrate images into designs for websites, advertising, packaging and many other media. The photographer often just supplies the images that are integrated, manipulated and processed by designers into the various applications. However, a photographer may benefit by mastering certain design skills to provide clients with a complete service.

Cost of digital technology

The cost of equipment and the need to update cameras are practical and financial concerns for a photographer. There seems to be an updated new digital model announced every month, and keeping up with the latest in digital equipment is all part of the cost of producing digital images. New generations of cameras produce photographs of great quality (resolution), but every generation requires new software. The need for better, faster computers with colour-corrected monitors makes digital photography as costly as film, or at least not as cheap as it is perceived to be.

Archiving

Today a photographer seems to be able to take unlimited numbers of pictures without being burdened by the costs of film and processing, but this is a fallacy. The image files have to be processed correctly and archived, which costs in terms of time. The cost of storage is a 'hidden' cost, but for the photographer the cost of hard drives, DVDs and server space cannot be overlooked.

Stock images

Many images used commercially are supplied online through major stock or photo libraries such as Getty Images, Corbis and Alamy. These libraries have acquired whole collections of photography, for which traditionally they have charged high permission fees. The quality of images produced by reasonable DSLRs has made the market available to all photographers and this competition has driven supply prices down. New libraries such as Pocketstock are crowd-sourcing (collaborating with users to supply and aggregate content) and now accept images from mobile phones to supply to customers. (See Stock libraries p. 249.)

Digital future

Digital technology will continue to develop and the future is very exciting for photography and its new associates. Photographers producing moving images will become the norm and 3D will become more widely available. As the technology surrounding digital photography evolves, a new generation of photographers will be there to enjoy and experiment with the fascinating creative possibilities.

Digital photography - the case for

- 'Film was horrible. Grainy, soft, totally unreliable and now waiting two seconds to see my photo seems slow. Film took two hours and with couriers was interminable, and that's not to mention the cost! I'm so happy to see the back of all those clip tests, loading rooms, Polaroids, bulk film orders, assistants mixing up rolls, 10M filters, push a third or push a half angst and the lab saying "we've had a rush". Now I can push the shadows half a stop, cut the highlights two-thirds and add 20R, but only in the yellows if I want, and I can go back to square one in one click. Another disadvantage with film: when you shot a transparency you had to give the client the original, you would probably never see it again. Now with digital you can supply AND keep the original file.'
- 'Digital has changed my life 100 per cent for the better! In fact I'm curious to see if anyone can say ANYTHING in favour of film....'

 Colin Thomas, advertising and publishing photographer.
- 'Digital photography has allowed anything to be done technology has liberated ideas by allowing them to be created with perfection.' Blaise Douglas, art director.
- 'Photography is about communication. Digital photography allows me
 to communicate quicker. If a magazine or record company on the other
 side of the world wants one of my pictures they can now have it in minutes.
 You can cover huge geographical distances so quickly, it's fantastic.'
 Dave Hendley, photographer.
- 'I don't have to worry anymore that someone's going to mess up the film, I don't have to wait for film to be processed or worry about booking darkroom time – I know if I've got a picture instantly.'
 J. Beauchamp, photographer.
- 'Digital photography gives every photographer a chance to reinterpret a picture after it has been taken. Many people have never had this opportunity before.'
 - John Myers, photographer and teacher.
- 'The debate about film and digital is exactly the same as that about vinyl records and CDs. Some are passionate about the quality and range of film as some are passionate about the quality and range of sound on vinyl.
 Others just see digital, like CDs, as progress.'
 Ed DeSouza, art director.
- 'I photograph in a way I would never have dreamt of before because of the expense of film and printing.'

Tom Clive, art student.

Digital photography - the case against

- 'Film actually makes us better photographers because it hones our senses. It makes us look a little closer at what we are shooting before we click.'

 Conor Masterson, photographer and filmmaker.
- 'I appreciate the advantages of digi but it has a lot of negatives, not least the amount of time I now spend in front of a £2k monitor I never used to need.'
 Martin Brent, advertising photographer.
- 'Digital is the rule of thumb, but it needs to be used as a tool, not a crutch. There are too many lame photographers using it as a crutch, thus diluting its primary use as a tool. "We can fix it in Photoshop" is heard every day on a shoot and is valid, unless you're talking about lighting. You can't fix lighting.' Vic Moss, owner of Moss Photography.
- 'Digital photography has totally devalued the worth of photographs. When the majority of photos were taken on slide film each image was a unique and precious sliver to be treasured. It was an original, a one-off, only able to be reproduced by printing. That slide offered the supreme possibility of the image. Digital pictures have none of this preciousness.' Alison Smithee, photographer.
- 'Once you have released a digital file it's gone for ever, it can be instantly distributed, reproduced or altered by anyone, anywhere. Photographers have lost control of their images through digital photography, which has eroded ownership and a photographer's ability to protect their work.'
 Eric Daley, photographer.
- 'The trouble with digital is you can edit far too quickly and delete and erase
 pictures that would later prove to be great. Contact sheets sit, mature and
 ferment over the years. The image you choose instantly is almost always
 different from the one you choose after a period of time, when you spot
 things that are much more interesting.'
 Johnnie Shand Kydd, photographer.
- 'Digital versus film is like choosing between a virtual world and the actual world. I know which world I like to live in.'
 Alan Latchley, photographer.
- 'Some of the magic is lost by seeing an image at once. Part of the joy was the trip to the lab to see what had come out.'
 Alex West, photographer.

Digital photography - neutral

- 'Film: look first then shoot.
 Digital: shoot first, then look.'

 Adrian Turner, advertising photographer.
- 'What is really interesting to me is the vast range of choice we now have and why we choose to work in a certain way. The pressure of commercial work forces the self-initiated, perhaps experimental project and in one way allows us to move in a different direction. The usual constraints of time, money and pleasing yourself and the client still apply. 10x8 film or iPhone? The choice is still ours and let's hope it lasts a good while yet.'
 Steve McCoy, advertising and environmental photographer.
- 'Advertising clients want moving images for their websites, it costs as much to show a small movie as it does to show a photograph. Photographers now have to provide both.'

Steve Stretton, creative director, Archibald Ingall Stretton.

What makes a great photographer?

Despite the inevitability that one generation's revolutionaries will become the establishment figures of the next, the work of great photographers always seems innovative. They see their subjects and use camera, lens, film or computer in previously unimagined ways. Their work is instantly recognizable as their own, often demonstrating a unique handling of composition, tone or colour palette.

Great photographers push photography to its extremes, into new terrain. Harold Edgerton wanted to find the shortest possible exposures, Hiroshi Sugimoto appears to want to find the longest. Although David Hockney followed a route trodden by every art student in sticking different photos of the same subject together, he went way beyond any previous exploration of this technique in his massive photo-collage *Pearblossom Hwy.*, 11–18th April 1986. (See The camera in the hands of artists, p. 134.)

Great photographers defy being labelled as a portrait photographer, fashion photographer or war photographer. They are simply photographers with their own vision of the world. A great photographer takes us somewhere new, creating not just single great pictures but a great body of work. They act as catalysts for changing how the whole medium of photography is perceived. Great photographers possess a hunger to take pictures. They are restless and driven, never settling for anything less than the best. They make us want to take pictures ourselves. There are very few of these visionary delinquents in any one generation.

Great photographers have an unstoppable passion for their art. Australian photographer Frank Hurley was described as 'a warrior with his camera' who 'would go anywhere or do anything to get a picture'. Hurley travelled on Ernest Shackleton's ill-fated Antarctic voyage in the ship *Endurance*, producing dramatic and incredibly innovative black-and-white pictures in the most extreme conditions, using up to twenty flash exposures. Hurley even defied Shackleton's orders by diving into freezing water to retrieve his glass photographic plates that had fallen overboard.

Etienne-Jules Marey and Eadweard Muybridge were so determined to photograph movement that they invented their own cameras, creating the first shutters to take exposures of fractions of a second. Erwin Blumenfeld went to extraordinary lengths to create a world of impossible beauty in his fashion pictures, as did Angus McBean in creating make-believe fantasy in his portraits. Man Ray undertook unrepeatable experiments in the darkroom, playing risky games of chance with how he processed his negatives and prints where hours of work could have been destroyed by exposure to too much light.

Great photographers follow Madame Yevonde's manifesto: 'Be original or die.' They have gained immortality through their pictures. Harold Edgerton, Milk Drop Coronet, 1957

Edgerton brought time to a standstill in photographs (opposite) taken with flash tubes that he created himself

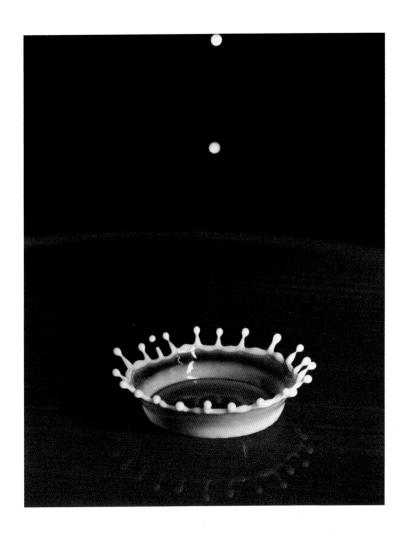

What makes a great photograph?

'For a photo to be great, the photographer himself has to be part of the picture. I mean by this that the more of himself, his views, his prejudices, his nostalgia, his love life, his background show through, and the more the photographer is committed, the more the picture will have a chance of being unique and beautiful.'

Henry Wolf, writer.

Photographs can be more than just a composition on a piece of photographic paper or yet another image in a newspaper or magazine. Great pictures make a person or event live in front of us and offer an intense experience to the viewer. Great pictures speak for themselves. They are loaded with emotion and a sense of history. They jolt us at once and each time we look at them. They have the ability to connect with new audiences.

'A great image will somehow have encoded in it things that mean a great deal to a lot of people personally. It is able to speak to them all individually.' Sandro Sodano, photographer.

The world's best-known pictures

There are a small number of images that are so imprinted in our consciousness as to be unforgettable. When a German art gallery held a show entitled 'Pictures in Mind', in which a series of blank squares were exhibited on its walls, each complemented by a caption such as 'The footprint of the first man on the Moon' and 'Albert Einstein sticking out his tongue', it was assumed that visitors would be able to supply the images in their own mind's eyes.

Many of the best-known photos have such power that their compositions are reused by other photographers, artists, printmakers, filmmakers, cartoonists, caricaturists, mural painters and graffiti artists as the basis for further images, building on their potency. Unforgettable pictures become iconic and pass into popular culture as T-shirts and posters. They so obsess us that they frequently become the subject of books, documentaries and films.

We live in an age in which we are numbed and desensitized to pictures of famine, disaster and the pain of others, in which at the turn of the page most photos are instantly erased from our minds. Truly great pictures, however, can stop us, provoke our imagination and pierce through our emotional defences, engage us and make us think. Some pictures have great consequences and can affect or change events.

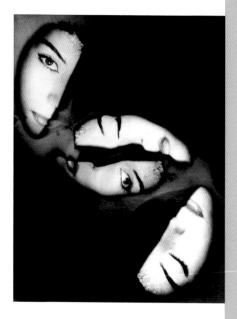

Erwin Blumenfeld, *Marua Motherwell*, c. 1941

Fifty years before the launch of Photoshop, Blumenfeld created incredible images in the darkroom that look both modern and innovative today.

Films and documentaries inspired by great pictures

The film The Wild One was inspired by a picture story about biker gangs in Life magazine. The 'search for the Afghan girl' followed the attempts to track down Sharbat Gula, the subject of Steve McCurry's stunning 1985 National Geographic cover. Robert Capa's photographs of the D-Day landings were recreated by Steven Spielberg in Saving Private Ryan and film director John Ford used Dorothea Lange's pictures as the inspiration for his screen version of John Steinbeck's novel The Grapes of Wrath, set in the American Depression. The participants of Old Glory Goes Up on Mt. Suribachi were swiftly celebrated by Hollywood in the movie Sands of Iwo Jima, starring John Wayne (left) as a sergeant who turns a bunch of raw recruits into a killing machine.

The girl fleeing a napalm strike

The Pulitzer Prize-winning photograph of children fleeing a napalm strike in Vietnam is a picture that changed events. It was taken on June 8, 1972 on Route 1 at Trang Bang by Vietnamese Associated Press photographer Nick Ut. A naked nine-year-old girl named Kim Phuc runs towards the camera; she has been burned by the napalm dropped from a South Vietnamese plane piloted by a US airman and her skin is beginning to peel from her back. Two of her brothers have been killed by the napalm. In unspeakable pain, her face is like that in Edvard Munch's painting The Scream, while the soldiers behind her show total indifference. One is casually lighting a cigarette rather than helping.

The photo shocked the world and caused the US to reconsider its involvement in the war. The picture, like the girl, begs you for help. Life magazine later reported that in the infamous, secretly recorded Nixon tapes, the American president is overheard wondering whether the 'napalm thing...was a fix'.

The hooded Iraqi prisoner in Abu Ghraib jail

Arms spread in crucifixion, a man stands balanced on a box, electrical wires trailing from his fingers. This digital snap taken in Abu Ghraib jail, Iraq, 2004, is an image of evil, echoing images of racist lynchings, executions and electrocution. It is the most haunting image of the early twenty-first century and it sent shockwaves around the world.

Che Guevara

In 1960 the Cuban photographer Alberto Díaz, popularly known as Korda, took photographs of Ernesto 'Che' Guevara at a service for slain Cuban revolutionaries. One picture showed Che gazing to left of frame, his beret – bearing the revolutionary star – slightly askew, his hair windswept. Korda chose the picture from the many he'd taken and titled it *Guerrillero Heroico*.

After Guevara was captured and executed some years later in Bolivia, gigantic ten-storey-high prints of the image were hung in tribute on government buildings in Havana. Korda's picture came to symbolize martyrdom, revolution and the desire for equality and has been described as 'the embodiment of idealistic longing'.

Forty-five years later the picture of Che is a common sight on T-shirts, badges and computer mouse mats. It is so strong as an image that it is still instantly recognizable even when it is reduced to a line drawing or cropped, altered or sampled.

Sightings of Che

A student sketchbook collection of found and sampled images of Che Guevara.

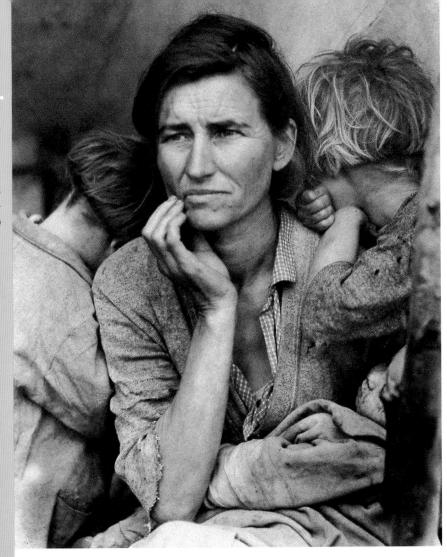

Dorothea Lange, Migrant Mother, Nipomo, California, 1936

One of five images the photographer took of Florence Thompson and her children, considered to be one of the most powerful images of the twentieth century.

The migrant mother

Dorothea Lange was driving home from a Farm Security Administration assignment when she passed a migrant workers' camp in Nipomo, California. Stopping on an impulse, she took just five pictures, one of which subsequently became one of the most well known of all time. The picture – entitled *Migrant Mother* – became instantly famous following its publication next day in the *San Francisco News*. Some readers sent food to the camp, though by the time it arrived the family had moved on.

The subject's name is Florence Thompson. She is thirty-two, married, with no permanent address and children to feed. She cradles a dirty sleeping baby. The photo echoes religious images of the Madonna and Child. While two other children turn away from the gaze of the camera, the mother's face expresses determination to persevere through the hard times. It is a picture that cries out for something to be done.

Raising the flag in Iwo Jima

The photograph of marines raising the American flag in Iwo Jima, *Old Glory Goes Up on Mt. Suribachi*, is said to be the most reproduced picture of all time. The photo was taken by Associated Press photographer Joe Rosenthal on February 23, 1945 on the tiny island of Iwo Jima during the Battle of the Pacific. It won Rosenthal the Pulitzer Prize. This image of American victory was so evocative that work began at once on a lifesize statue of the scene in Washington – the Marine Corps Monument.

Life magazine later wrote that it became 'a picture that symbolized American dominance in world affairs'. The potency of the image and its status as a national icon meant that over half a century later its composition was used in many illustrations depicting the bravery of firefighters and police following the 9/11 attacks on the World Trade Center in 2001.

Although three other photographers were present to record the event in Iwo Jima, the drama of Rosenthal's picture captured the American public's imagination. The flagpole appears frozen as the six men work as one, driving it into ground strewn with the debris of war to raise the flag against a clear sky.

Marilyn Monroe on the subway grille

Marilyn Monroe pauses on a New York subway grille as a train whooshes by below, causing her white skirt to billow up around her. She luxuriates in the sensation, creating an image of total glamour. The image was staged as a publicity stunt during filming of *The Seven Year Itch*. It only appears in close-up in the final movie. Many famous photographers were present at the shoot outside 590 Lexington Avenue, including Garry Winogrand and Elliott Erwitt, and many versions of the picture exist. Andy Warhol amassed a collection of them. The rest of us mould the different pictures in our minds to form a single, iconic one.

Ambiguity in great pictures

In many of the world's best-known pictures there are elements of ambiguity that add to their strength, allowing viewers to read their own meanings and associations into them. This is the case, for example, in Joe Rosenthal's Old Glory Goes Up on Mt. Suribachi, Robert Doisneau's Le Baiser de l'Hôtel de Ville (The Town Hall Kiss) and Alfred Eisenstaedt's A Sailor's Kiss, Times Square.

In Joe Rosenthal's picture the marines' faces are all invisible, hidden by their raised arms and camouflaged helmets, which turns them into symbolic unknown soldiers.

Doisneau's picture became a worldwide symbol of Parisian romance while Eisenstaedt's came to represent the joy at the ending of World War II. Numerous people have claimed to be the kissing couples. Since their faces are obscured in embrace, the images have a kind of universality.

Marilyn Monroe, *The Seven Year Itch*, promotional image, 1955

This image is a composite of the many photographs taken of Marilyn Monroe at the photocall for the film A Seven Year Itch. It is a distillation of many images, but one that we instantly recognize as iconic. It was used extremely successfully to promote both the film and the myth that was Monroe.

What happens if you are lucky enough to take an iconic picture?

If you are lucky enough to take an iconic picture, it could earn you a great deal of money, but it can also bring problems. Robert Doisneau is calculated to have made £50,000 a year from worldwide sales of posters and cards of his picture *Le Baiser de l'Hôtel de Ville*. It also landed him in court after a couple claiming to be the subjects demanded a share of the royalties. When Doisneau revealed that the picture featured not the couple in question but a pair of models, the models in turn tried to sue him. Both cases were thrown out. Korda went to court to contest the commercial exploitation of his picture of Che Guevara after it had been used without his permission to promote a brand of vodka. He won a \$50,000 settlement which he donated to a hospital.

The Hand of God – sport's most infamous picture allegedly showing the Argentine footballer Diego Maradona punching the ball with his hand as he heads it – was taken by Mexican photographer Alejandro Ojeda. Shortly after taking it, he sold the picture to another photographer who syndicated it to a news agency. The picture is reckoned to have made millions in fees – for someone. When interviewed, Ojeda commented: 'I got nothing out of it.'

During a twenty-minute shoot at the Dalmasia Hotel in Notting Hill, London, Martyn Goodacre photographed the band Nirvana. As is customary, he took group pictures, then individual shots of each band member including the singer Kurt Cobain. 'He wasn't talking much at all. I think he wanted to get back inside so I quickly shot a few frames and let him go.' One of those few frames that Goodacre shot off quickly has become 'the' picture of Cobain. 'When I came to print the picture I couldn't believe how well the neg printed and how soulful Cobain looked. I instantly realized it was a great rock and roll image.'

Goodacre's picture – taken in seconds, with no lights and no make-up – gained worldwide exposure following Cobain's suicide. 'Maybe because of what happened to Cobain the picture has taken on a life of its own. You can read into the shot and see a great brooding rock star but you have to know the story attached to Cobain... I own the picture and get royalties from agents that sell it to magazines. It's also been stolen and used against my wishes and without me being paid. It sells for T-shirts and posters but I don't get anything. I'm trying to sort this out but it is a long process. Images are hard to protect when they are used as much as this one and are so well known.' (See Syndication, p. 250 and Photography and the law, p. 254.)

Trusting photographs

We have learnt to trust photographs without question. Photography offers us proof that an event has happened or that someone or something exists. We trust news photos to tell us the truth. Our understanding of world events of the last century and a half has been shaped by photography. In order to maintain this trust, photographs have to be used with honesty.

Photographs continue to have an authority that cinema, TV and video images now lack. Digital special effects are now part of the language of almost every movie. Actors appear to fly, we see convincing visions of life in the future and 'virtual' performers created by computer programs do impossible stunts. It could be argued that

television has lost its authority through the proliferation of channels, reality TV shows, infotainment programmes and the marginalization of hard news and analysis. Pop videos are routinely squeezed by 20 per cent so that performers appear taller and thinner, and locations and backgrounds are combined seamlessly with studio images.

Although there have always been heavily manipulated photographs such as those by Angus McBean and Erwin Blumenfeld, they have always been seen as fantasy, never pretending to portray real events. While we know that glossy fashion, beauty and celebrity magazines retouch the odd spot or saggy jowl, we still think of photography

as a largely factual language. But this value is now in danger of being undermined by the ease with which photographs can be manipulated digitally. Digital photography may totally devalue the authority of photography in the public's eye. Will we trust any image any more? Will we see the death of truth in photography and a time when every image will be altered as a matter of course?

Behaviour behind the camera

Is it correct to restage events or manipulate objects in a picture? Is it wrong for a news photographer or photojournalist to ask someone to repeat a small action they have made that will help them better tell the story? TV reporters might use a second or third take to deliver their story to camera if they mess up the first time, so why not a photographer? Portrait photographers often tell their subjects how to pose, where to look or to move into the light in order to get the strongest picture. Should it be any different for other kinds of photography?

The lying camera - defacing history

Under Stalin's dictatorship in Russia the photograph lied, history was falsified, enemies vanished, pictures were defaced. People like Leon Trotsky who fell from favour were airbrushed from history, their faces removed from all official pictures issued for publication. Some of these manipulations were done very crudely and it has been suggested either that the retouchers wanted viewers to sense that something was wrong with the pictures or that signs of retouching were left to serve as a reminder that anyone could be removed from history.

In 1999 an official group picture issued to the press to celebrate a royal occasion in Britain had the head of a despondent prince digitally replaced with a smiling version. Although done from innocent motives, this created a dangerous precedent for tampering with pictures in today's newspapers.

While they have routinely darkened bright skies in pictures, burnt in details in the darkroom and retouched processing and printing faults, photographers have traditionally not altered key elements that affect the portrayal of events.

During the recent war in Irag in 2004, the Los Angeles Times sacked its staff photographer for doctoring a picture that had been used on its front page. He had amalgamated two different pictures of a British soldier in Basra directing a cowering crowd of Iragi civilians. The goal was to create a more dramatic composition, but identifiable members of the crowd clearly appear twice in the picture. Like most newspapers, the Los Angeles Times has a policy of not altering news photographs.

We need to be able to trust news photos, just as we need to be able to trust what we read in a newspaper. The idea of 'making up' a photograph was considered the equivalent of a news journalist making up the facts in an article, and the incident sent shockwaves through the newspaper picture desks of the world. Roger Tooth, picture editor of the Guardian newspaper in Britain, commented: 'It was good for the industry that an example was made. We have strict rules at the Guardian. Our photographers are told they can't manipulate a news picture. We needed to have that line drawn.'

Doctoring images

'Slice the hips', fashion photographer Cecil Beaton was once heard to yell at his retouchers. British newspapers have a code of conduct that obliges them to credit combined images as 'photomontage'. This is not the case with magazines. Some pictures undergo major surgery before publication, and we are none the wiser.

Used creatively in fashion stories, the effects of digital photography can be magical, though the artificial creation of superhuman models who appear thinner, smoother, fitter and clearer-eyed is morally questionable. Who can tell the effect that these images may have on the minds and bodies of (particularly young) viewers who continue to see the images as real?

Superstar celebrities now often appear in magazines looking frighteningly perfect, like a bland new human species with impossibly smooth, glowing skin, twinkling bright eyes, unwrinkled brows, perfect dentistry and glossy hair - all thanks to post-production rather than nature. How much retouching and manipulation of this sort is acceptable? It's a difficult question to answer, but it might be noted that the rise in the 1990s of the raw snapshot approach to portraiture and fashion - the antithesis of the retouched image - came at a time when exaggerated manipulation of pictures was rife. (See The snapshot, p. 157.)

A photographer's responsibilities

'By its nature photography is exploitative. It is after all called "taking" pictures. You've been trusted, and you take something.'

Alan Latchley, photographer.

Photographers have a responsibility to those they have photographed to ensure that the pictures they have taken are seen in the correct light. They should not exploit the privilege the camera has given them and should ensure that pictures are used appropriately when published, in particular in news photography and photojournalism where captioning can totally change the meaning of a picture.

News agencies and agencies that specialize in photojournalism distribute all their pictures with captions. Photographers and editors have a responsibility to ensure photographs are accurately captioned so that viewers have the correct information to help them interpret what they are looking at in an image. There have been instances in which the opposing media of warring countries have used the same picture for their own propaganda purposes, totally changing an image's meaning through the written captions they have attached to it.

When should a photographer stop taking pictures?

When war photographer Don McCullin was asked, 'How would you cope if a girl was on fire in front of you?' he is said to have replied, 'Round 5.6 at a sixtieth at a guess.'

When should a photographer on assignment no longer think of their responsibilities as a professional observer with a job to do and instead think of their responsibilities as a human being, and intervene?

A news photographer is our paid eyewitness. Shouldn't they just do their job and never not take a picture? Newspaper editor Harry Evans, in his classic book *Pictures on a Page*, recounts the case of a group of international press photographers offered a gruesome photo opportunity in Bangladesh – the bayoneting of some prisoners. 'Some walked away without taking a picture and others stayed to record "the event", he writes. One of the photographers who stayed won the Pulitzer Prize for his pictures; those who left in disgust felt that on this occasion it was possible to change events by not taking pictures. What would you have done?

The snapshot

Snapshots are photographs taken with little or no delay between the camera being aimed and the picture being taken. They record moments of spontaneity. Snaps are taken with handheld cameras – often amateur or compact cameras – with little regard given to formal composition, the photographer generally letting the camera focus and decide whether to flash automatically. The word 'snap' was first used in conjunction with photography about 130 years ago when picture-taking was described as 'snapping' because of the snapping sound made by the camera shutter.

Snapshot behaviour

At best the speed and casualness of snapshots can produce pictures that are gleeful and uninhibited, full of life and movement, though some amateur pictures show people standing stiffly, embarrassed and with forced smiles.

In many snapshots people grin, play up to the camera or make gestures. Japanese snapshots display different gestures from Western snaps, with young people particularly favouring the victory 'V' hand sign. Children everywhere poke fingers behind the heads of their friends and stick their tongues out when snapped, a pose made famous in the snap of the great physicist Albert Einstein.

Snapshooting to fame

Andy Warhol helped bring about the acceptance of technically unaccomplished photos when he exhibited and published Polaroid portraits with harsh shadows, flat and acidic colours, and blinding, bleaching flash lighting. Warhol was unconcerned about his lack of technical expertise – he loved the look that the camera and film gave when used in this way.

William Eggleston was the first photographer to receive acclaim for his casual snapshot approach to picture-taking. He snapped almost everything he saw – roadside motels, the inside of his fridge, bar-rooms, the sky, stray dogs and stray people. In Eggleston's pictures no chance meeting or place passed is given more or less attention than any other.

Wolfgang Tillmans photographs wherever he happens to be, whatever he happens to see – his friends, the chaos of his apartment, nightclubs, reflections, windows, passing planes. His book *If One Thing Matters Everything Matters* is a manifesto for the snapshooter – and features 2,400 pictures which together offer a fluid visual diary of his entire life, created using every roll of film he had taken from the age of ten. American author Hunter S. Thompson pioneered a style of writing known as 'gonzo journalism', in which he recorded his adventures in a stream-of-consciousness fashion; likewise Tillmans is a gonzo photographer, recording what he sees in an uninterrupted stream of unedited pictures.

The snapshot album

During the cardomania craze for collecting photographic cartes-de-visite, manufacturers produced books with slots pre-stamped in the pages into which the standard-sized photos could then be inserted. These were the first photo albums, allowing the owner to arrange pictures in order and look at them repeatedly. Most families now have a snapshot album. The London Times newspaper speculated that 'the average household contains around 1,500 non-digital photographs'.

Snapshot behaviour Snapshots often display gestures or types of behaviour unseen elsewhere.

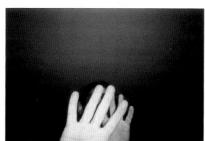

Japanese photographer Nobuyoshi Araki is another prolific artist who has created numerous books, obsessively photographing not only everyday scenes of the streets and sky but also sexual encounters, all snapped with the same casualness of a passer-by.

One for the album

Richard Billingham took the pictures in his famous book *Ray's a Laugh* using an inexpensive camera and cheap film processed at his local chemist. Some of the pictures are grainy, poorly exposed and badly printed, others are harshly lit by flash or blurred and chaotically composed. They are snaps,

blown up and bound together in a book designed to create the sense that you are looking at someone's very intimate family album. (See Telling a story in a book of pictures, p. 100.)

Nan Goldin's pictures are her personal snapshots. As in anyone's photo album, the snaps show personal and private occasions – groups of friends, parties and weddings, foreign holidays and new babies – moments in which the presence of her camera is clearly accepted and unintrusive. In addition to these everyday scenes are other casual pictures showing sex, drug use, violence and transvestism shot in exactly the same way. With her snapshots Goldin reveals her own and her friends' lives – chaotic, often brief, violent, passionate and tragic. Her snaps are now seen on the walls of international art galleries and in lavishly illustrated books.

Snapshot chic

Terry Richardson brought gonzo snapshot photography to high fashion, using \$4 disposable cameras to photograph supermodels. He's said to buy his equipment from the corner store on the way to a job. Richardson's approach creates fashion pictures that are fresh and very, very funny. He even manages to get himself into many of his own pictures.

German photographer Juergen Teller shows the wrinkles, roots, crooked teeth and scars of models and the fashionable, finding raw beauty where others see only imperfection. Teller takes pictures for *Vogue* magazine and creates campaigns for Jigsaw, Hugo Boss and Calvin Klein. His book *Go Sees* shows the hundreds of would-be models who have turned up at his studio hoping for work. Teller took a quick, unconsidered snap of each girl on his studio steps and in the street, creating an album of one of the cruel pageants of the fashion industry. Teller never plans shoots, preferring to figure out what he's going to do on the day after he's met the person he's been sent to photograph. He simply snaps what he finds.

The professional snapshot became popular in publications as a backlash against the digital age, which has made it possible to smooth away all imperfections on the computer, often causing any sense of reality to be lost. The grittiness and imperfection of a snapshot convey an impression of authenticity lost by the use of professional lighting and the staging of pictures. A photograph of a person stripped of make-up and styling can appear refreshingly honest.

The Lomo snapshot

'When I use a Lomo, I don't look through the viewfinder. Instead I concentrate on what's happening in front me, then when it's right I press the shutter, bang! – it gives you a real image. I believe photography is about real life. I hate being in the studio and setting things up. To get an image of real life you have to be part of it. You can't be a photographer standing there with a camera. As soon as you do that everyone starts posing or behaving in a different way. The Lomo is perfect for taking pictures without interrupting the flow of life.'

Fabian Monheim, Lomographer.

The Lomo compact camera has become the camera of choice for many photographers, sparking a worldwide craze for snapshots. It's pocket-sized and easy to use; you simply set one of three focus distances, then point and shoot.

The Lomo has a passionate following of devoted users who call themselves 'Lomographers'. They promiscuously photograph everything, taking vast numbers of snapshots. Their manifesto proclaims: 'Take your Lomo everywhere' and 'Lomography is not an interference in your life, but part of it'.

The camera - the time machine

Photography is not solely about preserving incidents we have witnessed or recording compositions we have created or found by chance. Photographers can also be the controllers of time. Cameras have the ability to see time in far finer slices than our eyes. They can also record the passage of time in a way impossible by any other means. Photography allows us to see our lives at many different speeds: it's a time machine.

Early war pictures taken on long exposures shocked viewers not only because they showed the brutality of battle but because the immobile dead were recorded clearly while the soldiers aiding them (and therefore moving about) were only visible as blurs; the dead appear solid and the living as ghosts. The longer the camera stares at a scene with its aperture open, the more fleeting our lives seem. In exposures of minutes or hours, humanity's presence totally disappears even from the busiest streets: we are simply not present for long enough to be recorded. The hands of clocks vanish too. Only the buildings we have created remain.

Different photographers have experimented with controlling time in different ways. Eadweard Muybridge mastered time in order to create photos that showed us for the first time exactly how we move. Harold Edgerton split seconds into hundreds of thousandths and brought time to a standstill, giving us visions of bullets in flight and of the beauty of drops of liquid as they fell. David Hockney created multiple-image portraits that tried to recreate the experience of seeing a person over time rather than once, at a single moment, as portraits traditionally do.

Exposures taken for many years

Every year for nearly thirty years Nicholas Nixon has taken a group photograph of the four Brown sisters: Laurie, Heather, Bebe and Mimi. Nixon is married to Bebe. The pictures are taken with the same large-format camera and are always similarly composed. As well as observing changing hairstyles and clothes, looking at the thirty-year span of images we see the subjects' lives slowly ticking by. The series acts like a time-lapse film: instead of flowers growing and withering, we see four people ageing in front of our eyes.

For her series *As Time Goes By* Barbara Davatz took photographs of six friends with their partners in 1982, 1988 and 1997. The first pictures show the friends as fashion-conscious teenagers, the last ones show them approaching middle age. Over time the friends' partners change, and the new boyfriend or girlfriend is photographed in the place of the foregoing one. These simple photos are mesmerizing.

Ross Cooper & Jussi Ängeslevä: the 'Last' clock

The 'Last' clock, invented by Ross Cooper and Jussi Ängeslevä, records a scene simultaneously with a one-minute, one-hour and twelve-hour exposure, allowing you to see how light and movement have affected a view over different passages of time. It produces images that are printed to echo the movement of a clock's hands around a clock face, in seconds, minutes and hours, producing photographs in which you witness time travelling rather than arrested

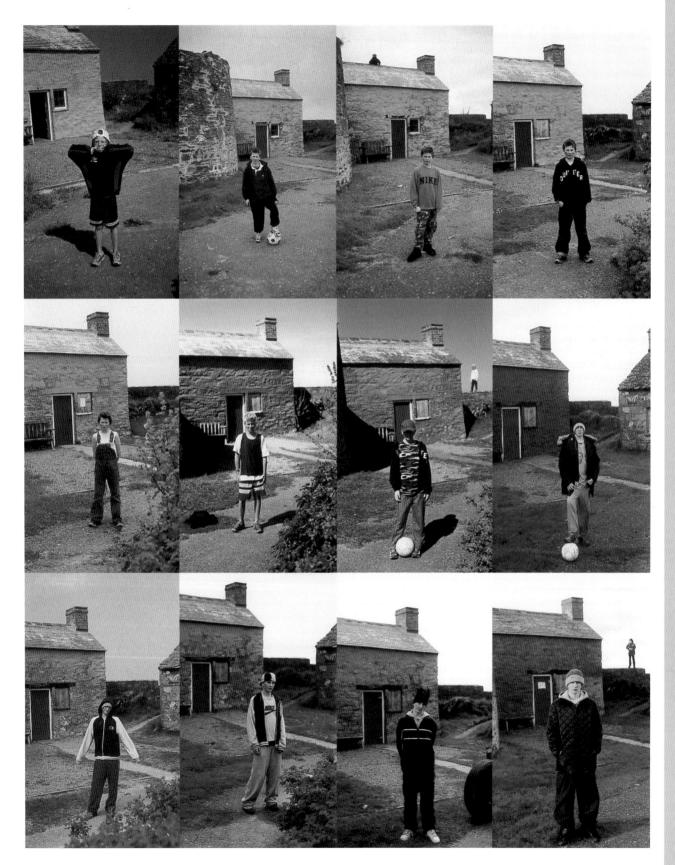

Beyond the print

Photography now extends beyond the creation of flat photographic images. Many photographers create works in the form of installations that can be seen as three-dimensional objects as well as in the form of prints.

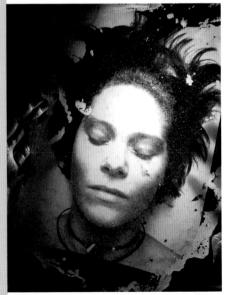

Isobel Brown, Les objets de désir, 2004 Isobel Brown created soft fabric caricature bodies for her installation Les objets de désir (above). 'I borrowed two-dimensional glossy airbrushed images from 'lads' mags" to create new three-dimensional soft sculptures with which the viewer has a different relationship', she explains. See also installations by Annette Messenger, Barbara Kruger and Christian Boltanski.

Makin Ma, Gazza, 1998

Makin Ma created this huge edible tribute to kebab-loving footballer Paul Gascoigne.

Tina Maas, Untitled, 2005

Tina Maas creates images on wax that has been sensitized using liquid photographic emulsion (left). Her pictures are exhibited floating in water tanks, illuminated by lights contained in the wax.

Dex growing, 1995-2005Pictures taken at the same spot over the course of ten years (opposite).

Where next for photography?

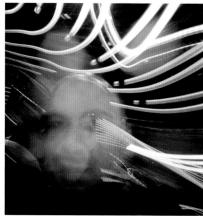

Walker designed a camera that is controlled by human emotion. During a fairground ride the shutter is fired at the thrill peak (left).

Patrick Richard Meny, Isolated, 2004 Meny experiments with images that contain messages that are only visible at specific

This Is A Camera Now Go Out And Take Some Pictures

The tools of photography

The tools used by photographers are cameras, light, colour, computers, film stock, aperture, composition, depth of field, exposure, focus, processing and printing.

Each of these tools has an impact on the quality and look of the final photograph. Photographers therefore pick each tool carefully for its ability to influence the images they create. Every one of the photographers in this book controls and combines the tools in a different way; that's what makes their work both unique and memorable.

Making sense of the numbers

Photography can seem as though it's been developed for mathematicians rather than as a creative medium. At first sight the numbers involved seem bewildering, some look like sums: 10x8, 6x7 and 21/4 squared. There are the 'f' numbers such as f16, f64 and f2.8, and there are all the measurements such as 35mm, 50mm and 500mm. Then there are also processing numbers such as +1/2, +1, +2 and the ISO numbers that become bigger and bigger. Digital photography seems to revel in really huge numbers of pixels and bytes.

All these numbers will be explained in this chapter and again, for quick reference, in the later Bible section.

Consistency, universality and standardization

For photography to work successfully consistency and standardization are essential. You need to be sure that your camera's settings precisely match those of any light meter or flash gun made by another manufacturer, that your digital camera speaks the same language as your computer and that any colour film you buy can be processed correctly by any lab.

To meet this need, scientists, engineers and manufacturers have created standardized settings and universal systems that allow consistent picture-taking, transfer and processing, no matter what brand of camera, lens, film or computer you use. For example, whichever lens you use on any format camera, the same aperture will give you the same level of brightness.

There are universal systems that classify the sensitivity of film to light, the qualities of lenses and the intensity and the colour of light. Digital photography likewise has standardized ways to indicate the image quality that a camera can give, its memory power and the relative sizes of pictures, together with universally used systems to transfer pictures to computers and from one computer to another. These matters are described in this chapter.

The camera

The camera is a tool of the photographer. Having an expensive or fancy camera is no guarantee of taking great pictures and there are no rules about how pictures should be taken.

'I can use anything from a 10x8-inch camera to a photo booth. The most important thing is to get my message across.'

Nick Knight, interviewed in Vogue, 2003.

All cameras are fundamentally the same. Each is simply a box with a hole in one end and a surface sensitive to light at the other. The hole allows the light to enter and the sensitized area records the image. The differences between cameras consist in how, how well and how easily they do this.

Manufacturers delight in trying to convince us that the camera we own is out of date and redundant. Despite their efforts, we treasure cameras and are very reluctant to throw them away even when they're beyond repair, probably because they have helped us save our personal memories.

The look and anatomy of cameras

Cameras have always been wonderful objects. Their designs reflect the times in which they were created. Old wooden cameras are like beautiful bits of furniture. The Lomo camera even has the look and smell of Soviet Russia. Increasingly small digital cameras and phone cameras are sold as fashion items with ultra-modern or retro styling, designed to be neat, stylish and pocket-friendly, or to be worn like jewellery.

The more you know about the camera and how and why it works, the more you can control the photographs you take. Despite this, camera manufacturers seem obsessed with wanting to take control away from photographers by making picture-taking more and more automatic. Cameras increasingly offer inbuilt pre-set values calculated to produce results for average conditions rather than letting you control the focus, framing, exposure, whether to freeze or blur action or use flash. By learning to use a camera manually, you can learn how to control these features and use them creatively.

A camera needs a lens to project the light from the subject, and a focusing mechanism to move the lens backwards and forwards in order to focus on near and far objects. It also needs a shutter to keep out the light until the moment arrives to take a picture, and an adjustable hole to control the amount of light falling onto the sensitive surface that will record the image. It needs a viewing system to let the user aim the camera accurately, and if the camera takes film there should also be a system for moving on the exposed film.

We regularly throw away bits of outdated technology but are curiously reluctant to dispose of cameras.

What's the difference between a camera that uses film and a digital camera?

Cameras that use film focus the image seen through the lens onto lightsensitive film, which then has to be processed to reveal the image. They are mechanical devices with some electronic parts such as the light meter and the motordrive.

Digital cameras are totally electronic. In a digital camera the sensitive surface onto which the light falls is a computer chip known as a CCD (charged coupled device). It records the photograph's light, colour and intensity onto a memory card which stores the images until they can be transferred to a computer or a printer.

Working with digital cameras

Most digital cameras don't look like film-based cameras. They show the view of the camera on a small LCD on the camera's back. Once a picture has been taken you can immediately see the results of each shot on the LCD screen and pictures can be erased if you don't like the look of them.

With a film-based camera, once pictures have been taken they have to be processed and printed in the darkroom or lab. With a digital camera you can immediately transfer pictures to a computer to look at them enlarged, alter their quality, print them or send them by email or publish them on websites. To transfer pictures from a digital camera to a computer you simply take the camera's memory card out and slot it into a card reader attached to a computer. Images can also be transferred directly from the camera by using a cable known as a USB.

Once images are transferred they can be saved on the computer and the pictures erased from the memory card so that the latter can be reused; this is known as reformatting and is one of the benefits of digital photography. Instead of buying many rolls of film you can reuse the same memory card again and again.

Another great benefit of digital cameras is that they allow you to change the camera's sensitivity to the brightness of light frame by frame, meaning that you can take one frame in very bright sunlight, the next in deep shade. With a film-based camera you would need to change rolls of film to get optimum results in such contrasting lighting situations. You can also alter the digital camera's sensitivity to different types of light from frame to frame. For example, at the press of a button you can change the camera from correctly exposing pictures in fluorescent light to correctly exposing in tungsten light. A film-based photographer in the same circumstances would have to change film or use filters to avoid getting an unwanted colour cast on the film.

Digital cameras react to light in different ways from film stock. Images transferred directly from the camera can often appear quite 'flat', lacking in contrast and impact, though with manipulation on the computer the character of film can be echoed.

Which camera?

'I am a photographer who uses various professional cameras and film formats to express the way I see and explore reality. Cameras become an extension of my vision and I need to love the thing. Each tool has its purpose and it is up to me to choose one to use for a particular photographic project.'

Bruce Davidson, photographer.

The vast variety of cameras on the market offer a massive choice of picture size, quality and image resolution. As well as conventional film and digital cameras, there are many others offering further creative possibilities. There are panoramic cameras, action-trackers, underwater cameras, disposable cameras and Polaroid cameras that produce instant prints. It's easy to make your own pinhole or multi-pinhole camera. Choose the camera for the picture you want to create. Before even picking a camera, consider the type of pictures you want to take and how they are to be seen – as small, medium-sized or huge prints, on screen or reproduced in books, magazines or newspapers. In order to make sure that the camera can do what you want it to do, read the manual, and talk to people who use and know the camera. Learn from their experience to discover its character and faults – every camera has some.

Your choice of camera affects how people react to you

'Using a twin-lens camera for photographing strangers is a much less aggressive way of taking pictures. You're looking down into a camera rather than directly in their eyes.'

Alan Latchley, photographer.

Some cameras look like pieces of serious scientific equipment. The steely monorail Sinar 5x4 camera would look at home in a physics lab or a dentist's surgery. The Gandolfi 10x8, with its polished wooden body, brasswork and 'old-fashioned' look, appears to belong in a comfortable Victorian parlour.

Your choice of camera affects how people react to you. The Gandolfi can appear cosily welcoming whereas the Sinar is a frightening, cold, shiny mechanical tool. Photographer Johnnie Shand Kydd photographed Naples with a battered fifty-year-old Mamiya – not because it was his only camera but because he thought it looked worthless and no one would try to steal it. In the three months he spent on the Neapolitan streets no one did.

'By choosing a digital camera you can instantly show people the picture you have taken in the LCD. By showing what you are trying to achieve, you can quickly involve people.'

Adam West, photographer.

Your choice of camera affects how people react to you and how you can work with them. Some photographers choose the small Lomo camera (above). As Fabian Monheim explains: 'The Lomo is great for portraits, there is no camera between you and the person you are photographing, you are really flexible, you can go closer or further away instantly.' On the other hand Alastair Thain prefers to use a massive large-format camera that he built himself (below). It moves on tracks made for a movie camera.

Selecting a camera that uses film

Different film cameras give you creative choice. The size of film determines the quality of the images the camera produces. The much greater area of film used on a 5x4 exposure gives more intense sharp detail in comparison to that of a 35mm picture. All these cameras can use any type of film of the appropriate size: colour slide, colour negative or black-and-white film.

The 35mm single-lens reflex camera (SLR) (1)

This camera uses film in light-tight cassettes which have either twenty-four or thirty-six exposures. The film is drawn out of the cassette inside the camera for exposure and rewound when the roll is complete. The winding-on lever also resets the shutter. The reflex refers to the built-in hinged mirror behind the lens which reflects the scene onto a viewing screen. When the shutter release is pressed, the mirror flips up to allow the picture onto the film. Lenses are interchangeable and the cameras have built-in light meters. The design of the 35mm camera allows users to see the scene they are photographing at its brightest through that lens. The lens only closes to a smaller size when a picture is taken.

Many types of 35mm camera are available, including Nikon and Pentax. Prices vary according to features and lens quality. The 35mm SLR is light and quick to use and master, but 35mm pictures become grainy when you blow them up really big. On the other hand, you may like that.

The medium-format single-lens reflex camera (2)

This camera uses 120-size roll film wound on a plastic spool and protected from the light by black backed paper. The film is taped to the paper and begins a few centimetres from the start, allowing the roll to be loaded in the light before being wound on inside the camera until the film is aligned with the lens ready for exposure. A mirror reflects the image onto a horizontal viewing screen that you look down into. This camera creates 6x6-cm (21/4x21/4-inch) pictures offering over four times the area of a 35mm picture. Lenses are interchangeable and the film is held in a detachable back, which can be changed instantly for one holding different film stock.

Different types of medium-format camera are available, offering slightly different image sizes including 6x7cm and 6x4.5cm. Some are tripod-based, others are easily handheld. Manufacturers include Hasselblad, Bronica and Pentax. Digital backs can be fitted to many medium-format cameras to produce very high-quality digital images.

This camera takes very good-quality negatives and slides. Medium-format cameras are more expensive than 35mm cameras. In some the image appears reversed in the viewfinder.

The 5x4 (five-by-four) view camera (3)

This is a large-format camera used mainly on a tripod. It is also known as a field camera or plate camera. The '5x4' refers to the size of the film used - five inches deep by four inches wide. The image that you see comes directly from the lens onto a ground-glass viewing screen, allowing you to see exactly the view of the lens - hence the name 'view camera'. Once the image is composed, the lens is closed and a sheet of film protected from the light in a film holder is inserted in place of the viewing screen. To take a picture, the protective cover of the film holder (called a darkslide) is removed and the shutter clicked to expose the film. The darkslide is then replaced, protecting the film until processing. Few types of large-format camera are available: the ones that are include Sinar and Deardorff.

The large-format camera gives a very intense quality to photographs the 5x4 can see microscopic detail. The image appears reversed and upside down on the glass screen, this can make composition difficult. Digital backs can be fitted to large-format cameras, offering high-quality digital images.

Greater image detail and higher quality when printed

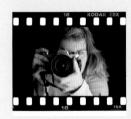

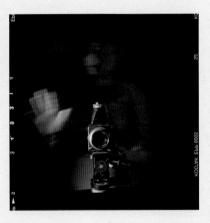

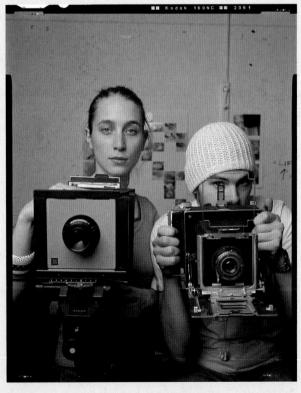

Selecting a digital camera

What digital camera you choose will depend on many factors. The first consideration may be cost and, fortunately, digital cameras have become less expensive. As with most purchases, the old adage 'you get what you pay for' rings true. A camera can be a fashion accessory, but it is important to consider what you hope to do with it. Do you want to look good with a camera over your shoulder, or are you aiming to produce great images? Before you select a digital camera think about what type of photographs you want to take and how they will be shown. Do you intend to create pictures that will be displayed very large in a gallery or take pictures that you wish to manipulate greatly? Do you want to output the images as small prints, display them on screen or use a camera like a notebook to make a record of things you come across?

Megapixels and resolution

The quality of a digital image is governed by a variety of factors, and the size of the sensor is only one of the complex things that affects the image quality. The number of pixels that capture the image is a major indicator of image quality. The size of the sensor and the number of pixels it can record is measured in megapixels (one-million pixels are known as a megapixel). Each pixel in a digital picture is a solid block of colour, so the more blocks of colour used to create an image, the greater the detail and the quality. By counting the maximum number of pixels a camera can use to record an image, you determine the best quality it can achieve.

Another major factor is the resolution of the optics, the lens that is fixed or attached to the camera. This is often overlooked when considering a camera, but a small good-quality sensor with the best-quality lens can outperform cameras that have high megapixels and a poorer quality lens.

As technology has improved, it is true that most cameras produce reasonable results, so it is increasingly important to select the camera for the purpose it is best suited to.

Compact and phone cameras, up to 8meg

Compact digital cameras feature integral lenses with an optical zoom and generally offer adjustable shutter speed, aperture and focus and various shooting modes. The sensors on these capture devices are small but can have over 8 megapixels, which can produce good-quality medium-sized prints. The great advantage of compacts is their portability and ease of use. Even professionals may use these small discreet cameras when larger cameras may not be employed. The LCD viewing sensor allows the image to be assessed, and some top models offer manual controls that enable these cameras to be very effective image-makers, rivaling the quality of digital single lens reflex cameras (DSLRs).

Phone cameras tend to be simpler than digital cameras and have a fixed-focus lens and no physical shutter. To take a closer shot of the subject, camera phones use a digital zoom function whereby the camera enlarges the pixels in an image to around double their size to increase the image's magnification. This gives an inferior quality compared to an optical zoom, in which a lens adjusts its glass elements to give a closer view. Camera phones often have a delay between pressing the shutter and the moment when the camera takes the image, known as 'shutter lag'. Shutter lag can mean you miss the moment, making phone cameras a poor choice for spontaneous photography. Phone cameras can now shoot 2D and 3D images and some top-quality smartphones offer a touch screen that enables the user to direct the camera to focus on a particular object in the field of view, giving even an inexperienced user a higher degree of focus control.

Digital single lens reflex cameras (DSLRs)

Digital SLR cameras have become the standard model for the more serious photographer. They feature interchangeable lenses, a variety of shooting modes and the ability to shoot movies of high technical quality. DSLR cameras use sensors over 10 megapixels. The sensor size is usually smaller than that of a 35mm film camera, so the lenses have to be of a shorter focal length to cover the same subject. DSLRs increase in price in proportion to the number of megapixels they can record.

There are many size variations and many different software programs that manufacturers build into the DSLR camera. Careful selection is needed because having to change cameras later may require a complete change of accessories and lenses as well. All major manufacturers produce good DSLRs and you can create great images with all cameras. Remember that it is not the camera that takes the picture, it is the person holding the camera.

A new generation of mirrorless interchangeable-lens cameras (MILC) produces high-quality results and is an alternative to the DSLR.

Stills and video

With new digital technology, photography and video has converged and high-definition (HD) video can be produced on many digital cameras. Some photographers choose the camera on the basis of its video capabilities.

Medium-format cameras

Many professionals use cameras that are produced for the general market, however, there are specialist professional cameras that evolved from the medium-format film cameras. Hasselblad and Mamiya are probably the most well-known models. These systems use digital backs such as Phase One and Leaf, which offer a higher megapixel quality. The digital backs attach to the bodies and lenses and have large sensors close to the 4.5x6-cm film size, producing images of exceptional quality. It is possible to attach very high megapixel backs to large-format cameras, producing data files of over eighty megapixels.

Specialist digital cameras

There are other specialist digital cameras, including field cameras, that allow movement. Examples are the Linhof Techno and the SpheroCam HDR (high dynamic range) cameras that capture 360-degree images in order to create 3D renderings for CGI applications. These specialist cameras are used in the creation of environments for the automotive and specialist industries.

Memory - recording data

The images from digital cameras are recorded on memory cards that are slotted into the camera or, in the case of professional cameras, downloaded to a computer directly using a tethered cable or wireless connection.

Camera manufacturers may use different types of card, and it is important to be aware that there are many variations, not all of which are compatible with every camera. A card that can store a great deal of information is said to have a greater 'memory' than one that can only store a small amount. The maximum quantity of digital information that each card is capable of storing is expressed in megabytes (MB) or gigabytes (GB – one thousand megabytes), and cards are available in sizes from under 1GB to over 128GB.

Cards come in different formats and specifications. Some can record data very fast, a valuable asset if you are taking pictures in quick succession. Memory cards are quite inexpensive to buy, but it is important to invest in good-quality cards from reputable manufacturers as there are many reports in the technical press of poor quality or pirate products that fail and lose precious data.

As pictures can be stored at different levels of quality, the number of pictures that can be recorded on any card varies according to the different quality settings at which the pictures have been taken. Pictures shot at maximum quality quickly take up lots of a card's memory space. Today, memory cards have much larger capacity to handle video recording.

Storage and archiving

After being downloaded on to a computer, images usually require additional storage methods, such as on a computer hard drive. With recent developments in file management, it is now possible to upload images to a cloud application, where files are stored securely on servers at a remote location. It is very important that you back up and archive images in a way that protects your image files and ensures that priceless images are not lost through a sudden computer failure.

Once the images are downloaded and secured, preferably in at least two separate places, then the memory card can be re-formatted and used again. Formatting is the way a camera prepares the card to receive data. If you have more than one camera it is important that you dedicate memory cards to each camera unless they are the same specification as formatting is done for the firmware (operating system) for each camera model.

RAW or JPEGs - formats to take pictures

JPEG and RAW are the two main types of file used for storing images created in digital photography. Cameras at the cheaper end of the market may only offer one way to record images, usually in the JPEG format.

Most cameras with a reasonable specification offer a choice of image file quality, from low resolution (basic quality) to large JPEGs and RAW format. JPEGs are readable on almost all computers without the need for a special software program. A RAW file is the 'raw' data from the camera's sensor. It is uncompressed by the camera and awaiting processing by a computer. JPEGs compress the images to make them smaller for storage, but these files are not stable and with repeated opening and re-saving, the files eventually become corrupt and show artefacts that degrade the image.

If you are serious about photography, the RAW format allows you to produce images of the highest quality; it is the optimum way that the maximum amount of data can be recorded. RAW files need to be converted to formats that can be read on all computers using software that the manufacturer supplies or by using processing programs such as Lightroom, Aperture or Capture One. RAW data could be considered as the equivalent of the negative that film cameras produce: you can go back to it and print or output many variations, but it does not affect the original RAW file.

To view on screen or to send to a printer, JPEGs are preferable as the files are opened up once and not re-saved. But, ideally, images should be captured as RAW files, processed and saved as TIFF, PSD (Photoshop file) or another stable format, so that the maximum data can be used.

The future

Now that 3D-capable cameras are becoming more widely available, there are very exciting technological advances to look forward to. Manufacturers continue to compete to create smaller camera bodies with a greater number of pixels that are better than the last generation. However, it is the image that is the most important element in photography. A great camera cannot take a great photograph by itself, but a good photographer can take a great photograph using the variety of devices at his or her disposal.

Try these cameras

The Leica

When launched in 1925, Leicas were known as miniature film cameras. Framing is through a viewing system mounted on top of the camera and known as a rangefinder. The camera's rapid action, lightness and near-silent shutter click had a radical effect on how and when pictures could be taken. It was especially significant in the evolution of photojournalism as used by Henri Cartier-Bresson and Martin Munkácsi. (See Fashion, p. 74, and Telling a story with photos, p. 82.)

The Minox

The Minox is the film camera that the spies use in old James Bond films. It gives 8x11mm pictures. Built with the precision of a watch and with a good lens, it takes surprisingly fine pictures for such a tiny camera.

The Lomo - shots from the hip

The Lomo Compact is a robust, inexpensive, lightweight, pocket-friendly, Russian-made camera manufactured in St Petersburg. It uses 35mm film. Loved by many photographers for its easy-to-use controls and fully automatic command of exposure, the Lomo gives accurate long exposures even in the lowest light. Unlike most compact cameras its shutter can remain open for many seconds or even minutes to give a correct exposure.

The Lomo's lens is designed to enhance colour and has a tunnelled effect which darkens and blurs the edges of each picture, so creating a unique Lomo look. The camera has a passionate and devoted following of Lomographers who organize regular exhibitions and publish books of Lomo photographs.

'If you use a camera in a conventional way you can anticipate what you are going to get back. With the Lomo, when you shoot, shoot, it can bring fantastic, joyous accidental results. Lomography is about not being precious with your photography.'

Fabian Monheim, Lomo ambassador to Great Britain.

There is now a Lomo World Archive, an ambitious attempt to photograph the whole planet. When Lomo announced it was to cease production of the Compact camera, Lomographers lobbied the manufacturer and Russian politicians including Vladimir Putin, whom they made an honorary Lomographer. Other Lomo-type cameras include the Colorsplash, which features a dial offering bright colour filters to your exposures.

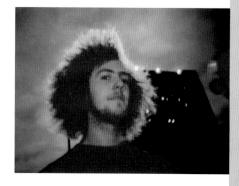

A picture taken with a Colorsplash camera (above).

Guy Patterson's unique pinhole postcards (above) are printed with sunlight.

Pinhole photography - make your own camera

Every photographer should try making a pinhole camera. You can make one from a matchbox, a shoe box, a film canister or even a plastic dustbin. Manufactured versions are available, but the DIY approach is more fun. The length of exposure necessary to make successful images depends on the size of the pinhole and the area of the light-sensitive material onto which you are exposing. Many pinhole photographers simply use photographic paper in their pinhole cameras. When developed, this forms a negative, which is then contact-printed to form a positive print.

Paula Indrontino's triple pinhole camera has a curved surface on which the image forms. Also shown here is her homemade loading jacket used in order to change the paper negatives on location.

You can also convert any conventional camera – film or digital – to work as a pinhole one: simply remove the lens and replace it with a piece of black card taped over the lens mount with a pinhole pierced in it.

'The pinhole camera is the bare bones of photography. It's got all you need. The magic black box. You go out and look with your eyes. You can't see through the pinhole camera, so you have to place it where you think it looks great. I'd go out into the Piazza in Covent Garden [in London] with my biscuit-tin pinhole to take pictures and people would say, "What are you doing? Are you going to produce a rabbit out of the tin?" When I said I was taking photographs they'd peer into the pinhole, asking if there was a camera inside. I'd say no, it is the camera.'

Neil Onslow, photographer and teacher.

Pinhole photography offers huge creative possibilities. Photographer Steven Pippin created pinhole cameras using old washing machines, placing the paper to be exposed inside the drum and adapting the wash cycle to use photographic chemicals. Further adventures can be had by having many pinholes in the same camera and by bending the paper inside the camera.

Artist Guy Paterson creates beautiful and unique pinhole-camera postcards to send to his friends when he is on holiday. Using an old coffee tin, lith film and cyanotype printing, he carries all the chemicals needed with him on his travels, printing the final images using sunlight.

The Diana

The Diana is a medium-format plastic camera made in Hong Kong by the Great Wall Plastic Company. It uses 120-format film. The Diana's design means that you sometimes get a surprise when you finally see your prints. Light leaks on the film and the viewfinder doesn't accurately show you the lens view. The camera also produces pictures that are clear in the centre and blurred at the edges. The shutter can be opened again and again to create multiple exposures, offering exciting creative opportunities. No two Diana cameras seem to work in quite the same way. The Great Wall Plastic Company manufactured many variations of the Diana, mostly with extravagant names including the Debonair, the Harrow Delux and the Leader.

Polaroid cameras

The Polaroid revives the principle of the daguerreotype in producing a unique object. It was invented by Edwin Land in the 1940s after his three-year-old daughter had asked why she couldn't see the pictures he'd taken of her at once. His brilliant design uses film packs containing pods of developing chemicals which burst and process the film when it is pulled through the camera – producing a positive image in about a minute.

Polaroid cameras and film became popular in the early 1970s with the launch of the SX70. Artist Lucas Samaras pioneered the manipulation of the Polaroid print's coloured dyes in the short time before they set.

British photographer David Bailey took the SX70, then the most advanced camera in the world, to the tribes people of Papua New Guinea, the people who lived the simplest life in the world. They apparently thought that a Polaroid photograph was like 'a useless mirror, they looked at it and turned it round, and found it didn't change'.

Legend has it that the giant 20x24 Polaroid was created when an old process camera, supported on a barber's chair, was rigged with a Polaroid back to take an anniversary portrait of Howie Rogers, the inventor of Polaroid Polacolor film. Edwin Land liked the result so much that his company manufactured the five cameras in use around the world today: they stand 5 feet high and weigh 235 pounds. Mary Ellen Mark used the behemoth 20x24 Polaroid for her *Twins* series. It has also been used by Andy Warhol and Arnold Newman.

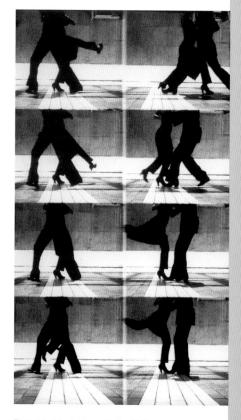

Be a mini-Muybridge with the Action Sampler camera.

Polaroid film for some of the older models is difficult to get, however, Polaroid still produces photographic products using ZINC (zero ink technology). Other companies have taken on the manufacture of certain Polaroid films, so it is still possible to create instant one-off photographs. Fuiifilm offers a similar product to Polaroid and continues to produce cameras and a variety of instant film that can be used on certain medium- and largeformat cameras with adapter backs. Try using these processes to discover real pictures that are unique and special.

The Holga, the Lubitel and multi-lens cameras

The Holga is a medium-format, lightweight, plastic film camera with a plastic lens and one shutter speed. It is easy to convert for use in pinhole photography. The Lubitel is a medium-format camera, manufactured by the Lomo company. Other cameras to try include the Action Sampler; the wonderfully lo-tech Super Sampler featuring a ripcord mechanism to reset its lenses; the eight-lens Oktomat; the golden-cased, plastic Pop 9; and the Action Shot 16. These cameras all shoot wonderfully unpredictable sequences of pictures on 35mm film.

Camera phones and iphoneography

The smartphone, led by Apple's iPhone, has become a major player in the creation of images. People who do not carry a camera around have their phone. The phone camera's increase in image quality and its ability to transmit images has made it the dominant camera of choice for many. Smartphones produce many of the news images or video footage on the web. Apps allow the user to create styles and effects that were previously only available in the domain of professional software, and a whole culture is growing around this phenomenon.

'It will become like a language. At some point people will start using it like text-messaging, using images like words.' Photographer Tom Hunter, interviewed in the Guardian, 2004.

1. Photographer Fabian Monheim using an Action Shot 16. 2. A colour pinhole camera with multiple pinholes, made by photographer and teacher Tim Marshall from a cine-film can. He takes many exposures onto single sheets of circular cut colour photographic paper, making each exposure by briefly removing the gaffer tape that covers each pinhole. 3. The Gameboy camera made by Nintendo. 4. The Snap camera, which plugs straight into the computer's USB port. 5. The portrait studio – a new spin on the photo booth.

Single-use cameras

Single-use cameras offer the chance to take pictures in ways you can't take pictures with conventional cameras and in places where you might not want to take your other cameras. There are single-use panorama cameras, underwater cameras and ones with built-in flash. Once called disposable cameras, they were renamed single-use cameras to reflect the fact that some parts can be recycled by manufacturers.

The infamous news photo of English footballer Paul Gascoigne eating a kebab on the eve of the World Cup was taken with a disposable camera. A journalist spotted Gascoigne in London's Soho and, knowing the tabloid value of a photo, bought a camera in a corner shop for a few pounds. The picture made him many thousands of pounds.

The photo booth - behind the magic curtain

From 1914 all American passports were required to include a photo as proof of identity. The coin-operated photo-booth machine was designed to provide the public with a cheap alternative to making the trip to a photographer's studio. The first photo booths were located in bus stations and train stations, and they produced eight images in eight minutes. In 1926 artist André Breton used the first photo-booth camera in Paris to create 'surreal' pictures of himself and his friends, including Salvador Dalí, who poses as if entranced. (See The Ideal Sitter, p. 34.)

Artist Dick Jewell created a 'Passport Approved Photo Album', named after the 'Passport Approved' sign on the photo-booth machine that guaranteed that the sets of photos it produced were of suitable size and quality for official use. Jewell challenged the booth's conventional use by creating thousands of sets of pictures, none of which could ever be used in a passport. He found that he could adjust the lighting by masking out some of the booth's flash lights and so create side lighting. By masking out all the lights he could even use his own lighting, such as candles and torches. He explored the time interval between the shots, creating sequences in which events seemed to occur in the pictures that would have been impossible in the seconds between flashes. He used props and mirrors, creating elaborate Busby Berkeley-inspired portraits, classical still lifes, and a photo-booth portrait of Leonardo da Vinci's Mona Lisa. He even explored candid-style portraits in which the people in the booth looked as if they were unaware that they were being photographed.

The photo booth was also used by Andy Warhol, who loved the idea that he could produce totally machine-made images. He used the pictures as a source for screenprints. Artist Babbette Hines has made a collection of thousands of photo-booth pictures taken over the last eighty years, while movie director Brett Ratner installed a third-hand photo booth in his Hollywood home which was used by his movie- and pop-star guests.

Tokyo officeworkers using a Print Club camera – a contemporary take on the photo booth that produces instant photo-stickers.

Stereoscopic cameras

Stereo photographs give the incredible and dynamic illusion of a threedimensional view. They are created using two cameras set apart at about the same distance as our eyes. The cameras shoot twin views of a scene. Images appear three-dimensional when looked at through a binocular magnifier called a stereoscope.

The first stereo photographs were produced in the 1850s. Beautiful and ornamental stereoscopic viewers were sold with adjustable stands and carved legs designed to blend in with other solid pieces of drawing-room furniture. It was the TV set of its day. Stereoscopic photography was also used by the prolific Jacques-Henri Lartique.

Photographic partnership Gary Welch and Doug Southall creates amazing stereoscopic pictures today. 'People's reactions to stereo pictures are really rewarding, everyone is always wowed by them. They look at the whole scene and into every corner. Your eyes wander off into the background, it's just more real than a flat photo', say the artists. 'They make galleries redundant. You can get an intense experience anywhere.'

Stereoscopic photography

A pair of stereoscopic images taken by Gary Welch (top left) using equipment that he designed himself (above). When stereoscopic pairs are looked at through a stereoscopic viewer (left), the images appear with great intensity. This is the case because the person looking at the images sees double the 'image information' that they would normally receive from a single photograph.

The photocopier and scanner as cameras

Dick Jewell describes his experiments: 'I started to try out the colour and black-and-white photocopier for portraiture, trying to see if it could convert the space under the photocopy mat into a photo studio by putting things on the glass. I was commissioned to do some posters for a band and was phoned at short notice to do the pictures. I didn't happen to have a camera with me so I just stuck their heads under the photocopier.'

The photocopier is a cheap and wonderful tool. You can copy images onto acetate and tracing paper in order to make contact prints, and experiment by moving images during the scan. The computer scanner, medical scanner and security scanner all offer fantastic creative possibilities. The raw, gritty quality of the security-camera image has been used for fashion shoots, portraits and advertising. The whole body scanner can even give a 360-degree image of the inside of the human body.

The photocopier can act as an instant photo studio.

Scanner as camera

Michael Golembewski built a scanner camera by taping together a film scanner, wooden boxes and a lens. The camera records moving objects in a unique way, compressing their motion. The pictures (below) show moving cars compressed by the camera and a figure distorted by movement during a scan. The camera can create billboard-sized prints.

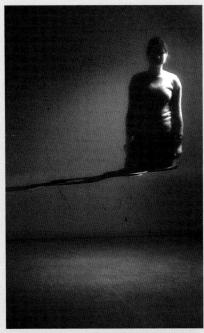

Thermal-imaging and night-vision cameras

Infrared thermal-imaging and night-vision cameras created for medical, security, military and fire-safety use offer amazing creative possibilities when appropriated for portraits, landscapes, still lifes and fashion shots. The night-vision control on the camcorder was used highly creatively in the film *The Blair Witch Project*.

Panoramic cameras

The word 'panorama' comes from the Greek word *pan* meaning 'all' and *horama* meaning 'view'. In panoramas we see the whole of a scene from a single viewpoint. The first panoramic camera was built by Friedrich von Martens in Paris in 1844. He created amazing pictures of the views from the roof of the Louvre using a special rotating camera he called a Megaskop, which used long, thin, pliable daguerreotype plates. Further photographic adventures can be had with security cameras, time-lapse photography, CAT scans, MRI scans, underwater cameras, synchroballistic cameras, satellite and sonar imaging, and the cine camera set to shoot single frames.

The controls of the camera

If a group of photographers was asked to take pictures of the same scene simultaneously, the resulting images would all be very different. The photographers would all see different things and control their cameras differently. Picking the instant to release the shutter is not the only factor that would make each photographer's work unique. Photographers select lenses for the view they offer, and carefully control focus, aperture and shutter speed. These things offer a great range of choices and in combination have a huge effect on the images taken.

Lenses

The lens is the eye of the camera. When light falls on an object, it bounces back from its surface. Both the human eye and the camera see the object when this light, travelling in straight lines, converges through a lens to form an image of it. In the case of our eyes, this image is sent to the brain to allow us to see it; in the case of the camera, it lands on the film or digital chip and creates a photograph. The range of our vision is fixed but the camera, with its interchangeable and zoom lenses, gives us the ability to see in many different ways. Lenses can let us see closer, wider and further than the naked eye.

Photographic lenses are made of layers of curved glass held in a barrel, and shaped and positioned to eliminate optical faults and distortion. The curvature of a lens affects the view we see through it. Most photographic lenses are convex, which means they are thicker in the middle than at the edges. A lens that is very thick in the middle and therefore very curved causes light from an object to converge in a much shorter distance than one that is thinner and less curved. Measuring the distance in millimetres from the lens to the point at which it causes light to converge is used as a way of indicating the degree to which a lens can magnify or widen the view. This distance is called the lens's focal length and is marked on the barrel or rim of the lens. Lenses are classified as being of short, medium or long focal length. Lenses of different focal lengths can produce radically different pictures of the same scene. It's your choice as to which one you use.

Short focal length/wide-angle lenses

A lens which causes light to converge in a short distance is said to have a short focal length. Such lenses have a wide angle of view. The light is gathered widely by the large curve of the lens. Wide-angle lenses in common use for the 35mm camera have focal lengths of 24mm and 28mm.

The wide angle was the preserve of the landscape photographer until creative photographers such as Bill Brandt (www.billbrandt.com) began to explore its potential. William Klein took the wide-angle lens camera into the streets in the 1950s. Commissioned to photograph New York, he approached the assignment like a 'fake anthropologist' with 'a technique of no taboos'.

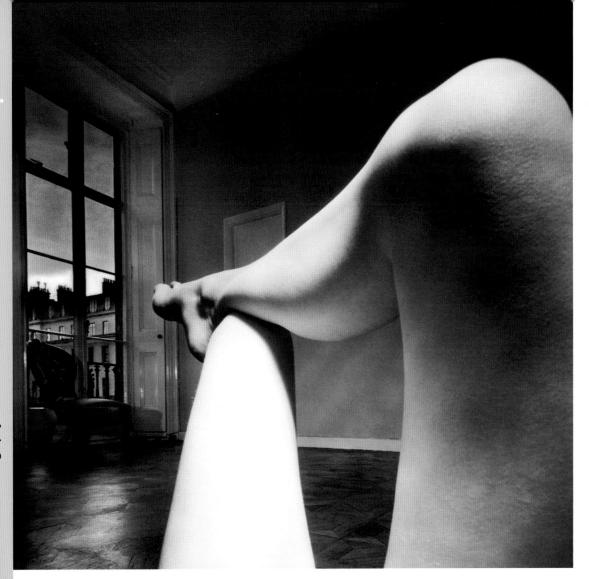

He thrust his camera into people's faces, provoking reactions from joy to aggression and creating a dynamic chaos. The city seems to be fighting its way into his camera.

Normal focal length/the standard lens

When using a 35mm camera, a lens that sees approximately the view that our eye sees is the 50mm lens. This lens is known as the standard lens and is called a normal or medium focal-length lens, as its view is one between that of a wide-angle and a long lens.

Henri Cartier-Bresson used the standard lens for its proximity to human vision. He is said to have taken nearly a million photographs without resorting to a wide-angle lens. This was part of his philosophy of photography – to photograph the scene he viewed without distortion. He also felt that the photographer should pass quietly and unnoticed, never interfering or altering the scene, the very opposite of William Klein's approach.

Bill Brandt, Belgravia, 1951

Bill Brandt used the wide angle to take a radical series of nudes in the late 1940s and 1950s. Inspired by Orson Welles' film *Citizen Kane* and its use of room sets, Brandt positioned his models for maximum distortion.

Long focal length/telephoto lenses

Lenses with a shallow curve that cause the light from an object to meet far from the lens are called long focal length lenses. They give a narrow and magnified view and are also known as telephoto lenses. Long lenses that are commonly used for the 35mm camera are the 135mm, 300mm and 500mm lenses. Long lenses were originally developed to get the photographer closer to the action in situations in which proximity was dangerous or prohibited. Again, the maverick William Klein made more creative and original use of them by using telephoto lenses for fashion pictures. While working for Voque, he was asked to photograph some bold striped dresses. Instructing his models to stride up and down a zebra crossing in the middle of Rome in the rush hour, he stood 500 metres away and took pictures as they struggled through the crowds. The choice of the telephoto lens created very strong and graphic pictures. 'Nothing like Klein had happened before. He went to extremes', said the legendary Vogue art director Alexander Liberman. 'He pioneered the telephoto and wide-angle lens, giving us a new perspective.' (See Elegance and elephants, p. 78, and A tabloid gone berserk, p. 102.)

Zoom lenses

A zoom lens has a variable focal length. Its construction allows it to be changed between a short, medium and long focal length by turning a ring on the lens or moving the barrel in and out. This allows you to gain a closer or wider view without moving position. Its ability to 'zoom' in and out on subjects gives it its name. With a zoom lens there is no need to refocus as you zoom: the image enlarges or decreases while remaining focused.

The macro (close-up) lens

The closest distance at which the human eye can focus is about eight inches. The focusing range of a photographic lens has no lower limit, and as a result photography can see things the eye cannot. Macro lenses – also known as 'close-up' lenses – allow subjects to be photographed larger than lifesize.

This can also be achieved using extension tubes, which fit between the camera body and the lens, or by using a special lens known as a proxar which fits in front of a lens. Some zoom lenses come with a macro feature.

The fish-eye lens

A large, highly curved lens with a protruding front element – which earned it the name 'fish-eye' – gives a very wide-angled and exaggerated view. It produces a circular image in which objects close to the top of the lens are greatly enlarged, while those further away become tiny.

Experimentation with the lens was very popular in the 1960s when the lens was first developed. Photographer David McCabe used the fish-eye extensively to photograph Andy Warhol during a year he spent at the Factory, its distortion perfectly suiting Warhol's extraordinary studio and entourage.

Focus - to infinity and beyond

The human eve is always in focus. On the other hand the photographer can choose whether to have some, all or no parts of a photograph in focus.

Most lenses are focused by turning the larger control ring of the lens while looking through the viewfinder. The viewfinder shows you the views through the lens reflected onto a ground-glass focusing screen. Some camera viewfinders show very slightly less than will be recorded on the film or CCD. By moving the focus ring you move the glass elements that make up the lens backwards and forwards. This varies the point at which the light rays come together inside the camera and causes the image to go in and out of focus. The indicator on the top of the lens shows how it is set. It is usually marked in metres.

When you look through the camera and rotate the focus ring clockwise you will see distant objects come into focus. When you move the ring as far as it will go in this direction, the lens is then described as being set to 'infinity'. This means the lens is set to the most distant point at which it can focus. This is indicated on the lens by a mark that looks like a figure eight lying on its side. By twisting it all the way in the other direction you can find the closest distance at which the lens will focus.

Soft or sharp focus?

When an object becomes clearly defined in the viewfinder it is described as being in focus or 'sharp'. If an object is not in focus it is described as being 'soft'. Choosing sharpness or softness can totally change a photograph.

The nineteenth-century pioneer Julia Margaret Cameron intentionally took many of her portraits out of focus. 'When focusing and coming to something which, to my eye, was very beautiful, I stopped there instead of screwing on the lens to the more definite focus which all other photographers insist upon.'

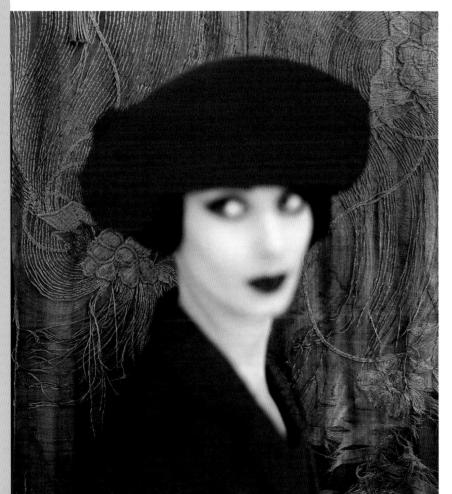

Norman Parkinson, Portrait after Kees Van Dongen (Adele Collins in an Otto Lucas toque), Vogue, 1959

Parkinson chooses to focus on the background rather than the model in this shot.

Aperture - the iris of the camera's eye

Our eyes react instinctively to how bright the light is. In very low light, for example at night, the iris in our eye becomes very large, giving us wide pupils to allow as much light as possible into our eyes. In very bright sunlight our pupils are reduced to tiny black dots as the iris contracts in response to the light's intensity.

The aperture of the camera lens allows the photographer to control the light entering the camera. By varying the diameter of the aperture, you can alter the brightness of a picture or control the amount of light found in different situations.

Early photographic lenses were supplied with a set of metal plates with different-sized holes drilled in them. These could be slotted behind the lens after being selected according to the intensity of the light. Aperture is controlled in today's lenses by a diaphragm made from a set of thin metal blades. You adjust the aperture by rotating the ring of the lens that clicks, with each click altering the size of the diaphragm.

f numbers and f stops

The aperture ring is calibrated in 'f numbers'. Lenses for the 35mm camera usually have f numbers 22, 16, 11, 8, 5.6, 4 and 2.8. The higher the f number, the smaller the aperture opening; f22 is the smallest hole, f2.8 the largest. The difference between any f number and its immediate neighbour is known as one stop. This phrase comes from those early drilled plates that stopped the light. The different apertures are often referred to as f stops.

The 'f' in 'f stop' is for 'factor'. The number given to each stop represents the number of times that that width of aperture can be multiplied to equal that lens's focal length. The f number is its factor of multiplication.

Stopping down and opening up

When you click the lens ring towards the higher f stops and decrease the size of the aperture, this is called stopping down the lens. When you click the aperture the other way and let in more light, this is logically called opening up the lens. These possibilities can be clearly seen by taking a lens off a camera body and looking through it while clicking the aperture ring.

What you see in the viewfinder compared to the picture you get on your film

When you look through the viewfinder of the camera and alter the aperture by stopping down or opening up the lens, you witness no effect on what you see. This is because once a lens is on the camera body it always shows the view through it at its widest aperture. A lens on a camera won't stop down to any smaller aperture you have selected until the moment you press the shutter to take the photograph. Even if you've set the lens to its smallest aperture of f22, the view through the lens remains that with it opened up at f2.8.

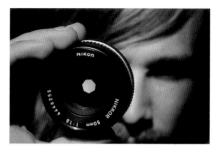

Try clicking through the different stops of a lens that has been taken off its camera body to see how the aperture changes according to its setting.

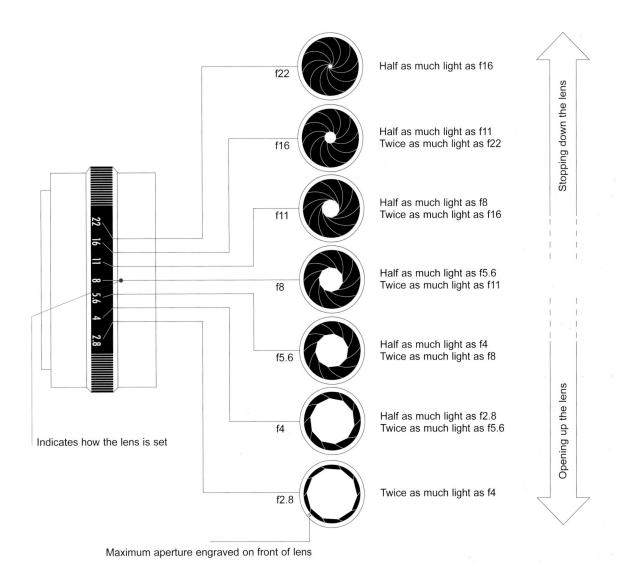

Fast lenses

A lens that can open very wide is known as a 'fast' lens. Because of the width of its aperture, a fast lens can be used in low light, so allowing a photographer to work without flash or extra lights. Fast lenses are more expensive to manufacture. Manufacturers write the maximum aperture of a lens together with its focal length on its front or barrel so you can see at once how fast it is together with its angle of view.

Ansel Adams, Edward Weston and Imogen Cunningham named their gang of photographers Group f64. The name reflected their love of the intense clarity achieved in pictures taken at f64, the aperture which gave them the maximum depth of field possible on their large cameras and therefore created pictures that were very sharply focused from the foreground to the distance. (See The camera in the hands of artists, p. 134.)

Shutter speed - all in the timing

You use the shutter as well as using the aperture to control light entering the camera. Before shutters were invented photographers controlled the amount of time that a camera's lens remained open by removing the lens cap, counting and then replacing it. Not until Eadweard Muybridge had made his discoveries did shutter times become short enough to freeze action. (See The weird world of Eadweard Muybridge, p. 103.)

The speeds at which a camera's shutter can open are marked on a dial on top of the camera, in the viewfinder or on the data display. Most cameras have shutter speeds of 1, 2, 4, 8, 15, 30, 60, 125, 250, 500 and 1,000: 1 indicates 1 second, the slowest shutter speed; 2 indicates half a second; 4 a quarter of a second, 8 an eighth, and so on up to 1,000, which indicates the quickest speed of one-thousandth of a second.

To take a picture you press the shutter release button on the camera. Shutter speeds share exactly the same doubling and halving relationship between adjacent settings as the aperture ring. Each shutter speed lets in twice as much light as the next-fastest speed and half that of the next-slowest speed.

'B' is also marked on the shutter dial. When the shutter is set to B it remains open for as long as the shutter release is pressed. This is used for making very long exposures such as at night or when multiple flash exposures are shot in a blacked-out studio.

Shutter speeds and movement

Shutter speeds affect the sharpness of moving objects in a picture. A fast shutter speed can freeze movement and a slow shutter speed can blur moving objects. The slower the shutter speed, the greater the blur. It is your choice whether to freeze a moving object, to blur it slightly or blur it a great deal. On a slow shutter speed you can also choose to 'pan' the camera – that is, to move the camera during the exposure to follow a moving object. This adds to the movement of the background of the picture. Movement and blur can bring feelings of joy, menace, vitality or immediacy to a photograph.

There is always enough light

It seems strange that shutter speeds of half a second and one second are always described as being 'long', as they only represent tiny moments in our lives. Pictures can also be taken with shutter speeds of many seconds, even many hours, to give radically different effects.

By controlling the shutter speed, it is possible to take pictures even when there appears to be no light – there is always enough to take pictures, no matter how dark it seems, you just have to keep the shutter open for long enough. If you want a sharp picture, you just have to keep the camera still. (See The camera – the time machine, p. 161.)

Exposure times

Extra-long exposure of 1½ hours used by Hiroshi Sugimoto; see p. 16.

1 second Twice the exposure time of 1/2 1/2 Half the exposure time of 1 second Twice the exposure time of 1/4 1/4 Half the exposure time of 1/2 Twice the exposure time of 1/8 Half the exposure time of 1/4 1/8 Twice the exposure time of 1/15 1/15 Half the exposure time of 1/8 Twice the exposure time of 1/30 1/30 Half the exposure time of 1/15 Twice the exposure time of 1/60 Half the exposure time of 1/30 1/60 Twice the exposure time of 1/125 Movement visible at shutter speeds slower than 1/60 Movement stopped at shutter speeds faster than 1/60 1/125 Half the exposure time of 1/60

Many minutes of exposure were needed to create this picture.

Moving things blur when shot at slow shutter speeds. The camera also 'panned' during the exposure, following the moving subject.

1/125 Half the exposure time of 1/60
Twice the exposure time of 1/250

1/250 Half the exposure time of 1/125
Twice the exposure time of 1/500

1/500 Half the exposure time of 1/250
Twice the exposure time of 1/1000

1/1000 Half the exposure time of 1/500

Extra-quick exposure of 1/100,000 of a second used by Harold Edgerton to photograph drops of liquid; see p. 147.

Moving things are 'frozen' by using fast shutter speeds.

Faster

Exposure - bringing together aperture, shutter speed and focus

The aperture controls the amount of light entering the camera, and the shutter controls how long the light comes in for. Together they control exposure. Exposure is the amount of light a photographer allows to fall on the CCD or film. To get the correct exposure you have to allow exactly the right amount of light to fall on the CCD or film so that the whole range of a picture's tones are recorded, from the shadows to the brightest areas. This will not happen if you allow in too much or too little light. Over-exposure means you have allowed too much light into the camera via the shutter and aperture, burning out highlight details and diluting colour. Under-exposure means you have not allowed enough light into the camera via the shutter and aperture, so causing the resulting images to appear too dark.

To ensure you have the correct exposure, you need to set the camera's ISO control for the film stock you are using or the level of sensitivity to light at which you want to take digital images. Since 1974, the ASA and DIN film-speed standards have been combined into the ISO standard. The current International Standard for measuring the speed of colour negative film is ISO 5800:2001. Digital cameras also use ISO settings to indicate varying levels of sensitivity to light at which images can be recorded.

Measuring the correct exposure

To measure the correct exposure you need a light meter. Most cameras have built-in light meters. A light meter contains a sensor that measures the amount of light falling on a scene, recording the range of brightness from light to dark and converting this information into an average reading.

Correct exposures are indicated with a light or needle in the camera's viewfinder or on the camera's data panel. This reading gives the photographer the starting point for many exciting creative choices.

Setting the correct exposure

To find the correct exposure for a scene you adjust the camera's aperture ring and the shutter dial. As we have seen, the aperture control and the shutter-speed dial share the same doubling and halving relationship between adjacent settings. This creates a link between aperture and shutter, which means they can be adjusted in combination to give you choices with regard to how correct exposures can be set. For example, the same amount of light can fall on the CCD or film from having a small aperture coupled with a long shutter speed, as will fall from a wide aperture coupled with a very short shutter speed.

Many cameras offer exposure programmes:

- with aperture priority you set the f stop and the camera automatically sets an appropriate shutter speed to give a correct exposure;
- with shutter priority you set the shutter and the camera automatically sets an appropriate aperture to give a correct exposure.

Correct exposures, different effects

Once you have taken a meter reading you can set the correct exposure in many different ways, with different combinations of aperture and shutter speed that together create equivalent exposures. All these combinations give identical exposures, but each setting gives a very different photograph.

The different ways of setting the correct exposure offer the photographer the creative opportunity to use the character of different apertures and shutter speeds in different ways. You can select the aperture first and then alter the shutter speed to gain a correct exposure. This allows you to control what is called the 'depth of field'. Or you can select the shutter speed first and then adjust the aperture. This allows you to control the movement seen in a photograph.

Light-metering problems, bracketing and clipping

As meters are designed to gauge correct exposure when there is a range of tone from light to dark, they can be fooled by scenes that offer little variation in tone or have extreme contrasts. Experience, a handheld light meter and 'bracketing' or 'clipping' your film can ensure correct exposure in these circumstances. 'Bracketing' is when you make several exposures, some that allow more light onto the CCD or film than the meter reading suggests, and some that allow less, thus ensuring that at least one exposure will give you a successful picture.

Alternatively film users can 'clip' their film. This is a means of ensuring correct exposure when processing a slide or negative film. One or more frames are 'clipped' from an exposed roll of film with scissors, in total darkness. This 'clip' is then processed and viewed by the photographer. The 'balance' of the film can then be processed at the same, a more prolonged or a shorter rate, according to the findings of the clip. (Clipping is further explained on p. 211.)

Setting the same exposure in different ways

All these combinations of f stop and shutter speed give the same exposure but each offers a different photograph – this is particularly evident when using the options with the smallest (f22) and widest (f2.8) apertures.

Once a correct exposure has been measured the photographer can select any combination of shutter speed and aperture that delivers the correct amount of light. In this example a correct exposure was indicated by the light meter as f8 at 1/125 of a second, the other combinations possible are f22 at 1/15, f16 at 1/30, f11 at 1/60, f5.6 at 1/250. f4 at 1/500 and f2.8 at 1/1000.

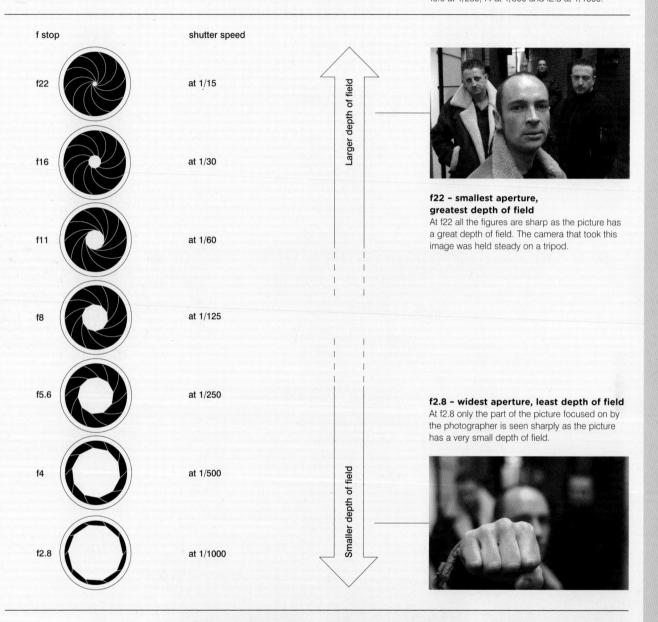

These three pictures were also taken at f2.8. In each image the camera is focused on different parts of the scene, showing the effects of a small depth of field.

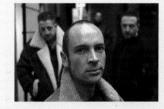

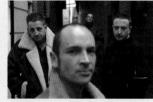

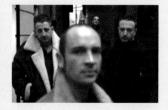

Controlling depth of field

Photographs taken with smaller apertures – such as f22 and f16 – have a large depth of field, that is, the vast majority of the image will be in sharp focus. Those taken with a wide aperture – such as f2.8 – have a small (or shallow) depth of field, that is, only the small part of the picture that has been focused upon will be sharply defined.

Depth of field can be controlled with great creativity. When a photographer chooses to take pictures with a shallow depth of field – say, at f2.8 – only the object in a scene that is focused on will be sharp, with everything else out of focus. This can be very effective: focusing on a near object causes the rest of the scene to melt out of focus. A shallow depth of field can be used to emphasize and isolate an object in a crowded scene.

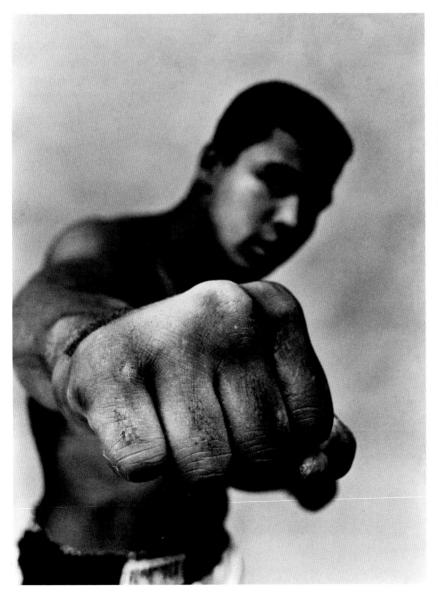

Depth of field varies with different lenses

The depth of field at each f stop varies between lenses of different focal lengths. Long lenses offer less depth of field at any given aperture than standard lenses; a 300mm lens will give much less depth of field set at f8 than a 50mm lens set at f8. Wide-angle lenses offer the greatest depth of field at any given f stop: for example, with a fish-eye lens, objects very close to the lens and those in the far distance will be sharp even at a relatively wide aperture. This variation gives further creative choice to the photographer when choosing his or her tools.

Thomas Hoepker, World Heavyweight Champion Muhammad Ali Shows Off his Right Fist, Chicago, Illinois, 1966

Hoepker accentuates Ali's fist by using a very wide aperture to give a very shallow depth of field. As a result only Ali's massive right hand is sharp.

Controlling movement

By choosing the shutter speed first and then adjusting the aperture to gain the correct exposure, you can control the movement in a picture. Action can be stopped with a fast shutter, moving and still objects can be mixed with a long shutter speed with a camera steadied on a tripod, or the camera can be moved during a long exposure to accentuate mood or create drama.

Weegee, Crowd at Coney Island, Temperature 89 Degrees... They Came Early, and Stayed Late, July 22nd 1940

Weegee's picture has a great depth of field. It was created using a small lens aperture that made the photo sharply focused from the very front right into the far distance. You can see the detail in the lady in the black swimsuit's straw hat at the front, the man looking through the rubber ring in the middle of the crowd, all the way to the Cyclone sign a quarter of a mile way.

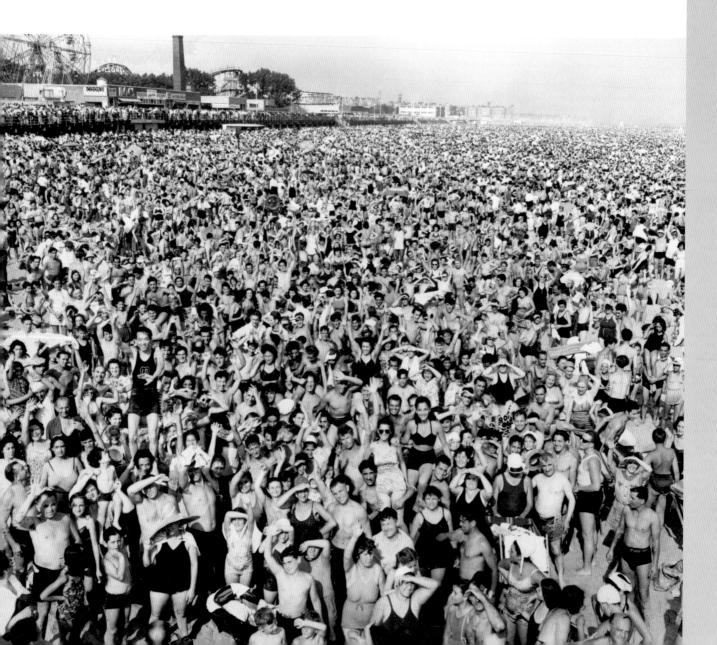

Composition - order or disorder

Composition is the photographer's way of ordering or reordering the world. The composition of a picture is how you choose to place things within the frame of the viewfinder. Some pictures are composed at great speed, some after much deliberation. Some photographers choose to work with the square-format camera, preferring its shape for composition. Others like the flexibility of the 35mm camera that can be used to take portrait or landscape pictures. Experiment with as many cameras as you can.

Composition can give stability to a photograph, with the elements arranged in a parallel or unified manner. The tripod can be a great aid in composing a picture, particularly when you are trying to create harmony in the viewfinder. On the other hand, a photographer can create pictures that are deliberately unstable and unsettling. Although our brains like order, harmony and symmetry, great impact can be gained from disharmony and disorder.

Picture editing

Editing is the process of choosing the best picture or pictures from all those you have taken, the pictures that are the closest to, or better than, the ones you imagined in your mind's eye when using the camera. Editing involves also finding pictures that you thought had failed when you took them, but suddenly afterwards appear to work because of some chance or unexpected element. Find the pictures that show your way of picturing the world.

Cropping

Cropping can add to the intensity of an image. Cropping can improve, concentrate and sometimes transform a picture. Some purists, like Henri Cartier-Bresson, printed the full frame of their images including the negative's border to show they were uncropped in printing, and that the composition was created in the viewfinder of the camera, not later in the darkroom. Cartier-Bresson saw cropping as somehow 'cheating'. Diane Arbus also printed full-frame, with an uneven black border at the edges of the prints caused by her filed-out negative carrier; she sometimes left all the faults of processing visible on the prints. Richard Avedon chose to print the whole sheet of his large-format negative uncropped, including black borders that seem to cage his sitters.

This is a landscape format

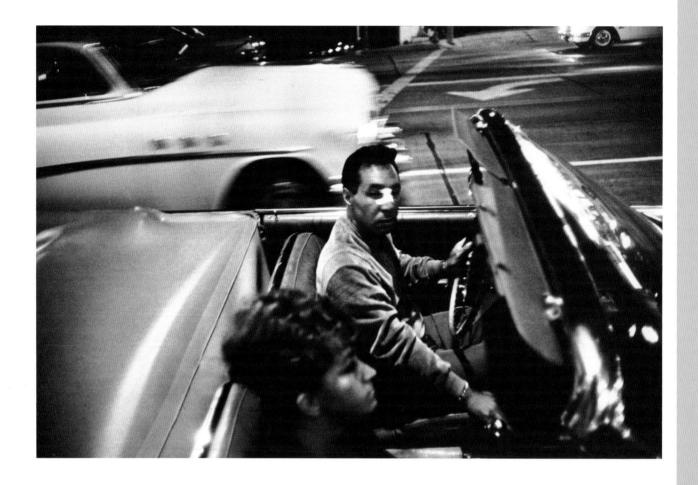

Black-and-white photography

Why still bother with black-and-white photography?

The vast majority of today's photographs are taken in colour. Why then should we still bother with black-and-white photography?

As we see the world in colour, black-and-white pictures immediately seem different. They offer clarity and purity; there are no distractions from the strength of a black-and-white composition, whereas colour can diffuse tension and drama.

Hiroshi Sugimoto photographs in black and white because the results are 'more beautiful than the real world'. Lois Greenfield prefers black and white as it offers 'not a replica of a scene, but a new creation'.

Black and white invests a picture with importance, realism and authenticity. Black-and-white pictures can have more weight and power, as well as more of a sense of history, than colour pictures. Great skill can go into creating a black-and-white print, as the photographer accentuates different areas and increases or reduces the contrast of each part of an image. This can make black-and-white photos seem more crafted than colour ones.

Garry Winogrand, Los Angeles, California, 1964

Some photographers pre-compose a shot and wait for the elements to fall into place. This image, on the other hand, is a 'grab' – an amazing, malevolent picture in which things have collided for a split-second and the photographer has had the instinct and speed to react.

Black-and-white film

Today's black-and-white film and paper still use silver as a key ingredient, over 150 years after its sensitivity to light was first used to create permanent images. Black-and-white film is made by coating clear sheets of thin plastic with a mixture of silver salts and gelatine. This mixture is called an emulsion. The gelatine bonds the light-sensitive silver salts to the plastic film base. The film is then sliced into different film formats and the manufacturer's name and frame numbers are exposed onto its edges. All this takes place in total darkness. When you look at any film the matt side of the film is the emulsion. the shiny side is the clear plastic film base. It is the emulsion side that is loaded into the camera towards the lens. When the emulsion is exposed to light through the lens, changes on the film are invisible to the eye until it has been developed. The film has of course to stay in the dark until it has been developed to prevent further exposure. Light affects the emulsion in negative by turning the highlights of the image black and the shadows white. To make a print, the image is projected onto paper whose emulsion has been made in a similar way, thereby creating a positive.

Choosing a black-and-white film

Photographers carefully choose film stock for its ability to influence their pictures. They select film for its graininess or lack of grain, or for the contrast it renders. Every film has its own character – try as many films as possible in many different situations to discover their qualities. Store film away from heat; protect it from moisture; load and unload it away from strong light.

ISO and black-and-white film

ISO is a system for classifying the sensitivity of film to light. Films that are relatively insensitive to light are given low numbers such as 100 or 200 and are called 'slow films'. Films that are very sensitive to light and can therefore be used in low-light situations are described as being 'fast' and are given high numbers such as 1600 or 3200. The terms 'fast' and 'slow' have led to a film's sensitivity being referred to as its 'speed'.

Digital cameras also use ISO settings to indicate how the camera is set to the sensitivity of light. The higher the setting, the greater the visibility of pixels. This effect is known as 'digital noise'.

Black-and-white grain

The tiny specks or clumps visible on film after development that together create a photographic image are known as 'grain'. When they are enlarged, our eyes merge them into continuous tones to form a believable image. The size of the grain of a film negative controls the clarity of the detail when a print is made. Higher ISO films have coarser grain than lower ISO films, which have finer grain.

Three questions

Why does film come in 36s and 24s?

For some reason film comes in multiples of twelve exposures. Perhaps it's because thirty-six and twenty-four frames were selected as convenient lengths to work with in processing. Confusingly, some 35mm film is still labelled '135 film' on the box. This was Kodak's original product number for this film size.

Why are some films labelled 'safety' films?

Around 1890 cellulose nitrate grew in popularity as the film base for black-and-white film. It was highly flammable and very dangerous to store. In the late 1930s new 'safety' films were introduced which used plastic bases less prone to combustion. The word remains on some brands today.

How many pictures should you take?

'An amateur wants to get thirty-six different pictures on one roll of film. A professional will take thirty-six rolls to get one picture.' Alan Latchley, photographer.

	Film speed	Sensitivity	
Finer grain/greater detail	50	Half the sensitivity of 100ISO	ilms
	100	Twice the sensitivity of 50ISO Half the sensitivity of 200 ISO	d as slow films
	200	Twice the sensitivity of 100ISO Half the sensitivity of 400ISO	Described
	400	Twice the sensitivity of 200ISO Half the sensitivity of 800ISO	
Coarser grain/less detail	800	Twice the sensitivity of 400ISO Half the sensitivity of 1600ISO	Described as fast films
	1600	Twice the sensitivity of 800ISO Half the sensitivity of 3200ISO	
	3200	Twice the sensitivity of 1600ISO Half the sensitivity of 6400ISO	
	6400	Twice the sensitivity of 3200ISO	

Alison Jackson makes use of the large grain of high ISO film in her mock-paparazzi pictures of celebrity lookalikes caught in wickedly funny predicaments, while Portuguese photographer José Luís Neto made massive enlargements from old negatives he'd tracked down in the Lisbon city archives documenting the treatment of prisoners in jail in around 1900. He made a sequence of super-large prints of tiny details from pictures of groups of hooded inmates and corresponding series once their hoods had been removed, enlarging the part of the negative showing each man's face from that of the size of a match head to actual human scale. The grain is as big as paint splashes but each individual tortured face is clearly visible in the mass of black marks, the images echoing the recent pictures showing the treatment of prisoners in Iraq.

The origin of black-and-white prints

Photography only came to be seen as black and white after half-tone printing started to be used to reproduce pictures. Previously, images had always had a chemical tint; for example, Julia Margaret Cameron's prints are a beautiful rich aubergine-brown colour.

Digital grain

Digital cameras also use ISO settings to indicate how to set the sensitivity of the camera. The higher the ISO, the poorer the quality of the image as it becomes less stable in the processing. This creates noise, where information has not been recorded correctly. This appears as a digital grain – because pixels are not recording light, the camera 'guesses' the colour of the pixel to fill in missing data.

Printing by hand

'Every hand-printed black-and-white print is unique. The skill of the printer and how he or she interprets the negative coupled with the age and batch of photographic paper, the freshness of the developer and even the humidity at the time of printing all create an unrepeatable image.'

Pete Guest, master black-and-white printer.

All prints from negatives were made by contact printing until the invention of the enlarger in the 1850s. Contact prints are the initial form in which a photographer sees a film negative in positive form and are made by placing a negative in contact with sensitized material before then passing light through it to create a print the same size as the negative. For every degree of enlargement in printing there is some loss of quality. Some photographers dislike any loss of quality and prefer only to create work as contact prints made from large-format negatives.

Black-and-white printing

Black-and-white printing in a darkroom is not difficult to learn. Many photographers refuse to let anyone else print their pictures as the darkroom offers an infinite number of possibilities in interpreting each negative and they want to control exactly how their final images appear.

Every negative can be interpreted in a multitude of ways – in contrast and tone and by accentuating different areas through 'dodging' and 'burning in' different areas. 'Dodging' is lightening an area of a print by shading it during exposure. 'Burning in' means darkening a chosen area of a print by additional exposure. There is no right way to print a negative. Bill Brandt described a negative as 'only the starting point'. Hand prints can possess a completely different, unique character from the negatives from which they are made.

Digital black-and-white images can be printed in as many different ways as traditional darkroom prints. Digital printers offer archival inks that create prints that should last as long as those created in the darkroom.

Great printers pay huge attention to detail. Go and look at a photographer's prints, not on screen or in books, as those are just reproductions. Search out the real thing – the prints the photographers have created themselves – in exhibitions and galleries.

Multigrade printing

Most black-and-white printing is done using the multigrade system. A series of filters are used in the enlarger that affect the emulsion in multigrade photographic paper in different ways. The filters are graded from 0 to 5. Low-grade filters create images with the least contrast, 3 has medium contrast while 5 gives the greatest contrast.

Selenium printing, platinum printing, copper toning, 'flashing' prints, albumen printing, photo-etching and gum-bichromate printing are some of the fantastic further adventures to be explored in the darkroom.

'I like the backlash against the digital image, with many photographers now seeking out and rediscovering processes like tintypes and gum bichromate.'

Eric Daley, photographer.

Liquid photographic emulsion

Charlotte Baker-Wilbraham, Untitled, liquid photographic emulsion, 1997

This is one of a series of images of circus performers taken by Charlotte Baker-Wilbraham, who creates prints on large sheets of aluminium using liquid photographic emulsion. Liquid photographic emulsion, sometimes known as 'liquid light', offers photographers the freedom to produce black-and-white images on materials of their choice. Prints can be made on glass, metal, wood, canvas, cloth, plaster and three-dimensional objects such as stones and tiles.

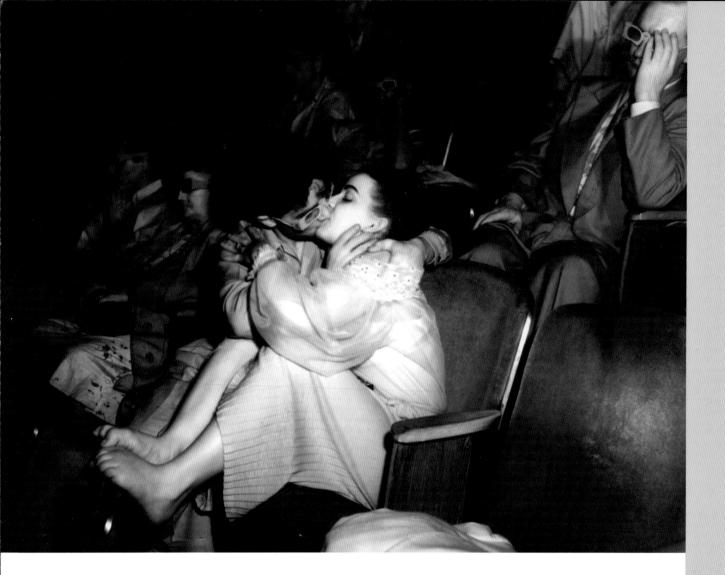

Contrast

The contrast of an image is the difference between the light and dark tones. Images in which there is a great difference are said to be 'high contrast'; these are images of almost pure black and pure white. Those in which the tones are closely related are said to be 'low contrast'. Although it is the convention to print images at medium contrast, with a full range of tones from black to white, altering the contrast of a black-and-white image can be very effective. Photographers who have created brilliant high-contrast images include Bill Brandt, John Deakin and Daido Moriyama.

X-rays

Wilhelm Röntgen discovered X-rays in 1895, winning a Nobel Prize for his work. An X-ray tube produces wavelengths of light that can penetrate most substances to form a black-and-white shadow image on film. X-rays have been used creatively by many photographers including Helmut Newton.

Weegee, Lovers at the Palace Theatre, 1943

Weegee took a series of pictures of lovers in the cinema and on the beach at night. By using infrared film and infrared-emitting flash bulbs whose flash is invisible to the human eye he was able to take pictures in which the subjects had no idea that they were being photographed.

Infrared black-and-white film

Infrared film is sensitive to infrared radiation waves that are invisible to our eyes. Black-and-white infrared film makes foliage appear as if covered by snow. Skin tones look very luminous and eyes appear very dark.

Helmut Newton, High-Heel X-Ray and Cartier Bracelet, Paris, 1994

© The Helmut Newton Estate. Newton had the great idea of using X-rays for a fashion shoot

Colour photography

Some photographs simply do not work without colour. Martin Parr's and David LaChapelle's pictures throb with colours brighter and more intense than those found in real life. Vivid colour is critical to the impact of these photographers' work. Wolfgang Tillmans and Juergen Teller use a totally different, flat and muted colour palette to convey ordinariness and casualness in their snapshot approach to photography.

Colour is a tool of the photographer. You can control colour by your choice of film stock, lighting and computer manipulation.

Digital cameras record colour differently at each ISO setting. Lower ISO settings render both finer-quality images and stronger colour rendition. Pictures shot at higher ISO settings on digital cameras have flat colour and digital noise.

Some pictures wouldn't work in black and white

Photographers can control colour by their choice of film stock. In this case, in order to photograph the walk through the Colourscape sculpture created by artists Peter Jones and Lynne Dickens, a slow ISO film was selected for its intense colour rendition.

Colour film

Painters have known for centuries that you can create just about any colour by mixing a few basic hues – red, green and blue. Colour film uses three layers of emulsion, each one sensitive to either red, green or blue. In development, different combinations of these three layers recreate the many colours seen through the camera. (See How does film-based photography work? – colour, p. 12.)

No two colour films work in the same way. Each manufacturer uses different dyes which give each colour film its own unique character. Some films offer soft colour, others offer brighter colours; some are 'warmer' or 'colder' in colour than others or offer more contrast. Try films from different manufacturers to discover the qualities of each.

The origins of colour film

In the 1840s portrait studios began to offer hand-coloured daguerreotype portraits; colour was added with a brush straight onto the mirrored surface. In 1861 physicist James Clerk Maxwell photographed a tartan ribbon through red, green and blue filters and then superimposed the transparencies to create a colour picture. This use of red, green and blue is the basis of all colour photography. It was nearly another fifty years before the first practical method of creating colour photographs was launched. Created by the French brothers Auguste and Louis Lumière, the Autochrome process dominated colour work for the first quarter of the twentieth century.

Autochrome used sensitized glass plates coated with millions of grains of orange, green and violet potato starch. These created unique, large glass transparencies that could either be projected by magic lantern or looked at against the light or on light boxes. The network of starch grains in Autochromes means the images always look grainy, like Pointilliste paintings. Photographers using Autochrome included Jacques-Henri Lartigue and Léon Gimpel.

Many alternative colour processes were marketed using similar principles, including the Vivex system that was used to brilliant effect by Madame Yevonde in the early 1930s. She posed her wealthy clients – mostly duchesses – in mock-classical attitudes and used the rich and sumptuous Vivex colours to accentuate their beauty. (See The studio portrait, p. 30.) Vivex was similar to the vibrant colour cinefilm process Technicolor, also launched in the 1930s. See the films Gone with the Wind (1939) and Snow White and the Seven Dwarfs (1937).

Kodachrome slide film was launched in 1936 and became the preferred choice of many professional photographers for its rich saturated colour and long-lasting colour dyes. Colour print film was introduced in the late 1940s along with further slide films.

ISO and the colour balance of film

Colour slide and negative films are classified by their sensitivity to light exactly like black-and-white film. Films that are relatively insensitive to light have lower numbers and are called 'slow films'. Those that are very sensitive to light are described as 'fast' and are given higher numbers. Slower colour films are sharper and offer stronger colour rendition. Films of the same speed made by different manufacturers can have very different characters.

Most colour slide and colour negative films are 'balanced for daylight', which means that they are designed to be used outdoors in natural light, indoors with flash or a mixture of natural light and flash.

More precisely, they have been manufactured to give colour accuracy in the colour 'temperature' known as daylight. The colour of a light source can be measured exactly using a colour meter, which gives a reading for its warmth or coldness, expressed on a colour temperature scale. Readings are given in Kelvins or K. For example, the colour meter reading for candlelight is very different from that for a fluorescent lighting tube because the candle gives a warm, yellow light and the fluorescent tube a cold, blue-green light. The colour of 'daylight' is fixed at a colour temperature of 5500K. A light source exactly matching this would give colour accuracy on 'daylight-balanced' film. Midday sun has a reading of 5500K, though at other times of the day it is slightly colder or warmer.

All professional light boxes are balanced for daylight, as are studio flash heads and camera flashes. One advantage of taking colour pictures with digital cameras is that most offer in-camera controls for correcting colour balance. You can also alter settings from frame to frame should you move from one dominant light source to another.

Colour slide film

Colour slide film, also known as 'transparency film' and 'colour reversal film', produces unique, direct positive images. The vast majority of professional photography was once undertaken on slide film. If you were taking pictures for publication in a magazine, book or brochure, you had no choice but to shoot on slide film as all the technology for colour reproduction was set up to work from slides. Today digital photography has totally changed this practice. Colour slide film is processed using chemicals called E6. Low ISO slide film offers beautiful colour and a very fine grain. Slide film offers near-permanent images that if correctly stored will not fade.

There are also disadvantages to colour slide film. Colour slide is totally unforgiving of any mistakes. Any over- or under-exposure is clearly visible. Any variation in colour balance will also be visible. Unless used in bright sunlight, slide film can lack contrast and higher ISO slide films give flat and grainy images. You may like this effect, though.

As each slide is a unique image, once you have handed it over to a client there is a risk that it is gone forever and will never be returned to you.

Colour negative film

Colour negative film produces an image whose colours are opposite to the scene photographed. Images are printed onto colour negative paper to make a positive. Colour negative film is processed using chemicals called C41.

Colour negative has great latitude. Images that are under- or over-exposed can be printed with acceptable results, though the best ones are obtained from correctly exposed negatives. Colour negative film gives good-quality colour images even with higher ISOs.

It is debatable whether a print from a colour negative can match the intensity, detail and colour of a beautifully exposed colour slide. Colour prints may also lack the permanence of colour slides.

Clipping your film

Clipping ensures correct exposure when processing a slide or negative film in a professional lab. One or more frames are 'clipped' from an exposed roll of film with scissors, in total darkness. This 'clip' is then processed and viewed by the photographer. If it is unsatisfactory the 'balance' of the film can be given extended or reduced development.

Film can be given more or less development to slightly brighten or darken it. This is usually done in units of time that increase or reduce the exposure of the film by an amount equivalent to the effect of half an aperture stop. For example, if you judge your film to be the equivalent of half a stop too light, you would ask the lab to process the balance of your film at -1/2 stop, reducing its brightness. If your film is too dark you can process the balance +1/2 stop or more. The most you can adjust your film before the effects become very noticeable is 11/2 or 2 stops.

Uprating

Uprating means you deliberately expose a film at a higher ISO setting than its manufactured speed – for example, if you expose a 400ISO film at 1600ISO. Once the film has been exposed you need to extend the processing time since the images have been under-exposed. The effects of uprating are to increase grain and contrast. You choose to uprate if you need to handhold a camera in low light or if you simply like the effect that uprating has on your images. 400ISO film rated at 800ISO is said to be uprated one stop. 400ISO film rated at 1600ISO is said to be uprated two stops. You can uprate both colour and black-and-white film. You can also downrate your film – shooting it at a lower ISO and processing accordingly.

Tungsten and infrared film

Tungsten film is balanced for use in tungsten light rather than for daylight. When tungsten film is used in daylight it creates a blue cast on the pictures since daylight has a colder temperature than tungsten bulbs.

Infrared colour film is sensitive to both visible light and infrared radiation waves that are invisible to our eyes. It reveals intense and surprising colour.

Cross-processing

Cross-processing is when you process a colour slide film through the chemicals normally used for processing colour negatives. You can do this with any slide film. Many labs were initially reluctant to do this since it was thought to mess up the C41 chemicals. The slide film becomes a dense, high-contrast colour negative in cross-processing. When printed, cross-processed film can produce striking colour prints. Each different type of slide film produces a different result. You can also process a colour negative film through E6 chemicals, which are normally used to process colour slides.

Know your lab

Most high-street labs now use digital processing machines, even when printing from negatives or slides. Images are converted into digital data, and a wide range of correction measures can be used to improve contrast and sharpness, as well as to minimize problems of exposure, backlighting and flash. Negatives with surface dust and scratches can be automatically detected and corrected. As with all machines, the skill and experience of the operator are the most important factors in getting the best results.

Get to know your local lab; find out about all the processes they offer, how each works and how each can be experimented with.

Colour printing

Colour prints from colour negatives are known as C type prints, C prints and Type C prints. Like black-and-white printing, colour darkroom printing from negatives is not difficult to learn. The colour darkroom offers fantastic creative possibilities. The colour negative is just the start. Many effects can be achieved in printing, including enhancing colour and contrast, removing unwanted colour casts or creatively adding colour. Further adventures can be had creating dye-transfer prints and colour photograms.

Colour and digital images

The partnership between digital images, computers and printers gives photographers fantastic creative possibilities. Images can be greatly altered and manipulated on the computer to increase or decrease colour, contrast and brightness. Digital images can be printed on many surfaces. Some printers offer a wider range of colours than others, together with finer graduation of colour and sharpness. Some use dyes rather than inks, so offering a much greater degree of permanence.

'You never have creative accidents with a computer – only disasters. In the darkroom interesting things often happen by mistake that you can take advantage of. This never happens on the computer screen.' Kjell Ekhorn, photographer.

Professional film

Manufacturers claim that the ISO and colour balance of films marked 'professional' are more consistent and accurate than those made for the amateur market, hence their higher price. Some cheap film produces fantastic colour in some situations; other cheap film is of very poor quality.

Film and all other light-sensitive photographic materials are marked on their packaging with a batch number. As variations in sensitivity can occur during manufacturing, photographers can ensure consistent results by using materials from the same batch.

An example of cross-processing: this strongly coloured picture was created by shooting using slide film. This was then processed as a negative, from which a print was made.

'Cross-processing gives an exciting unpredictability to the results. Sometimes an image goes totally red, or totally green. It adds another layer of chance to picture-taking.' Fabian Monheim, photographer.

Daniel Alexander, Screaming Heads, 2004

Alexander's images are made through creative use of the colour and black-and-white darkroom. 'I'm fascinated by newspapers - especially tabloids. They're such a strange mix of sex and really terrible things happening. I found this picture of a woman screaming at a police van containing someone accused of murder. I had the idea to use the head twice so that it looked as if it were screaming at itself. I wanted the head on the right to look like a brain scan - if you could look inside the woman's head this is what it would look like full of all this information. I wanted to express the idea that the way the tabloids pack all this information inside our heads makes us angry enough to scream, which then feeds back into being another story in the same paper. 'I took the image and a lot of the text about the case and blew them up to make a collage on acetate which I then used to make photograms in colour and black and white in the darkroom.'

Photography and light

You need light for photography. Many different light sources can be harnessed to create photographs. Each can be controlled in different ways to create radically different effects on a subject and how it appears. Photographers choose a light source for the quality and character it brings to their work. Every photographer uses light in a different way. Some photographers love working with daylight, some love direct flashlight, while others will take a truck full of lights to every assignment. They will alter their position to make the best of the sunlight or position and reposition their lights until they have the effect they wish.

Sunlight and available light

Some photographers choose to work only with the light that is present when a picture is to be taken. They use the light from the sun, street lighting or the lighting that happens to be inside the building in which they're photographing. This is known as using the 'ambient light' or the 'available light'. Great photographers who only work with available light include Henri Cartier-Bresson and Tony Ray-Jones.

Using available light is an unobtrusive way of working; you can blend into a scene and take pictures when the moment is right. You can travel light, unencumbered by tripods and stands, and work quickly and with freedom. Pictures taken in available light can appear more natural in mood and more atmospheric than those illuminated by flash or tungsten. The angle and colour of sunlight changes a lot throughout each day as the sun travels through the sky, giving you many choices of how to photograph a location.

The disadvantage of using available light is that it can be excessively bright, dim, uneven, or overly contrasted. Very bright and direct sunlight can be very unflattering, though photographing in the shade on very bright days can give great results, as can photographing a subject against the light.

Light indoors can be of a very low level, forcing photographers to move their subject to where there is more light – for example, next to a window – or to work with fast lenses and fast film stock or a high ISO setting on a digital camera. This can create results with poor colour, large grain or pixellation, and a very narrow depth of field, though you might like this.

Artificial light

If a photographer takes lights with them to take pictures, or uses lights in a photo studio, this is known as using 'artificial light'; the light source is man-made, rather than the natural light from the sun. Artificial light frees photography from the whim of the sun, while mirroring its look. (See The plain-background portrait, p. 30.) The great brightness given by artificial light sources – such as flash light and tungsten light – guarantees that a photographer will be able to use slower, more intense and finer-grained film stock or digital ISO settings and smaller apertures.

There are many ways to bring light to a photograph

- 1. Flash light in daylight. A 'soft box' used with a large battery-operated flash pack.

 2. Tungsten lights and a reflector.
- 3. Tungsten light held by an assistant.
- 4. Ring flash on location.
- 5. A light box is used to light a still life in a studio.

Flash light power

In the 1860s lighted magnesium ribbons were first used as a light source for photography. Their intense white light was used to take pictures in mines, caves and Egyptian tombs. 'Flash light' powder was made in the 1880s by crushing magnesium. When a photographer was ready to take a picture, he or she ignited the powder with sparks from a flint wheel, producing a brilliant burst of light. Danish photographer Jacob Riis used this method of creating artificial light to photograph the territory of the gangs of New York in 1890. (See Opening the eyes of the world, p. 90.)

Flash light powder was difficult to use. Its explosiveness made it very dangerous, and photographers had difficulty regulating the burst of light so that it was hard to gain good exposures. These problems were solved with the invention of the single-use flash bulb in the 1920s. The design of a glass 'bulb' shape, filled with oxygen and containing a very thin strip of magnesium or aluminium, gave a brief, controlled burst of light when electronically ignited.

Dr Flash - quicker than a wink

Modern flash was invented by Dr Harold Edgerton. In 1929 Edgerton needed to study the rotors of an electric motor while they were spinning, and reasoned that this could be possible by synchronizing bursts of light to the speed at which the motor was turning. Realizing that single-use flash bulbs would be of no use, he designed and built a high-speed electric flash light, a tube filled with gas that could repetitively emit a brief, brilliant burst of light when subjected to a surge of electricity.

Edgerton's creation of flash tubes that could be quickly fired again and again gave photographers and scientists a brilliant tool. As he refined his experiments he found he could create flashes as short as 1/100,000 of a second, and control very rapid sequences of flashes – known as 'stroboscopic' lighting – so that he could view the rotors.

Edgerton was able to bring time to a standstill in his flash-lit photographs. He stopped the movement of bullets, drops of liquid and, in *Wester Fesler Kicks a Football*, showed the incredible distortion of a ball at the moment of a boot's impact. Using sequences of flashes, Edgerton was able to photograph the swing of a golfer and the movement of a tennis serve. His work with flash light earned him the nickname 'Dr Flash' and won him an Oscar for his film *Quicker than a Wink*, which was made using stroboscopic flashes. (See What makes a great photographer?, p. 146, and The camera – the time machine, p. 161.)

Measuring flash light

Flash light is a quick, intense burst of light, too swift to be recorded by light meters designed to measure available light. To measure flash light you need to use a flash meter.

Many cameras have a built-in one in the lens (TTL), which adjusts the output of the flash to match the camera's setting.

Handheld flash meters measure the brightness of flash light hitting a subject.

After matching the ISO setting to that of your camera, hold the meter's sensor next to the subject and trigger the flash to obtain an aperture reading.

Larger and more powerful portable flash lights, which run on mains electricity or rechargeable batteries, are synchronized with a sync cord between the camera and the flash.

Small flashes fit on to a camera 'hot shoe', a mount that also provides an electronic connection to fire the flash when the shutter release is pressed.

Direct flash - raw lighting

Some photographers like the light emitted by a camera-mounted flash aimed directly at a subject. It gives a flat, two-dimensional effect that shows every detail of the subject with a brutal, merciless blast of light. In direct flash pictures the foreground is brighter than the background as the light quickly becomes dimmer. If the subject is close to a wall or backdrop, a black, harsh shadow is created. Photographers who used flash for these effects include Diane Arbus and Roger Ballen.

Garry Winogrand also used raw, direct flash for impact, its light reflecting back into the camera from windows, shiny surfaces, even from his subject's glasses. William Klein described his choice of flash in his book Close Up: 'I go from table to table ordering, "Don't move!" Then, "Terrific", and unleash the flash. In those days, the photographic word was "Available Light" and the flash, shades of Weegee reserved for Associated Press and weddings. But its raw lightning could generate an inimitable schlock document.'

Camera-mounted flash light can be 'bounced' from a ceiling or wall onto the subject to give a much softer and more even lighting than direct flash light. Many camera-mounted flash lights have heads that tilt to make this easy. It can also be softened using a diffuser or tracing paper.

Flash to stop the action

As flash is a quick burst of light, it stops movement. This can be very useful and effective in news photography, photojournalism and sports photography. Harold Edgerton's pictures of stopped movement inspired numerous photographers, including Albanian-born Gjon Mili. He used flash to freeze the movement of dancers in mid-air, including the amazing Willa Mae Ricker and Leon James Demonstrating the Lindy. His pictures were to inspire later photographers, including Lois Greenfield. (See The body in motion – dance, p. 72.)

Series of flashes can reveal the rhythm of a movement and show events unfolding. Mili created pictures using sequences of flashes, photographing Gene Kelly dancing across a stage in six flashes. Ralph Morse photographed an entire sixty-yard sprint race at New York's Madison Square Garden on one frame of film, by using a sequence of three flashes during its 6.2 seconds. Photographing from a position in which the whole track runs towards the base of his camera, he placed flashes near the start, middle and end of the race, their bursts of light freezing the action at each point, revealing who was leading at each stage.

Although the results can look similar, using sequences of flashes and multiple exposures are different ways of taking photographs. Sequences of flashes are made in a blacked-out studio or dark area while the camera's shutter has been left open. Multiple exposures are made by taking one picture, then resetting the camera's shutter to take another on top of the first, then resetting the shutter to take another on top of that, and so on. Both methods work best against dark backgrounds.

Mixing flash in available light

Flash can be used with great subtlety or drama and theatricality when mixed with available light. The balance between the power of the flash and that of the available light can be varied greatly according to the preference of the photographer. Flash can provide an additional light source that can be used in bright sunlight to brighten shadows and reduce strong contrast. This is known as using 'fill-in flash'. It can also be used as a more creative tool.

Bruce Gilden used flash on bright days to photograph New Yorkers rushing to work. People are crammed into each frame. The flash adds menace to the pictures, a blast of light that catches the people grimly determined to get to their destinations.

Flash can be used in daylight to intensify the mood of a photograph. Many photographers use it to separate their subjects from the background in which they are positioned. Rineke Dijkstra used this method in her series of photographs of adolescent girls on the beach. (See The plain-background portrait, p. 30.) Others who work in this way include Annie Leibovitz.

The use of flash in daylight can be exaggerated and used very theatrically by positioning subjects against dramatic skies and choosing to use the flash as a main light source. Backgrounds can be further darkened by increasing shutter speed. When taken to extremes the background is not exposed at all while the subject is still lit by the flash.

Flash mixed with long exposures

Shutter dials indicate the highest speed at which a flash can synchronize with the camera's shutter – generally 1/125 or 1/250 of a second. There is no lower limit of shutter speed at which a flash can synchronize. A flash can be set to fire and the shutter can be left open for 1/4, 1/2, 1 second or even much longer. This can be used to mix flash with low levels of available light. For example, in order to photograph someone standing in front of a city skyline at night, the person is lit by flash light and the shutter left open for many seconds to expose the lights behind. In order to have a successful picture, the camera must be kept still on a tripod and the subject not move too much during the long exposure.

Flash and blur

Long exposures mixed with flash can also create 'flash and blur', in which most of a subject is frozen by the flash but its continued movement, or the photographer's movement of the camera, continues to be recorded by the open shutter. Flash and blur, also known as 'open flash', was used by William Klein to photograph the backstage chaos of the Paris fashion shows.

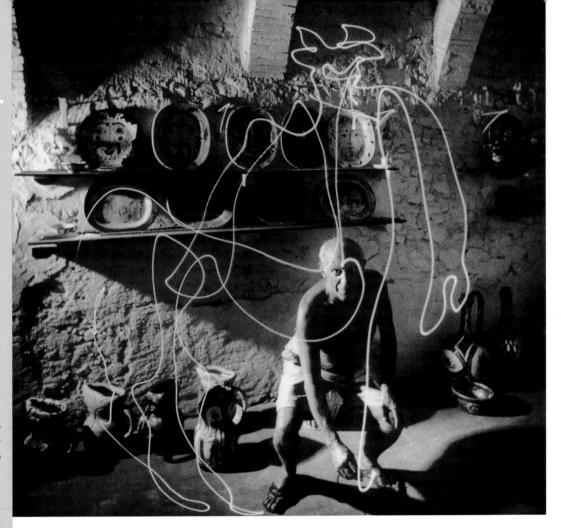

Mixing flash with other light sources

Gjon Mili created a brilliant picture of Picasso in the darkness of his pottery workshop in Vallauris. Posing Picasso among his work, he lit him from the side with a burst of flash lasting a fraction of a second, then left the camera's shutter open for many seconds while the artist drew a huge centaur in the air with a light pen. Mili mixed the two light sources wonderfully, his camera held steady on a tripod to record the fineness of the drawing.

Ring-flash

Ring-flash light comes from a circular flash tube which is fitted around the lens of the camera. The circular flash tube gives a soft, even, frontal light and an even shadow all around the subject. Ring-flash has been used creatively in fashion photography by Helmut Newton and Nick Knight, and in documentary photography by Martin Parr.

'Red-eye' can occur with ring-flash and other flashes mounted close to the camera lens. It is caused by flash light being reflected back into the camera from the retina at the back of the subject's eye. Photographer Paul Graham used red-eye creatively in a series of close-up pictures of young clubbers – their glowing red retinas giving them a predatory look.

Gjon Mili, Picasso at the Madoura Pottery Workshop, Vallauris, France, 1949

Inspired by the work of Harold Edgerton, Mili experimented with light. Here he mixes two light sources – a flash and a light pen – during one exposure, as Picasso draws a centaur in the air.

The pros and cons of flash light

Flash can be an important creative force in how you create your own pictures. In a situation where you have to work fast, flash is a great means of immediately increasing light. The flash's big burst of light means you can use low ISO settings on digital cameras and slower-speed ISO films, together with small apertures giving a large depth of field assuring sharpness. Flash light gives natural colour since it is 'balanced for daylight'.

However, flash can totally spoil the mood or atmosphere of a photograph. Unless you are using a digital camera, you will be unsure of the results until your film is processed since the effect of flash light does not match that seen through the camera's viewfinder.

Tungsten light

Tungsten lights emit a bright, constant light source. They are called 'tungsten' as they produce light from an electronically heated filament made of tungsten wire. Tungsten lights generally use either very large bulbs that look like oversized versions of household bulbs, or very small bulbs in which you can see the coiled filaments when the bulbs are turned off. Tungsten lights have a light temperature of 3200 Kelvins. To our eyes they appear to produce a very warm or yellow light source. Natural colours are achieved by using tungsten-balanced film with tungsten light. Tungsten light can be used directly, reflected, focused, diffused or bounced, exactly like flash light.

Using tungsten light with daylight film

If tungsten light is used with daylight-balanced film, the results are very yellow. This can be 'corrected' by using a blue 'correction filter' over the lens or by using the light to 'cool' the tungsten colour temperature to that of daylight, 5500 Kelvins. Using film stock in light that is different from that for which it was designed can create great results. Get to know your film stock and light sources and the colours they emit.

The pros and cons of tungsten light

Tungsten light is easy to mix with daylight, particularly if filtered to match its colour. The view through the camera viewfinder will approximate the one recorded. Basic tungsten lights are inexpensive, portable and can be used in numerous ways – direct, directed with a snoot or barn doors, bounced, reflected and diffused.

However, tungsten bulbs get very hot and can make the place in which you are photographing very warm and uncomfortable. Tungsten lights can burn you and the subjects you are photographing. They only have a limited life, much shorter than that of a flash.

Larger tungsten lights such as 'redheads' or 'blondes' are designed to be used in studios with powerful electricity supplies. They can 'trip' the electricity or blow the fuses if plugged into a normal household socket, as they draw so much power.

Using flash light

Flash light can be used as a harsh light source or to recreate soft daylight where there is none. It can also be used very creatively. Once a flash has been moved from a camera onto a stand that can be positioned by the photographer, there are far more lighting options. There are numerous ways in which flash light can be intensified, softened or diffused, including using snoots, lighting umbrellas and soft boxes.

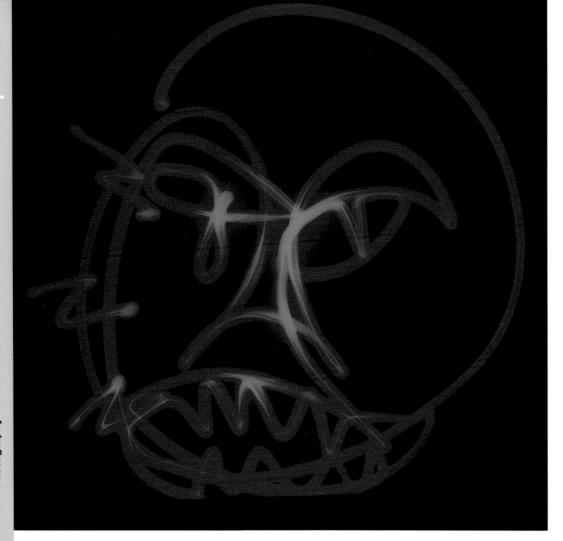

Studio lighting

Studio lighting offers the photographer maximum creativity and total control over a photo. The disadvantage of using studio lighting is that it can lead to a tendency to 'over-light' shots, thereby killing the mood.

Further adventures with light

Bill Brandt loved to photograph by moonlight; his pictures of London by moonlight were taken with exposures lasting half an hour. Brandt also published pictures entitled The Magic Lantern of a Car's Headlights, which included ghostly pictures of a graveyard lit solely by his car's headlamps. Torch light has been used creatively by Kim von Coels and Paolo Roversi. (See Lust, camp and colour, p. 80.) Infrared flash light was used by Weegee to take pictures unobserved by the audience in a cinema and to photograph at night on the beach (see p. 206). Light boxes, candle light, neon light, fluorescent light and ultraviolet light can also be used to take photographs. Remember, there's always enough light to take a photo. You just have to leave the shutter open for long enough.

Kim von Coels and Ken Chung, Face, 2004

This was the result of a collaboration between photographer von Coels and illustrator Chung. 'We did a series of experiments with torches and long exposures', explains von Coels, 'Ken wore dark clothes and painted in the air with a small torch covered with a red gel. I kept the shutter open for about ten seconds until the drawing was complete. It was taken with a Hasselblad medium-format camera on a tripod in a blacked-out studio.'

Light waves

The human eye can only see some of the electromagnetic waves that are all around us. We see a very small group of waves in the middle of the electromagnetic spectrum, known as the 'visible spectrum'. Some films and cameras can photograph beyond the power of our eyes by recording X-rays, infrared and heat.

The colour temperature of light

Colour film and digital cameras are very sensitive to changes in the make-up of different light sources. Although our eyes tell us that a white shirt looks white both outdoors in bright sunlight and indoors in artificial light, our photographs record the colour of the shirt differently in either situation. This happens because different light sources have different 'colour temperatures' – greater warmth or coldness. Exact coloured temperatures can be measured with a colour meter and are expressed in a measurement of Kelvins (K).

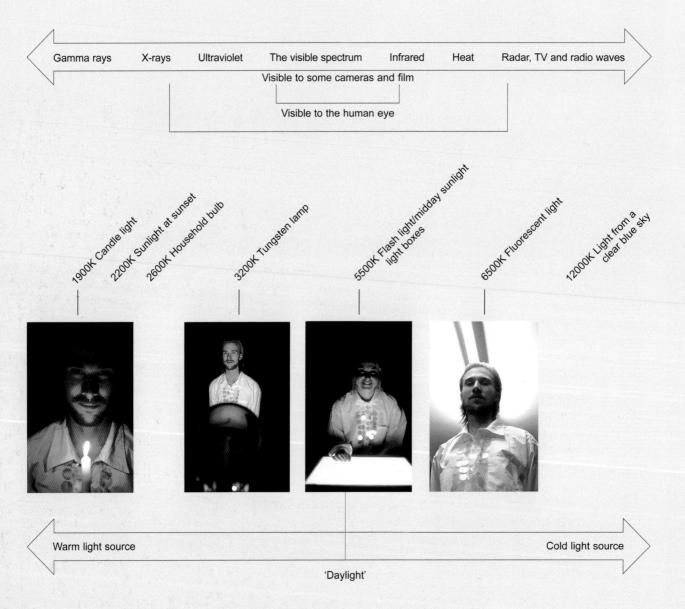

Photoshop

Photoshop is the computer program adopted by many photographers as the standard tool to manipulate, alter and retouch photographs. It offers an almost infinite number of possibilities for changing images, and can be used to create images impossible by any other means.

Photoshop - digital postproduction.

Photoshop has become a generic term for 'making perfect'. The software from Adobe has become increasingly more powerful as each new version is released. New tools and processes have been developed and Photoshop has become the industry standard for the post-production of photographs.

There are many 'plug-in' applications and, as part of the digital workflow, Photoshop may only play a small part, for example, in cleaning an image, or it may be the tool that is used to create an image that defies reality, with infinite possibilities of execution. The only limitation is the imagination and skill of the operator. Whatever the origin of the image, be it shot on film or digitally captured, it is Photoshop that creates a digital image that can be used and archived. Today's photographers need as many skills as possible, but a good understanding of and an ability to use Photoshop is essential in the digital world.

The program allows the operator to perform simple tasks like retouching an image, but also to produce multipart composites and to prepare images for web use or for a massive ambient poster site.

George Logan, Loch Scridain, 2007

George Logan created this image by first shooting the landscape on the Isle of Mull and then photographing the silverback gorilla in Cameroon. Logan intended the image to appear real and it is a testament to his photographic skill and excellent retouching using Photoshop that Logan has been asked 'How did you get the gorilla to Scotland?'. This image is the cover of *Translocation*, a book that supports The Born Free Foundation.

Photographic software

There are many other software programs that can process a digital image, such as Lightroom, Capture One and Aperture, as well as those produced by camera manufacturers, but Photoshop is generally used as part of the digital workflow, from taking the photo through to its final destination.

The photographic studio - Narnia

A photographic studio is like C.S. Lewis's Narnia – a magical place where wonderful and unexpected things occur. A studio offers a photographer the chance to be incredibly creative. Anything is possible in one. It frees photographers from the problems of sunlight, which can spoil a photo by being too bright, too dim, in the wrong place or non-existent. In the studio photographers can place the light exactly where they want, or use multiple light sources to achieve exactly the mood they desire. The studio frees them from the problems of having to work with the elements found on location; in the studio they can control everything in a picture.

Artists have for centuries had studios with huge windows positioned in such a way as to give strong light by which to paint. Some photographers like to use daylight in their work too, enjoying the way it illuminates their subjects. When good daylight is not available, studio lighting can be used to echo the look of daylight.

A studio is an empty room. The bigger, higher, longer and wider it is, the better. Size and height maximize options of viewpoint and the choice of lenses that can be used, and they offer the opportunity to build larger sets and lighting set-ups.

Studios have white walls with grey or black floors. Any coloured walls can cause huge problems by reflecting back unwanted colour onto a photographer's work. Studios can be blacked out so that no unwanted light enters to spoil long exposures.

Equipment can be used in a great variety of ways. Many lights can be used, synchronized together with 'magic eyes'. Multiple exposures or multi-flash pictures can be taken and light sources subtly mixed. Amazingly creative studio work has been done by photographers such as David LaChapelle, Nick Knight and William Klein using fantastic sets, oversized props and false-perspective sets, and controlling and mixing lighting. Some studios are fitted with coves, sometimes called infinity coves. These are curved white backgrounds which, when lit, give the impression of an infinite space behind the subjects being photographed.

Studios are expensive to hire by the day or half-day. Some studio owners charge not only for the use of the space but for every metre of backdrop paper and every centimetre of gaffer tape you use, as well as imposing expensive overtime rates. Plan your shoot very carefully to maximize the use of a hire studio.

Pictures without a camera

Photograms and chemograms

A camera isn't necessary to create photographs. There are numerous ways to create pictures without one. For example, photograms are photographic prints made without a camera. Photograms may have been named in the 1920s by the Bauhaus teacher and photographer László Moholy-Nagy, who experimented widely with the technique. The name – photography meets telegram – expresses a sense of urgency. However, the first photograms were probably created in the late 1830s by W.H. Fox Talbot, who placed flowers on sensitized paper and called the process 'photogenic drawing'. Photograms are also known as Schadographs after German artist Christian Schad who experimented with the process in the 1920s, placing scraps of paper and text on photographic paper.

Photograms are created in the dark by placing flat, 3D or opaque objects directly onto a sheet of photographic paper or other sensitized surface before making an exposure using an enlarger or a household light bulb. Those parts of the paper not covered by objects turn black. The areas covered stay white as they are left unexposed. Grey areas also form, caused by refraction of light or partial exposure. Objects can be introduced and withdrawn from the image during the exposure, and photograms can be combined with conventional printing and *cliché-verre* (see p. 226).

That wizard of invention Man Ray placed objects onto paper and exposed them again and again, often using a moving light source to create the image. He called his photogram experiments 'Rayograms'. Photographer Nigel Henderson created photograms that look like what you see through a microscope, or from an aeroplane. He called his 'Hendograms'.

Chemograms are made by painting developer and fix onto absorbent materials, which are then pressed onto photographic paper before processing. The developer and fix can be thickened with wallpaper paste to prevent the mixture from running.

The photo stencil

'As soon as I cut my first stencil, I could feel the power there.' Banksy, quoted in the book Stencil Graffiti.

Photo stencil images possess great potency. They can look like messages that could start revolutions and stop wars. Great examples have been created by Bristol-born artist Banksy, an outlaw with a spray can whose real name is unknown (there are warrants out for his arrest). Banksy's wonderful stencil graffiti work has pushed urban street decoration to new heights with its skill, wit and humour. His work can be seen in London, Paris and Barcelona. See www.banksy.co.uk.

A student sketchbook of photogram experiments

Cliché-verre

In this process, marks are scratched into a thin coating of black paint applied to a sheet of glass. The sheet is then used as a photographic negative and contact-printed onto photographic paper. Light passing through the scratched areas creates an image on the paper. Images can be dynamically combined with photographic images by contact-printing onto paper previously exposed with images from negatives.

Cliché-verre was experimented with as a drawing tool by nineteenth-century painters including Jean-François Millet and Camille Corot

Further adventures

Further photographic adventures can be had by painting directly on photo paper with chemicals, drawing on film, placing items directly on a computer scanner, placing them inside an enlarger, with photo-batik and photo-silkscreen, and with Lazertran, a special photocopy film onto which you can colour-copy images which can then be soaked off and transferred onto wood, canvas, ceramics or fabric.

Cyanotypes

Cyanotypes are created by laying objects on paper that has been specially sensitized. After exposures of many minutes or even hours, depending on the strength of sunlight, the paper turns a beautiful cyan or blue colour when it is washed. Commercial versions called solar printing kits are available.

Nancy Wilson-Pajic, Les Apparitions: Felicia, 1998

A beautiful cyanotype image created by placing a dress made by Christian Lacroix onto sensitized paper (left). Parts of the fabric have been moved during the long exposure.

So You Want To Be A Photographer

Photo opportunities

Some photographers like Cecil Beaton, Richard Avedon and Henri Cartier-Bresson had successful careers stretching over half a century. Jacques-Henri Lartigue took pictures over nine decades. Photographers never stop working and are never not at work – they are always open to inspiration from the world around them and think constantly about their work.

To have a career in photography, you not only need to be able to take great pictures but also earn a living. You have to learn as much as you can about the medium and go out to find clients who will give you work. When you do find work, you don't want your career to be over in a flash. You have to think about how your career could evolve.

Photography jobs and opportunities are rarely advertised. To find work as a photographer you need to know how the creative industry works so that you can become part of it.

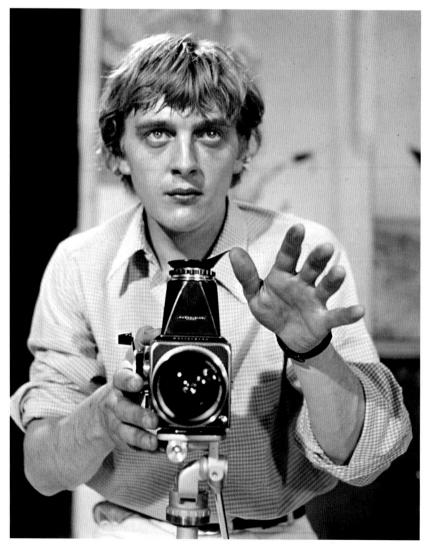

The ten stages of a shoot: the photographer's inner monologue

- 1. Calm, confident 'I've done all this before.'
- The shoot begins stomach-churning self-doubt. 'I won't get anything on the film, I'm going to be found out, they're not going to publish it, I'm not going to get paid.'
- 3. Panic... until -
- 4. 'I think I might have got something OK after all... I might get away with it.'
- 5. 'Yes, that frame is usable. Yes, I might get paid.'
- 6. 'That one was great, I will get paid.'
- 'It's a fantastic picture I'm going to get paid loads.'
- 8. 'Thank you!'
- 9. Exhaustion, can't speak 'I've just done a whole day's work in three minutes.'
- 10. 'Oh my god, I've still got seven more shots to do.'

A photographer's life seems as cool as that portrayed by David Hemmings in the 1966 film *Blow-Up*. This celebrated film by Michelangelo Antonioni was inspired by the lifestyle of British photographer David Bailey and 1960s London. It was a major influence on the public's perception of photography, but the reality is that photography is a competitive and demanding profession that requires talent, passion, very hard work and a lot of luck in order to succeed.

Creating a career

Great photographers can take great pictures of anything. In order to create a career and keep working, most photographers have learnt to have very broad skills. Although some photographers are specialists, the majority work on a very large range of creative challenges. All photographers' work evolves in response to the assignments given to them by clients and most photographers move between different areas of photography throughout a career.

There is no one route to becoming a professional photographer. Some have learnt to take pictures by trial and error, some begin by working as assistants to established photographers, some have studied – some have done all these things. This section looks at the variety of different careers in photography and the different paths on which to embark upon them.

Today's photographers have to offer great talent and skills in an everchanging industry. They may have to work for many clients and produce work for a variety of assignments. In addition, they will earn money from commissions, stock photography and sales of prints through syndication. To improve their chances of success, they may learn additional skills in IT, web design, multimedia, editing, video and sound.

Photographer's portfolio - marketing

To secure commissions, photographers have to market themselves. A photographer's portfolio is required to show prospective clients what you can do, but in the digital age photographers must have a presence on the internet, either on large group sites or via their own website. Many photographers are choosing to develop their own online blogs, which invite viewers to comment on their photos. Building up a substantial following on social-media and photo-sharing sites is a powerful way to market your work. As everyone with a camera is now a photographer, a professional needs to present his work in a clear and impressive way to prospective clients.

The portfolio should be beautifully presented and only have a limited number of images, representing the best you can produce. Portfolios, also known as your 'book', come in many sizes and most can be updated and edited to suit your audience. You need to carefully consider the differences between making a digital presentation of your portfolio on an iPad and presenting a 'book' consisting of several pages. Screen-based portfolios may be right for certain clients, but a stunningly printed folio is appreciated by all who love good images.

Lens-for-hire or staff photographer?

There are some staff jobs for photographers on daily and weekly newspapers, in news agencies and sports agencies. There are also specialist photography jobs with the police and in the medical profession. The vast majority of photographers, though, work on a freelance basis: that is, they have many different clients that employ them by the day or for an assignment. Advertising agencies, design groups and magazines commission all their photography from freelance photographers.

In order to earn a living and build a career as a freelance photographer, you need to find regular work. Many clients give regular assignments to a small number of photographers that they know will deliver the exciting pictures they want. Photographers can keep clients for many years, building a relationship with other creative people who understand what they can bring to an assignment.

Getting clients

In this increasingly busy world it is difficult to get an appointment with potential clients. It is usual to be invited to show your portfolio after your work has been seen online, and commissions are often made on this basis. If a client is considering a number of photographers, you may need to leave your portfolio with them for a few days, so a duplicate book may be required, especially as you become busier.

Promotions

A photographer's reputation often takes years to develop; there are few overnight successes. To promote your work, you need many different types of exposure. Perhaps the one that works best is winning competitions. A win can launch a career; even just selection in a reputable awards competition can bring your work to the attention of potential clients.

Exhibitions, mail campaigns, postcards and especially the use of social media are all ways that a photographer can get noticed. But never forget that the basis for all your marketing is the ability to create great work, having a passion for what you do and producing images that stand out.

Website

A website is essential for a photographer and is probably your most important showcase. You can buy a domain name for just a few pounds, but the website should look as professional as you can make it. Many companies offer readymade sites that are suitable for photographers, but remember that the site has to function across many platforms, including smartphones and tablets, so ensure that it shows off your work, not the clever design of the website. The site can generate income and manage the sales of images for publication or even prints. However, it is critical that your website is found, so knowledge of search-engine optimization is essential to enable potential clients to find your site among the millions of others out there.

The brief

Part of being a professional photographer is responding to someone else's brief. A brief is a creative challenge that needs an inventive, original and creative solution within a set deadline. Each brief is an opportunity for you to find a visually exciting solution. The better you respond to and resolve the problems of the brief, the greater the chance that you will be given more work.

Editorial photography - working for magazines and newspapers

The pictures taken for magazines and newspapers to partner the articles are called editorial photographs. Many freelance photographers have careers in editorial photography, enjoying the huge variety of assignments available.

Every magazine's staff has a vision of exactly who their readers are, their age range, jobs, tastes, aspirations and spending power. Staff know their title's position in the market and have often even named their imaginary 'ideal' reader: Brenda from Brighton, Hannah from Hamburg or Nicky from New Jersey.

Newspaper publishers also think they know exactly what their readers want to read about and look at. They know whether their readers' views are forward- or backward-looking - that is, whether their title is for society's leaders or followers.

The editor

Every magazine and newspaper has an editor. The editor is the person ultimately responsible for everything printed in a publication. He or she makes the big decisions about every issue, including which stories and articles are printed, who's on the cover, the voice in which the publication speaks and which staff and contributors are employed. The editor is appointed by a publisher or board of directors. If a magazine or newspaper makes an error or if sales fall, the editor bears the responsibility.

The art director

The look of a publication is the job of an art director, who oversees the design of every issue. His or her job is to create a unique vision for the publication through the choice of photographers, illustrators, use of design, typography and layout of the pages.

The art director leads the art department, appointing designers to help create the look of the publication and picture editors to commission and coordinate all the photography.

Must-see work by art directors

- · Alexey Brodovitch's work for Harper's Bazaar. Brodovitch was also a great photographer, creating a famous book of dance pictures which he designed himself. (See The Body in Motion - Dance, p. 72.)
- · Alexander Liberman's work for Vogue.
- · George Lois's work for Esquire.
- · David Hillman's work for Nova.
- · Derek Birdsall's work for Town and the Independent magazine.
- · Fabien Baron's work for Interview, Harper's Bazaar and Italian Voque.

The picture editor

On the picture desk there are often several picture editors coordinating photos for different areas of the publication, with juniors to organize the return and filing of photographs. Leading titles have a picture director in charge of all the work of the picture desk.

The picture editor's job is to ensure that all the photography used in a publication is amazing. Picture editors commission photos, organize shoots, source images from photo libraries and photographers, arrange picture clearance and negotiate syndication. They edit the work of photographers whom they have commissioned, seeking the very best images.

The newspaper picture editor gives assignments to the paper's own staff and freelancers. Different picture editors have responsibility for each area of a paper: news, sport, features, etc. News picture editors find photographs for stories when there is no time to commission pictures. They look at the thousands of images available from picture agencies worldwide and select the ones best suited to partner the stories that the editor wants to include in that issue, working swiftly to the deadlines of their publication.

Getting work from magazines and newspapers

In order to work for magazines and newspapers, you need to show your work to the picture editor or the art director. Magazines need portrait photographers, celebrity photographers, still-life photographers, photojournalists, beauty and fashion photographers. (See Fashion magazines, p. 237.) Magazines are always seeking new talent, often finding new photographers by visiting exhibitions and college shows. Part of the art director's job is to keep the look of his or her publication fresh, so they often nurture young photographers at the beginning of their careers, building long-standing commissioning partnerships with them.

National newspapers give many commissions to freelancers, in particular for regional assignments. Newspaper picture editors have national networks of photographers who get the call to cover breaking stories on their patch. Some newspapers have training schemes for young photographers. Places on them are often offered as the prize for winning photo competitions run by the newspaper. (See Competitions, p. 249.)

Far more news photographers now work for news agencies rather than on staff at a newspaper. News agencies syndicate use of their photographers' pictures. (See Syndication, p. 250.) Many news agencies nurture the talent of young photographers, helping them to begin their careers.

So you want to be a news photographer?

Newspaper pictures have to compete against bold headlines, which means they need impact and immediacy. As such, they are often very simple and easy to interpret. News pictures have to communicate 'who, what, where, when and why' – that is, who the participants are, what they are doing, where they are, when the event took place and what its significance is.

Every news photographer wants to be front-paged. Good news photographers break free from the press pack and find their own views, even at photo-calls and staged photo opportunities. American president Richard Nixon's press secretary coined the term 'photo opportunity' to describe a brief staged session for photographers and cameramen at which he attempted to portray his boss in the best possible light and control the images available.

Great news pictures can come from run-of-the-mill assignments when a photographer sees an event through fresh eyes or finds a unique angle. News photographers need initiative and an instinct for 'right place, right time', an ability to get into places they shouldn't really be and a head for being at the centre of the action. They have to have patience. They sometimes have to wait for hours or days and still be able to react in an instant, always getting a picture, no matter what the conditions and circumstances, with total trust in their equipment. They have to be able to think and take pictures at high speed, even when working in confusion.

News photographers and photojournalists shoot both landscape- and portrait-format pictures to give their picture editors alternatives about how the photos can be used when published. Portrait-format pictures suit being used for covers or single pages, landscape-format pictures can be enlarged across an entire double-page spread. If you're a photographer you don't want to miss having an image used on a cover just because you've shot a whole story in landscape format and none will fit the cover format. (See Composition – Order or Disorder, p. 201.)

News photographers have to be thick-skinned. They have to witness very highly charged events and may be sent on assignments they do not relish, such as when they are asked to 'doorstep' people. Doorstepping means a photographer is sent by an editor to take pictures of a person thrust into the news by scandal or tragedy – as they appear on their doorstep.

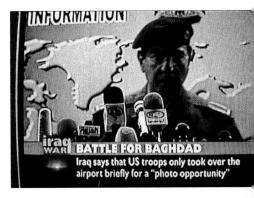

A news photographer should seek a new angle on every event.

News photographers may also be asked to photograph people – such as politicians – to show them in a bad light, suiting the bias of their publication.

Media handlers, public-relations and press officers, minders and security will often steward photographers in an attempt to control angles and access to the subject, to keep them at a distance. Journalists and photographers sometimes have to collude with this system in order to get any access at all. It takes courage and planning to avoid getting penned in.

You have to shoot, shoot and shoot because you may not know the whole story nor how it is going to unfold. Shoot both horizontal and vertical (landscape- and portrait-format) pictures. You don't know the outcome, who the winners or losers will be. Sometimes you don't even know who the participants are. So where do you point your camera? You point it at the story.

So you want to be a photojournalist?

Photojournalists have to be questioning, humanitarian and fascinated by everyday life. They need to have an eye for human detail, be compassionate and have a discreet presence so as to be able to observe unfolding events. As with the news photographer, the photojournalist must shoot, shoot, shoot both landscape- and portrait-format pictures. There are agencies that employ photojournalists and syndicate their photo stories. They also nurture the talent of young photographers. (See Syndication, p. 250.)

So you want to be a portrait photographer?

Portrait photographers are curious about people. They must have empathy with their subjects, make them feel comfortable in front of the camera and engender trust. Portrait photographers usually love working with others, possess charm and good humour, and are at ease in the company of many different types of people.

So you want to be a sports photographer?

Many newspapers and photo agencies employ specialist sports photographers. The vast majority of sports pictures are taken with digital cameras and are sent digitally by phone to the paper or agency while the event is still in progress so they can be laid out at once for tomorrow's paper. At a huge sporting event an agency will send more than one photographer to cover the action together with assistants to send back the pictures.

Sports photographers are often corralled at the sides of the pitch or track, though in some sports accredited photographers may more or less be allowed to choose their own vantage points. Sports photographers need a passion for the sport they are photographing. They often have to work in terrible lighting conditions and at a distance from the action. They must work quickly to meet urgent deadlines and need luck to find themselves in the right place when a pivotal moment in a game occurs.

'You can't get away from the element of luck in sports photography; but what makes a great sports photographer is that, when we get lucky, we don't miss.'

Sports photographer Neil Leifer was interviewed in the *Observer* newspaper after his picture of Muhammad Ali celebrating victory over Cleveland Williams, shot from the lighting rig above the boxing ring, had been acclaimed as the greatest sports photograph ever.

Many sports photographers work with more than one camera, so as to be able to get different views quickly and to ensure that a key shot is not missed when changing lenses. Some arrange multiple cameras around the sports arena that can be triggered remotely. Big demands are made of sports photographers. They need to be able to stay calm while the crowd is going crazy and to capture all the goals, tries, wickets, home runs, etc, together with all the celebration and desolation of winning or losing.

So you want to be a celebrity portrait photographer?

Celebrity photographers need to make their sitters feel relaxed and at ease. The celebrity photographer must be comfortable in the presence of fame and beauty, and be able to create fresh pictures of people who have been photographed thousands of times before. The novice celebrity photographer needs to be able to work very quickly, as the first greeting from a celebrity is often 'Will this take long?'

The superstar picture has its own unique set of rules and conventions. Different levels of celebrity demand different levels of control over a photoshoot. A superstar has the greatest amount of control over how they are portrayed, often dictating exactly how they wish to appear.

Publications always want exclusive photographs of celebrities, especially for cover photos. These are usually specifically shot for the publication, to fit their style and readership, and to avoid the possibility that a rival magazine has the same picture. The first hurdle for any publication is to get a star to agree to be photographed. Celebrities will often only agree when they have something to sell or promote – a new movie, record or product.

Once a request has been tentatively accepted, a photoshoot will only take place once a long list of conditions have been met in a pre-shoot agreement negotiated with the star's representatives; all the conditions have to be paid for by the magazine. Stars may choose their own photographer, clothes, hairdresser and make-up artist; stipulate that the resulting pictures appear on the cover; approve the location at which the photographs are to be taken; and approve the final photographs and their retouching.

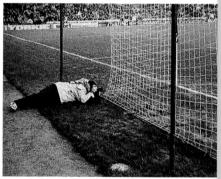

These images, and those on the previous page, show sports photographers taking and editing pictures. In the black-and-white picture above a photographer sets up his camera before kick-off in a position in which he will not be allowed to remain during the game itself. The shutter can be triggered remotely. On p. 235, a shade is improvised so that the photographer can see the pictures clearly on a screen.

Fashion magazines

The fashion department of a magazine is responsible for all the series of fashion pictures – known as fashion stories – that appear in a particular publication. Each fashion department is led by a fashion editor whose job it is to commission all the fashion photography.

'The fashion department of a publication is a separate magazine within the magazine. They are totally focused on their thirty or forty pages or fashion pictures.'

Stuart Selner, art director, Marie Claire magazine.

Fashion stories feature the clothes that will be available in the shops. They are inspired by the international fashion catwalk shows – the big fashion circuses staged in Milan, Paris, New York and London every spring and autumn, where the top fashion designers showcase their clothes for the next season. These very expensive high-fashion outfits will be the clothes available in the leading fashion stores in the following months, while filtered-down versions of the same looks will be stocked in high-street clothes shops.

The fashion editor

The catwalk shows are attended by every fashion editor and all the buyers from the major stores. After each set of shows, the fashion editors pick out trends and themes – the styles and colours of the clothes they've seen – and create fashion stories inspired by them for their next issues. At the same time the buyers place orders for their stores.

The job of fashion editors is to create exciting pictures in the visual tone of voice that will 'speak' to their readers. They do this by carefully selecting the fashion photographers, stylists, hair and make-up artists and models that can give life to their vision. As publications cater for very different readerships, fashion editors are careful not to create pictures that could alienate or lose them readers. They must also remember to include clothes made by the manufacturers that advertise in their magazine.

There are many smaller fashion and style magazines that don't have to work under these pressures. These take inspiration from young designers, street fashion and popular culture.

The cover

'The cover is critical – on a shoot the only thing that really, really matters is the cover.'

Stuart Selner, art director, Marie Claire magazine.

As each page of a fashion magazine is designed, it is stuck on the wall by the magazine's art director.

Fashion magazines take their cover pictures very, very seriously. Great covers sell far more copies of an issue. On every fashion shoot the photographer and fashion editor will do 'cover tries' – attempts to create a great cover photo. The art director will pick out three or four pictures from each attempt to create mock-up covers to discuss with the editor. Cover pictures have to compete with the magazine's logo and cover lines – the text relating to stories in the issue – and are often very simple, strong pictures selected to stand out on the newsstand.

The beauty section

Fashion magazines have beauty editors as well as fashion editors. The beauty editor is responsible for all the pages about make-up, hair and beauty products. Like fashion photography, beauty photography is another very creative area in fashion magazines, and the beauty pages are often illustrated with bold, vivid colour, huge close-up photos of eyes and lips or creative still lifes of products.

So you want to be a fashion photographer?

Fashion photographers have to live and breathe fashion. They need great imagination, passion, originality and creativity. Many fashion photographers begin by working on the many smaller fashion and style magazines. These titles are the ones that drive visual imagery forward by having a far more radical and innovative approach to photography, and they are the ideal starting place for new fashion photographers.

Design groups and advertising agencies

Most companies do not have their own design department, so when they need a brochure, a website or a catalogue they employ a design group to create it for them. Design groups specialize in creating visually exciting communication. These companies vary in size from a few people sharing an office to large enterprises.

Most companies do not have their own advertising department either, so when they want to advertise a new or established product they employ an advertising agency. Agencies do everything from creating the advertisement to booking the billboard sites and the spaces in magazines and papers to display it. Advertising agencies are also responsible for developing brand identities for their client company and its products or services. The most important people in an advertising agency for a photographer to know are the art directors and art buyers. An advertising art director performs a very different job from that of a magazine art director.

The advertising art director and art buyer

An art director in an advertising agency thinks of ideas for advertisements. His or her job is to devise brilliant and original advertisements that sell a product to the client's target market. An art director works in partnership with a copywriter. The art director comes up with the visual ideas and the copywriter provides the words. As advertising evolves, however, these roles begin to blur. Although the titles of art director and copywriter are still used, in addition to bringing their traditional design skills to advertising campaigns, these creatives now work across all types of digital and social media that dominate advertising.

Art buyers are a vital part of advertising agencies. An art buyer's job is to keep up with the very latest developments in the creative world. This involves seeking out the work of new creative photographers and illustrators by looking at portfolios and exhibitions, and filtering the best work through to their art directors. The art buyer's job also includes negotiating the fees that advertising photographers are paid. As the media spend for a campaign is often in the hundreds of thousands, the choice of photographer is critical and only very experienced photographers will be employed. However, small campaigns and clients may employ younger up-and-coming photographers, who may have a great portfolio and some experience of editorial work.

Advertising art directors and art buyers are constantly looking for new photographers to keep the output of their agency fresh. They often find talented photographers by looking at editorial photography, and by going to exhibitions and student shows. It is these key people that an aspiring advertising photographer must impress.

So you want to be an advertising photographer?

Advertising photographers are usually at the top of their game, both technically and creatively. They are specialists in the type of work they produce, are able to adapt to new technology and are constantly developing their craft. The developments in digital interactive media mean that an advertising photographer will be employed to shoot stills (photographs) and video. For online advertising campaigns this is increasingly the case.

Advertising photography can be very demanding. The studio-based advertising photographer has to turn over a greater amount of work to pay for the rent of an expensive property, especially in cities, so many hire the studio they need for each commission, or share facilities with fellow photographers.

The photographic agent

'Photographers want an agent for their contacts within the creative industries. It can be very difficult for a new photographer to get appointments with some top creatives.'

Alan Latchley, photographer.

The right photographic agent can help build a photographer's career. Agents have relationships with agencies, magazines, picture editors, art directors and art buyers that have often been nurtured over years. They make appointments for their photographers and send out their books to prospective clients. They sometimes take their photographers' books into a magazine or agency themselves to 'sell' each photographer's talent. Agents recruit new photographers from student shows and as a result of seeing striking editorial work. However, it is unrealistic to expect to be properly represented until you have gained some recognition in your field as a full-time photographer, with awards and an exceptional portfolio. Agents do, however, employ assistants and this is one way to break into photography.

Agents can help coordinate photographers' shoots by finding locations and arranging for assistants, permits and insurance. They also take charge of a photographer's billing and chasing payments. For their services photographers usually pay their agents between 10 and 20 per cent of their fees for work obtained.

'In essence an agent can take all the worry from a photographer except getting the pictures on the film.'

Alison Smithee, photographer.

To be represented by a good agent means that clients are reassured and know that with the support of a strong back-up team and an agent's years of experience, the photographer will deliver a very good result. The advantages for the photographer are that he or she can be away on location or in a studio and concentrate on what he or she does best: taking great photographs.

Further photo opportunities

Documentary photographers often gain support for their long-term projects with grants or they subsidize their projects with commissions for other types of photography. Still-life photographers need to have great patience, technical skill and tremendous attention to detail. They must be able to create beauty from the banal. Many photographers, including Eve Arnold, Bert Stern, Ernst Haas and Terry O'Neill, have worked on film sets as stills photographers. Stills photographers are commissioned to photograph a film's production for use as publicity.

Theatre and dance photographers are commissioned to take pictures that recreate the feel of a show. Time constraints mean that they are often obliged to do this at a chaotic dress rehearsal when costumes, sets, lighting and even performers are still uncertain. Live-music photographers are often only allowed to take images during the first few songs of a show.

Architectural photography is another specialist career in which the photographer's job is to display and reveal the qualities of a building. The convention is to view a building flat on, with all lines shown straight. These pictures are often taken using a plate camera to achieve this perspective and give great quality of detail.

Event photographers photograph arrivals at film premieres, openings and parties while standing by the edge of the red carpet, corralled behind a rope.

Other opportunities for photographers lie in the areas of interior design, gardening, cookery, scientific imaging, weddings and catalogue products. There are also specialist careers in forensic, scene-of-the-crime and medical photography – all fascinating areas if you have the stomach for corpses, autopsies and operations.

Stock libraries also now offer the opportunity of work for photographers. (See Stock libraries, p. 249.)

So you want to be a paparazzo?

Italian film director Federico Fellini coined the term 'paparazzi' to describe the breed of press photographer he had witnessed in Italy in the 1950s. In his brilliant black-and-white film *La Dolce Vita*, a playboy journalist is pursued through nocturnal Rome by a posse of Vespa-riding press snappers eager to grab pictures of his glamorous conquests, both in nightclubs and on the street. Fellini named one of the flashlight photographers Paparazzo – Italian for a buzzing insect; the name not only reflects his scooter-riding mobility and behaviour but also neatly echoes the pop of the flash gun.

The term paparazzi has come to be used to describe photographers who take pictures of stars without any regard for personal boundaries. Often behaving in a predatory and provocative manner, they are the antithesis of the invited photographer. In truth, there is nothing new about such behaviour; in 1898 photographers climbed through a window to photograph German statesman Otto von Bismarck on his deathbed.

The original Paparazzo in Federico Fellini's 1960 movie *La Dolce Vita*.

Modern paparazzi satisfy the public's appetite to see glimpses of celebrities' private lives – images of stars on the beach, drunk or misbehaving, as well as clandestinely taken pictures of celebrity weddings from which all photographers have officially been barred.

The competition between the newspapers and celebrity magazines for more and more outrageous pictures of stars has been driven by the public's huge appetite for celebrity flesh. The more extreme paparazzi have taken on the roles of modern-day bounty hunters. They track down stars who are avoiding or in hiding from the press, confident in the knowledge that there is a highly lucrative market for their pictures in the increasingly salacious tabloids. Agencies often hold auctions for the rights to an exclusive picture, selling to the highest bidder.

Paparazzi pictures are often technically poor because of the constraints under which they are taken – through a limousine window, from half a mile away or while hanging out of a helicopter. The success of such paparazzi images lies perhaps in the fact that they are the complete opposite of the posed, groomed and retouched pictures that stars like to use to control their image.

Alison Jackson uses the language of paparazzi photography in her satirical photos. Celebrity lookalikes act out the intimate, unseen lives of superstars, royalty and politicians in front of her camera which the real paparazzi would give anything to have access to. Imitating the long-lens views, blurry foregrounds, grainy, skewed compositions and missed focus of real paparazzi shots, the photographs are compelling images that feed on our desire to see every detail of celebrities' private lives. Jackson creates pictures that, if real, would be worth millions – a naked, bloated Elton John being given colonic irrigation; the Duke of Edinburgh looking at porn...

Being an assistant - the sorcerer's apprentice

Serving an apprenticeship as a photographer's assistant is a good way to learn about how professional photography works. You can do this before, during, after or even instead of going to college. Photographers have always had assistants. The history of photography is filled with assistants of great photographers who have become great photographers themselves.

Assistants are paid a small amount to help established photographers carry out their work. Some assistants are given great responsibility, others not as much. Assistants set up and take down shoots, prepare studios, look after clients, pick up props, stand in for test shots, load film, anticipate what the photographer needs, and make tea and coffee.

'Assistants have to gauge what the photographer wants and give it to them before they ask for it.'

Kitty McCorry, photographer.

Some people love assisting and make a career of it, though most see it as a way to learn and build up contacts while developing their own work and building a portfolio. Assisting is a chance to see how things are done in the real world of professional photography, to meet art directors and people from magazines together with other young people just starting out in the creative professions.

'Assistant's rule number one: an assistant should never ask a photographer's client if they can make an appointment to show their book. This is a sackable offence!'

Alan Latchley, photographer.

Some studios employ permanent assistants to be on hand to work with photographers who have rented a studio. Some photographers would rather employ an assistant who knows next to nothing rather than one who thinks he or she knows everything. After all a photographer wants assistance not hindrance.

You gain most by working for a photographer whose work you really like. Remember that many photographers have been assistants themselves and will help young people trying to get a start in the business. When you get an appointment with a photographer seeking an assistant, take your own work to show; even if you don't get the job you may make further contacts. Assistants often advertise their details in photo labs and hire studios. Some professional photographers' associations post vacancies on their websites.

What do you need to be a photographer?

Knowledge

Study the medium. Know where it has come from and where it is now, and have opinions about its future direction.

Embrace new technologies as photography develops constantly. Be familiar with all of photography's tools. Knowing how to control lighting, focus, colour, contrast and quality is essential.

Vision and curiosity

Be curious and take a delight in looking at and trying to make sense of the world.

Fresh eyes

Find a fresh approach to looking at the world. In order to be successful, your pictures should be stamped with your own unique vision so that they are immediately recognizable as your own.

Creativity and imagination

Be very creative and imaginative. You need to be original and to have great ideas.

Risk-taking

Constantly try new things and push your work in new directions.

Passion

Have a passion for your work, for people, society and culture, and a passion for the next assignment.

Resourcefulness

Be resourceful and have a spirit of improvisation so that you get the result you want, no matter what the circumstances.

Energy and optimism

Go above and beyond what is asked for and see your ideas through to completion.

Good communication

Learn to express your ideas verbally in order to involve other people in your projects and in order to be able to discuss and promote your skills.

Luck and persistence

Be in the right place at the right time, with your camera and portfolio. Take your opportunities.

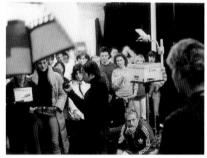

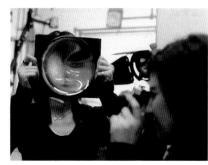

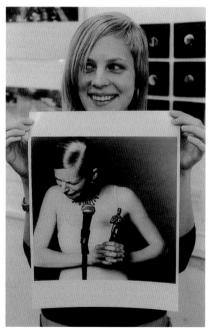

Art college and university

Studying in the creative community of an art and design college or university gives you the opportunity to develop your thinking about photography, improve your technical skills, experiment with new equipment, learn about the history of the medium and explore possible career paths.

Colleges aim to create a dynamic and exciting learning atmosphere in which students are given opportunities to meet and work with people from many other creative disciplines. Colleges also help students develop the verbal skills needed to present, discuss and 'sell' work and ideas.

Courses are structured around answering creative briefs; the resulting work is reviewed in critiques or 'crits'. Briefs are written by staff to develop the different professional skills required. Such projects are coupled with technical learning and classes examining photography's history, impact and future. Staff also encourage students to enter photography competitions, which may reward winners with exposure in publications and exhibitions, or alternatively provide work experience or prizes in the form of equipment.

At the end of their college courses, students exhibit the work they have produced as a result of their studies. These shows give them the opportunity to show their best work to prospective clients, including art editors, art directors, art buyers, fashion editors and the general public.

Colleges aim to create an exciting atmosphere in which to learn about photography.

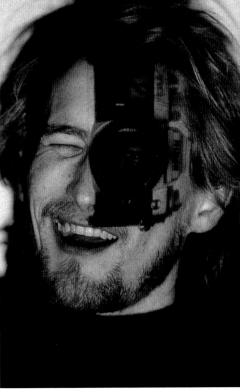

Choosing the right course

Pick the course that suits the way you want to learn. There are a great variety of photography courses available, both full-time ones and part-time weekend and evening classes. Some courses are aimed at developing the skills of photographers ready to work in the creative industries, often offering periods of work experience. Some focus on photography as a personal medium of expression and others are based on the study of theories about how photography is used. Courses can be biased towards digital photography or may emphasize traditional ways of working; the best fuse both.

Some courses offer broad learning experiences, such as the possibility of an extended period of study abroad at a partner college or university. Some are very tightly structured and timetabled, others expect students to be very active in their own learning, research and planning of their time.

Photography is also taught as part of many creative courses, including many design and communications courses. Some choose these courses in preference to pure photographic courses in the belief that a very broad knowledge of visual communication is the key to a successful career. On these courses photography is often taught in partnership with design, multimedia, illustration and advertising.

Read the different college prospectuses and websites, go to the open days. You may be investing years of your life in a course, so find out as much as you can before you begin. Talk to staff about the curriculum and get students on the course to tell you about their experiences. Also talk to graduates and view the facilities.

To get a place on most courses, you have to fill in an application, submit a portfolio and have an interview. Most colleges will overlook a lack of academic qualifications if an applicant has dynamic and original work and a passion to learn. Teachers and lecturers want to see work that is self-directed and that you are passionate about. They want to see completed projects and experimental work, as well as sketchbooks showing ideas and visual research. In the interview you will be asked about which photographers' work you like, which exhibitions you have visited and what subjects interest you most. Staff will ask you about your work and its direction together with why you have chosen their particular course.

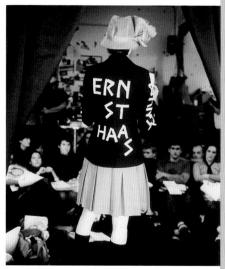

Competitions

Many newspapers and magazines, design, advertising and photography associations, and photographic manufacturers and suppliers run annual photography competitions. Many companies now sponsor prizes and exhibitions of entrants' work. Competitions are published in the photographic press, newspapers, magazines and on the internet. When entering your work for a competition, never second-guess what you think judges will like. It is best to enter work that you really believe in and are passionate about.

The rewards for entering and winning a competition can be very significant, including publication of your work, assignments, newspaper and magazine work, travel bursaries, contacts, money, equipment and even exhibitions in national and international galleries.

Stock libraries

The original stock libraries

Picture libraries were begun by newspapers as a way of filing photographs of people and events for later use. They soon became valuable sources of instant images and a small fee began to be charged when other publishers asked to use the pictures. They have now evolved into today's picture libraries, which have huge quantities of photos. *National Geographic* magazine has a library of ten-million images for sale to other publishers.

Specialist resources known as stock libraries also evolved to supply designers and advertising agencies with pictures of every subject imaginable. Photographers offered these libraries pictures from their archives and received a payment if they were used. Stock libraries began to display their images in glossy printed catalogues the size of phone directories.

To say to a photographer that one of their images looks like stock used to be an insult, as stock catalogues were full of images of clichéd sunsets, holiday destinations and impossibly happy and beautiful families with beaming smiles and amazing teeth. Today stock photography is very different.

Modern stock libraries

The internet has radically changed the use of stock photography. Stock has become a huge business and has had a radical effect on professional photography. Where many art directors, art editors, picture editors and designers would once have commissioned a photographer to take their images for them, they now turn to stock libraries on the internet instead.

Billions of stock pictures can be instantly downloaded and laid out. There are numerous versions of every possible subject, often available at a fee far below what it would cost to commission an original photograph. Stock libraries have therefore deprived photographers of many avenues of potential work.

Stock in space

In the 1970s NASA sent 116 classic stock images into outer space on the Voyager probe. These pictures depicting life on earth featured classic old-school stock themes – skyscrapers, mothers and children, babies. Quite what the aliens made of them we do not yet know.

Stock libraries now invest heavily in trying to predict the issues, trends and fashions that will dominate the media in the near-future. Rather than waiting for photographers to come to them with images, they commission shoots of their own to try to ensure they have images available for every conceivable contemporary issue. Commissioned stock photos can sell very well in what is now a global market. This demand from stock libraries has created work for a small number of photographers.

The stock photo fee is negotiated by the library's sales team according to how an image is to be used and by whom. The rewards for creating this new type of stock photo can be huge for both the stock library and the photographer. If you want to take pictures for stock libraries make an appointment to show them your portfolio.

Your archive

Your archive could be your pension. The pictures you have taken – even ones you think are of little significance – could earn you money in the future. Carefully store all your work. Keep everything, including your prints, negatives, slides and digital files. Their value may not be apparent now, but time changes photographs. People you have photographed may become famous, giving your pictures a totally new value. Even pictures of everyday things and everyday life can gain a historic or nostalgic value, thereby creating a commercial one. You are able to maximize the worth of your own archive through syndication.

Syndication

Syndication is a process by which a photo is made available for sale to the widest possible clientele. The internet has made this easy. Photographic news and sports agencies and picture libraries are in business to sell their pictures to anyone who wants them, showcasing them on their websites. The price charged depends on how the images are to be used.

If you are in a position to spend a few minutes taking a picture of a celebrity, you can earn money from it for many years to come. The greater and longer-lasting the fame of the star, the longer your income will continue. But you do have to take a great picture for it to be worth anything.

If you then place your work in a picture library, you have a chance of making money while you're sleeping – though, again, you first have to take pictures that people want to buy.

Royalties from syndication

Income resulting from sales of archive pictures is called royalties. There are industry-standard payment rates for the use of photographs. These vary according to how large a picture is used – a quarter-page, a half-page, a full page or a cover – and separate rates for use in design and advertising. If your pictures are used in huge billboard advertisements you will receive royalties fit for a king.

The fee for the sale of an archive picture from a picture library is generally shared equally between the library and the photographer.

Exhibiting

'Today, there is an alternative to being a commercial photographer. If you have the vision there is a future in exhibiting and people buying your work as an artist.'

Nicky Michelin, curator, The Photographers' Gallery, London.

A new breed of young photographers have created careers for themselves based around selling their work through galleries, rather than undertaking commissions for magazines or agencies. Some have established international reputations in this way and now have an audience of eager collectors. As well as exhibiting in private galleries, they gain recognition through publication in books and through winning or by being nominated for prizes and awards. Photographers who have followed this path include Wolfgang Tillmans, Philip-Lorca diCorcia and Roger Ballen.

Prints and limited editions

Selling prints

There is an increasing market for prints by new and famous photographers. Prints are bought by public galleries for their collections, by private collectors and by investors, in the same way as galleries and collectors buy paintings. The print market is particularly established in America and prices can reach hundreds of thousands of dollars at auction.

Print sales are such a new phenomenon that until recently much of photography's history had been carelessly treated. There are sorry stories of huge archives being consigned to bonfires and of historic glass negatives being used to re-glaze greenhouses. One photographer interviewed for this book remembers Diane Arbus's prints – each now worth the value of a large house – being stuck up on a pinboard among the chaos of *The Sunday Times* art department for anyone to take home, so little were they valued.

Limited editions

The value of modern prints is maintained by producing limited editions of them. A photographer produces a small number of hand-printed pictures from a negative, maybe ten or twenty at the same size at the same time. The price of each print is decided with the gallery or dealer. There is nothing to stop photographers from creating another edition at a later date or, indeed, from making as many further editions as they please.

Limited editions of digital images can be produced in the same way, with the guarantee that no further prints will be created in that edition. Digital images are created with archival dyes or inks designed not to fade.

Vintage prints

A vintage print is worth much more than a modern one. Vintage prints are those created by the photographer at the time, or soon after taking the picture. They have often been printed on kinds of photographic paper that are no longer available.

'Vintage prints can have a fantastic feeling when the image has relaxed itself into the paper.'

Nicky Michelin, curator, The Photographers' Gallery, London.

The vintage prints of famous photographers are much rarer and are much more highly valued by collectors than modern prints, especially if signed. Owing to their rarity, the value of vintage prints can be enormous. There are only three known vintage prints of Man Ray's *Tears* picture, for instance: each is now worth hundreds of thousands of pounds. After the death of a photographer, his or her family or estate will often continue to issue modern editions of their photographs.

Photography and the law

Free expression versus the right to privacy

A photographer is a citizen with a camera who, like everyone else, has to abide by the law. In most countries, the law attempts to balance the right to free expression and a free press with the individual's right to privacy. In essence, if a subject is on their private property, such as in their house or their garden, a photographer cannot take a picture without permission. Photographers are also not allowed to take pictures in certain zones at airports or in court.

Photographers in court

Laws about photographing members of the public in the street and photographing people who are in the news differ from country to country and are open to very broad interpretation. In Britain, for example, creating a blanket law regarding intrusion and privacy has proved impossible. This has led to hours of courtroom argument, the main winners being legal teams from the huge fees they charge. As soon as a judgment in one case appears to set an important precedent, it is challenged or overruled by another court. The situation is further complicated by the different areas of the law that can affect images and publishing – areas including libel, privacy and human rights.

In Europe there are conflicts between the laws of individual states and European Union law. In America the principle of freedom of artistic expression as a constitutional right is itself complicated because laws vary from one state to another.

Celebrities regularly rush to the courts attempting to stop the presses rolling on a story showing them in a bad light. Companies are also now quick to take photographers to court over how their products are used in shots. Members of the public have tried to claim royalties from photographers after they have by chance appeared in photographs that have become well known.

Such developments could lead to the absurd situation in which it would no longer be possible to publish or exhibit any photograph, or to comment on any person or product. Photographers should have the right to photograph in public places and to express challenging and creative ideas without ending up in court as a matter of course. On the other hand, the introduction of legislation in Britain to restrict the covert use of camera phones, for example, has been widely welcomed by the press and public alike.

Copyright

In British law, if you are the creator of a photograph you own its copyright, unless a written agreement exists to the contrary. Copyright gives creative people protection in law from the unauthorized use of their work and lasts for seventy years after the creator's death.

Copyright can be licensed to someone else. For example, if a publishing company wanted to print a poster of one of your photographs to be sold in shops, you can negotiate a licensing agreement with them. There are industrystandard rates for licensing the use of photographs in different media which would serve as the basis for such an agreement.

If a company publishes one of your pictures without first obtaining your permission, they have infringed your copyright. You can go to court to prevent further infringement and to claim damages. Awards are usually based on the sum that should have been paid to license the copyright of the photograph. You also have the right to have all stock infringing your copyright destroyed. Creative people also have what is called 'a right to integrity', whereby they can object to any addition to or deletion from their work, or any alteration or mutilation that might be prejudicial to their reputation.

The language of photography

A

Airbrush – mechanical sprayer invented in the 1890s that uses compressed air to spray paint or ink. A pre-digital photographic retouching tool.

Albumen prints/albumen printing albumen printing paper is made by coating thin paper with an egg-white and salt solution which is then sensitized with silver nitrate. Albumen printing in conjunction with wetcollodion negatives became the standard method of creating photographs around 1850. Julia Margaret Cameron used it in the 1860s. It remained the most popular process until about 1900. It is still used today by some photographers. The albumen adds to the brightness of the paper and the highlights of the print. Albumen prints can be toned with gold chloride to give a purplishbrown colour.

Ambient light – the light that already exists where a photograph is to be taken, as opposed to the light introduced by the photographer. Sometimes referred to as 'available' or 'natural' light.

Ambrotype – a direct positive image on glass.

Anaglyph – a picture giving the illusion of a three-dimensional view when looked at through red and green or red and blue '3D' glasses.

It is created using two cameras with lenses set apart about the same distance as our eyes. Twin views of a scene are shot which are printed in different colours – usually red and green or red and blue – and then superimposed on each other. Horror films of the 1950s used the effect creatively and with great humour – as in House of Wax and The Creature from the Black Lagoon. Some photographers specialize in creating anaglyphs. See Stereoscopic photograph.

Aperture – the size of the lens opening through which light passes, indicated by the f number.

Archival – a process designed to protect a print or negative from deterioration caused by a chemical reaction or light.

Artificial light – light from an electric bulb or flash.

Autochrome – the brand name of the first colour photographic process, launched commercially in 1907 by the Lumière brothers. Used by Jacques-Henri Lartigue.

Autofocus – a system by which a camera adjusts its lens to focus on a given area, for example, when the subject is in the middle of the picture.

В

Back light/back lighting – the light that comes from behind the subject and towards the camera.

Back projection – a system used to create location backgrounds in a studio. A scene is photographed and projected onto a screen with objects or people placed in front.

Barn doors – hinged black metal flaps slotted in front of lights to control the direction and width of the beam.

Batch – a set of identifying numbers printed on packets of light-sensitive materials. As slight variations in sensitivity can occur during the manufacture of films and photographic paper, photographers can ensure consistent results by using materials from the same batch.

Blonde – a type of tungsten light used in photography studios, sometimes known as 'Marilyn', a famous blonde.

Blueprint – see Cyanotype.

Bounced light – the light that does not fall directly on a subject from its source but that has been reflected from another surface such as a reflector, wall or ceiling.

Bracket/bracketing – the process of making several exposures, some at more and some at less than the meter reading. Used to ensure you have a successful picture.

Burning in – darkening a chosen area by additional exposure.

C

C41 processing – the chemicals

used to process colour negative film.

Cabinet print – a format for printing photographic portraits dating from the 1860s and still in use today. School photographers offer 'cabinet'size images as an option when ordering prints - 31/2 x 41/2 inches. The novelty of photographic calling cards (see Cartes-de-visite) began to wane in about 1860 and slightly larger cabinet photographs became popular. These were designed to be put on display on the cabinet in your front room. They were usually mounted on card, with the photographer's name and studio elaborately embossed on the back.

Cable release – a flexible cable used for firing the shutter. Often used for making long exposures with the camera on a tripod, when any movement might ruin the pictures.

Calotype – also called the 'Talbotype' after its inventor William Henry Fox Talbot; patented in 1841. Negatives were contact-printed to produce a positive, using sunlight as the light source. This use of a negative/positive process became the standard for pre-digital photography.

Camera lucida – an optical drawing device used by artists, a prism mounted on a stick attached to a drawing board. By adjusting the prism, the artist can see the scene projected onto the drawing board, where it can then be traced.

Camera shake – the movement of the camera during exposure that causes distortion or lack of focus. Can be used creatively or eliminated by using a tripod.

Card reader – device connected to a computer or printer that can read the information from a digital camera's memory card.

Cartes-de-visite - Popular portraits patented in France in 1854 by André Disdéri. He had the ingenious idea of printing photos of his customers at the size of the then-traditional visiting card - about 21/2 x 4 inches - with the sitter's name and address printed on the back. This led to people presenting pictures of themselves as gifts and to a 'cardomania' craze for collecting photos of prominent people, including Queen Victoria and Napoleon III. A sequence of four, eight or twelve portraits was taken on a single negative using specially designed cameras. The pictures were then contact-printed before being cut to size.

CCD – the sensor of light, colour and intensity in digital cameras, scanners, television and video cameras. CCD stands for Charged Coupled Device.

Cibachrome – a print made from a colour slide. The Cibachrome process was created by AGFA.

Cliché-verre – means 'glass plate'. Marks are scratched into a thin coating of black paint applied to a sheet of glass. The sheet is then used as a photographic negative and contact-printed onto photographic paper. Light passing through the scratched areas creates an image on the paper.

Clipping your film – a means of ensuring correct exposure when processing a slide or negative film. One or more frames are 'clipped' from an exposed roll of film with scissors, in total darkness. This 'clip' is then processed and viewed by the photographer. The balance of the film can then be processed at the same time, or a prolonged or shorter time according to the result of the clip.

Collodion process – see Wetcollodion/wet-plate process.

Colour cast – a trace of one colour in all the colours of a photograph.

Colour correction – the process of correcting or enhancing the colour of an image.

Colour filters – thin sheets of coloured glass or plastic placed over the lens to absorb or allow through particular colours of light into the camera.

Colour negative film – film that provides a colour image in negative form after processing.

Colour reversal film – film that provides a colour image in positive after processing, also known as colour slide film.

Colour slide – a positive photographic image in colour. It can be viewed on a light box, projected using a slide projector or scanned for reproduction in magazines, books, etc. The standard medium of professional photography from the 1970s until digital photography.

Colour temperature – a term that describes the colour composition of a light source. Calibrated in Kelvins or K.

Colour transparency – a positive photographic image in colour, also known as colour slide.

Compression – a process of reducing the size of a digital image to aid easy transmission or storage.

Contact sheet/contact print – the initial form in which a photographer sees a film negative in positive form. It is made by placing a negative in contact with sensitized material before passing light through to create a print of the same size as the negative. Contact prints were the only method of printing before the invention of the enlarger.

Contrast – the difference between light and dark tones in an image.

Contrasty – an image with a great difference between the tones of light and dark; the opposite of 'flat'.

Correction filter – thin transparent coloured acetate placed over the lens or light source in order to match the colour balance of the light entering the camera to that of the film that is being used.

Cove – a curved studio background which gives the impression of infinity behind the subject being photographed. It can also be lit with colour or shapes.

Crop - to alter the edges of a

photograph by changing the position of the camera, adjusting the enlarger or easel during printing or by trimming a final print.

Cross-processing – a term used to describe processing a colour slide film through the chemicals normally used for processing colour negatives. The slide film becomes a dense, high-contrast colour negative which can produce striking saturated colour images when printed. Also used to describe processing a colour negative film through the chemicals normally used for colour slides.

C type print/C print/Type C print – colour prints from colour negatives, also known as a dye coupler print.

Curator – person who coordinates exhibitions in galleries and selects photographers and artists to exhibit.

Cut out – a subject is photographed against a white or neutral coloured backdrop so that it appears to have been 'cut out' from its background.

Cyanotype – a process invented by Sir John Herschel in 1842 that creates prints with a wonderful blue background. A permanent print is made in sunlight by laying objects or placing a negative against paper that has been sensitized by being soaked in a solution of potassium of ammonio-citrate of iron and potassium ferricyanide before being left to dry in the dark. After exposure, when washed the paper is a beautiful cyan, or blue, colour. The cyanotype is the source of the blueprint or dyeline process today, used

creatively by photographers and by engineers and architects.

Daguerreotype – the first commercial photographic process, which produced small, highly detailed, unique and unreproducible images on a silver surface – the mirror image of the original view.

Darkroom – a light-tight room used for processing and printing, incorporating safelights for the materials used. A magical place where amazing things suddenly appear on white sheets of paper.

Darkslide – a light-tight film holder for large-format sheet film.

Daylight film – film designed to produce accurate natural colour rendition when a scene is lit by light of a colour temperature of 5500K, such as midday sunlight or flash.

Dedicated flash – a flash gun designed to give correct exposure automatically when used with a compatible camera.

Depth of field – the zone of sharp focus in a picture. The area in front of or behind the point of focus in a photographic image at which other details remain in acceptable focus.

Developer – a chemical that changes an invisible latent image into a visible one.

Diffuse – to scatter or soften a light source so that it is not all coming

from the same direction. It occurs naturally when sunlight is scattered on a cloudy day.

Digital imaging – the combination of digital photographs and the computer.

Digitize – to take or convert an image into a form that can be processed, stored and electronically reconstructed.

DIN – a system used to describe the sensitivity of a photographic film to light.

Direct positive image – a photograph without a negative.

Dodging – lightening an area of a print by shading it during exposure.

Dupe – a photographic copy of an original slide or negative. Short for duplicate.

DX – a film-speed recognition system used on some cameras that take 35mm film. It allows the camera to read a film's ISO automatically.

Dye coupler print – a print from a colour negative, also known as a C type print.

Dye-transfer print – a method of colour printing offering great longevity. It allows museums to acquire prints without the worry of instability or impermanence and is made by rephotographing an original photograph three times under different filtrations of red, green and blue. These negatives are then used

to make gelatin surfaces that absorb dyes of the associated colours. Combined, they recreate the original image. The process offers the photographer great control of the colour, which can be sumptuous. It was used by Harold Edgerton.

E

E6 processing – the chemicals used to process colour slide film.

Edge reversal – see Solarization.

Ektacolour print – a C type print made on Ektacolour paper. Used by Philip-Lorca DiCorcia.

Emulsion – the light-sensitive coating on film and photographic paper.

Enlargement – a term for a photographic print from a negative that is bigger than the original. It is made by projecting a magnified image of the negative onto photo paper or sensitized material. For every degree of enlargement some quality is lost.

Enlarger – a machine designed to project a negative onto sensitized paper. Once known as a projection printer.

Exposure – the amount of light a photographer allows to fall onto photo-sensitive material.

Extension tubes/extension rings – metal tubes that fit between the camera body and the lens which allow subjects to be photographed close-up or larger than lifesize.

F

Fast film – film stock that has a high sensitivity to light and can therefore be used in low-light situations.

Fibre-based paper – black-andwhite photographic printing paper for dish development.

Fill-in – light source that lightens shadows, so reducing contrast.

Film – transparent plastic material coated in light-sensitive emulsion.

Film cassette – a light-tight metal or plastic container holding 35mm film loaded straight into the camera.

Film speed – the relative sensitivity of a film to light. Film stock that has a great sensitivity to light is said to be 'fast', while film that is not very sensitive to light is described as being 'slow'.

Fish-eye lens – an extreme wideangle lens. Used by David McCabe.

Fish fryer – photographer's slang for a medium-size studio light.

Fix/fixing – the process of making a photographic image permanent and no longer sensitive to light.

Flare – light that scatters or reflects inside a camera. Mainly caused by a light shining directly into a lens. Flare can be used creatively.

Flash – an artificial light source giving a brief, very bright burst of light.

Flash head – a unit that holds a flash tube emitting a bright burst of light when triggered.

Flash meter – a meter that measures the intensity of light from a flash, allowing the photographer to set the correct f stop.

Flash pack – a large electronic unit that, when connected to a flash head, allows repeated bursts of controlled bright light.

Flat – this describes a scene or image with little difference in brightness between the light and dark areas; the opposite of 'contrasty'. Also, the term for a board used to block unwanted light or a reflector – a piece of cardboard or shiny material – used to bounce or reflect light onto a subject.

Focal length – a system used to indicate the degree to which a lens magnifies or widens a view. This is marked on the lens barrel or rim.

Format – the size of a negative, paper or camera-viewing area.

Formatting – the process of preparing a reusable memory card to record photographs by deleting all previous images.

Fresnel screen – a viewing screen used to intensify light when looking through a viewfinder. Particularly useful when the subject is backlit.

Front projection – a technique from movie-making in which a subject in a studio and an image of a location are

combined together simultaneously in one photograph. An image is projected onto a screen in front of which the subject is positioned. The subject is lit separately, carefully avoiding spilling this light onto the background. The photo has to be taken from the same axis as the projection to avoid overlap, producing very theatrical images.

f stop/f number – a number expressing the aperture of a lens. The higher the number, the smaller the aperture.

Full bleed – borderless pages in books and magazines filled entirely with a photograph or other image.

G

Gelatin silver print – the standard contemporary method of printing black-and-white photographs from a negative in a darkroom.

Gigabyte – a thousand megabytes. *See* Megabytes.

Glossy print – a photographic print with a shiny surface. The smoothness of gloss paper gives very fine detail to prints.

Grade/graded paper – a classification of photographic paper by contrast from 0 to 5, 0 having the least contrast, 5 the greatest.

Grain – the tiny specks or clumps visible on film after development that together create a photographic image. When they are enlarged, our eyes merge them into continuous

tones to form a believable image. The size of the grain of a film negative or slide controls the clarity of the detail when a print is made. Grain size varies from 'fine' to 'coarse' depending on the film stock used, exposure and processing. Coarse grain is used by Alison Jackson and José Luís Neto.

Gum-bichromate – a thick, viscous, light-sensitive material that can be applied to many surfaces, including paper, fabric, wood and metal. It has to be handmade as it is no longer commercially manufactured. Watercolour paint can be added to the mixture to colour the image. Used by Edward Steichen, Pictorialist and member of the Photo Secessionist group. See Pioneering artists with cameras, p. 136.

H

Health and safety – the term used to describe the common sense that must be used when working with photographic equipment and processes. Photographers need to be vigilant while working and to observe manufacturers' advice, particularly when working with equipment that uses mains electricity and with processes that can be harmful if incorrectly used.

Heliographs – 'sun drawings', the name given to the first photographs by their creator, Nicéphore Niépce.

High contrast – pictures that use the opposite extreme ends of the grey scale: just the blacks and whites. This is achieved in lighting,

processing, printing or manipulation. Used by Daido Moriyama.

High-key photographs – pictures that use only the upper portions of the grey scale: the predominantly light tones. Achieved in lighting, processing, printing or manipulation.

Highlights – the lightest tones of a photograph.

Hot shoe – the bracket on top of a camera for connecting a flash. It provides an electrical connection for triggering the flash when the shutter is pressed.

Incident light – the light falling onto a surface.

Infrared film – stock that is sensitive to both visible light and infrared radiation waves that are invisible to our eyes. Black-and-white infrared film makes skin tones appear very luminous and eyes very dark, and creates landscape pictures that appear ghostly. Black-and-white infrared film was used by Minor White and Weegee.

Inkjet printer – prints a digitized image with millions of near-invisible coloured dots of ink or dye.

IR or R – the indicator on a lens that gives the focus change needed to take infrared pictures. It is necessary because the visible waves by which we focus are refracted differently from infrared waves

Iris print – a computer-printed colour image.

ISO – A system used to describe the sensitivity of a photographic film to light. ISO stands for International Standards Organization.

J

Joiners – artist David Hockney's term for his photographic collages.

Joule – a unit used to quantify the output of an electronic flash.

JPEG – an abbreviation of Joint Photographic Experts Group, pronounced 'jay peg'. The format used for sending and storing digital images.

K

Kelvins or K – units of measurement of colour temperature, used to express the relative quality of light sources: for example, daylight is 5500K and tungsten light is 3200K.

Knuckle – a clamp allowing universal positioning, used to hold lighting equipment.

Kodachrome – fine-grain, high-colour-saturation colour slide/transparency film produced by Kodak.

L

Lamda print – a digital image exposed on photographic paper using lasers to create prints of very high resolution.

Large format – cameras that use 5x4-inch and 10x8-inch film.

Latent image – an image that is present on a light-sensitive surface but not yet visible to the eye (i.e. needing to be developed).

Latitude – the degree by which exposure can be varied and still produce acceptable results.

LCD – the small screen on the back of digital cameras. Used for reviewing pictures taken either one at a time or several at once. LCD stands for liquid crystal display.

Lens – the glass element that bends light.

Lens hood – a round or square tube that prevents unwanted light from falling on the camera lens.

Lenticular photography – the process that creates '3D' prints that can be viewed without the need for 3D glasses.

Light box – a means of viewing slides. Light boxes are illuminated with 'daylight'-balanced tubes.

Lighting gels – sheets of thin, transparent, coloured acetate that are used to change the colour of light.

Light meter – the equipment that measures light intensity.

Linen tester – an alternative name for a magnifier used to view slides and negatives; also known as a lupe.

Liquid photographic emulsion/ liquid light – photographic emulsion that can be applied to many materials, including glass, metal, wood, canvas, cloth, plaster and three-dimensional objects such as stones and tiles.

Lith printing – a printing process used in the black-and-white darkroom that creates dramatic prints with strong tones and contrasts.

Lomo camera – an inexpensive camera favoured by photographers who like its simple controls and accurate long exposures in low light.

L shapes – tools for cropping pictures on a light box, used in pairs; shaped like a very large letter 'L'.

Lupe – magnifier used to view slides and negatives; also known as a linen tester.

M

Macro lens – this allows subjects to be photographed larger than lifesize. Also known as a close-up lens. Some zoom lenses come with a macro feature.

Magic eye – an electronic device that triggers a flash unit when it senses a burst of light from another flash. Also known as a slave.

Magic lantern – the forerunner of the slide projector and cine projector. A hundred years ago magic lanterns powered by hydrogen cylinders could cast images as powerfully as modern cinema projectors.

Manual camera – a non-automatic camera with which the photographer controls the focus, aperture and shutter speed.

Mask – a material used to block out part of an image.

Matt paper – non-reflective photographic printing paper.

Medium format – a term describing cameras that use 21/4-inch-wide film: for example Hasselblads, Bronicas and Mamiyas.

Megabytes – units of digital information used to describe the size of a digital image and the space available on a digital camera's memory card.

Megapixels – a million pixels. Units of megapixels are used to indicate the relative quality and fineness of detail given by a digital camera.

Memory card/memory stick – the means of recording and transferring digital pictures.

Mixed light – a combination of light sources, such as flash and daylight.

Modelling light – a small tungsten light built into a flash unit, used to position the direction of the flash.

Mono pod – a single-legged camera stand.

Motordrive – an automatic film windon system used in some cameras.

Multigrade printing – a system of filters and photographic paper in common use in black-and-white printing. A replacement for the system using graded papers to print black-and-white negatives.

N

Negative – the image produced on photographic emulsion by exposure followed by development in which tones are reversed.

O

Opaline pictures – photographs that are printed permanently onto glass.

Over-exposure – too much exposure of film or photographic paper, which destroys the quality of the image.

P

Panning – following the movement of a moving object with a camera.

Panoramic camera – a camera providing an ultra-wide view.

Perspective-control lens – a lens that can be moved up, down and sideways to prevent or correct perspective distortion.

Photogram – a photographic print made without a camera, created in the dark by placing flat, 3D or opaque objects directly onto a sheet of photographic paper or other sensitized surface before making an exposure using an enlarger or a household light bulb.

Photograph – an image formed by the action of light on a light-sensitive surface.

Photogravure – a printing process used to reproduce photos. Used by the Pictorialists. See Pioneering artists with cameras, p. 136.

Photomontage – an image composed of several different photographs. The term used in newspapers to tell readers that an image has been manipulated or is the combination of two images.

Photoshop – a computer program adopted by photographers as the standard tool to manipulate, alter and retouch photographs.

Physiogram – an image formed by a moving light source usually attached to a swinging pendulum.

Pixel – an abbreviation of pixel element. The tiny blocks of colour that together create a digital image.

Plate camera – an alternative name for a large-format camera.

Platinum print – a print from a negative that offers a subtlety of tone beyond that of a 'silver' print.

Platinum printing died out during World War I when there was a scarcity of platinum owing to demand for its use in munitions. There has since been a revival of platinum printing owing to the unique quality and great longevity of the resulting images. See Pioneering Artists with Cameras, p. 136.

Polarizing filter – a filter that reduces or eliminates reflections from water and glass according to its position. It can also be used to darken skies.

Polaroid – a film and camera system that produces unique positive photographs in about a minute.

Polaroid film back – a camera back containing Polaroid film that can be fitted to other kinds of camera in order to take Polaroids. Many photographers use this system to check exposure and composition prior to shooting on film. Polaroid film backs are available in all film-based camera formats.

Print – a photographic image, usually on paper.

Print film - negative film.

Proxar – a lens that fits in front of a standard or long lens to give a close-up or macro view.

R

RA 4 – the chemicals used to develop colour negative film.

Red-eye – the effect of flash light reflected back into the camera from the retina at the back of the subject's eye. It occurs most frequently when the camera flash is close to the camera lens and with ringflash.

Redhead – a type of tungsten light, affectionately known as Nicole, a famous redhead (Nicole Kidman).

Reflex camera - a camera that uses

a mirror to reflect the image onto a screen for viewing and focusing.

Resin-coated paper – photographic paper in which the surface is strengthened with a thin layer of plastic, making it ideal for machine-processing. It can pass through the rollers of a machine, and therefore it can also be used for dish processing. Available in a variety of finishes, including gloss and matt.

Resolution – the relative quality and fineness of detail in a digital photograph.

Retouching – altering an image to make corrections and improvements, or to change its character.

Ringflash – a circular flash tube fitted around the lens of the camera.

R-type print – a colour print made from a colour slide.

S

Sabatier effect – see Solarization.

Safelight – low-level lighting used in a darkroom which allows you to see what you are doing, without giving unwanted exposure to black-andwhite prints.

Scan – the process of turning prints, negatives and slides into digital images.

Schadograph - see Photogram.

Silhouette – an image in which a person or object is shown in outline

filled with solid tone. A hundred years before the invention of photography, silhouettes provided the public with an inexpensive means of producing their own likenesses. Silhouettes are used by contemporary artists such as Kara Walker, who creates subversive images of class and race.

Slave – see Magic eye.

Slides – direct positive images, also known as transparencies. Possibly derived from magic-lantern slides which were slid in and out of a projector.

Snapshot — a spontaneously, casually taken image, often with a handheld camera.

Snoot – a cone attached to a light source to create a narrow beam of light.

Soft box – a large square or oblong unit containing diffusing material fitted to a flash head to soften direct flash light.

Soft focus – a slightly diffused image in which lines and edges are softened without distorting the image. It can be created with a specially made filter or by shooting through glass smeared with petroleum jelly. Used by Norman Parkinson.

Soft-focus lenses – lenses manufactured in the early 1900s to help amateur photographers create the effects of the popular Pictorialist group of photographers. See Pioneering artists with cameras, p. 136.

Solarization – briefly exposing a print or film to light or a flash during the developing process creates images that are part positive and part negative. Its unpredictability made it a favourite technique of the Surrealists, particularly Man Ray. Used by fashion photographer Erwin Blumenfeld in the 1940s in both colour and black and white. Also known as edge reversal and the Sabatier effect in honour of Armand Sabatier, the Frenchman who discovered the technique in the 1860s.

Spot meter – a light meter used to measure the light falling on a small area of a subject. Used to calculate exposure in difficult lighting conditions: for example, when a subject is backlit.

Stereoscopic photograph – a photograph giving the illusion of a three-dimensional view. Created using a camera with lenses set apart at about the same distance as our eyes, which shoots twin views of a scene that then appear three-dimensional when looked at through a binocular magnifier called a stereoscope. Used by Jacques-Henri Lartigue and experimented with by Eadweard Muybridge.

Stop bath – a solution used in processing to halt development before photographic film or paper is placed in the fix.

Strobe – a general term used in America for a flash light.

Strobe light/stroboscopic light – bursts of flash light in rapid sequence. Harold Edgerton photographed the swing of a golfer using 100 flashes in one second.

Swimming-pool light – an old-fashioned term for a massive studio light.

Synchroballistic photography – pictures taken with a photo-finish camera.

Sync lead – an electrical cord linking a flash unit to a camera so that the flash can be fired when the photographer wishes.

T

Talbotype – see Calotype.

Telephoto lens – a term indicating any lens with a long focal length: for example, 300mm or 400mm lenses. Also known as long lenses.

Test strip – a trial-and-error method of calculating the exposure of a photographic print. A number of different exposures are given to a strip of photographic paper placed over an important part of the image to help judge the correct exposure of the final print.

Tintype – a direct positive image on metal.

Tones – the strength of the greys between black and white.

Toning – using chemical baths to change the colour of a print.

Transparency – colour slide film.

Tripod – a three-legged stand that allows the photographer to steady the camera, aiding careful composition and focus. Used to anchor the camera during long exposures when camera shake might spoil a photo. It has the amazing ability to help us see the world beyond the power of our eyes by allowing really long exposures of many seconds, minutes or hours. Used, for example, by Hiroshi Sugimoto.

TTL – this stands for 'through the lens'. A sensor inside the camera reads the amount of ambient light falling on the film. Some TTL systems also read the amount of flash light emitted by a flash gun, then automatically adjust the flash output.

Tungsten film – colour film designed to give natural colours when used in artificial light created by tungsten bulbs.

Ultraviolet – lightwaves beyond the visible portion of the spectrum which can be recorded on some photographic materials.

Umbrella – an accessory used to soften a light source. Some are designed to reflect light when it is shone into them, others diffuse light when it is shone through them.

Uprating – to expose a film at a higher ISO than is standard to the film. This under-exposure is

compensated for during processing.

USB – a socket on computers allowing easy connection to cameras, printers and card readers using a USB cable. USB is short for Universal Serial Bus.

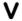

View camera – a camera in which the image to be photographed is viewed on a ground-glass screen at the back of the camera. View cameras are usually large-format cameras using either 5x4- or 10x8-inch film.

Viewfinder – a small window in a camera through which the subject is viewed and the photograph composed.

Vignette – the process of clouding the edges of a photograph, achieved in camera, in printing or by computer manipulation.

Vintage print – a photographic print created by a photographer at the time of or soon after taking the picture.

Wet-collodion/wet-plate process -

a nineteenth-century photographic process for creating negatives. Glass plates were sensitized to light with a sticky mixture called collodion mixed with light-sensitive silver salts. While still damp, the plate was placed inside the camera and exposed; if the plate was left to dry its sensitivity greatly decreased.

Used in combination with the albumen print. It replaced both the Calotype and the daguerreotype, and was replaced by the dry process from the late 1870s. Used by Julia Margaret Cameron.

White balance – the control on a digital camera that can be set to compensate for light sources that differ from daylight balance in order gain accurate natural colour rendition.

X-ray – a light source invisible to our eyes that produces wavelengths that can penetrate most substances to form a black-and-white shadow image on film. Used creatively by Helmut Newton.

Zone system – an aid for determining the correct exposure and developing times to achieve the maximum gradation of grey values in a negative print. Created and used by Ansel Adams.

Zoom lens – a lens that can be adjusted to a range of focal lengths.

Photographers' and artists' websites

Ansel Adams www.anseladams.com

Nobuyoshi Araki www.arakinobuyoshi.com

Diane Arbus www.masters-of-photography.com

Eugène Atget www.masters-of-photography.com

Richard Avedon www.richardavedon.com

Roger Ballen www.rogerballen.com

Banksy www.banksy.co.uk

Peter Beard www.peterbeard.com

Bill Brandt www.billbrandt.com

Brassaï www.masters-of-photography.com

Edward Burtynsky www.edwardburtynsky.com

Julia Margaret Cameron www.masters-of-photography.com

Henri Cartier-Bresson www.henricartierbresson.org

Robert Capa www.magnumphotos.com

Bruce Davidson www.magnumphotos.com

Robert Doisneau www.masters-of-photography.com

Nikos Economopoulos www.magnumphotos.com

Elliott Erwitt www.elliotterwitt.com

Lee Friedlander www.masters-of-photography.com

William Eggleston www.masters-of-photography.com

Walker Evans www.masters-of-photography.com

Ernst Haas www.ernst.haas.com

Horst P. Horst www.horstphorst.com

Peter Kennard www.peterkennard.com

William Klein www.masters-of-photography.com

Nick Knight www.showstudio.com

David LaChapelle www.davidlachapelle.com

Dorothea Lange www.masters-of-photography.com

Jacques-Henri Lartigue www.lartigue.org

Richard Long www.richardlong.org

Robert Mapplethorpe www.mapplethorpe.org

Steve McCurry www.stevemccurry.com

Vik Muniz www.vikmuniz.net

Eadweard Muybridge www.masters-of-photography.com

Martin Parr www.martinparr.com

Irving Penn www.masters-of-photography.com

Sebastião Salgado www.masters-of-photography.com

Cindy Sherman www.masters-of-photography.com

Aaron Siskind www.aaronsiskind.org

Chris Steele-Perkins www.magnumphotos.com

Paul Strand www.masters-of-photography.com

Oliviero Toscani www.toscani.com

Andy Warhol www.warhol.org

Bruce Weber www.bruceweber.com

Weegee www.masters-of-photography.com

Edward Weston www.masters-of-photography.com

Minor White www.masters-of-photography.com

Donovan Wylie www.magnumphotos.com

Further siteseeing

Adbusters www.adbusters.org

Lomographic Society www.lomography.com

Photography, copyright and the law www.dacs.org.uk

Pinhole cameras www.pinhole.com

Must-see photo books

Mary Warner Marien, *Photography, A Cultural History*. Laurence King, London. 2002.

The Photography Book. Phaidon, London.

20th-Century Photography. Museum Ludwig Köln. Taschen. 1996.

Index

Numbers in **bold** are illustrations and numbers in *italics* are for the definitions of terms

5x4 view camera 171, **171** 35mm SLR cameras 170

A

abstraction 68, 73 Action Sampler photography 178, 179 Action Shot 16 camera 179, 180 Action Tracker 169, 169 Adams, Ansel 58, 62, 136, 193, 264 The Tetons and the Snake River 59 Adbusters Media Foundation 111 advertising 6-7, 37, 63, 65-6, 74, 108-11. 135, 139, 141-2, 184, 230, 239-40, 248, 251 airbrush 255 albumen prints/printing 255 albums 106, 157 Alexander, Daniel Kim 119 Screaming Heads 213 ambient light 214, 255 ambiguity 152 ambrotype 255 anaglyph 255 Apagya, Philip Kwame 39 aperture 192-200, 255 Araki, Nobuyoshi 158 Arbus, Diane 28, 100, 102, 135, 201, 217, 251 architectural photography 241 archival 255 archives 249-50 Arnold, Eve 25, 45, 241 art directors 108, 231, 239-40, 243, 247, 249 Arthus-Bertrand, Yann 61 artificial light 214, 255 artist photographers 135-9 ASA 196 assistant, photographer's 243-4 Atget, Eugène 49 Autochrome 209, 255 autofocus 255 automatic cameras 176, 196 available light see ambient light Avedon, Richard 8, 26, 30, 45, 118, 201, 228 Dovima with Elephants 78 In the American West 30 Ronald Fischer, beekeeper, Davis, California, May 9 1981 31

В

back light/back lighting 255
back projection 255
backgrounds, for portraits 30–3, 63, 128
Bailey, David 80, 108, 178, 228
Baker-Wilbraham, Charlotte, Untitled 205
Ballen, Roger 93, 217, 251
Banksy 225
Barnak, Oscar 85
barn doors 255

batch 255 Battista della Porta, Giovanni 17 Bayard, Hippolyte 41 Beard, Peter 34, 104, 113 'I'll Write Whenever I Can...' 44 Beaton, Cecil 30, 77, 107, 155, 228 Broken German Tanks at Sidi Rezegh 98 beauty editors 238 Becher, Bernd and Hilla 105 bellows cameras 22 Benetton 108, 111-12 Billingham, Richard 100, 102 Ray's a Laugh 102, 158 Black, James Wallace 61 black and white 12, 16, 202-7 blonde 220, 255 'bloody news' 85 blueprint see cyanotypes Blumenfeld, Erwin 78, 114, 146, 154 Marua Motherwell 148 body, the 66 Bohnchang Koo, In the Beginning #10 134 books of pictures 100 bounced light 29, 188, 217, 220 255 Bourdin, Guy 80 Bourke-White, Margaret 88 bracket/bracketing 197, 255 Brady, Mathew 37, 94 The Gallery of Illustrious Americans 37 Brandt, Bill 29, 68, 88, 118, 188, 205-6 Belgravia 189 The Magic Lantern of a Car's Headlights 221 Brassaï 51 Brazil 91 Breton, André 181 Bridges, Marilyn 61 briefs 231, 247 Britain 37, 68, 80, 88, 91-2, 136, 155, 176, 254 Brodovitch, Alexey 102, 231 Ballet 72-3 Brook, Will, Pinhole project 132 Brown, Isobel, Les objets de désir 163 Browne, Malcolm 86 Brownie camera 23 burning in 205, 255 Burrows, Larry, Reaching Out 99 Burtynsky, Edward, Nickel Tailings No. 34 62

C

C type print 212, 257 C41 processing 211, 255 cabinet print 256 cable release 256 Calotype 22, 100, 256 cameras 14, 58, 118, 134, 161, 167 choice and types of 118, 142-3, 167-83 controls of 188-200 digital cameras 7, 12, 22, 140-5, 166-8, 172-4, 196, 203, 208, 210 early models 17, 19-24 camera lucida 256 camera obscura 17-19, 21-2 camera phones 140, 167, 172-3, 179, 254 camera shake 256 Cameron, Julia Margaret 136, 191, 204, 255 Sir John Herschel 136

Capa, Robert 96-7, 149 D-Day Landings 96 captions 156 card reader 256 careers 228-9, 231, 241, 251 carrier pigeons 85 Carter, Kevin 86 cartes-de-visite 37, 157, 256 Cartier-Bresson, Henri 45, 88-9, 96, 100. 118, 135, 176, 189, 201, 214 Behind the Gare Saint-Lazare 89 CCD 14, 168, 191, 196, 256 celebrity portraits 37, 70, 236 censorship 99 CGI 81, 141 Che Guevara 150, 153 chemogram 225 China 82, 86, 89, 110 'chrono-photography' 104 Chung, Ken, and Kim von Coels, Face 221 cibachrome 256 city, photographs of 39, 49-57 Civiale, Aimé 58 Clark, Larry 93 Clerk Maxwell, James 209 cliché-verre 225-6, 256 clipping 197, 211, 256 Close, Chuck 13, 29, 135 close-up lens 190 CND photomontage 115 Cobain, Kurt, portrait (Goodacre) 153 collage 68, 112-6, 138, 213 collections 104 college courses 247-8 Collishaw, Mat 13 collodion process 22, 257 colour balance 210 colour cast 256 colour correction 256 colour filters 256 colour negative film 196, 210-12, 256 colour photography 12, 16, 208-12 colour reversal film 256 colour slides 210-12, 256 colour temperature 210, 220, 222, 256 colour transparency 210, 257 communication 245, 248 competitions 249 composition 201 compression 257 computers see digital photography; Photoshop Constantine, Elaine, Girls on Bikes 75 contact sheet/contact print 84, 103, 144, 184, 205, 226, 257 contrast 206, 257 Cooper, Ross, and Jussi Ängeslevä, the 'Last' clock 161 copyright 254 correction filter 220, 257 cove 257 cover pictures 237-8 Cranham, Gerry 73 Croner, Ted, Central Park South 124 crop/cropping 201, 257 cross-processing 212-3, 257 Cunningham, Imogen 193

curator 257

cut out 257 cyanotypes 178, **226**, 257

D

Dada movement 114 Daguerre, Louis-Jacques-Mandé 19, 21-2, 41 daguerreotypes 19, 21-2, 29, 135, 178, 186, 209, 257 Daley, Eric 205 Dalí, Salvador 34, 44, 181 dance 72 darkroom 257 darkslide 257 Davatz, Barbara, As Time Goes By 161 Davidson, Bruce 90, 93, 102, 169 Davies, Robert, Epiphany 73 Davis, Chalkie 65 Dawson, Derek, A Life in Pictures 9 daylight film 220, 257 Deardorff camera 30, 61, 171 death, as subject 8, 41, 84, 94 dedicated flash 257 deletion, digital 141 depth of field 29, 138, 166, 193, 197-200, 214, 220, 257 designer/photographers 142 design groups 230, 239 developer 257 Dex Growing (snapshots) 162 Diana camera 178 Díaz, Alberto, (known as Korda), Guerrillero Heroico (Che Guevara) 150, 153 diCorcia, Philip-Lorca, 51, 251 Eddie Anderson: 21 years old: Houston, Texas: \$20 53 Heads 36 Tinseltown 53 Dieuzaide, Jean 34 diffuse 257 digital cameras 7, 12, 22, 141, 166-9, 172-4, 196, 203, 208, 210 digital fog 141 digital grain 203 digital imaging 258 digital photography 7, 12, 50, 140, 142-5, 154, 166, 175, 248 ISO and colour 196, 203-4, 208, 210, 212, 214, 222 black and white 205 and manipulation 41, 116, 139 news photography 82, 84, 86, 94, 155-6, 217, 233-4 self-portraits 39, 41, 45 digital zoom 173 digitize 258 Diikstra, Rineke 218 Hilton Head Island, S.C., USA, June 24 33 DIN 196, 258 direct flash 214, 217 direct positive imaging 258 Disfarmer, Mike 39 disposable (single-use) cameras 181 distortion 68, 102, 188, 190 Dobson, Jamie, Sound project 133 documentary photography 82, 90, 92, 241 dodging 205, 258

Doisneau, Robert 33, 49, 88, 104, 153

Le Baiser de l'Hôtel de Ville
Dreams of a Tattooed Man
To
Donovan, Terence 80
Drew, Richard, The Falling Man
DSLR cameras 140–2, 172–3
Duffy, Brian 80
dupe 258
DX 258
Dyche, Ernest 39
dye coupler print 258
dye-transfer print 258
dyeline see cyanotypes

E

E6 processing 258 Eastman, George 23-4 edge reversal 258 Edgerton, Harold 104, 146, 161, 195, 216-17, 219 Milk Drop Coronet 147 editorial photography 231, 239-40 Eggleston, William 92, 157 Eisenstaedt, Alfred 87 A Sailor's Kiss, Times Square 82, 152 Ekhorn, Kjell 8, 212 Classmates project 128 Ektacolour print 258 emulsion 258 enlargement 258 enlargers 22, 258 Frmanox camera 84 Ernst, Max 28, 113-4 Erwitt, Elliott 66, 104, 152 Not That Naïve, New York City 105 Evans, Walker 36, 91 event photographers 241 exhibitions 136, 230, 232, 248, 251 exposure 21, 24, 166, 170, 194, 196-8, 258 long and multiple 21, 61, 78, 120, 123-4, 128, 139, 161, 176, 178, 194, 200, 218, 221, 224 extension tubes/extension rings 190, 258 eyes, and the camera 14

F

fashion 74-81, 116, 159, 232, 237 fashion magazines 74, 237-8 fast film 203, 214, 258 fast lenses 193, 214 Fenton, Roger 94 The Valley of the Shadow of Death 95 fibre-based paper 258 fill-in 218, 258 film 12, 14, 85, 140, 166, 168, 178, 196-7, 203-4, 209-12, 220, 258 film cameras 118, 168-70, 173, 176 film cassette 258 film noir 118 films (movies) 97, 118, 131, 149, 176 films, documentary 90 film speed 203-4, 210, 220, 258 fish-eye lens 190, 199, 258 fish fryer 258 five-by-four (5x4) view camera 171 fix/fixing 258

f stop/f number 166, 192, 196, 198, 259

flare 258 flash 28, 51, 84, 104, 157, 210, 214-21, 258 flash and blur 218 flash head 258 flash meter 216, 259 flash pack 259 flat 259 focal length 173, 188-90, 192-3, 199, 259 focus 191 see also autofocus; soft focus format 259 formatting 174, 259 found photographs 114 Frank, Robert 92, 100-2, 110 The Americans 101 fresnel screen 259 Friedlander, Lee 28, 45 Hill Crest, NY 125 Frissel, Toni 78 front projection 259 FSA project (US) 91 full bleed 259

G

galleries 118, 134, 251 Gameboy camera 180 Gandolfi camera 169 Garnett, William 61 Geilhausen, Katrin, Eye (Close-up) 15 gelatin dry-plate process 24 gelatin silver print 259 Georghiou, Nick, Maasai 109 Giant Camera, San Francisco 17 gigabyte 174, 259 Gilden, Bruce 218 glossy print 259 Goldbeck, Eugene O., Indoctrination Division Goldin, Nan 8, 106, 159 'gonzo snapshot' 159 Goodacre, Martin 153 grade/graded paper 259 Graham, Paul 219 grain 203-4, 259 Graphex camera 85 Greenfield, Lois 73, 202, 217 Griffin, Brian, self-portrait 47 Griffith, Phillip Jones 92 Group f64 136, 138, 193 group portraits 40 Guest, Peter 204 gum-bichromate 259 Gursky, Andreas, Rhein II 139 Gysin, Brion 113

H

Haas, Ernst 241
The Cross, NYC 48
Halsman, Philippe 34
Hardy, Bert 88
Harries, Steve, and Mel Bles, Locations project 131
Hatakeyama, Naoya 49
'head shots' 29
health and safety 259
Heartfield, John 114–6
The Spirit of Geneva 114

heliograph 19, 259 188-90, 218, 224 long focal-length lenses 190 Henderson, Nigel 45, 114, 225 Close Up 217 Lorant, Stefan 87-8 Hendley, Dave 128, 143 Variation on Gun I 50 Los Angeles 53, 202 Jamaican roots reggae project 129 Knight, Nick 11, 63, 74, 76, 81, 100, 108, Lubitel camera 179 high contrast 66, 78, 119, 206, 212, 259 110, 167, 219, 224 Lumière brothers 209 high-key photographs 260 Snakes 80 lupe (or linen tester) 261 highlights 260 knuckle 260 Hine, Lewis 90-1 Kodachrome 209, 260 Hines, Babbette 181 Kodak cameras 23 Hiroshima 98 Koh, Robin 58 Maas, Tina, Untitled 163 Hiscock, David 68 Konttinen, Sirkka-Liisa 51, 53 macro lens 190, 261 Hockney, David 68, 114, 135, 138-9 Korda see Díaz, Alberto Madame Yevonde 30, 146, 209 multiple-image portraits 161 Kruger, Barbara 111, 163 Madani, Hashem El 39 Pearblossom Hwy., 11-18th April 1986 magazines 74-6, 87-88, 113, 232, 237-8 138, 146 magic eye 261 Photo Collage Nude, 17th June 1984 68 magic lantern 19, 105, 209, 261 Hoepker, Thomas, World Heavyweight L shapes 261 Magnum 82, 88-9, 92 Champion Muhammad Ali 199 LaChapelle, David 37, 76, 81, 108, 110, 208. Makin Ma, Gazza 163 Holga camera 179 Mamiya camera 54, 131, 169, 173 Hong Kong (Monheim) 56-7 'Giving birth to a shoe' story 79 manipulation 112-3, 116, 154-5, 'Hooded Iraqi prisoner in Abu Ghraib jail' 150 Lamda print 260 Man Ray 63, 68, 137, 146, 225, 252 Hoppen, Michael 6 Land, Edwin 178 Le Violin d'Ingres 68, 137 Horst, Horst P. 77 landscape 58-62 manual camera 261 hot shoe 216, 260 Lange, Dorothea 90-1, 149, 151 Mapplethorpe, Robert 43, 63, 66 Hou Bo 110 Migrant Mother 151 Lisa Lyon 67 Hovningen-Huene, George 77 large format 28, 58, 84, 260 Marey, Etienne-Jules 104, 135, 146 Hunter, Tom 179 Lartigue, Jacques-Henri 6, 28, 106-7, 183, Mark, Mary Ellen, Twins series 178 Hurley, Frank 91, 146 209, 228 marketing 229 Hurrell, George, Jean Harlow 38 Bichonnade Leaping 107 Martens, Friedrich von 186 'Last' clock (Cooper and Ängeslevä) 161 mask 261 Latchley, Alan 118, 156, 169, 202, 240, 244 Mass Observation project (UK) 91 latent image 260 matt paper 261 iconic pictures 148, 152-3 latitude 260 Mayne, Roger 49, 90 impact 108 law, and photography 254 McBean, Angus 30, 146, 154 incident light 260 Lazertran 226 McBroom, Bruce 72 Indrontino, Paula, pinhole images 177 LCD 168, 172, 260 McCabe, David 190 infrared 118, 186, 206, 211, 221-2, 260 Lee, Vincent 11 McCabe, Eamonn 73 inkjet printer 260 Leibovitz, Annie 37, 218 McCorry, Kitty 119, 243 installations 163 Leica camera 85, 89, 176 McCullin, Don 99, 156 internet images 99, 118, 229, 249 Leifer, Neil 73, 236 medium formats 170, 173, 178–9, 261 megabytes/MB 174, 261 IR or R 260 lenses 188, 190-93, 260 iris print 260 and aperture 192 megapixels 172-3, 261 ISO 166, 196, 203-4, 214, 220, 260 lens hood 260 memory card/stick 168, 174, 261 and colour 208, 210-12 lenticular photography 260 Meny, Patrick, Isolated 164 Leonard, Hayley, Nan's Hands 29 Metinides, Enrique 85 Life (magazine) 88, 97-8 Michals, Duane, I Build a Pyramid 104 light 214-22 Mili, Gjon 217 Jackson, Alison 11, 204, 243, 259 and aperture 196 Picasso at the Madoura Pottery Workshop Jacobs, Harry 39 and shutter speed 218 219 Jarecke, Kenneth 99 light box 260 Minox camera 176 light meter 196-7, 260 Jewell, Dick 45, 72, 105-6, 184 mixed light 261 light-sensitivity 12, 166, 168, 196, 203, 210 light waves 222 A Change of Face 115 modelling light 261 Olympic Incident 106 models 74-8, 80-1, 159 'Passport Approved Photo Album' 181 lighting gels 260 Moholy-Nagy, László 110, 225 joiners 114, 138, 260 limited editions 252 Mole & Thomas 40 Jones, Peter, and Lynne Dickens, linen tester (or lupe) 260 Monheim, Fabian 13, 81, 113, 160, 169, 176. Colourscape sculpture 208 liquid photographic emulsion/liquid light 163, 180, 213 ioule 260 205, 260 Hong Kong 56-7 JPEG 175, 260 lith printing 261 mono pod 261 Li Zhensheng 86 Monroe, Marilyn 68, 70, 152 Logan, George, Loch Scridain 223 The Seven Year Itch 152 Κ Loher, Natalie, 360° Female Nude 69 Moon, Sarah 80 Karsh, Yousuf 29 Lomo camera 13, 160, 167, 169, 176, 261 moonlight 221 London 17, 26, 39, 49, 51, 54, 63, 90, 115, Keïta, Seydou 39 Morimura, Yasumasa 70, 72 Kelvins (K) 210, 220, 222, 260 139, 153, 177, 181, 221, 225, 228, 237 Self-Portrait (Actress), Red Marilyn 43 Long, Richard 26, 27, 61 Kennard, Peter 115 Morley, Lewis 68 long exposures 123, 161, 176, 194, 218, Kertész, André 63, 68, 87, 96, 135 Morse, Ralph 217

221, 224

Morton, William 72

Klein, William 50, 78, 91, 100, 102, 118, 135,

motordrive 261
movement 103–4, 106, 146, 157, 194–5, 197, 200, 217–8
movies 97, 118, 131, 149, 176
mugshots 36, 90
multigrade printing 205, 261
multi-lens cameras 15, 179
multiple exposures 78, 123, 128, 178, 217, 224
Muniz, Vik 61, 113
Munkácsi, Martin 77, 87, 89, 176
Museum of Modern Art, New York ('New Documents' exhibition) 28
Muybridge, Eadweard 22, 103–4, 135, 146, 161, 194
The Horse in Motion 103

N

Nagasaki 98 naked body 66-72 Naples 17, 54-5 National Portrait Gallery, London 26 natural light see ambient light negatives 204-5, 212, 261 colour negative film 211-2, 256 Neshat, Shirin 139 Neto, José Luís 204 Newcastle 53 Newman, Arnold, Georgia O'Keeffe, Ghost Ranch, New Mexico 35 news agencies 83, 85 news photography 82-7, 233-4 careers in 211, 228-34, 238, 243 war as news 94 Newton, Helmut 45, 72, 80, 219 High-Heel X-Ray and Cartier Bracelet 207 New York 50-2, 84, 86, 93-4, 105, 107, 124, New York Daily Graphic newspaper 83 New York Daily News newspaper 84 Niépce, Joseph Nicéphore 19, 22 night images 124 night-vision cameras 186 Nilsson, Lennart 72 Nixon, Nicholas 161 normal (medium) focal length 189

0

nudes 135, 137, 189

Ojeda, Alejandro, *The Hand of God* 153 Oktomat camera 179 Onslow, Neil 177 opaline pictures 261 opening up 192–3 over-exposure 196, 261

P

Page, Tim 93
panning 261
panoramas 58
panoramic camera 186, 261
paparazzi/paparazzo 241, 243
Paris 49, 51, 83, 89
Parkinson, Norman, Portrait after Kees Van

Dongen 191 Parr, Martin 11, 65, 208, 219 Sedlescombe 92 Patterson, Guy, pinhole postcards 176 Penn, Irving 30, 63, 65-6, 78, 80, 110 American Summer Still Life 63 Joe Louis 32 perspective-control lens 261 persuasion 108-9 Petzval, Josef Max 21 phone cameras 167, 172, 179 photo-booth self-portraits 45, 181 photocopiers 118, 138, 184 photograms 137, 212, 225, 261 photograph 261 photographer 146, 156, 228 and manipulation 112-3, 116 and the sitter 28-31, 34 as subject 39, 41, 45 photographer/designers 142 photographic agents 240 photographic studio 224 photogravure 262 photojournalism 82, 87-9, 110, 156, 233-4 photomontage 112, 114-6, 155, 262 photo opportunities 228-44 Photo Secessionist movement 136 Photoshop 113, 116, 140-2, 144, 148, 223, photo stencil 225 physiogram 262 Picasso, Pablo 61, 113, 135-6, 219 Pictorialists 136 picture editing/editors 201, 232-3 picture magazines 87-8 Picture Post (magazine) 87, 88, 97 Pierre et Gilles, Self-Portrait 42, 43 pinhole photography 132, 169, 177, 178, 180 pin-ups 70, 72 Pippin, Steven 178 pixel 262 plate camera 262 platinum print 262 polarizing filter 262 Polaroid 80, 138, 143, 157, 169, 178-9, 262 Polaroid film back 262 political campaigns 108, 114 Pop 9 camera 179 pornography 72 portfolios 229-30 portraits 26-40, 234 self-portraits 41-7 Print Club camera 181 print film 262 printing black and white 204-5 colour 212 prints 163, 204, 251-2, 262 processing numbers 166 projects 128-33 propaganda photojournalism 108, 110, 114, 156 proxar 190, 262 Pulitzer Prize 83, 86, 149, 152, 156

R

RA 4 262 Rauschenberg, Robert 137 **RAW** 175 raw lighting 217 Ray-Jones, Tony 214 reality, and manipulation 112-3, 116 red-eye 219, 262 redhead 220, 262 reflected images 125 reflex camera 170-3, 262 reformatting 168 reportage 82, 87 resin-coated paper 262 resolution 172, 262 retouching 81, 155, 223, 236, 262 Revell, Giles, Scarab 10 Richardson, Terry 37, 81, 159 Riis, Jacob 216 How the Other Half Lives 90 ringflash 219, 262 Röntgen, Wilhelm 206 Rosenthal, Joe 83, 86 Old Glory Goes Up on Mt. Suribachi ('Raising the Flag in Iwo Jima') 149, 152 Roversi, Paolo 80, 221 Rowell, Spencer, Man and Baby 71 royalties 153, 251, 254 R-type print 262

S

Sabatier effect see solarization safelight 262 Salgado, Sebastião 91 Salomon, Erich 36, 84 Samaras, Lucas 178 Sawada, Tomoko 45 scan 243 scanners 7, 118, 184-5 Schadograph see photogram 'scoop' pictures 84 security camera 118, 184, 186 seeing 130, 124-7 self-portraits 41-7 self-promotion 141, 230 sequence 9, 103-6, 127 settings 166, 194, 196, 203-4, 208, 210, 214, 220 shadows 121 Shand Kydd, Johnnie, 144, 169 Naples 54-5 Sherman, Cindy, 72, 118 Untitled Film Stills 41 short focal length 188 'shutter lag' 173 shutters 22, 146, 194, 218 shutter speed 194-8, 218 Sidibé, Malick 39 silhouettes 126, 262 silver salts 19, 203 Sinar camera 68, 169, 171 single-use cameras 181 Siskind, Aaron 61, 137 sitters 26, 28-30, 34, 36 fashion models 74-81 slave 263 slides 263 colour slides 210, 256 slide shows 105

slow film 203-4, 210

SLR cameras 170 Smith, Chris 73 Smith, W. Eugene 99 Smithee, Alison 240 Snap camera 180 snapshots 157-60, 158, 160, 263 snoot 263 Sodano, Sandro 63, 148 fashion photography 122 still lifes of bags 65 soft box 214, 220, 263 soft focus 263 soft-focus lenses 263 software programs 142, 223 solarization 78, 137, 263 South Africa 93, 108 Southall, Doug 183 Speed Graphic camera 84-5 sport 73, 153, 217, 232, 234-6 spot meter 263 standardization 166 standard lens 189 Stanton, Hannah, and Vanessa Marisak, Photographic behaviour project 130 Steele-Perkins, Chris 82, 88 The Teds 90 Steichen, Edward 45, 136 stencils 225 stereoscopic cameras/photographs 14, 183, 183, 263 Steiglitz, Alfred 136 still life 63-5 stills photographers 241 stock libraries 142, 241, 249-50 stop bath 263 stopping down 192-3 story-telling 82, 94 books of pictures 100-1 fashion 'stories' 75-6 photojournalism 87 Strand, Paul 36 strobe/stroboscopic light 216, 263 student shows 239-40, 247 student work Heroic self-portraits 46 Classmates project 128 Sightings of Che 150 Sketchbook of photogram experiments 225 studio lighting 30, 214, 221, 224 studio portraits 30-3 Sugimoto, Hiroshi 37, 61, 146, 202 Cabot Street Cinema, Massachusetts 16 Sundsbø, Sølve 81 Super Sampler camera 179 Surrealism 78, 135 swimming-pool light 263 SX70 camera 178 synchroballistic photography 263 sync lead 263 syndication 250 Szarkowski, John 26, 28 'New Documents' exhibition 28

T

tabloids 84 Talbot, William Henry Fox 22, 225

Latticed Window at Laycock Abbey 20 The Pencil of Nature 100 Talbotype see Calotype Tamano, Tetsuya, Untitled 112 telephoto lenses 190, 263 Teller, Juergen 81, 159, 208 Burning Jacket 77 Testino, Mario 37 test strip 263 Thain, Alastair 169 Richard Long 27 thermal-imaging 186 three-dimensional works 163 TIFF 175 Tillmans, Wolfgang 81, 208, 251 If One Thing Matters Everything Matters 157 Tinseltown 53 tintype 263 Tokyo 36, 49, 181 tones 263 toning 263 Tooth, Roger 155 Toscani, Oliviero 108, 111 training courses 247-8 transparency 210, 263 tripod 263 trust 154 TTL 216, 264 tungsten film 211, 264 tungsten light 214-5, 220

U

ultraviolet light 221–2, 264 umbrella 264 under-exposure 196 universal settings 166 uprating 211, 264 USB 168, 180, 264 Ut, Nick 83, 149 'Girl Fleeing Napalm Strike' 86

V

variable focal length 190
Vietnam 86, 96–7, 99, 149
view camera 171, 264
viewfinder 191–2, 201, 264
viewpoints 122
vignette 264
vintage prints 252, 264
Vivex colours 209
Vogue magazine 66, 77–8, 159, 167, 190, 231
Voigtländer, Peter von 21
von Coels, Kim, and Ken Chung, Face 221

W

Walker, Brendan, The Thrill-Sensing Auto-Portrait Machine 164 war 94–9, 152, 155, 161 Warhol, Andy 30, 44–5, 104, 137, 152, 157, 178, 181, 190 Watson, Andrew 9, 61 Figsbury Ring and A303 and Tumuli, Salisbury Plain 60 Weber, Bruce 80–1

websites 140, 142, 168, 230, 244, 248, 250 Weegee 51-2, 84, 221 The Critic (Opening Night at the Opera) Crowd at Coney Island, Temperature 89 Degrees 200 Lovers at the Palace Theatre 206 Weisz, Minnie, Norfolk Suite Camera Obscura Welch, Gary 183, 183 West, Adam 63, 169 Weston, Brett 61 Weston, Edward 61, 65-6, 136, 193 Pepper No. 30 64 wet-collodion/wet-plate process 22, 264 White, Minor 61, 137 white balance 264 Widdows, Lee 74, 76, 118 wide-angle lenses 68, 73, 78, 188, 190, 199 Wilson-Pajic, Nancy, Les Apparitions: Felicia Winogrand, Garry 28, 73, 110, 152, 217 Los Angeles, California 202 wire photos 85 work, as a photographer 228-49

Xerox see photocopiers X-rays 72, 118, 206, 222, 264

Yamanaka, Manabu, Gyahtei 66 Yass, Catherine, Descent 139 Yosemite National Park 58

zone system 264 zoom, digital 173 zoom lenses 190, 264

Photo sources and credits

- 1, 226 © Pajic/Wilson-Pajic. Produced with the collaboration of Slobodan Pajic. After a robe by Christian Lacroix Haute-Couture. Private collection
- 7 Lorentz Gullachsen
- 9 Courtesy of Susie Dawson
- 10 Courtesy of Giles Revell
- 13 Lorentz Gullachsen
- 15 Katrin Geilhausen
- **16** Hiroshi Sugimoto/Courtesy The Pace Gallery
- **18** The Kings Cross Stories, The Norfolk Suite, The Great Northern Hotel, Courtesy and © Minnie Weisz
- 20 ©NTPL/Nick Carter
- 23 Corbis/Bettmann
- 27 Alastair Thain
- 29 Havley Leonard
- 31 © The Richard Avedon Foundation
- **32** Joe Louis (A), New York, 1948. Photograph by Irving Penn. Copyright © 1948 (Renewed 1976) Condé Nast Publications Inc.
- 33 Courtesy of Rineke Dijkstra
- 34 Philippe Halsman/Magnum Photos
- 35 Photo by Arnold Newman/Getty Images
- 38 The Kobal Collection
- **40** Eugene O. Goldbeck/Photography Collection Harry Ransom Humanities Research Center, The University of Texas at Austin
- 42 Courtesy of Pierre et Gilles
- **43** © 1996, Yasumasa Morimura; Image courtesy of the artist and Luhring Augustine, New York
- **44** © Peter Beard, Courtesy of the Peter Beard Studio / Art + Commerce
- 46 Heroic self-portraits by: Jessica Finaurini, Anke Delke, Anya Bachtin, Hannah Werning, Jessica Lundgren, David Andréas, Danielle Joyce, Georgina Bennet, Kira Trowell, Matt Hyde, Tina Röeder, David Tanguy & Alex Czinczel & Regine Stefan, Emma Lewis, Jessica Antwi-Boasiako, Helen Yeung
- 47 Courtesy and © Brian Griffin
- 48 Ernst Haas/Getty Images
- **50** Courtesy of William Klein/Howard Greenberg, New York
- **52** Photo by Weegee (Arthur Fellig)/ International Center of Photography/Getty Images)
- 53 Philip-Lorca diCorcia/David Zwirner Gallery
- 54-55 Johnnie Shand Kydd
- **56–57, 160, 176, 180** Fabian Monheim, fabianmonheim@mac.com
- $\bf 59 \ @$ 2012 The Ansel Adams Publishing Rights Trust
- 60 Andrew Watson
- 62 Courtesy Toronto Image Works
- **64** Edward Weston/Collection Center for Creative Photography ©1981 Center for

- Creative Photography, Arizona Board of Regents
- 65 Sandro Sodano
- **66** Courtesy of Manabu Yamanaka/Stux Gallery, New York
- **67** © The Robert Mapplethorpe Foundation. Courtesy Art + Commerce
- 69 Natalie Loher
- 70 Robert Doisneau/Getty Images
- 71 Courtesy and © Spencer Rowell
- 75 Courtesy of Elaine Constantine
- 77 Courtesy of Juergen Teller
- **79** Courtesy of David LaChapelle/Art + Commerce
- 80 ©Nick Knight/Trunk Archive
- 89 Henri Cartier-Bresson/Magnum Photos
- 90 Chris Steele-Perkins/Magnum Photos
- 92 Martin Parr/Magnum Photos
- 95 SSPL/Getty Images
- 96 Robert Capa/Magnum Photos
- **98** Cecil Beaton with the permission of The Trustees of the Imperial War Museum, London
- 101 Lorentz Gullachsen
- 103 Library of Congress
- **104** © Duane Michals, Courtesy Pace/ MacGill Gallery, New York
- 105 Elliott Erwitt/Magnum Photos
- 106, 115 Dick Jewell
- **107** Photograph by Jacques-Henri Lartigue. © Ministère de la Culture France/AAJHL
- 109 Courtesy of Nick Georghiou. Agency:
- RKCR/YR. Art Director: Jerry Hollens

 112 Courtesy of Fabrica/Tetsuya Tamano
- 114 Private collection. © The Heartfield Community of Heirs/VG Bildkunst, Bonn and DACS, London 2012
- 119 Daniel Alexander,
- www.danielalexanderphotography.co.uk
- **120** Courtesy of Fabrica / concept Guillermo Tragant, photo Enrico Moro
- 123 Courtesy Fabian Monheim, fabianmonheim@mac.com, Simon McCann and Gary Wallis, www.wallispictures.com
- 124 Courtesy Ted Croner/Howard Greenberg, New York
- 125 © Lee Friedlander/Fraenkel Gallery, San Francisco
- 127 Courtesy Joana Niemeyer
- 128 Kjell Ekhorn
- 129 © Dave Hendley
- **130** Hannah Stanton and Vanessa Marisak, AnotherAlbum.com
- 131 Steve Harries and Mel Bles
- 132 Will Brook
- 133 Jamie Dobson
- 134 Courtesy of Bohnchang Koo
- **136** Mansell/Time and Life Pictures/Getty Images
- **138** © David Hockney/Collection J. Paul Getty Museum, Los Angeles. Photo Richrd Schmidt
- **139** Andreas Gursky/VG Bild-Kunst, Bonn and DACS, London 2012. Image courtesy

- Sprüth Magers, Berlin London 147 © Harold & Esther Edgerton Foundation, 2005, Courtesy of Palm Press,
- 148 © Yvette Blumenfeld, Georges Deeton and the Estate of Erwin Blumenfeld.
 Courtesy Kicken Galerie Berlin and Bruce Silverstein Gallery, NYC/Art + Commerce 151 Library of Congress
- 152 20th Century Fox/The Kobal Collection
- 161 Ross Cooper and Jussi Ängeslevä
- 163 Isobel Brown
- 163 Tina Maas
- 163 Chung Kin Ma (Makin)/Makin Jan Ma Ltd
- 164 Brendan Walker
- 164 Patrick Richard Meny
- 167 Lorentz Gullachsen
- 169 Alastair Thain
- 177 Paula Indrontino
- 179, 182 Jo Jackson, Tom Vernon-Kell, Harriet Banks and Rory Brady
- 183 Gary Welch
- **185** Michael Golembewski. Creation of this work was supported by the Audi Design Foundation.
- 189 Bill Brandt, © Bill Brandt Archive
- **191** © Norman Parkinson Limited/Courtesy Norman Parkinson Archive
- 195 Alec East
- 199 Thomas Hoepker/Magnum Photos
- 200 Weegee/Getty Images
- **202** © The Estate of Garry Winogrand, courtesy Fraenkel Gallery, San Francisco
- 205 Photography: Charlotte Baker Wilbraham, Costume design: Kim Francis
- 206 Weegee/Getty Images
- 207 © The Helmut Newton Estate
- 213 Daniel Alexander, www. danielalexanderphotography.co.uk
- 219 Gjon Mili/Getty Images
- **221** Kim Von Coels and Ken Chung, www.thekrumbleempire.com
- 223 Courtesy and © George Logan
- 228 Courtesy MGM/Ronald Grant Archive
- 229 Lorentz Gullachsen

Acknowledgements

I would like to thank Lorentz Gullachsen for all his work on the new text for the second edition. His updates on digital photography and advertising, insights into changing practices and terminology, and advice on new images have been invaluable. He has also kindly provided permission for the use of some of his own photographs.

Thanks to Jo Lightfoot, Sophie Drysdale, Sue George, Sarah Batten and Robert Shore at Laurence King, who commissioned and edited this book, to Dani Salvadori and Thembi Morris-Hale at Central St Martins, to Claire Gouldstone, Peter Kent and Mari West for helping gather the pictures and to Michael Lenz for the design.

Many thanks are also due to all the following people for their invaluable contributions to this book:

Tim Marshall, Lee Widdows, Stuart Selner, Dan Weston, Michael Hoppen, Nicky Michelin, Andy Watson, Steve Harries, Mel Bles, Dave Hendley, Gary Wallis, Alec East, Dick Jewell, Vincent Lee, Jo Jackson, Katrin Geilhausen, Martyn Goodacre, Blaise Douglas, Brendan Walker, Jamie Dobson, Dominic Dyson, Natalie Loher, Joana Niemeyer, Kitty McCorry, Neil Onslow, Hannah Stanton, Vanessa Marisak, Bugsy Steel, Tetsuya Tamano, Antti Ohrling.

Thanks also to the following collaborators and supporters:

Geoff Fowle, Andrew Whittle, John Myers, Omar Vulpinari, Francis Glibbery, Mana Mohebbi, Andy Haslam, Phil Baines, Rupert Blanchard, Jonathan Barratt, Franco Di Lauro, Chris Stevens, Nikolai Kolstad, Joe Boylan, Sue Walker, Alfie Walker, Mac McAulay, David Jones, Richard Doust, Ian Hessenberg, Oscar Gush, Stuart Taylor, Alan Latchley, Chris Ekins, Andy Vowles, Lisa Comerford, Martin Scully, Diego Paccagnella, Jim Powell, Angela De Marco. Tim Douglas, Hugh McDermott, Joe Cox, Valroy Simpson, Georgina Matthews, Pat Dibben, Hiroshi Kariya, The Riffs, Kuka, Nigel Langford, Ray Barker, Tyrone Messiah. Michele Jannuzzi, Muz Mehmet, Douglas Bevans, Red Saunders, Ian Gordon, Margaret Gordon, Stuart Tidley, John Edwards, Mike Sossick, Margaux Ruiz De Luzuriaga, Jimmy Turrell, Kyung Park, Julien Queyrane, Alex Shields and Arthur Miller.

This book was written with the support of a research grant from The University of the Arts London.

Dedication

For E.J., D., O. and D.R.